Kitchen-table
Society

Published simultaneously in the Norwegian series: Kvinners levekår og livsløp
(Women's Living Conditions and Life Course). Editor: Helga Maria Hernes.

MARIANNE GULLESTAD

Kitchen-table Society

A case study of the family life and
friendships of young
working-class mothers in urban Norway

Universitetsforlaget
Oslo – Bergen – Stavanger – Tromsø

© Universitetsforlaget 1984
ISBN 82-00-06778-5

Distribution:

IN GREAT BRITAIN
Global Books
109 Great Russell Street
London WC 1B3NA

IN UNITED STATES AND CANADA
Columbia University Press
136 South Broadway
Irvington-on-Hudson
New York 10533

Printed in Norway by
Tangen-Trykk A/S

*In Memory of
my Mother*

Preface

In this study I have used information about a small number of women in a particular stage in life to say something more general about being a woman in Norwegian society. To protect the anonymity of my informants I have used several devices. The names I have given them are pseudonyms, not their real names. In a few places information is slightly blurred to make it less possible to trace the persons involved. None of the photographs are of the suburbs or the homes of any of my informants.

This piece of research has been funded by the Norwegian Research Council for Science and the Humanities (N.A.V.F.). I was first a research fellow for three years under the Council for Social Science Research (R.F.S.). At the moment I am a researcher on the Research Program on Norwegian cities, administered by the Council for Research for Societal Planning (R.F.S.P.). Thus I want to thank the Norwegian Research Council for support and assistance.

Many people have in one way or another given me help at different stages of the making of this study. First of all I want to thank the young women studied, for their hospitality, friendship, and for what I have learned from them. The fieldwork was a good and inspiring experience for me personally.

When it came to writing up the results, one important source of support has been the women's studies milieu in Norway, headed by Harriet Holter and Helga Maria Hernes. By inviting me to publish in this series, and by encouraging my decision to write in English, Helga Maria Hernes provided crucial inspiration. I have also had the opportunity, several times, to present parts of the material to an interdisciplinary work group on child care in the family, led by Harriet Holter. The other participants are Inger Haugen, Lisbeth Holtedahl, Hanne Haavind, Annemor Kalleberg, Lise Kjølsrud, Anne Solberg and Hildur Ve.

Several other persons both outside and within my own discipline have been kind enough to read some part or some version of the manuscript. I should like to thank Dag Album, Daniel Apollon, Ida Blom, Eeva – Liisa Broman, Ottar Brox, Arent Greve, Abdel Hamid, Sue-Ellen Jacobs, Otto Mathisen, Nigel McKenzie, Howard Newby, Anne Rasmussen, Per Morten Schiefloe, Einar Skogseth, Harald Tambs-Lyche, Ulf Torgersen, Kari Wærness and Dag Østerberg for their comments.

Two persons have more than any other followed the progress of the work and influenced my thinking. One is Jon W. Anderson, who for several periods provided shelter in Heidelberg where I could write in peace. Through his comments on early drafts and through our stimulating discussions, he has encouraged my interest in symbolic anthropology and the study of culture.

The other person I am indebted to is Jan-Petter Blom. In spite of a very heavy work load, he has found time to give me valuable comments on several versions of the manuscript. Our discussions have helped me to bring out more clearly what I wanted to say.

None of the persons who in one way or another have supported me do, however, bear any responsibility for the result.

Last, but not least, I should like to thank Svein Erik Rastad and Gudrun Ølnes of Bergen og Omegn Boligbyggelag for the drawing of a typical apartment plan, Reidar Kvam for taking 16 of the 20 photographs and for skilful assistance in editing the pictures, Bjørg Lygre for her excellent typing of all the different versions of the manuscript, Hans Wilhelm Gullestad, my father, for his general encouragement, and Maria and Frida, my daughters, for putting up with a mother always busy writing.

Bergen, March 1983
Marianne Gullestad

Contents

1. Introduction

This book does not focus on subordination or on power relations between women and men, but on the shape and content of some women's lives, in the context of urban Norway. My aim is to contribute to the current debate in women's studies by providing a detailed ethnographic account of how a small group of young working-class[1] mothers in Bergen, the second largest city of Norway, occupy themselves in everyday life, how their lives are shaped, and what dignity and self-respect means to them. I examine their activities, categories and values, how they define their identities as women, and how they cope with the problems they have. In other words I answer questions about how things are, not what they ought to be, and focus on the problems they actually feel and express. By this detailed approach I want to show what it is that makes people adopt a certain life style, – what sustains cultural differences in everyday life –, and also how these women play a crucial role in creating and maintaining the social networks and cultural life style for their families.

The young women of my study move about in the suburban neighbourhoods where they live and visit friends and relatives. They go to their jobs as charwomen and office workers. On Friday or Saturday night they sometimes visit discotheques and dance restaurants in the city. The most important fora are, however, their homes. Family life and most social life take place in the home, and friends often meet there. Female friends most often gather over a cup of coffee around a small table in the kitchen[2] – the same table that the family members use for their daily meals – or around the coffee table in the living room. The husbands, children, neighbours, colleagues, mothers and other relatives play important but minor parts in the analysis, compared to the young women themselves.

The women can in some ways be regarded as fairly typical of

11

their class and age. They may even, in some respects, represent important trends in current Norwegian social and cultural change. I want to portray as fully as possible the qualities of the lives of these women, to depict what it means to be one of them, not only regarding aspects of their life situations, but also of the ideas and values which shape the way in which they cope with the circumstances of their lives.

In my view, this approach is a fundamental and vital part of what is needed to understand the cultural meanings of biological sex, of why and how the fundamental structure of gender[3] roles in a society is so resistant to change, so tenacious of life. As a research strategy it complements other familiar kinds of research, especially those based on statistical comparisons of social groups and categories. Through these methods women, working-class people and underprivileged groups are often described and analyzed in terms of their misery and what they miss or lack in comparison to other classes and groups. They may for instance be described as having lower education, lower housing standard, and more "passive" leisure activities than middle-class people. These are important facts, but they also reflect research methods that are culturally biased by taking middle-class values for granted, and thereby they do not take account of the conceptions and categories of the people studied, what their lives are really about.

In this study the qualitative methods of participant observation are employed, but statistical indices are also used when they supplement the understanding of the problems examined. I used an empirical discovery procedure, taking as the point of departure problems female friends often and explicitly express and discuss among themselves. In this way I hope, as already noted, to make visible and tangible not only their problems, but also their resources, their problem-solving abilities, and the dignity of their lives.

Some of the problems expressed have to do with marriage, family and household. Something happens to marriage and family when women take on new roles or when traditional roles are changed in certain respects. It is part of the ethnographic picture that studying women implies the understanding of the meaning of family and household. Changes in the larger society, like the labour market, the housing market, and commercial leisure life, have repercussions for the "private" domain of family and house-

hold. And, on the other hand, what happens in the families and the households have consequences for the ways women explore and adapt to the opportunities of society. This study will trace and assess such connections, and explain some of the background for recent changes in family life, especially the rising number of divorces. Divorce has, in my view, different and more profound reasons, meanings and consequences than what is commonly believed. Knowledge of the women's own categories and values is vital to understanding both the direction in which these domains of society are changing, and the reasons why women are more active and visible in some domains of society than others.

Friendship and family life may seem like minor facts. Minor facts, however, speak to large issues. Starting with women as actors one puts a different emphasis on the picture of society. By contrasting and comparing the knowledge gained to descriptions of former and contemporary women in different classes, I hope also, to contribute to an understanding of Norwegian society and culture-at-large, and of the crucial role that women play in their creation and maintenance.

To foreign readers Norway is, ethnographically speaking, a relatively unknown area on the map. Not much has been published on the everyday life ethnography of Norway.[4] To Norwegians, the side of society I describe is at the same time both unknown and too well known. It is about the ordinary lives of ordinary people, and therefore to some extent well known. At the same time there are more subcultural variations in Norway than Norwegians often recognize. What middle-class people, like planners, social workers, social scientists, doctors and lawyers know about the lives of working-class people like plumbers and charwomen, is relatively limited, a fact that certainly influences negatively the quality of their analyses, plans or advice. To such readers the ideas and values described here are both trivial and "exotic". They may seem trivial because in a general sense all Norwegians (and Northern Europeans?) share certain ideas and values. What is interesting and "exotic" is the different contexts for such general ideas and values and their specific meaning in different social circles and situations. Norwegian culture is, for instance, home-centred. Most Norwegians want "a nice home", but what this means varies in terms of equipment and use. Meaning depends on situation and context, and these are the variables I examine.

Analytical framework

Studying women[5]

The last decades have brought a new and, in my view, very necessary academic interest in the lives of women, both in the social sciences and in other disciplines. New and interesting material as well as a range of new perspectives and theoretical work have come out of this wave of studies. Because it is a recent phenomenon, it is difficult to get a necessary distance to what has been done, and to make an assessment of what questions have by now been answered and what questions have not yet even been asked.

Many studies have focused on power relations between women and men and on the subordination of women. This holds not only for the study of Western society but also for the anthropological studies of other cultures, for instance in Rosaldo (1974), Reiter (1975), and Ardener (1975). Ingrid Rudie (1984) and Manda Cesara (1982) suggest that Western women were predisposed to concentrate on this aspect of social relations. According to them one reason is the history of Western feminism. The other reason is the vast amount of material, mainly collected by men, that could be interpreted to support not only the statement that sex is always used as the basis for some social differentiation, but also that there is a universal subordination of women by men (Cesara 1982, Rudie 1984). By considering universal power relations, students have demonstrated that social and cultural meaning is invariably attributed to biological sex. Differences between the sexes had earlier generally been taken for granted and therefore had not been analyzed. To this general tendency notable exceptions may be found; among them the works of Margaret Mead (1928, 1935, 1953, 1961) are most widely read. The new interest in women's studies, however, was often assumed to imply, because of political aims, a tendency to emphasize the universal similarities between women at the expense of the cultural differences between them. Being biologically women became somehow more important or at least as important as what cultures they belonged to. By emphasizing for political purposes the differences between women and men, similarities are hidden and perhaps reinforced (Eichler 1975). Women become more peculiar than they in fact are, in most instances, in relation to men.

14

Cultural analysis is one field that illustrates this tendency to focus on universal subordination. It is indeed striking in cultural analysis how varied are both findings and conceptualizations. It varies from one culture to another what fora women have of their own. In some places they have fora of their own, like the village laundry place or the village well or, in this study, the morning coffee klatches at the kitchen-table. Such fora and relationships are the source of some strength for the development of separate shared understandings between women. There are also variations in what conceptualizations and analytical frames researchers use, how researchers codify the fact that women and men participate in the same overall culture, at the same time as they have, to a greater or lesser extent, activities, ideas and values of their own. Some, like Edwin Ardener (1975) in a well-known article, first published in 1972, and a group of female anthropologists at the University of Oxford (Shirley Ardener 1975, 1978, 1981), have put forward the theory that women generally are *muted* and *inarticulate* concerning overall models of society. Edwin Ardener made the very important point that anthropologists have mostly listened to and written about the ideas and values of men in different societies. But instead of urging female anthropologists to start listening to women in whatever domains of society they are active, he postulated mutedness on the part of women. One reason why this theory has seemed fascinating is probably that it describes so well the situation of Western female anthropologists; what it means to be a Western woman at the university, in political life and in bureaucratic organizations. It describes perhaps less well what goes on in other domains of society. In my view this theory thus seems to have universalized the experience of Western women in areas of life where men have set the rules. After all it posited universal mutedness, even if respect was paid to cross-cultural variation. It left little room for the discovery of eventual domains of life where women might not be subordinated, and where articulate models of society might be discovered.

One question that this study leads me to ask is what are the criteria to define whether or not models are what Ardener calls "grand models". Are, for instance, systems of ideas about the proper handling of personal relationships grand models? Such a system of ideas is not *comprehensive* in the way that it comprehends all of society, but it certainly is *crucial* and basic to the

15

functioning of the whole society.

Another question is from what kinds of data "grand models" may be derived. Often, but not necessarily, studying women means studying "everyday life", because that's where they, in many cases, are surely to be found. Studying ideas and models of society from data about everyday life, instead of mostly listening to the interpretations of specialists on myths and ritual, is a fascinating challenge in anthropology. Everyday life is informed by ideas and values. Even if these ideas and values are often both more fragmented and contradictory than the systematic interpretations made by specialists, they together make up implicit models of society. Such an approach may sometimes make the anthropologist's task hard, but the result will be closer to the life of the majority of both women and men in a given population.

To compile this book I have listened to women's talk when they are together and examined their activities. As we shall see, this material leads to different conclusions than mutedness and inarticulateness. My approach is, in a way, closer to the perspective implied in the concept of women's culture or female culture (Chesler 1972, Ås 1975, 1982) than it is to the theory of mutedness. This perspective concentrates more on everyday life than on "grand models" of society. According to the concept of women's culture, women are not inarticulate and their models muted; on the contrary they have a culture of their own. Positive as this notion is, it has had the merit of highlighting and making visible the activities and ways of women, as well as functioning as a "therapeutic tool" (Ås 1982) for Western women. The problem is, however, that this concept also postulates instead of being a procedure for discovery. It is an empirical question to what extent and under what conditions and circumstances women may be said to have a culture of their own. One may also discuss to what extent female culture or women's culture is the best label for women's "ways". The choice one makes depends on whether one sees the difference between cultures or the difference between women and men as most important, and upon what one wants to explain. It also depends on which theoretical approach to the study of culture is used. The uneasiness in this respect reflects a general looseness and vagueness in the study of culture. My own view is that culture always is relative to fora and relationships. Women are both different from men and similar to men in cultural terms; they share at the most general

level the same ideas and standards of evaluation, but through the different circumstances of their lives they struggle with dramatically different dilemmas. Thus, from my point of view, general values and ideas are, through life experiences and behavioural solutions to problems of daily life, interpreted, elaborated, and given particular form and meaning which differs between the two sexes, at a specific level.

Related to the above discussion is the problem of the meaning and impact of sex and class in Western capitalist societies. This is an old problem, but has not yet found a satisfying solution. Still the problem is often put in a very crude way: What is most important, sex *or* class? The difficulty is to find suitable ways of handling analytically how *both* sex and class and other factors, in complicated ways, come together and shape the lives of women, to make analyses that pay due respect to the multiplicity of dimensions simultaneously at work.

There is thus, in my view, still work to be done in collecting ethnographic material about the shape of women's life in different cultures and their roles in creating and maintaining important instructions, ideas and values. To give fuller pictures of society and culture there is a need for data about women's everyday activities, data where women have not only been observed, but have also been talked to and listened to. As examples of such ethnographies several works could be mentioned, for instance Jean Briggs's (1970, 1974) work on Eskimos and Anette Weiners' (1976) study of Trobriand women. When theories are constructed on the basis of such kinds of information, there is reason to believe that the statements of universal subordination and universal muteness can be modified, qualified and nuanced. There is also reason to believe that new research questions, less Western based, will become more prominent in anthropological studies of women.

Studying urban life

The present study is an urban study, a fact that implies certain analytical challenges. A city is a very different kind of physical and social environment from a rural village. Theoretically the urban/rural distinction is dead, but it survives as a continuum with the complex interaction of several different factors (Frankenberg

17

1966). Ulf Hannerz (1980) has made the important point that urbanism is not one way of life (Wirth 1938) but many ways of life. In his view one fruitful way of approaching the city is to use what it means to be a city inhabitant as a guiding question. And since there are many different city dwellers, one arrives at something like an ego-centred perspective with variable egos. Each can be seen as carving out a personal round of life from the totality of the metropolis (Hannerz 1980).

My main interest is, however, to study patterns of life style in an urban context. Starting with the social person is but a means to that end. This procedure implies, as we shall see, a somewhat unusual combination of research traditions. This has forced me to deal with problems of method that have not been adequately treated in the literature.

By mapping out her participation in different activities, settings and types of social relations, the social person and her round of life provides the empirical point of departure for an analysis of life style and patterns of cultural themes in this part of Norwegian society. While keeping the total round of life in view, particular attention is given to selected social occasions, belonging to different activity fields or domains. By domain I simply mean elementary contexts, foci for activities, fora and relationships, that informants themselves compartmentalize and categorize as separate and distinct from each other. Hearth and home, paid work, discotheque-life, and the neighbourhood are, for instance, distinct domains in the lives of my informants. I examine how and to what extent participation in some domains influences and sets the premises for what goes on in other domains.

Life style patterns are studied as they manifest themselves in social relationships. The empirical focus is on personal face-to-face relations, especially in family and friendship relations. These are important for company and emotional contact. Husband, friends and relatives are people whose judgement and confirmations count. This research focus is close to some of the core questions in social anthropology, both in primitive and complex societies. In urban society personal face-to-face relations are, however, only one among many kinds of interactions. They may be divided into traffic relations (physical presence with little more contact than avoiding bumping into each other), greetings in more distant relationships, personal and formal face-to-face relations,

and systems of indirect relations (Barth 1978). While traffic relations and impersonal face-to-face relations may be most distinctive for city life, indirect relations may sometimes be more important. Decisions with drastic consequences for the lives of city dwellers are often taken in fora beyond their reach. For instance, decisions about setting up a new plant or regarding slum clearance profoundly affect the fora and major conditions of life. Also city dwellers influence each other indirectly in important ways non-hierachically.

In my view city life is most aptly characterized, not by any one of the different kinds of relationships noted above, but by the existence of all of them simultaneously. A study of family and friendship relations, of how urbanites build some kind of "communities" around themselves, has, to some extent, also to take these other kinds of relations into account. Firstly, indirect relations are often involved in large scale changes that affect people's roles in personal relations. Secondly, people make choices to establish or avoid closer contact on the basis of categorical relations. A woman who dresses and makes herself up in ways that are considered "cheap" may for instance be automatically placed by other women in a category of being "cheap", of not being "one of us", and closer contact is therefore avoided.

It is thus fundamental to an analysis of friendships to establish their boundaries. Knowledge of the attributes of outsiders is important in order to understand who is inside. Which outsiders are potential insiders, and which outsiders are not, are important questions. I analyze the categories relating to who fits in with whom, and some of the signs used for presenting oneself and to codify other people's presentation of themselves. When people talk about events and incidents they evaluate the performance of the persons involved. They also reveal important categories and values while legitimizing their own actions to others. The young women distinguish themselves both from "students", "high-up people" and stigmatized "social cases". They apply sanctions to each other if one of them tries to put on airs or breaks important moral rules.

Family, friendship and neighbourhood are part of what Eric Wolf has called "interstitial, supplementary and parallel structures in complex society" (Wolf 1966). I believe, like Wolf, that such structures are worth examination. Both men and women in

Norway participate in such structures and activities. But a larger part of women's lives is acted out in these domains than men's. To study women is accordingly to make female activities and scenes more visible in descriptions and conceptualizations of society, and to change the perception of these domains of society as being of little importance.

Some attention has earlier been given to two poles in Western women's lives, work and family, and to the need to see connections between them so as to understand women's social participation. Sometimes a third field is included, neighbourhood or local community. This is sometimes seen as a field with a dynamic of its own, at other times as an extension of the family as opposed to the rules of occupational life.

In this study I examine aspects of family life, neighbourhood and especially relations with friends, wherever they are located. Some female friends are also neighbours, but many of them are not. I also discovered in my fieldwork that restaurants and discotheques are important fora. They are fora whose influence on urban women's lives has received little attention up to now in social studies.[6] The city is more than a collection of workplaces and neighbourhoods; it also includes a variety of centralized functions, among these different kinds of commercial amusements. For the women of this study, restaurants and discotheques serve as fora for acting out aspects of their identities as women. It is interesting to ask what this new activity for married women without male escort means to the women themselves, and how participation here influences participation in other activities. During my fieldwork this, in fact, became one central theme.

Changes in society and family life represent a challenge to both husband and wife, but this has a different meaning and different consequences for the two sexes. In the web of relations between family, work, personal life and friendship lie some of the mechanisms and intermediations between the individual and the macro-level of society, between a, in many cases, subjectively relatively meaningful life on the micro-level and the situation of women generally that can be read out of the gross statistics: Women are invisible in the central and powerful parts of society. They have very few acknowledged leading positions, but, as we shall see, there are domains of life where the women described here are both strong, active and enterprising. By actively pursuing values that

20

are important to them, in the context of the opportunities and constraints of their life situations, the women of this study are, however, caught in a magic circle leading from hearth and home out to paid work and discotheques and back again.

Social identity as a relational concept[7]

Kitchen-table society consists of female friends conversing with one another. When talking they introduce topics from their other fora and relationships. Roles and positions are central concepts in my analysis of their conversations, as well as the tasks at hand (Barth 1972). Positions define rights and duties in social relationships and roles are the dynamic aspects of positions. Positions and roles govern what people do in encounters and in what ways they do it. When young female friends converse together the way they talk and what they talk about are governed, for instance, by the norms and expectations of friendship. But the content, the topics of their conversations, also comes from relationships and domains other than the friendship relation in question. To understand more of what their conversations are about and how their lives are composed and lived, I have found it useful to elaborate on the concepts of identity and identity-management. People bring other aspirations and parts of themselves to social encounters than what can be summarized in terms of the positions and roles at hand. These dimensions of their persons influence actual behaviour to a considerable extent. Social identity may be regarded as the answer to questions about what kind of a person one is or wants to be. I see identity-management as a part of the communicative aspect of behaviour, how people seek self-respect and confirmation from others. Self-respect in my view is ultimately linked to confirmation from others. The problem of these women in a complex urban society is that they have no clear and unambiguous notions at hand about what it means to realize oneself as a woman. Ideas and values are contradictory when brought together in concrete situations. These young women thus face problems of how to handle standards of evaluation in their different personal relationships. Identities realized in one relationship (for instance being a mother and a wife) are also submitted for confirmation in other relationships.

Sociological and anthropological literature is very vague and

21

confused about the concepts of self, social identity, personal identity, position, status and role, because different writers define these concepts in different ways. To develop a perspective on identity-management, I have had to borrow bits and pieces from different sources and develop them further to fit the needs of the present study.

One key problem, as I see it, is how the concept of identity is to be used in relation to the concepts of positions or statuses and roles.[8] As already noted, I see the relationship between social identities and the positions available to actors as a complex one. It is useful to distinguish between the statuses/roles that define situations and other identities/statuses/roles that are part of the content of the same relationship, because identities that people want for themselves or that they ascribe to others are often not directly connected to positions. Some identities, like those defined by ethnicity, age, sex and class, do not refer directly to positions. They constrain recruitment to, and the form and content of, role-relationships (positions), but they are not in themselves positions in the structure of social relationships. Other identities, like that of being a mother, are more directly relevant to how a person, in the capacity of being a woman, relates to her own children and to the outside world with reference to her rights and duties in this capacity. Being a mother, in the Bergen population studied, is a composite role that is all important and directly transformed into an identity. It is particularly important to the incumbent.

Through my fieldwork I have isolated two identities which do not refer directly to any position but at the same time they are both extremely important for the young women studied, for their feeling of worth and self-respect as women. One identity is being a morally responsible woman. The other identity is being a sexually attractive woman. These identities are easy to overlook precisely because they are not directly connected to positions, and because they are often not acted out in verbally explicit ways, but as extra non-verbal dimensions of other activities and roles. They are there all the time, but are not always made verbally explicit in situations. When one is talking about other people and events or legitimizing one's own actions, their importance may be revealed. Positions do, however, give greater or lesser opportunities of acting out one or both of these identities. Sometimes they are conflicting.

Often, then, identities are not positions *per se* but influence

specific ways of performing one or several roles and the personal characteristics associated with this way of performing. The attractive woman identity is particularly expressed as a dancing partner at discotheques, but this is not the only role that provides opportunities for acting out that identity. Being morally responsible is also expressed in most roles. A woman wants for instance to show not only that she is a mother, but that she is a good mother in the way it is defined in her circles. Signs of this may be dressing her children neatly and putting them to bed early in the evening; and awareness of this is relevant in other relationships. By this she signals both competence, moral responsibility, and social class – what reference groups she identifies with. Persons signal several identities at the same time in many situations.

In this way individuals often build up personal relations in such a way that their performance in other roles may be evaluated and confirmed. Performance in other roles and relationships are then transformed to communicative resources or limitations, to social identities presented, in one particular relationship.

Important social identities may consist of a feeling of belonging to a category or a reference group. Statements like "I am such and such kind of a person" imply ways of categorizing persons and certain standards for the evaluation of their behaviour. As such they are especially important in cities with their relatively fluid social life. Because of social and geographical mobility and the heterogeneity of the city, many situations are characterized by few explicit rules, different competing codes, and a minimum of specific information about other participants. Standards belonging to an individual's different identities need not always be harmonized and may sometimes be partly in conflict.

In line with McCall and Simmons (1966) (but disagreeing with other parts of their definitions), I see social identity as being what people regard as important about themselves. They define an identity as "the character and the role that an individual desires for himself as an occupant of a particular social position. More intuitively, such a role-identity is his imaginative view of himself *as he likes to think of himself being and acting* as an occupant of that position" (McCall and Simmons 1966 p. 67). Moral values that are strongly held determine the identities one seeks for oneself. The anthropologist records somehow the emotional investment people put into some activities compared to others, and the joys or

disappointments of success or failure. By this it is possible to isolate the diacritical signs and markers in which social identity is expressed. In an analysis of identity-management one wants to know the diacritical signs used to symbolize identities, and the social processes whereby identities are confirmed or rejected by other relevant persons.

Persons differ in terms of the communicative resources that their knowledge, their personal biography and life situation represent for identity-management. They may use elements of behaviour, objects, settings and attitudes expressed to serve as diacritical sign objects. Persons often build up identity by elements that they themselves regard as prestigious or, in some cases, least stigmatizing, and that they believe may be confirmed by others. In doing this they may choose from large repertoires of signs, repertoires in relation to which they are differently situated. What they seem to be doing is to put repertoires together, out of heterogeneous experiences.

When people meet in an encounter they need to find out what are the frames of references and the identities of the participants. They need to know with whom they most probably would fit in in terms of way of life and personal characteristics. The question is what people think of each other and by what diacritical signs for identities they arrive at an agreement about complementary positions and other parts of the definition of the situation.[9] Identities, like positions, tasks and occasions are negotiated in encounters (McCall and Simmons 1966). Participants in an encounter are both performers and audience to each other. In these capacities they negotiate the different elements of the total definition of the situation.

Social class and subculture

Social identities are, among other things, about categorization of oneself and others. Some categories have to do with subculture or social class, they express different kinds of social groupings – reference groups or actual corporate groups. For this reason the study of identity-management is one approach to the understanding of social stratification and status groups.

The perspective I use is also inspired by Barnes (1952), who introduced the influential concept of social networks. In his analy-

24

sis of a Norwegian island parish, Barnes saw social networks as an expression of class. Because of its general topic, his argument is perhaps the most widely known single piece of Norwegian ethnography.

In this study I look at the field of friends and acquaintances, without necessarily calling this field social class, as Barnes did. What I have studied is subculture, not social class *per se*. I give a detailed account of one way of life in contemporary Norway, of a constellation of behaviours, ideas and values acted out within specific social boundaries. This way of life is compared to other contemporary and former ways of life. I also look at how people categorize themselves and others, and how they construct social relations on the basis of such categorizations. The perspective may be called a folk view of social class.

The information about their way of life and what model they have of how society is composed of different social groupings living different kinds of lives, is not exhaustive for Norwegian society. One needs more information of the same kind from other social groupings to make comparisons and contrasts. Systematic information of this kind is scarce. Based mostly on reading but also to some extent on personal experience, I have made some comparisons and contrasts to other social groupings. The idea is to make a tentative sketch of parts of a typology of Norwegian urban subcultures. Since I have less systematic knowledge about lifestyles other than the one I have actually studied, this may seem clumsy or even unscientific as a procedure. Its value is, eventually, to stimulate further research.

My problem while making these contrasts has been how to label different subcultures. My informants use particular expressions of their own when referring to different social groupings. In addition to their categories I have found it necessary to find some labels or shorthand expressions to characterize their milieu in relation to other subcultures in urban Norway. I label their milieu working class, in spite of the fact that strictly speaking some of them do not belong to this category (see chapter eight and Appendix II about paid employment), and use this label as a shorthand expression to characterize them in relation to the life styles of what I term business upper middle class, academic or "student" middle class, and different kinds of stigmatized groups. The point is that there are divisions concerning life style in the middle and upper class as

well as in the working class. I am not very satisfied with these shorthand expressions, because they are neither analytically precise nor an adequate translation of my informants' categories. Such expressions are commonsensical to social scientists, but not necessarily so to informants who tend to de-emphasize class. It is also problematic to use the term class for what really is not class, but life styles or subcultures. The drawback of this procedure is thus to confuse class and subculture. Its advantage is, however, that such a confusion is common in the social sciences, and the reader is thus given the best associations about what kind of social grouping is meant by the label.

It is probably clear by now that my approach is very different from a Marxist class analysis. In some respects it is somewhat closer to a Weberian analysis of status groups. Max Weber (1971) made the distinction between status group *(Stand)* and class. Status groups are subjectively recognized by the members of society.

Information about the classifications people use themselves may, in my view, by being supplementary to a class analysis in economic terms, contribute to a more complete understanding of a class society. Most class analysts would probably agree that the usefulness of an analysis of economic class structures is demonstrated by its being able to explain (or even predict) social and cultural differences and conflicts. It has been an ever-present theme, both in the writings of Marx and in the different later traditions of thought, that the working classes do not always engage in the struggles predicted by the class structure. This has led to various efforts, either to extend the analysis to cover not only economic but also social and ideological realities, or to incorporate other traditions of thought into Marxism, especially Freudian thinking. Compared to this, my project is different; it is to start at the other end, so to speak. Class analysts start by analyzing class structure, and I start by analyzing social and cultural differences, as they emerge in the daily lives of my informants. I see a cultural treatment of the class dimension as an important supplement to treatment in economic terms.

The problem is only, as already noted, that there is no one-to-one-relationship between the class structure and the way people live, the way each social grouping perceives themselves in relation to others. Most of us have a strong feeling that there is a connection between class and subculture, but the connection is a loose

one. Position in the class structure gives some important conditions for how each life can be composed and lived, but other factors also play a role and complicate the picture.

My solution to this problem is to list occupations and to use them as a kind of anchoring point for stratificational or status group differences. Occupation is not the same as class position, but together with other data, like rough estimations of income and consumption profile, it gives some indication of class position.

There are as already noted many unsolved problems in class analysis. One kind of problem has to do with social change. Erik Olin Wright (1978, 1980) is one of those who have revised and supplemented Marxist categories to make them fit better the reality of advanced capitalist societies. But still many questions about how education and the welfare state influence class structure, and especially questions about women and class, are unresolved. Neither traditional nor newer class analyses fit the situation of women very well. Are they to be placed according to their father's, their husband's, or their own class position? What difference does it make if they work part-time or full time? What does it mean that women generally have different kinds of jobs than men? It is outside the scope of this study to participate directly in this debate, but its findings may perhaps contribute some material of relevance.

Identifying patterns of cultural themes

As noted earlier, I want to identify culture patterns, patterns of life style in an urban context. The young women struggle with a set of dilemmas, or cultural themes, which together may be seen to make up a pattern.

Working in other societies than our own has taught anthropologists sensitivity to cultural differences and to the problem of cultural translation. Culture is about meanings, about ideas and values. Like Clifford Geertz (1975) I hold that culture cannot be studied in isolation from social action: "If anthropological interpretation is to construct a reading of what happens, then to divorce it from what happens – from what, in this time or that place, specific people say, what they do, what is done to them, from the whole vast business of the world – is to divorce it from its applications and render it vacant". (Geertz, 1975, p. 18).

To achieve this end I have utilized different analytical tools. While being cognizant of social action, I try to extract what is most striking in their way of life. I make few comparisons between the life situations of different informants in the light of the opportunities they have and the different choices they make. I rather extract the average, what is most typical in their way of life, and compare this information with information about a few other groups in Norwegian society.

The mapping out of the actors' participation in different activities and the identities they pursue is one step in this analysis. It has also been important for me to record not only what the women do, their actions, but also their notions, and the terms by which they interpret action, their ways of thinking, their universe of discourse. Seen from this perspective what people say is not less important than what they actually do. The ideas and values implied in what they say are premises in actions, as well as in the interpretation of actions.

Following Gregory Bateson (1972) I hold that codification and evaluation are two sides of the same coin. If people for instance strive to have a nice home this is an important value to them. But the value of a nice home is closely connected with the ideas they have about what a home is and what a nice home looks like.

The women in this book participate in various domains of life and want to confirm identities that are important to them. Some identities and domains are conflicting and present value dilemmas to solve. Integrating various domains is on one level the problem of harmonizing moral "rules" and practices. But domains and the integration of them also articulate more fundamental cultural dilemmas.

As women, they struggle with the conflict between being at the same time attractive women and morally responsible, a particular female dilemma. In its particular sense they share it with other women of their social milieu – and in its most general sense probably with all Western women, regardless of ethnicity or class.

As Norwegians, they struggle with a cultural theme that has to do with egalitarianism. Variations of this theme are found in different domains of life. Equality, for Norwegians is social equality (Jayavardena, 1968). In the article already mentioned about "Class and Comittees in a Norwegian Island Parish" J. E. Barnes (1952) pointed to the way Norwegians construct social relations

28

such that similarity and not difference is confirmed. The present study may in many ways be regarded as a confirmation, elaboration and expansion of this empirical theme, extending Barnes' statement to other domains of life. I will demonstrate that equality is codified as similarity, as being and doing the same, and how this idea makes handling all kinds of differences, including differences between the sexes, problematical. The egalitarian theme exists in many different domains and is in its most general version common to women and men. It has however dramatically different consequences in the lives of women and men.

By identifying dilemmas this stepwise way, I am thus able to identify a culture pattern that very much of the lives of my informants evolves around, and can be explained by. By the questions I ask and by the way I build up the analysis, I am in many ways analytically inspired by scholars so different as Ruth Benedict (1934, 1946), Gregory Bateson (1972), and Clifford Geertz (1972, 1975, 1976), without, strictly speaking, following the methodology of any of them.

What I do is mainly to record one way of life and its connected ideas and values, but also, to some extent, to abstract their more general meaning, and ask what the empirical references for those ideas and values are. There is no easy answer to such questions. It is easy to commit the fallacy of thinking in terms of one society, one culture, and reify cultural boundaries. I see it as outside the scope of this study to be precise about answering this question and choose to leave it partly unanswered, to be deliberately vague and imprecise. Western Norway or the nation state of Norway is obviously the reference for some cultural ideas, the region of Northern Scandinavia, Northern Europe and even the entire Western World for others. Cultural variation is continuous, and it is a matter of the problem at hand where to draw the boundaries. As a hypothesis it seems reasonable to state that Northern Scandinavia is an empirical reference for some of the most abstract generalizations of ideas identified and discussed.

Some notes on the setting

Norway is a sparsely populated country in North-western Scandinavia. Ethnologists often distinguish between Northern and Southern Scandinavia, concerning livelihood, stratification and

culture. Southern Sweden and Denmark belong to one social sphere, whereas Norway, middle and Northern Sweden belong to another. Northern Scandinavia has been more homogeneous and less stratified than Southern Scandinavia.

In this region lies the nation-state of Norway. Historically Norway is a new nation, first ruled by Denmark during 400 years, until 1814, and then ruled by Sweden until 1905. The area is some 324 000 km^2 and the population is slightly above 4 millions (1980 census).[10] Long distances and dispersed habitation have influenced social life. Traditionally fishing, agriculture, forestry and shipping have been the most important bases for livelihood. Industrialization started relatively early in Norway, but in the beginning industry was dispersed and the part of the population employed in industry was small. Today Norway is an industrial country moving into the "petroleum age". In agriculture and fishing there have also been, over the years, changes towards fewer people occupied and a higher technology. Agriculture is, however, still a relatively important sector in the economy. Seven per cent of the male population was occupied in agriculture in 1970.[11]

Urbanization on a major scale has been late in coming. In 1960 43 % of the Norwegian population lived in sparsely populated areas and 57 % in densely populated areas. By 1970 the picture had changed. Thirty-four per cent of the population lived in sparsely populated areas and 66 % in densely populated areas.[12] The largest cities have a somewhat different development from the smaller ones. In the first half of the last century the three largest cities (Oslo, Bergen and Trondheim) contained a substantial part of the Norwegian urban population but only 5 % of the total population of the country.[13] In the second half of the nineteenth century their share of the total urban population rose to one half, and their share of the total population to 15 %. In this century the larger cities have had considerable expansions in area, but less growth in population. Inside the cities population size has been reduced in the inner zones and has risen in the outer zones. In recent years, at the end of the 1970s, population development in the largest cities has stagnated or been somewhat reduced. This means that many rural families moved into the city in the second half of the last century, that quite a few are first generation inhabitants in cities, and most urbanites have relatives in the countryside.

The traditional peasant adaptation along the West coast often consisted of a combination of farming, with a few cows, sheep and goats, and of fishing and economic activities in the homes, like making nets, slippers and so on for the market. Farms were usually small, and they used many resources to survive. The division of labour was one where the wife tended the farm while the husband went fishing (or doing construction work). Women were thus often used to rough work, and to being alone for long periods with total or major responsibility for the household and for the farm. This is one of the backgrounds against which the women of this book may be regarded. Three of them have grown· up in the countryside and several others have rural origins one, two or three generations back.

There are, traditionally, some regional variations in Norway. In Western and Southern Norway social life was relatively egalitarian. Holdings were small and there were few big landowners. Economic differences often depended to some extent on luck and personal ability and gave less foundation for social stratification than in the broad valleys in the Eastern parts of the country where one found, relative to Norwegian conditions, both rich owners of farmland and forests and a landless proletariat of some size. In a classic article, first printed in 1957, Gabriel Øidne (1975) has shown how the differences are not really between the Eastern and the Western parts of the country, but between (a) the North Sea coast and the rest of the country, and (b) between those Eastern rural communitics in a flat country and the rest of the country. The North Sea coast (in the West and part of the South) is sometimes humoristically called "the dark coastal strip" *(den mørke kyststripa)*, because it is traditionally characterized by strong adherence to pietist religion, to total temperance and to missionary work.

There are also strong differences between life in the cities and life in the rural areas. Pietist religion and total temperance have their strongest hold in the rural areas. But the recent urbanization of Norway is all the same reflected in ideologies and notions both in everyday life, in politics, and even in the social sciences. Norwegians, like other Northern Europeans since the Romantic period, have relatively few positive images of urban life, with the exception that the small town is often romanticized together with rural life. The big city is often depicted as being full of evils, inconve-

niences and temptations. Such ideas are common and deeply held. Ideas of the good life often look back in time, to the supposed qualities of local communities and tiny little peaceful towns with white wooden houses.

One aspect of urban life is that there is more heterogeneity and social stratification than in the Norwegian rural areas. Especially Western, Southern and Northern Norway has, as already noted, been relatively egalitarian. According to historians, life in the Norwegian upper class is more different from its counterparts in Europe than from life in the working class (Dahl and Vaa 1980). People in the upper class have been less wealthy and more divided between themselves than the upper class in both Denmark, the Southern part of Sweden, and in other European countries, both historically and today. There has never been, in the European sense of the word, a landed aristocracy of really wealthy families in Norway.

Class differences are today also modified by the social democratic welfare state. In this respect life in Norway is similar to other Northern European countries. Especially since World War II there has been considerable governmental effort in the sectors of housing, social policy, health care, state insurance funds for the old, the disabled, the unemployed, unmarried and divorced mothers, and so on. For the women of this book, in the stage of life that they are in, the support given to unmarried and divorced mothers is important. These payments make it possible to survive, but not live well, as a single female with children.

The straitened economic situation during the last few years, from about the middle of the seventies, implies little further growth of social welfare provisioned by the state, but this fact has not yet (1982) had any drastic consequences for the women described here.

Economic class differences, thus, do exist in Norway, but there are reasons to believe that they are smaller than in other European countries. Part of the picture is, however, in my view, that Norwegians like to think that class differences are small, supported by the already mentioned interactional style that de-emphasizes differences. Also studies of differences other than class differences may be interpreted to support this view. Blom (1965) has for instance shown that in spite of considerable variations in life style resulting from adaptational strategies with reference to general and shared

standards, mountaineers and lowland peasants are not differentiated into ethnic groups. The differences between them in everyday life style is related to their adaptational strategies to be similar, that is to realize shared cultural goals about hospitality. In an earlier study (Gullestad 1979 a) I have demonstrated the same thing for the relationship between established multi-generational urbanites and recent rural migrants in Bergen.

The city of Bergen may perhaps be characterized as the most urban of Norwegian cities. Founded more than 900 years ago, flourishing on trade through hundreds of years, and the largest city of the Scandinavian peninsula in the late middle ages, it is a city of some tradition. Bergen is situated on the coast of the North Sea, between seven mountains, and oriented outwards rather than to a rural hinterland. The harbour has been important for the livelihood of its people. Traditionally, Bergen is a city of commerce and shipping, used to being open to contacts and influence from abroad. The Hanseatic league[14] dominated its commerce for several hundred years, trading in dried cod and furs from Northern Norway and cereals from the Baltic countries. Many of the German Hansa merchants settled in Bergen, as well as merchants and artisans from The Netherlands, England and Scotland.

Perhaps because of the Hanseatic influence, the merchants of Bergen are said to have been different from those of other Norwegian cities. They formed social circles that were more or less closed to outsiders, but somewhat isolated from the rest of Norway. The social polarization between rich and poor was also somewhat higher in Bergen than elsewhere in Norway. The Bergen merchants formed a bourgeoisie with "European" values. They had experienced ways of life abroad that they tried to realize in a small-scale city by European standards. Working class people of Bergen may be said to have had a "craftmanship ethos" that dominated their life style (Gullestad (1979a), whether separate individuals were artisans or not.

Because of its orientation outwards, and its trading in fish from Northern Norway, polarization between Bergen and the rural hinterland also seems to have been stronger than elsewhere. It is for instance believed to have been more stigmatizing to have a rural background in Bergen than in other Norwegian towns and cities.

According to both the national and local stereotypes, people

33

from Bergen are known for their extreme local patriotism, as expressed in the standard joke "I am not from Norway, I am from Bergen!" They are also famous for a certain sense of humour and verbal virtuosity. They are known to be fast talkers, in contrast to Norwegian peasants, who in comparison are rather slow, careful and indirect talkers.

People from the rural hinterland, moving in to Bergen, have thus met and, after one or two generations, been assimilated into, a distinct urban culture. But to be a *real* Bergener takes 3–4–5–6 generations, according to the real Bergeners themselves.

Today Bergen is the second largest city of Norway with some 209 000 inhabitants (1980),[15] and hosts one of Norway's four universities. Service occupations have been rising in numbers. Industry is numerically the most dominant occupation, while commerce and shipping still seem to be the most important ones in the minds of the inhabitants. The economy is, however, somewhat stagnating. The development of commerce and communication has changed the city's traditional means of livelihood. Its location seems to be less favourable than earlier, since airlines and motor vehicles have taken over much of the transport from the coastal ships. New firms are more easily placed in Oslo, Trondheim or Stavanger than in Bergen. Therefore textile industry, commerce and shipping are stagnating. Its traditional mercantile bourgeoisie too, seems not to have been able to follow up the new development by, for instance, seizing the new elite positions that the university or the banks have opened up. Many of the university professors and the bank directors seem to have moved to Bergen from Eastern Norway. But there is also new growth potential in the oil activities in the North Sea. The consequences of the oil activities may make themselves felt in Bergen in the years to come.

The city of Bergen is spread out between seven hills. The young women described in this book live in four different suburbs located 4–12 km from the centre in different directions. Their kind of housing consists of cooperative apartment blocks with 3 or 4 floors, from 25 to 5 years old. Cooperative housing is developed in the larger Norwegian cities instead of municipal housing. Municipal rented dwellings exist in the inner city, but constitute, in comparison, a rather small sector. In cooperative housing each household owns a share in the cooperative. This kind of dwelling

exists alongside other kinds of housing and ownership more closely examined in chapter seven.

Society changes as well as the content and meaning of social class. Social life is varied, different groups live different kinds of urban life and have different ideas about it. The more well-to-do commercial families have an established bourgeois life style. Students and lecturers at the university have moved in from other parts of the country. New categories of office holders in banks and other service institutions have emerged. There seems to be a main division in terms of life style in the middle and upper middle class between 1) those who are employed mostly in private businesses, and 2) those who are employed by the State or Municipality, or by publishers and newspapers. People employed at higher levels in private business seem to have life styles which are more at one with traditional "bourgeois" values than those employed by the State or Municipality. Many of those who have benefited from the "educational explosion" after World War II have to a considerable degree found their way of living in the service of the expanding welfare state, as social workers, artists, teachers on all levels and so on. There are obviously many differences concerning income, working conditions, and life style, within such a broad category. There is, however, a common ethos in this part of the educated middle class that for some purposes justifies lumping them together. They look for identity both in the ways of the traditional middle class or upper class and also in Norwegian peasant traditions.

The content of the lives of the working class is also changing. New occupations and qualifications proliferate, for instance in service occupations. These groups are numerically most dominant, but form to a large extent a "silent majority". This book is about the way of life of a group of working-class women, how they intellectually and emotionally strive to integrate diverse and conflicting elements of their lives.

How the book is organized

The chapters follow each other in a circular way, following a magic circle in the women's lives extending from hearth and home out into society and back again to hearth and home. But not all the

chapters are as tightly knit to this structure. The most important chapters are the following: Chapter four examines who fits in with whom, the folk view of social class. Chapters five and six examine the values of hearth and home and the relationships of hearth and home. Chapter eight is about paid employment. The climax of the book arrives late, starting with chapter ten about going out to discotheques and dancing places. Chapters ten and eleven are tightly linked. Chapter eleven has given the book its title; it examines the talk between female friends at their coffee klatches as a moral discourse that reveals important dilemmas and categories, and the analysis is extended to show the consequences of their discourse for female solidarity and conflict. Chapter thirteen turns back to the household, examining the changing ideas about division of work between the spouses. In chapter fourteen I ask what the data tell about what it means to be a woman. I examine the whole magic circle of their lives, and put forward a theory about contradictions in marriage and family life that may explain the findings and also the rising number of divorces. In the last chapter I discuss what the data tell about Norwegian culture, both in a general and a subcultural sense. I also discuss the generality of the material.

Compared to these chapters, the chapters not yet mentioned are more loosely tied to the main structure, but they do each expand on parts of the ethnographic picture. They are included because they add both to the ethnography and to the complexity of the analysis. Chapter two is an account of how the fieldwork proceeded, and it exposes some limitations of the material. Chapter three gives the life situation of one young mother. Its value is to show how different factors go together in the life of one individual. Chapter seven expands the analysis of hearth and home by analyzing the housing market and their position in relation to it, and how housing is a sign of identity. Chapter nine, about visiting, provides ethnographic material about the occasions when people meet in daily life. Chapter thirteen examines some meanings of money. It expands on the sub-cultural qualities of the milieu described, as well as providing more documentation on the changing division of work in the household.

2. The fieldwork

The data for this study have been collected on the basis of participant observation, combined with a few unstructured interviews. These data are of many different kinds: recording of what goes on in encounters, informants' own evaluations of these contexts, as well as data about the allocation of time and resources.

Using anthropological techniques in a complex society like Norway poses some problems about where to start and what the meaningful units of analysis are. One cannot achieve the same kind of holistic perspective that anthropologists do in small villages elsewhere.

I did not want to study a neighbourhood, the most village-like setting of a complex society, (Hannerz 1972) but instead to confront what is most urban in an urban society by following social networks wherever they led me. The focus was on mothers with small children, and having chosen one, I continued from her to her friends, and the friends of her friends. They all turned out to be young women in different suburban cooperative apartment estates of Bergen. In this way I got a sample of 15 women. Each woman is connected to at least one other by a friendship tie. Some are connected to each other with several ties.

The fieldwork proper started in August 1979 and lasted two years. During that period several of the women took on new roles or changed the behavioural standards and the solutions of the roles they already had. I saw and heard how these changes made them think differently, change some of their conceptions, especially of what it means to be a mother and a wife.

The initial problem was where to start. I interviewed several women who lived in different suburbs of Bergen before I chose the one who should be the starting point for the complex tracing of networks. One of them was Elisabeth.[1] A friend of mine told me about Elisabeth, her husband's sister. She had two children and

was working two hours a day as a charwoman in the afternoon. Her husband was a worker in a small industrial company. My friend asked Elisabeth if I could come and ask her questions about her work both at home and as a charwoman. Elisabeth accepted. I could come between 11 and 12 in the morning was the reply. As she did not have a telephone, I went to see her one day without previous notice. She lived in a 4-storey cooperative apartment house.

When I rang her doorbell, a tall, slim girl, 25 years of age, with long fair hair opened the door. That morning she was dressed in very tight navy blue corduroy jeans, blue sweater, and a blue and white shirt. Around her neck she had a thin gold chain with a piece of jewelry made of gold and a pearl. She gives an impression of being neat and at the same time modern and youthful. She has a charming and bright smile, but this smile also reveals some bad teeth. Her first words, after having asked me to come in, were "Would you like some coffee?" I accepted. In the months to come I was to be offered coffee many times in the kitchens and living rooms of different homes in this and similar cooperative apartment house areas in Bergen. The time between 11 a.m. and 2.30 p.m. is the time for informal visits and coffee klatches between friends and neighbours. Elisabeth had finished the morning housework. Her five-year-old boy was playing in the neighbourhood with his friends. She had just put her one-year-old daughter to bed with her bottle, to have her usual morning nap of a couple of hours.

Especially in the beginning of the fieldwork, I most often used these hours for my interviews and visits. I asked Elisabeth if I could come back, and I also asked her to ask some of her friends to meet me. We agreed that I should come back on a Wednesday, same time, and she would escort me to Mette, a neighbour in the apartment house next to her. And she would ask Ellen, a friend in another part of the city where Elisabeth herself grew up, if I could talk to her. She thought Ellen would be interesting to me, because she, in addition to her own two children, took care of two children in her own home while their parents were at work. (The Norwegian word for this role is *dagmamma,* literally day-mummy.)

Next Wednesday I approached the apartment house where Elisabeth lived. Her son, playing outside, recognized me and told me "Mummy is not at home". "Where is she?" I asked; and he

showed me the way to Mona, a neighbour. I rang the bell, and was promptly invited in by Mona. Soon I found myself in the middle of a coffee klatch with five young women, four children, and a dog. Two of the women had been invited. They lived in other parts of the city. The other three, including me, had just dropped in.

I will never forget the astonishment I felt at this first coffee klatch. Most astonishing to me was the elaborate decoration of the apartment. The apartment was small, 2 ½ rooms plus kitchen, hall and bathroom. It was newly redecorated with fancy wallpaper, on some walls an imitation of velvet. The furniture was all new. Dark wood, glass tables, a real abundance of lamps, brass candlesticks, brass pots with green plants, and other ornaments made of brass and porcelain. The impression was uniform and luxurious. I thought myself in the middle of an American film. Mona's home was exceptional, I later learned. Few women were as successful in realizing common cultural ideals about what a nice home looks like. This gave her both prestige and some dilemmas in social relations.

The women were sitting in the living room. They were served coffee. A plate with a few cookies and a small bowl of jam was standing on the table. The visiting women were dressed in new modern youthful clothes; tight jeans, high-heeled boots and often a small handbag formed as an envelope. Hair and make-up was modern and elaborate in a "natural" style. Their appearance seemed neat and fashionable to me. They were talking about several topics, among them the jobs three of them had as cleaners. One of them, they all agreed, had a "good job". A good job is one that can be done in a shorter time than one is paid for. She was paid for 3 hours a day, but could finish her work in 1 ½ hours.

Two of the women had brought children with them, and Mona had a boy herself. The children were ordered to play in the child's bedroom, called only the room (*rommet*).

"Go play in the room," the mothers said every time a child turned up in the living room. The smallest baby of 1 ½ was more easily allowed to stay with the mothers than the older children, 3–4–5 years of age, but none of them obeyed very consistently. The women did not make any special arrangements for the children, but tended their needs when the children claimed attention. They solved noisy conflicts, comforted crying children, saved Mona's porcelain figures when someone was about to break them, and so

on. The children were several times offered some of the cookies on the table if they would go back and play in the child's room. Mona was herself most active in looking after the children, probably because she was anxious about her newly decorated home. Elisabeth later told me, when we were walking back together, that she was shocked over one of Mona's friends who let her 3-year-old daughter have a cookie with jam. The jam could easily have damaged the couch or the carpet.

In this way my fieldwork proceeded. I became friends with Elisabeth and gained more of her confidence. She told me about some of her personal problems, and gave me information about friends. "Don't say that I have told you, but . . ." used to be the introduction to the most confidential pieces of news. At the same time knowing Elisabeth gave me access to several of her friends and connections. Some times she would ask for me; at other times I myself asked women I met with her. Some connections were close and some distant, some in her neighbourhood, some in other parts of the city. From them I went further to some of their connections. In this way I became acquainted with 15 women. In addition to these women I came to know friends that I met in their homes or heard a lot about.

Some information about how the fieldwork proceeded and about the different circumstances of each woman is systematized in Table I and Figs. I–IV (Appendix I). It is difficult to describe what is common to the women while at the same time paying some respect to their individualities. There is for instance Eva, quiet and shy, from a suburbanized rural area in the south of Norway. She longs to go back to this area, with its open fields and gardens, where she "knows everyone". Asbjørg and Audhild both grew up on farms and also moved into Bergen. Audhild is married to a man who is also of peasant origin. She is the only one of these three who keeps her dialect, and the only one of all of them who really does home production to any extent, like baking and making jam and juice. When Asbjørg was expecting her second child, she married a man from Bergen who turned out to be a heavy drinker and to be unable to hold down a job. He left her with three children.

Then there are cliques of women who grew up in the fifties and the sixties in one of Bergen's first suburban cooperative housing estates of apartment blocks. When the children, who all moved in at more or less the same age, became adolescents, this area was

notorious for its gangs, petty criminality and youth problems. Some of the women and their husbands were involved in this ten to fifteen years ago. Elisabeth, Georg, Kirsten and both her former husbands, Sissel, Benny, Gunvor and several others who were involved, now live stable respectable lives. But everyone has former friends, acquaintances or even a sibling brother or (more rarely) a sister who continued to live on the fringes of society.

Then there is Irene who went to the same class as Elisabeth, Ellen and Sissel, but who never really has been one of them. She has been interested in politics since primary school, works for the Marxist-Leninist party, and wants to be an artist. She belongs more to artist and student milieus than to their circles. Since she still lives in the same area close to Ellen, Sissel, and Gunvor, she has some contact with them, and passes along some elements of "student" culture.

Elisabeth has moved from the area where she grew up. In her new neighbourhood live both Asbjørg (before she moved), Audhild and Turid, already mentioned, and Mona, Mette and Beate. Beate is known for her temperament. Nothing can stop her from giving her unvarnished opinion when she is angry. There is also Gro, one of Mona's several neighbours who often visit her. Gro is a little older than the rest, and has slightly more "middle class" values than they do. She thinks, contrary to them, that coffee klatches are really a waste of time.

Kirsten is one of the "gang members" of the sixties who now lives in a fourth cooperative estate. "I am not really a housewife," she says. "I clean up and make dinner. That's all!" Marie is a former colleague of hers who lives some blocks away. Anne was also a friend of Kirsten. She lives in an estate many kilometers away. She used to come, in spite of the distance, every day by bus to visit Kirsten. Their friendship broke up during fieldwork.

How did the fieldwork proceed, from the initial contact and onwards? How did I present myself and what techniques did I use? Every time when I first visited a new woman I usually did an unstructured interview. That was my legitimation for coming and gave me valuable background material. I had defined my research project as one about family life, focusing on the two dimensions of work and networks of social relations. I presented myself as being interested in women's work, not only paid work, but all kinds of activities that women do. The first interview I asked them mostly

about the "hard facts" of their lives, like paid work, history of housing, but also about division of work between the spouses.

When I came to know them, however, I learned more about their lives and about the things female friends talk about, and realized that what was to be found out there, in society, was different from what I had thought. My research focus thus changed somewhat so as to be able to take these things too into account. In addition, part of the motivation to undertake a scientific examination of their moral discourse probably also came from my own situation as a Norwegian woman. As a woman I struggle with problems similar to theirs. When writing down fieldnotes I was constantly amazed by how different their codifications were from mine, how differently they talked about moral problems compared to academic women that I know. At that point in time I was thus mostly aware of subcultural differences. When I was analyzing the material, however, trying to go behind the surface level of their discourse, I was struck by the opposite point of view, by the similarities between me and them, as Norwegian women, in our basic conceptions and values.

While doing fieldwork, during the first interview, I normally took down notes while we were talking. Before I left I usually asked if I could come back later. When I came back I did not bring my notebook with me. Anthropological fieldwork implies broad social relations, becoming friends. This is what gives descriptions vividness and closeness to real life. Once the relationship was established, I would again do an unstructured interview on one or two occasions, with my notebook, about informal childcare practices.[2] Most often I would act as a participant observer, only asking such questions as seemed "natural" in the circumstances.

I never used a tape recorder. I was afraid that this would influence encounters too much and make informants less confident about me. A notebook was only used in the few situations that were explicitly defined as interviews. Most often I participated, observed, listened and wrote down notes at once when I got home afterwards.

After a while I also participated in other activities besides morning coffee klatches. I visited several families at different hours. Most Norwegian workers finish work at four o'clock, and "normal" dinner-time is five o'clock. From five and onwards in the evening, and on Saturdays and Sundays, I would often find a

husband at home, if the woman was not separated or divorced. I also went outside the homes with some women, to shops, discotheques and dancing restaurants. I was invited to a few Saturday night parties. Together with my children I was invited to some of the children's birthday parties.

During fieldwork I realized how important sewing circles (where one seldom sews) were for female friendships. When I asked Elisabeth to ask the other members of her sewing circle if I could be included for some time, I was more nervous than before any exam. They accepted me, and this gave me access to one more forum.

I thus combined the roles of researcher and friend. The researcher role was necessary as a legitimation device on first contact, and later I used it very carefully and only on a few occasions. They knew that I would write a book about them, and sometimes joked about it. While they sometimes probably found my questions odd and inappropriate to the situation, they were at the same time proud of having a "writer" as their friend. But other aspects of my social person, more directly relevant to them, were most important in developing contacts. I was there to learn their world and their points of view. This made me a good listener. They seemed to appreciate having good company. The nice things they used to tell me were that I was always smiling and good humoured. What they may have disliked about me I do not know for sure. In Norway such things are not said direct to your face unless there is a serious conflict.

Besides education and profession as a researcher, there were other differences between my informants and me. One was that I at the time lived in an old single-family house in a residential area with a symbolic value as "high class". If they ever advance to a terraced house or a single-family house, it will most probably not be to that area. It is an area of the city where they do not normally have personal contacts.

This is probably one of the reasons why they did not feel as free to visit me as I did to visit them. I invited some couples to a Saturday night party once, and a few families to coffee one Sunday afternoon. The members of the "sewing circle" that I joined came to my place when it was my turn. Some of the women or the couples told me they would pop in and see me one day, but they never did. Perhaps they had expected me to propose a day and a

43

time for the first visit, if I really wanted them to come.

I went to see them by car. Sometimes, in the afternoon, I would bring one of my two daughters, 3-year-old Frida. In the evenings I most often went alone.

With the husbands or male friends of the women I had distant but easy and friendly relations. In my first fieldwork in Bergen (1972–73) I found it easy to relate to older men, but difficult to relate to men of more or less my own age. They seemed to find it difficult to combine relating to me as men towards a woman of their own age with the respect that they also had for my education and ambition to write a book. This time it was much easier, partly, it seems, because the relations between the sexes has changed somewhat during the last years, partly because this time I was five to ten years older than they, and therefore no "natural" object for show-offs of authority and manliness. But the relations between the sexes in the working class still seem to be somewhat more distant (their roles more segregated) than in encounters between academics. Mixed gatherings, for instance, very often consist of two conversations monitoring each other, women monitor men and men monitor women's talk.

The differences in class and way of life did not always mean that the women had or showed respect for me. Quite the contrary. In several ways the young women found me less successful than they were. I did not live up to their standards of how to be nicely dressed and have hair and make-up done. Both because I wanted to be as unobtrusive as possible to the social circles I participated in, and because I was influenced personally, I changed my appearance somewhat. I did for instance cut my hair and start using gold jewelry instead of more heavy ethnic jewelry made of silver or unprecious metals. After fieldwork I have slowly, but not completely, changed back, to the standards of my own reference group. Part of the change seems, however, to be permanent.

In several ways doing fieldwork in one's own city provides new challenges. There is for instance no natural end of fieldwork, like the departure from the exotic field far away. I found it morally and emotionally very difficult to finish doing fieldwork. I felt that these people had become my friends. I could not stop seeing them to sit down and write. Instead of the brusque departure that traditional fieldwork necessitates, I had to make a more gradual departure – from the intensive almost daily contacts to more distant relation-

ships. It has taken some time, also, to get the necessary distance to the material. But as anthropological work always implies some time and emotional effort to turn personal experience into data, it is difficult to judge whether this is more salient in fieldwork at home.

In most respects I tried to make the field situation resemble foreign fieldwork as much as possible. This implies immersing oneself in social life. Immersion and some personal social dependence in the field is of advantage in the learning process. One learns more if one cannot easily escape. Thus in a personal way I became aware of some positive qualities and limitations of their ways of life. The positive qualities, to me, were the warmth and the kind of inclusiveness of much sociability. Compared to this, intellectual circles often have a colder and more formal atmosphere. Some limitations also became tangible. Especially towards the end, I developed for instance a thirst for theater, concerts, books and talk about these things, elements of bourgeois culture that were missing in the lives of my informants.

The fieldwork delineation procedures I used in Bergen are thus close to traditional fieldwork techniques. In traditional fieldwork the procedure is similar, but the boundaries of the universe, for instance a village, a region, an ethnic community or a ghetto seems easier to delineate *a priori*.

Some methodological problems

I tried to go about the establishing of contacts, the tracing of links and knots in the networks, in such a way that there would be women in the sample who had grown up in both city and countryside, and so that there would be some cliques or friendship circles in it. (See Figs. I–II in Appendix I.) Otherwise the selection of women is fortuitous. Some of the women are in contact with several of the others, some are in contact with only one or two. Each woman has her own personal smaller and bigger network of friends and acquaintances, parts of which may form a clique or a friendship circle. They live in different suburbs of Bergen. (See Figs. III–IV in Appendix I.)

When visiting or meeting the women, I most often met them together with children, often together with friends and sometimes together with husband and relatives.

The women studied do not make up a community or a partial network for other purposes than my fieldwork. Since several of the women are connected, it gave me all the same the opportunity to study family and network processes. They are not a sample, but rather reference points or "peepholes" from which to get information about a culture and a way of life. They are natural cogs in the machinery of my analysis. The analysis is about a social and cultural universe. The total population studied is far larger than the reference women. Together these persons and their activities make up the basis of the generalizations in the study.

I was also in contact with some women more often than with others. The amount of information about each woman is therefore not equal. Because of this, and because I have information about more than the listed 15, there are few tables and figures (except the ones in Appendix I) and no percentages.

By following this procedure I ended up with a "slice" of Norwegian society consisting mainly of young women at a particular stage in life and belonging, speaking in terms of stratification, to the same kind of people. Holism is achieved in some respects, but not in all. As they grow older and go through other stages in both the individual life cycle and the developmental cycle of the familiy, their way of life will change accordingly.

I tried to get some information about the importance of stage in life by interviewing some of the mothers of the young women who live in Bergen. Some of the mothers of the urban women I had already met before I interviewed them at the end of fieldwork. The mothers of the few women of rural background I have never met. There are most data about the lives and the adaptations of the urban women, especially the members of the sewing circle that I participated in. In earlier fieldwork in Bergen (Gullestad 1979a, 1978b) I found important distinctions between first generation (formerly rural) urban women and women who had lived in the city for several generations. This distinction is still there in the present material, but the differences are a lot more blurred. Several of the urban girls (like many urban Norwegians) have a rural background one, two or three generations back.

It is also a limitation of the material that the men do not figure more as subjects than they do. They are strongly present, but more as objects, seen through the eyes of their wives, girl-friends, and daughters than as subjects in their own right. This limitation

reflects boundaries around the husband/wife relationship. Urban fieldwork in western societies imposes limitations on studying the most "private" spheres of life. I got more data about how the women discuss their relations to husbands among themselves, than I got first-hand information about the relationship between husband and wife. A full portrayal of familiy life is difficult to make and to conceptualize.

Looking back I ask myself whether a larger population could have added to analysis and comparison without losing some of the depth and richness of the material as it is now. It is difficult to answer this question. My own attitude is that this side of society is a blank space on the map, ethnographically speaking, and it deserves a detailed and thorough ethnography. The aim of the study is explorative, to explore connections between fields of society which are normally analyzed separately and to generate hypotheses on that basis. Once this is done it is easier to do shorter, more economical and comparative data collection and analysis, and to test hypotheses further.

"Pulling oneself up by one's boot straps"

The anthropologist doing participant observation is herself both the research instruments and the filter through which the lives of the informants are sifted. I am Norwegian myself, and have lived most of my life in Bergen, which makes me a student of my own culture. Being a student of my own culture makes it difficult to grasp the culture of people so very like me. The likeness implies a danger of taking too much for granted. The fact that I belong to the same overall culture and society may easily make me blind to important features of the lives of my informants. Anthropologists often hold that one needs greater cultural contrasts, a totally foreign and "exotic" culture to grasp its patterns. One gets the impression that to study one's own culture is almost like trying to pull oneself up by one's boot straps.

Where anthropologists see too little cultural contrast, other people of my own social circles often see too much of it. People often ask me curiously how I can be friends with charwomen up to ten years younger than myself. They point to the fact that my father has an academic degree and is a business director, that I was

formerly married to a physician, and that I have myself more or less been a student or worked at a University all my life. How can I be friends with girls who have little more than primary education? What can we have in common to talk about? Will the differences not be too great to develop true communication? Both kinds of view point to relevant dimensions of the situation, and their apparent contradiction illustrates some general facts about doing fieldwork in one's own society.

The questions asked by the non-anthropologists indicate the existence of social and cultural barriers between social groupings in Norway, and one aim of this book is to specify what they, in this case, consist of. Anthropologists, on the other hand, are sensitive to the problems of taking too much for granted. Being part of the culture means that one knows more about it than an outsider. The drawback is to be too close and to lack a more general theoretical framework. There might, however, in my view, be an advantage if one manages to draw on this knowledge in a comparative and systematic way. In this study I have used, in addition to anthropological literature on cross-cultural variation, my knowledge about Norwegian society to make comparisons and characterize the milieu studied. This knowledge is basically of three kinds, and of these the first two are less controversial than the third. The first kind is various research and statistics. The second kind is data and interpretations from my earlier fieldwork in Bergen. The third kind is personal experience. Especially family background and current social milieu provide me with two contemporary contrasts.

Together with anthropological literature about cross-cultural variation and different kinds of literature about Norway, my background provides perspectives from which I look at the material. This works both ways. By providing me with a contrast and a perspective from which to look at my own social circles, doing fieldwork has also taught me a lot about the ways of life of Norwegian intellectuals in addition to knowledge about Elisabeth and her friends. In this way closeness but not identity of experience may perhaps be turned from a disadvantage to an advantage, by providing useful comparative material and a higher sensitivity to telling details.

Having thus explained general outline, analytical tools, and how the fieldwork proceeded, I now turn to the material itself. The next chapter is a description of the circumstances of one life. It

provides an introduction to the material and demonstrates how values, ideas and circumstances combine in the round of life of one person, Ellen. Ellen's situation is not an average, but fairly typical for one constellation of circumstances, among several.

3. One woman's situation: Ellen

At this stage in the presentation, a description of how specific ideas, values and circumstances come together and manifest themselves in one life situation might be useful. One individual and her life is the topic of this chapter. The choice of Ellen as this person is in a way arbitrary. Each of them could have been chosen because each of them is both unique as a human being and represents variations on some common cultural and organizational themes. Ellen is married. She is from Bergen as opposed to those who grew up on a farm. She has her parents in the same area where she lives as a married woman. In these ways she represents one fairly common situation among the women in this study.

Ellen is slim and a little taller than the average Norwegian woman. Her hair is always dyed blond and given a chic cut by her husband. She grew up in the area that had youth problems, but never participated fully in its adolescent life. She had an alternative clique of friends on the other side of the main road. At the end of 1978, Ellen was about 24 years old with two children, a boy aged 2 and a girl aged 5. She is married to Arne, then 27 years old. They live in an apartment in the cooperative estate built in the 1950s, where she grew up. Ellen's parents and younger siblings live in the same area only five minutes' walk away. Like several of the other women of the study she got pregnant and married early. First, she and Arne lived for some months in the one room he rented as a bachelor in the middle of the city. Then they lived for a few months in a small apartment situated between the centre and where they now live. "One of the neighbours was insane. We had to move." Then they rented an old apartment not far from there. They liked the neighbourhood, but the wind blew right through the walls. They managed to buy a new cooperative flat on the opposite side of the city. "We bluffed like mad and said we had the money, but

we didn't have a penny. We had to borrow it all. We lived there only for five months. I felt so isolated and lonely. My sister was a nursemaid *(praktikant)* at the time. She came with the child to see me every day." Ellen wanted to live near the place where she used to live, and they managed to swap flats with another family. "We put up advertisements in the two grocery stores here. Sissel helped us. In the advertisement we wrote 'wonderful view'. We really had a wonderful view, but that did not help *me* very much. In the family who swapped with us, she came from *that* side and wanted to move back. She could not get accustomed to the fact that it is not so easy here to go to the seaside with the children in the summertime."

Her husband spent some of his childhood outside the city. He would like to have a garden, but they have no plans to move. Arne is a barber. The first year of my fieldwork he went to an evening school after work to qualify as a master in his craft. Ellen hopes that he will never open his own salon. "I am scared. If Arne opens his own salon and perhaps earns a lot of money, it will be too easy to put on airs, too easy to think that our friends are not good enough any longer, because they do not have as much as we have. People nowadays only think about buying, buying, buying . . . I am also afraid that we would grow apart. Hairdressers are special people. If Arne gets a salon, he will perhaps be more like the others who own salons."

Ellen herself was about to become a hairdresser when she got pregnant and married. The training takes three years, and she was in the middle of the second year. "Now I regret it, in a way." She stayed at home with their child for one year, before she began part-time work as a cleaner. She has had different jobs. First she worked three hours a day in the same office where a friend worked. She was fired, she says, because she had taken a roll of toilet paper. Then another friend got her another cleaning job for 1 ½ hours a day. She had this job until she became pregnant and quit for a period. Now she works 1 ½ hours a day cleaning a nearby branch of a large bank.

Ellen also periodically used to take care of one or two children in her home for a payment while their parents worked. (The Norwegian word for this role is *dagmamma.*) Like the other women of this study she has never advertised but has been asked by mothers in the neighbourhood. During part of the first year of my fieldwork

she took care of a one-year-old baby from 7 a.m. to 3 p.m., the daughter of Irene, a neighbour in the same block. She usually sent her own youngest boy and the child she is taking care of out for a stroll with two 12 to 14 year old girls in the neighbourhood at about 3 p.m. (The Norwegian word for the role of these girls is *passepike*, i.e. a girl who looks after small children.) Then she left for her job as a cleaner at about 3.30. She came back a little after 5 p.m. By that time, the mother of the other child was also back, and the children were brought back by the two girls. Ellen only periodically is a *dagmamma*. When she does not have a child to look after *(dagbarn)*, she complains. "I have got used to the money. Now it is difficult to stop."

In 1978/79, when he attended evening classes, Ellen's husband was not home before 8.30 p.m. and dinner was ready for him then. "In this house it happens only twice a year that dinner is not ready when he comes home." The children would have eaten earlier, before the small ones are taken out by the two neighbourhood girls *(passepiker)*.

Ellen is at home most mornings. She makes one trip a day, to the grocery store. The children keep her at home, and therefore she likes friends or her mother to come and visit her. She has several friends in the neighbourhood who come visiting. Her friends within five minutes' walking distance are half a dozen women; some are friends from childhood, others moved in later. Ellen also has friends and acquaintances in other parts of the city who come and see her once in a while. She is a member of two sewing circles, one that meets every fortnight and one that meets every month.

When her friends and acquaintances are dissatisfied with her, they say that "Ellen has a long tongue *(Hun er slapp i munnen)*. She talks too much and makes intrigues. Whenever there is some trouble, she is always at the bottom of it." When they are satisfied with her, they find her witty, understanding and helpful.

Ellen's mother works as a home helper for old people in the area. She often comes in for a short visit on her way back from work. If she sees through the kitchen window (Ellen lives on the ground floor) that one or two of Ellen's friends are already there, she sometimes comes in and chats with her friends, most often she just passes by. "I really can't stand the friends you have," she often says. "They come here with their children and drink your coffee and make your house dirty, while their places stay nice and clean,

after the morning's housework." Ellen, however, urges her friends to come. She sometimes also goes to see them in the evening, but then her husband complains. "You see them all day. Why can't you stay home in the evening!"

The elder child, and later the younger one, often go to their grandparents. Perhaps they get some dinner or some dessert, or they watch the children's television programs. Ellen's parents do not, however, take any regular responsibility for child care. "I am tired of child care, and I have enough with my own business", Ellen's mother says. But they like the children to come and go without having responsibility for them. Ellen's mother drops in at Ellen's place for a short visit almost daily, and once a week to have her hair done by Arne. Her father, a craftsman, almost never comes unless invited. Her brothers and sisters come more often.

Her parents-in-law are divorced and have each established new relationships. "My mother-in-law always complains about her illnesses. My father-in-law is nice. He has always treated me kindly", Ellen says. Ellen and Arne often visit Ellen's parents or her parents in-law on Sundays.

The flat Ellen and Arne live in has three rooms, a kitchen, hall, and bathroom. The living room is decorated with dark brown textile wallpaper on two walls and a lighter brown textile wallpaper on the others. There is a couch ensemble, with a loveseat and a chair, covered in dark brown leather. "We chose it because it is so practical for children. You just wipe off dirt with a wet piece of cloth. We have had this set for one year and it is still like it was new." To this set there is a large dark brown coffee table. In front of the television are two comfortable leather chairs and a table with a glass top. "The glass table is very unpractical", Ellen says. "You have to wipe off dust every day. We chose it because it looks so nice." There is also a small white shelf with a few books, radio, tape-recorder and several ornaments. On the window sill, on the wall, hanging from the ceiling are lots of green plants, some of them in brass pots, the great fashion at the moment. On the walls, reproductions and other ornaments are hung up in orderly fashion with some distance between each piece. The lighting consists of a hanging shaded lamp casting a pool of light on the coffee table in front of the couch ensemble and several smaller lamps on the wall and on shelves and tables. Immediately, the room gives off a neat impression. Like the other women Ellen

has plans for how she wants the apartment to be decorated. The floor is covered with linoleum. She wants a carpet when they can afford it. The shelf is from her husband's adolescent room at his parental home. She wants a new one, bigger, made of polished wood and more suitable for a living room. She would also like new curtains. The ones she has are made of simple canvas inherited from a friend.

The other rooms give off a somewhat less orderly impression. Wallpaper, painting and floor-covering are, for instance, often amateurishly installed or torn down by the children. The kitchen is narrow with painting and wallpaper in different brown colours. At one period, she lacked a lot of household utensils and often complained that she was unable to find an unchipped cup for her visitors. She gave her children juice from empty jars of prefabricated baby food because most of her glasses were broken.

In the kitchen there are, besides counters and cupboards, an electric stove and an electric refrigerator, a small dining table with steel legs and formica top, and four old chairs. Counters and cupboards are of painted wood. Drawers and shelves seem chaotic. One cupboard is full of unpaid and paid bills, advertisements and other papers of varying importance. One drawer is full of Ellen's make-up kit, hair curlers, hair drier and so on. There is a broken mirror on the smallest counter. In front of this she usually sits to style her hair and to put on make-up.

One of the more important items in the kitchen is the coffee percolator, standing on one of the counters. In this she makes coffee several times during the day for herself and for the visitors who turn up.

Ellen likes to put her kitchen in order every day. That means basically and minimally to do the dishes, clean basins and counter-tops and clean the floor.

Beside the kitchen there is a small room for the laundry. In it is a washing machine and a large basin. She mostly uses the washing machine. It is new; the first one they had broke down. They do not have a deep freeze. "We could not afford a deep freeze since we had to buy a new washing machine," she says. The room is otherwise full of clothes, broken household utensils, pots with brown withered plants and so on. Ellen is however very relaxed about it: "It is Arne's job to tidy up. I leave the mess until he does it."

The bathroom contains a bathtub with shower, washbasin and

toilet. Over the washbasin is a small cupboard with a mirror. The electric lighting is over the cupboard. The bathroom is decorated with red and white wallpaper, and carpet. The toilet flush has been defective for more than half a year: one has to remove the top lid and open the valves. They seem to be very relaxed about this, however. The reason it is not repaired seems partly to be that they always feel short of money and any bill that can be postponed is postponed. Partly, the reason is that they are waiting for some suitable occasion to find an acquaintance with expertise in plumbing to do the job informally. This would make the bill a lot smaller.

The children's room is divided into two parts, one for each child. One of the parts does not have a window. Altogether this room is about 10–12 m². The window has curtains with childish motifs. It is lit by a ceiling light. The furniture consists of beds, old furniture not good enough for the living room, and many toys.

The parent's bedroom is dominated by a huge double bed. The room is seldom used during the day, and visitors are normally not supposed to enter it. Often clean clothes that have not yet been folded are lying on the bed, and items like the vacuum cleaner and table for ironing are stored away there. Guests who stay overnight are never allowed to lie in the double bed. "*Only* I, Arne and the kids are allowed to lie under the eiderdown" Ellen says strongly. "When Gunvor (a good friend) and I both were pregnant we often lay down on top of the cover, reading magazines and talking. That was OK with me, since it was *on* the bedspread."

Ellen is very particular in holding such attitudes so strongly. She is also a little bit "superstitious". She firmly believes for instance that if a pair of shoes is put on the table there will be a row (*husbråk*) that day, or that if a knife or a fork is dropped on the floor, a male or a female visitor respectively will come that same day.

During my fieldwork they bought new brown glass coffee cups. The kitchen floor got a new cover, installed professionally by a man from the store where they bought the covering. For the living room they bought a small carpet to put under the coffee table, two onyx ash trays, and a few more brass pots. They had a carpenter they know help to rearrange the division between hall, bedrooms and closet. The door between hall and bedrooms was removed and replaced by a portal. The younger child got a bigger room where

the closet used to be, but it still has no window. The carpenter was paid; but he did not ask for much money, since they knew him and he probably would not pay tax on this money.

The installation of wallpaper and so on was done by Arne with some help from a friend who is a painter by profession. This friend also painted the ceiling of the kitchen and the living room. They proposed to pay him but did not really expect him to accept, "because Arne has cut his hair for years." The friend did not accept any money. Arne also made a bed for the younger child, and the elder child got a new bed and a desk. These things they bought cheaply by chance from someone who had older children. Arne is not particularly handy, nor is he as interested in tasks of this kind as some other men in this study.

Most weekends they spend in town, either at home or, sometimes in the evenings, they will go out to discotheques and restaurants in the centre of town. They sometimes go together, sometimes only one of them goes. Such an evening out leads once in a while to quarrels and fighting back home. Either Ellen does not come back home "in time", or Arne does not. Both of them, and especially Ellen, are jealous. In the beginning of their marriage, they were separated for a period because he found another woman. This is not completely forgotten, but still Ellen most often holds that they have a good relationship. She was very pleased when she heard from a female colleague of his that he is not flirting at his workplace, that "only work and home counts for him". "I knew it is so," she said, "but it is good to hear it from others."

On weekend evenings at home they are sometimes alone with the children, sometimes friends or relatives drop in. They usually drink beer or hard liquor. Arne and Ellen are one of the few couples who drink regularly, mostly beer, during the week. They often want to stop, because of the expense, but it has become a habit to drink a couple of bottles with dinner.

They buy most large items, like the couch ensemble or the washing machine, on the instalment plan. Arne's wages as a hairdresser are relatively low and paid in cash every week. Often, when large bills or instalments and interest on the loans on the apartment are due, they "do not know where to get the money". "It is difficult to save when the wages come every week", Ellen says. The amounts are so small every time, and it is so easy to use all the money. When wages are paid monthly, the amounts are

bigger, and one can first deduct enough to pay the bills, and then live on what is left.

Before one seventeenth of May, the Norwegian National Day, they opened an account in one of the larger stores to enable Ellen to buy a nice dress and a white coat, and a new coat for their daughter.

At this stage of life, they seldom have the money to go away on holidays. In 1979 they stayed home the whole summer. In the summer of 1980 they managed to rent a house in Denmark with another family.

Arne has relatives with farms in the countryside near Bergen whom they visit once in a while, at weekends. The relatives have many people visiting them, so they cannot go too often to the house of Arne's cousin nor that of his aunt. Ellen helps the cousin's wife in the kitchen, but not the aunt, "because there are always so many people at her place". When there are many women, Ellen lets the older and more experienced ones help out.

Ellen's parents have a small cabin in the countryside, but Ellen and Arne seldom seem to use it. It becomes too crowded with all of them there. Besides, because of a large unexpected bill, they had to sell their old car and do without a car for a long period, a fact that also made them more tied to home. They are somewhat more tied to the city than the average in my study group. Most of the others possess a car, and several of them do use their parents' cabins or farms in the summer season.

In 1979 Ellen's plans for the future were to begin full-time work perhaps when the elder child starts school. Her mother opposes her having too much paid work and tries to persuade her to stop at least one of the jobs, as charwoman or as *dagmamma*.

Ellen said that she enjoyed being at home with the children together with the part-time and *dagmamma* work. But then several of her friends started working or going to class in the daytime. Sissel is separated and was helped by the social welfare office to get a place in a trade school for herself and a place in a daycare centre for her youngest child. Gunvor started part-time work as a saleswoman. Irene, also separated, was admitted to an art school. By these experiences, they got new things to talk about. Ellen, by comparison, felt more isolated, unhappy and stuck with life at home. She later had to quit the cleaning job because of pains in her shoulders and arms. Even her husband admitted that she seemed

to need more variation. For a while she thought of being a home helper, employed by the municipality to do housework for old people, like her mother does. She also thought of being a car mechanic. However she did not apply for a job or try to find out what possibilities there were. A neighbour, who is a nurse employed by the municipality to nurse old people in their homes, once hired her as a night attendant for senile old persons. The municipality paid her wages. She continued periodically as a *dagmamma*. Then in 1981 she was, also through connections, offered a job as waitress in a pizzeria when extra help was needed. She accepted and no longer took *dagmamma* work. As her working hours were on shift, she had to improvise child care for her own children. Her husband, friends and neighbours took care of her children while she worked. They needed less care now, since they were playing outside most of the day. When she had evening shifts her husband gave them dinner and put them to bed. After some time she got a more or less full-time job as shift worker in the pizzeria. Her husband begrudged the extra work for him and not seeing her so much. One of the very few husbands who cannot cook, he had to learn how. He had, for instance, to learn how to make hot cocoa for the children. But they are both very satisfied with the extra money. They can now afford more than before and indulge in fashionable clothes, a dinner out at a restaurant, another used car, and so on. Ellen's friends say that Arne does not understand that she is changing because of her new job. "Before it was only home, husband and children for Ellen. Now she is getting other interests."

Ellen's life is fairly typical for a young working-class woman raised in the city. She has extensive contact with friends, relatives and in-laws. Women who have moved into Bergen from the rural areas generally have fewer relatives, friends and acquaintances around. Compared to that of the other women in the study, Ellen's economic and material situation is not one of the best, but not one of the worst either. She and Arne seem to be less handy in installing and repairing and just a little less efficient in managing their economy than the average, but all in all fairly typical of people in their situation.

Compared to them Asbjørg is a contrast. She is separated, has three children who range in age from ten to one years, and has only one relative in town, a sister, and few friends and acquaintances.

Being separated she has no husband to help her with the male tasks in a household. Having few relatives and acquaintances in town she has few others to ask informally for help, paid or unpaid. Living mainly on social security money she has an extremely tight economic situation that allows for no extra luxury. Having three children at home she does not feel like taking a job (apart from informal child-minding in her own home from time to time) or profiting from the opportunities to get an education. Her main social circle consists of a few women, some on the same stairwell, some a few minutes' walk from where she lives, and people she meets out at discotheques and other public dancing places. (See also next chapter.)

When Sissel and Irene separated from their husbands, on the other hand, they were better off because a) they started going to school, and b) they have more relatives, friends and acquaintances around who help them in different ways. Audhild is like Asbjørg in that she also grew up in the rural areas. But she is happily married to a man from the rural areas close to Bergen. His parents and the farm they own are a great help for them because they live close by.

Marital status, number of children, where one has grown up thus seem to be some of the important circumstantial factors shaping the lives of these women, accounting for much of the difference there is between them. In the next chapter I shall examine more closely some of the criteria they have for perceiving other people as different from or like themselves.

4. Who fits in with whom?

A folk view of social class

In some ways the women in this book belong to "the same kind of people" as the men they are associated with as wives, daughters, and friends. By interpreting signs like dress and manners people categorize each other and construct social relations on the basis of these categories. Such categorization is one important factor determining which persons potentially marry each other, become friends or develop neighbourly relations of more contact than the bare minimum of nodding when meeting outside and helping out in minor crises, like, for instance, if one of them has lost her key.

The question I ask is: How do people look at themselves? What models of society do they have, and how do they categorize themselves in relation to others? What are minor differences and what are crucial differences in kind? One broad answer is that people speak relatively little about class differences. Notions and categories about class differences are often more implicit than explicit. By listening to many conversations about a variety of topics, one discovers all the same some recurrent categories and ideas. There is both a concern, when meeting new people, to decide whether one "fits in" *(passer inn)* with them or not, categories both for those that one does "fit in" with and those that one does not "fit in" with and a variety of signals for the different identities.

The undercommunication of differences and the idea of fitting in demonstrate their notions of equality. Persons with ways of life that are regarded as too different, do not "fit in" with each other and are not potential friends. Equality is similarity and applies more to personal relationships than to formal relationships, where hierarchical rules based on division of work may apply.

Decent ordinary folk

The women and men of this book see themselves as decent ordinary people *(skikkelige alminnelige folk),* as plain ordinary folk *(ganske alminnelige folk),* or sometimes as ordinary working people *(vanlige arbeidsfolk).* The categories emphasize being respectable and being average. They talk and interact in terms of a division of people into categories very similar to the ones Barnes found a generation ago in the Western Norwegian village of Bremnes (Barnes 1954). In Bremnes people saw society divided into three reference groups, with themselves in the middle as ordinary folks. In Bremnes lived ordinary folks like themselves. People who were better off and worse off lived mainly in cities, as they saw it (Barnes 1954). In a study of households in rural Sweden Gunilla Bjerén also reports that most people see themselves as ordinary folk (Bjerén 1981).

The difference between the village of Bremnes in the 1950s and the city of Bergen in 1978–80 is that all kinds of people live in the city, although not necessarily all close to each other, and that categorizations are also more nuanced. My informants and their men have relatively little education and work in unskilled, semiskilled and skilled occupations. A few are also self-employed. (See chapter eight, for an examination of occupations.)

"High-up" people

The broad category of ordinary folks is different from *fine folk. Fin* means refined, nice, delicate, stylish and is also often used as a positive adjective in everyday speech. The expression *fine folk* means something like the English expressions "high-up" people, or the upper crust. *Sossefolk* or *sosser* are other, less positive, expressions about the same kind of people. High-up people are both admired and looked upon with contempt. The stereotypes describe *fine folk* as people whose men have occupations as company owners (capitalists), directors (top leaders), and a few semiautonomous professions like successful doctors and lawyers. In the most well-off stages in their life cycles they live in big single-family houses and have nice cars, one cabin at the seaside and one in the mountains. Their houses are in other and "better" parts of

the town. There is thus a distance, both socially (in terms of actual relationships), culturally and geographically, between my informants and people of this category. The young mothers do not know many "high-up" people, and do not often have the opportunity to compare themselves directly with them. The difference seems to be less of a contrast than a social distance, because there are some parallels in the underlying patterns of the life styles of high-up people and my informants. (See next chapter and later chapters for demonstrations of these similarities.)

One way in which these groups used to be in personal contact was when unskilled women worked as maids in middle- and upper-class homes. This practice has diminished. Only a few young unmarried women now work as maids. (More young women however today, work as nursemaids, as trainees before they enter teacher's colleges and the like.) Only a few middle-aged women work as domestics by day in the homes of high-up people *(fine folk)*.

The expression "high-up people" is used in different situations. One example is when discussing a newly established fashion shop: "Who has the money to buy a blouse for 400 kroner! Nobody that I know! Only high-up ladies from Fana *[fine damer fra Fana,* a middle- and upper-class district] can afford this!"

Another example is the reflections of a woman after an evening out at a discotheque: "The evening was a complete failure, right from the start. We had to sit at the same table as a lot of high-up kids from Fana *(sossunger fra Fana).* They were the 'my father does this and my mother has that' kind of people. We saw at once that we did not fit in with them, so we might as well start tormenting them at once. And they did the same thing to us. It was awful."

Social cases

In their image of society plain ordinary folks are in the middle and below them are different kinds of stigmatized people, people who in one respect or another do not live decent respectable lives. These are people that they more immediately compare themselves to, and that they know well. Everybody has some former friend or a relative who is not able to keep up what is regarded as a decent stable life.

There are a lot of terms for such people, depending somewhat on the kind of deviance in question:

Slaur	Bum. A person who is not able to lead a decent life, hold down a job, keep up a home and a neat appearance. It is connected with misuse of alcohol and minor deviance like making mischief and breaking informal social contracts.
Sosialtilfeller	Social cases, i.e. people who in their view unreasonably seek aid from the municipal welfare office.
Sånn som går på sosialkontoret	The person or the family concerned lives on social welfare money, more or less on a day-to-day basis. The social welfare office is a municipal agency that takes care of problems brought on by poverty, alcoholism, mistreatment of children and the like. (It is not in the same way stigmatizing to receive money that one is entitled to, like unemployment benefit, social security payment as a single mother, disability benefit, and the like. Most pensions and benefits that one is entitled to in these ways are paid by state agencies).
Fyllik *Alkis* *Alkoholiker* *"Driver bare med fyll og fest"*	Alcoholic, one who drinks too much.
Stoffmisbruker	Drug addict.
Fengselsfugl	"Jailbird", i.e. a recidivist.
Sånn som går inn og ut av fengsel	Often in jail.

Hore	Whore	
Ludder	Tart	Woman with loose sex morals
Typejente	Vamp	

Of these terms *slaur* is the most general and most often used. It is a term for people who are not able to lead a stable and decent life; for men this means to keep a job, for women to be a respectable and decent mother and housekeeper.

Women who are mothers have homes and do not necessarily have to take up paid employment in the same way as men. (Because they are dealt with by different public agencies, unmarried mothers are, however, urged by the relevant agencies to start paid work earlier than divorced mothers. Unmarried mothers are urged to take up paid work when the youngest child is three years old, divorced mothers when the child is ten years old. It is, however, to some extent possible to resist these pressures.) To live on social security money as a single mother is not in itself heavily stigmatizing. She is aided by society to fulfil her role as a mother and a housekeeper and may thus be an ordinary decent human being, in the way defined by her culture.

Women do, however, lose status as decent human beings if they are considered extremely bad mothers. The social welfare office does take children away from those they consider to be bad mothers. Being deprived of her children is the worst conceivable loss of identity a woman can suffer. There are also weaker degrees of stigmatizing behaviour linked to uncleanliness, not keeping her home and children well, drinking, dissipation, and what are considered loose sexual morals.

Being decent, for a man, is first and foremost to be able to get and keep a job. Being decent for a woman is first and foremost to be respectable and morally responsible. There are clearer criteria for men than for women. Both women and men may be a *slaur;* but it is mostly used about men and it is easier, it seems, for a man to become one than for a woman. Men lose their identities as respectable persons if, because of alcohol or other reasons, they are not able to keep a job. If they divorce, they most often lose their home.

In some ways men thus have a harder time than women. The roles and identities open to them seem to be more polarized than the roles and identities of women. One is either a decent stable worker or has a stigmatized identity without a job and a home.

Whole families may be stigmatized by their social surroundings for their deviant way of life. These are often typically what are called social cases *(sosialtilfeller)*. Leaving small children out all evening and smelling of alcohol in the middle of the day are, for instance, signs of being un-desirable as an interaction partner to a stable working-class person. The following example shows how drinking in the middle of the day is one such sign:

> We are on our way to do some shopping, Beate, Elisabeth and myself. Beate drives by the workplace of her husband to give him his lunchpacket. He had forgotten it at home. Beside him in the garage is another man. When we have left the place Beate says that she does not know why this man comes to the garage every day. She knows his name. "He seems to drink every day now. I have seen him dead drunk several times lately. He lives in the neighbourhood. He has a very nice wife. She works at the same place as X. I do not understand why she keeps on with him. He is so dense *(sløkket,* e.g. switched off, not in tune with others). Once he said to Nils that they should start their own firm, he and Nils. "Yes", Nils answered. But let him dare! . . . You have to watch out for such people, otherwise you risk that they come and see you all the time. He came to us once. Nils gave him a glass of beer. I said to Nils: "You just dare take one more bottle from the fridge!" Otherwise he would never have left!"

There are thus both active markers of contrast and at the same time more contact and interaction between the decent ordinary folk of this book and different kinds of stigmatized life styles, than is the case with high-up people.

Students

So far I have presented a folk view of society divided into three classes, with the informants in the middle. In the complex urban

setting of Bergen, however, categories are both more numerous and more nuanced. One category of people that the people of this book meet as neighbours, old classmates and, to a limited extent, as relatives, is that part of the young educated middle class who favour a more rustic life style. Those people that my informants know, are usually young and in the "bottom" layer of this social category: students, social workers, nurses and teachers. There is no common label for this broad and varied category. "Students" and "student-like" or "freaky people" *(frikete folk)* are the words they use that are closest to such a label. Some of the persons they know belong to a very small Marxist-Leninist party, which has an explicit ideology of the political desirability of mixing socially with "real" working-class people. There is, however, an active contrast and boundary between these life styles, even if a few individuals get on well together. With their values of luxury, representative-ness, and cleanliness my informants despise the rusticity and what they perceive as shabbiness of typical "student" appearance and life style. According to the stereotypes, students, teachers, social workers and the like typically favour a rustic style in dress and manner which combines corduroy, traditional handicraft and materials (hand-woven or hand-knitted sweaters), and some exotic touches. According to common stereotypes they also vote for one of the parties from the centre and to the left. Ecological balance, marxism, disarmament and feminism are political issues associated with a student-like appearance.

Dress is thus one important sign of which category one belongs to. If a student, for instance, is in a situation where she can only afford one set of clothes to wear out-of-doors, she often uses anorak and hiking boots as an all-purpose outfit. If in the same situation, my informants use very high-heeled Italian boots and a fashionable (but not very warm) tweed sports jacket for the same purposes. As a single mother with three children Asbjørg is in the most difficult economic situation. She has no pair of flat shoes, only a few pairs of boots and "city clogs" (high-heeled shoes without heel counters).

Irene, the Marxist-Leninist art student, went to primary school together with Ellen, Sissel, and Elisabeth and has the same background as they do. She still lives in the same neighbourhood as Ellen and Sissel. Irene and Sissel became separated at about the same point in time, and the problems of this situation united them

for a period. There was both sameness and difference in the relationship between them. Sameness was communicated when they talked together in their homes. When going out they always quarrelled about where to go. They wanted to go to different places with different kinds of regular customers. After a period of trial and error they stopped going out together. This is what Sissel related, after having gone out with Irene to a student pub once:

Irene insisted that as she had gone with me to A [a popular discotheque with many, but not exclusively, young working-class customers], I had to accompany her to those places. She really took advantage of that one evening at A! But now I am fed up. My goodness, these places are really awful! *(Gu for nokken steder)!* And what customers they have! *(For nokken folk så går der!)* B is the worst place I have seen. The types there! *(De typene!)* With long disgusting beards! Only narco-wrecks *(narkovrak)* and Marxist-Leninists seem to go there. I felt a complete outsider. *(Eg følte meg helt utenfor.)* There was I in those very tight pants. They could see, just from my looks, that I wasn't one of them. *(Det syntes jo utenpå meg at eg ikkje var så de.)* And then they talked politics all the time. When they asked me what I thought about what's going on here and there, I only answered that I'm not interested in politics. This made them give me some queer looks *(med de forbausede trynene).* They seemed never to have heard anything like it. But Irene enjoyed herself. That's the way she is. And it was so dirty and disgusting in those places. It really is a hole! *(Det e' jo den bulen!)* I told Irene that I just had to get away! I couldn't stay there any more.

The incident shows the distance and contrast between two kinds of people, a distance consisting both of disgust for what was perceived as shabbiness and some insecurity because of the students' knowledge.[1]

At this stage in life "students" are often not better in terms of appearance and belongings, but more in terms of some kinds of knowledge. Between the working class and the business middle-class differences seem to be gradual, whereas between these milieus and the academic middle-class there seems to be more of a difference in kind. They despise people who prefer living together without being married, They are completely shocked to learn that

67

one of their old classmates has left the child with the father when she divorced him. They learn about other ways of living, and react strongly against parts of what they learn. Since, however, people of these different categories do compete more and more on the same segments of the housing market (see chapter seven) and thereby interact with each other, it is also probable that some bridging of cultural differences does take place. Some "students" have similar backgrounds to my informants and know both life styles intimately.

Putting on airs

Between my informants and high-up people there is, as already noted, some social and geographical distance. There are, however, kinds of people in between themselves and high-up people that they are more frequently in contact with, but for whom . they have no similar label. Instead of a label, there are complaints about people who "put on airs", who "try to go one better". One might say that putting on airs is a fifth category, a category for those who try to be high-up people, but have no real right to such a claim, in ego's view. This is not, however, completely correct, since the use of this label is more situation-specific than the other labels. By these complaints the division of society into three levels with ego in the middle is competing with a more hierarchical one, with ego next to the bottom. Complaints about others putting on airs reveal sore feelings of being left behind or not being good enough.

Such feelings are, for instance, expressed in situations where one might meet unknown people. Fitting in is important to my informants, and they largely avoid going to parties or other gatherings where they do not know the other guests and often decline such invitations. They are afraid that they will not "fit in" with the others, and, in their case, not "fitting in" is often felt as being "not good enough".

The relation between young working-class people and "students" is, as we have seen, one of contrast. Relations with people who are perceived as putting on airs are stressful in a less contrastive and more painful way. Between high-up people and plain ordinary folks there are many shades of difference in prestige and

way of life. There are numerous vivid expressions to describe behaviour and attitudes that are "too highfalutin":

Er fin på det	Tries to be refined.
Skal liksom være så fin	Tries to be highfalutin.
For god til (å være med oss)	Too good (for us).
Sete nesen i sky	To walk around with one's nose in the air.
Hun/han tror hun/han er like så høy så kongen	Literally this expression means that one believes one is as high as the king. An equivalent English expression might be: She thinks she's Lady Muck. He thinks he's Lord Muck.
Overlegen	Haughty, stuck-up.
Prøver å være bedre enn en er	Trying to be better than one is.

Arne feels that a friend became "too good" to talk to him when he became a driving instructor. Ellen felt that Gunvor "kept her nose so high that her neck almost broke" when she became the girl-friend of a locally famous sport star. The sport star himself "acts as if he were a member of the royal family".

Most sore feelings are produced when one feels used *(brukt)*, that one is contacted only because of any goods and services one can supply. "Now that they are sick I am good enough, otherwise they never come and see me." Constant confirmation of a friend-ship by visiting and sociability is necessary to preserve it. Not visiting is often codified as there being something wrong with the relationship, either a conflict or one is not good enough for the other any longer.

Thus there seem to be strong feelings of social vulnerability. The danger comes from two sides. On the one hand there is the danger

of losing respectability. On the other hand, there is the danger of being left behind by friends and relatives who are socially mobile. Part of the reason for these feelings of vulnerability may be that the women are young. They are not yet fully established and do not have as much social experience as older persons. The main reason is, however, in my view, a contradiction between their egalitarian ethos and the stratified capitalist class society. People want to show what they are good for, but they have few legitimate means by which to express being different or being better.[2] Equality means both not being better and not being different, it means being similar. Rank becomes problematic because of this contradiction between the egalitarian ethos and the specialized division of labour, with differentiated income and other benefits.

It seems to me that rank is generally problematic in Norwegian society, but being relatively low-ranked, lower class people are more sorely aware of hierarchy than higher ranked persons. In social encounters there are implicit negotiations about the definition of the situation and the identities of the participants. Identities in informal social encounters have to be harmonized in such a way that sameness is confirmed and difference is under-communicated. A very important point is that egalitarianism is not necessarily in itself likeness; it is a way of handling difference by emphasizing sameness. Its consequence is that persons who do not "fit in" with each other to some extent form separate social networks and separate subcultures.

The women and men of this book seek confirmation of identities that are important to them. Some identities have more to do with rank than others. Differences in particular in material objects, what one owns, sometimes lead to envy and difficulties in personal social relations. Difference, not fitting in, is expressed both in terms of having and in terms of being and doing.

The solution of this interactional dilemma between prestige and equality is found in the under-communication of success by the successful. Acting as if one is better than others is banned in personal relations. One must act in the idiom of equality. The successful person, who for instance has an especially nicely decorated home, must communicate equality even more than anybody else. Otherwise she is no longer "one of us". She cannot claim prestige. Prestige is given her by others. When the others praise her, however, they have the opportunity of showing their capaci-

ties for evaluation, that they share central standards of evaluation.

Home decoration is one way the spouses symbolize their familiy and what they are good for, both to themselves and to other people (see next chapter). Mona's home is particularly nice. It gives her prestige, but also some difficulties:

Once, at a discotheque, Elsa was drunk and acted very unfriendly towards me. I asked her what was the matter. "I'm envious", she said. "Your hair style is so nice. And you are so well off. You have such a nice stereo equipment, cupboard *(reol)* and everything." Several of my friends sat there. She made me feel very embarrassed. She has apologized, but it was very embarrassing for me. As a matter of fact I finished with her a long time ago. *(Eg har kuttet hon ut for lenge siden.)* Earlier she did not have very much, and therefore she always said to us. "You and Edwin should go out more. You sit too much at home, being miserly *(gnikker på pengene)."* She was an unmarried mother, then. Now she is married. The husband is a welder. She is an assistant nurse. They are as well off as we are. But they seem to use their money in a different way. Others buy a new pair of jeans. I buy a lamp or something for the house. It is as easy as that.

Mona also had a similar incident to tell about another friend:

Her name is Wenche Helene. She is a single mother. I got to know her by meeting her often while going out. Once she invited me home to her apartment. I told her she had a nice home *(at det va' fint hos hon).* Then she came to my place. She was completely amazed. Afterwards she sat a whole evening out, talking about the difference between her home and mine. How could I say she has a nice place, with the home that I have. It was just as if she implied that I had lied to her. But I know how little money she has to live on *(kor lite hon har til å rutte med).* She has both cupboard *(reol),* couch, stereo-equipment and a double bedroom. All this has cost her a lot. Besides, I enjoyed myself at her place. But she did not seem to understand. It was all very embarrassing. Since then I have not visited her. *(Eg har ikkje gått te hon siden.)* It was just as if she implied that I had lied to her . . .

71

These examples show some of the difficulties that difference creates when it is considered too great to be under-communicated. Equality is being, doing and having the same. The other woman seems to feel that she cannot be confirmed as a clever homemaker by somebody who has a better home. Mona considers the other's success in relation to her means, but this is not accepted. Only equals can really give each other such confirmation, it seems. And much equality is very finely calculated.

The dilemma between equality and prestige may also be phrased as one between independence and community. One value is to be a valuable human being in the eyes of both oneself and others by being an autonomous individual. At the same time one wants to be "one of us", to be similar to others, not being different, not being individualistic.

When people put on airs or try to be different, there are informal sanctions to keep them in line, to enforce equality. Accusation in gossip of having become too highfalutin is an indirect sanction and a way for the talkers to confirm agreement about values. Sanctions ensure sameness even when times are changing. There is an attempt to keep in step under changed circumstances.

As long as most people in a network live in cooperative apartment blocks, moving to a terraced house may be codified as being better off. If or when everybody lives in terraced houses this will have become "plain ordinary living". When none of the women had a driving licence, the first to get one had a lot of prestige. Now it is the normal thing.

Dialect is a more permanent sign of identity, both rural dialect versus Bergen dialect and middle-class versus working-class Bergen dialects. They codify differences between Bergen dialects as speaking ordinarily, as they do, or speaking in a highfalutin way *(snakke fint)*. Such talking is trying to be different and better, a sign of pretentiousness. Ellen once related that when she was a hairdresser's apprentice she had to speak stylishly at work, but her friends told her that if she spoke to them like that, she would no longer be their friend.

As noted earlier, one's way of dressing proclaims signs of identity. Sissel, for instance, was tormented once by her other friends when she wore one of Irene's student-style coats: "Take that coat off at once. You have frequented Z (a student dancing place) too often!"

Another example is smoking. All my informants smoke. In some urban Norwegian milieus, as in other Western countries, there has developed during the past ten years a trend in favour of those who do not smoke. This trend has not, it seems, reached these urban working-class milieus. People with higher education stop smoking before those with less education. The statistics of average Norwegian smoking behaviour show that men's smoking has gone down, whereas women's smoking is still rising. Middle-class men stop smoking, it seems, whereas working-class and lower middle-class women take up smoking.

As the only one who did not smoke, I once tried out some jokes at the expense of smokers in an encounter. They checked me unusually promptly by saying that if I did not enjoy the polluted air, I was free to leave. Non-smoking was codified, in that situation, as middle-class behaviour, as not being "one of us". It was silently accepted as long as I did not brag about it or try to use it as a sign of being better. When I called attention to it, they promptly came down on me.

In this way the content of life styles changes, but at the same time differences and boundaries between categories of people to some extent persist. People belonging to higher ranked categories also, in my view, experience dilemmas between prestige and equality. The higher rank one has, the "nicer" one has to behave in personal relationships, in terms of egalitarian idioms. But in higher ranked milieus it seems that rank is less precarious; one does not as easily codify distance and difference in personal terms, neither that one is not good enough for the other, nor that the other is putting on airs. One reason may be that working-class people constantly lose some of their best people to other classes. Social mobility is not great, but it is there, and creates sore feelings among those who do not feel good enough any longer to be friends with the socially mobile ones. At industrial workplaces working-class men have developed typical strategies for solidarity as against the management, and sanctions to enforce such strategies. These strategies emphasize equality as sameness, that the workers have identical positions and interests versus management (Lysgaard 1961, Hoel 1982).[3] This is part of traditional working-class culture. Social mobility and individual achievement is a more central part of what may be called middle-class culture.

Elements of working-class culture in workplaces can thus be

found among working-class people outside workplaces, also among women. Women and men belong to the same social universe of "ordinary folks", and the general dilemma between equality and prestige is similar for both sexes. But the specific content of the general dilemma is different.

What it means to be "fairly ordinary"

In the city of Bergen different kinds of people live closer to each other and there is more social mobility, more awareness of difference and ranking, than in Barnes's Bremnes. The people of Bremnes saw themselves as the whole community. Ordinary people in Bergen implicitly see themselves as part of a stratified society. The notion of being ordinary seems to be more ambiguous in this urban context. The ambiguity reflects the stratified society and the general dilemma between prestige and equality. Again Mona may serve as an illustration. Often she is praised for her good taste and her nicely decorated apartment: "She has so many beautiful things and at the same time she is so nice and ordinary herself." In these situations she is praised for her nice belongings and for not bragging about them. She does not use her belongings to act as if she is better. She over-communicates equality in behaviour. In this case ordinary means "being one of us", being equal to "us" in spite of what she has.

In another situation Beate tells that she, except on one specific occasion, never felt degraded or looked down upon because she was an unmarried mother. "The reason is", she says, "that I have never acted like a vamp (vært en sånn typejente), I have always been fairly ordinary." In this utterance fairly ordinary is also positive. It means being a decent girl as opposed to (stigmatized) vamp-like appearance and actions.

Fairly ordinary also has more negative connotations. Beate once told the other members of her sewing circle about a divorced friend who works as a hairdresser and all the beautiful clothes she has. She buys expensive clothes, shoes and bags instead of the less expensive items the others usually buy. Beate gives a detailed account of her nicest fashion clothes and accessories, and says that she herself could imagine buying something like that: "Instead of buying three cheap things one could buy one expensive thing that

does not hang on everybody."[4] Then somebody asks about the home of her friend. "Is her apartment as nicely decorated as she is herself?" "No", Beate answers, "her home is nothing special, it is fairly ordinary." In this and other cases fairly ordinary means nothing special, no prestige to the owner in this field of activity. The general dilemma between equality and prestige as a difference that is difficult to handle in social relations, is thus also expressed in the different meanings of being fairly ordinary *(ganske alminnelig)*.

One may ask in what sense the category of ordinary folks is a reference group. It is a reference group in the sense that there are some common typical life situations, role routinizations, ways of life, and symbols and values pertaining to such people. Within a city of Bergen's size it is in addition also often possible to trace some links of common friends and acquaintances when two persons meet.

One example of this is the easy relations that often obtain between my informants and different kinds of service personnel. Taxi-drivers, waiters and artisans are, for instance, the same kind of people as my informants. They often engage in personal conversation on an equal basis with these people, and thereby often get better service. They often immediately assume that service personnel are like themselves and that common understanding is possible. Service given to equals is different from service given to higher or lower ranked persons. Often such an easy relation starts off by the customer asking if for instance the taxi-driver knows this or that taxi-driver that she herself knows. And, I believe, the equality in rank is also signalled without any such links, through signs like dialect and clothes. For a man, for instance, when buying car parts, wearing an overall and not wearing an overall are two very different matters in terms of the service received (Harald Tambs-Lyche, personal communication).

Similarly, there is a parallel in the relationship between a mother and the *dagmamma* (a woman who takes care of child(ren) for a wage during working hours) of her child. A working class mother often has an easier relationship with a working-class *dagmamma* than a middle-class mother has. They are often friends and emphasize personal and egalitarian aspects of the relationship. An educated mother often somehow looks on herself as an employer, in hierarchical terms. Many problems in the *dag-*

mamma institution are basically due to different expectations because of such class differences.

In the same way as educated persons get better service from other educated persons like bureaucrats, planners, doctors, lawyers and so on, working-class people get better service from taxi-drivers, waiters and plumbers. They know each other's codes, and better understanding is thereby possible. The difference is only that actions of, for instance, bureaucrats affect social change more profoundly than the actions of waiters.

Throughout this book I specify, in one domain of life after the other, the nature of the life style of my informants and the signs they use to present themselves as plain respectable ordinary folks and to place other people in this or other categories. Such data answer questions about the nature of cultural and interactional boundaries. The rise in service occupations, the interactional mix between service and manual occupations, social mobility on the part of a few old friends, cousins and siblings, and the (until lately) rising standard of living, produce dynamism and change in social life, changes that lead to new life styles in the working class. The content of life changes, but still some kind of social and cultural boundaries between status groups persist.

Religion and rural background

It is impossible to finish a discussion of who fits in with whom in Bergen, without mentioning pietist religion and rural versus urban background. Pietist religion has a strong hold in Western and Southern Norway, both in the State Church and in different organizations and sects. The degree to which people are influenced by it varies. Most Norwegians only attend a church for baptism, comfirmation, weddings and funerals, and perhaps sometimes on Christmas Eve. But pietist influences are strong, both directly and indirectly. Some people are actively engaged in organizations and lead lives very different from most of the women of this book. Pietist religion and rural background is to some extent connected, but there are quite a few urban low church organizations too. Recent urban migrants who are religiously active often seem to belong to low church organizations and urban people belong to the congregations of the state church Belonging

to a lay-organized church does often mean that one also belongs to the state church. Lay-organized church is more pietist than state church congregations.

In its broadest sense religion determines attitudes towards sex, drinking and dancing. Some of the activities of my informants would not be possible if they were active practitioners of pietist religion. There are many different shades and nuances in the ways people think and act in these matters. Such attitudes determine to a great extent who fits in with whom.

Like most Norwegians my informants are members of the State Church, but not active religious practitioners. They use the church mainly for rituals like baptism, confirmation, weddings and funerals.[5] But attitudes to alcohol, partygoing, and going out vary somewhat. Such practices are more closely examined in a later chapter.

In addition to religion, rural versus urban background also differentiates between people. The Bergener's name for a person from the rural areas around Bergen is *stril*. Today this word is more or less used about all people with a rural background from Western Norway, and the meaning is less derogatory than it used to be. The differences between townspeople and rural people seem to play a lesser role compared to former days. But still rural people stick together when facing urban life. The dialect is the main sign for a rural versus an urban identity. The dialect cannot, in most cases, be completely changed, but it may be modified, to different degrees, in the direction of the Bergen dialect. During the last years more people, especially academics, consciously keep their dialect as unmodified as possible. Among the people of this study rural background is evidently not such a barrier to personal contact with Bergeners as before. But even today speaking dialect is somewhat stigmatizing. Audhild is for instance married to a man who is of rural origin *(stril)*, and he will inherit a farm that they now use as a summer residence together with his parents. She has not changed her dialect. By this she presents an unambiguously rural identity. Asbjørg was married to a man from Bergen and Eva and Nils (Beate's husband) both have spouses from Bergen. All three of them have changed their dialects drastically. Asbjørg says that it is difficult to be admitted by Bergeners, to come to know them. "They have only jaws and hindlegs" *(det e' bare kjeften og bak-beina med de)*, i.e. they are too talkative and too quick-tempered.

Asbjørg's circle of friends do, however, consist of both women from Bergen and women with a rural background. Asbjørg and Audhild are friends; they saw each other often during the period when they lived close to each other. They have a similar background. But Audhild is much more different from Asbjørg's Bergen friends than Asbjørg herself is. Asbjørg has the same attitudes towards fashion, drinking, going to discotheques and home-production as the other women described in this study. Audhild is a little too special in their view.

Sketches of two ego-centred networks

As noted earlier (in chapter two about fieldwork), the network of my study is arbitrarily delineated. Some, like Elisabeth, are central in this network. Others, like Asbjørg are peripherally located. Each of the women does, however, have her own much wider circle of friends, relatives and acquaintances. These ego-centred circles vary considerably in both form and content, for instance what range there is in terms of age, occupation, place to live, etc., and what kinds and how much of goods, services and information are exchanged. I here use Asbjørg and Elisabeth as illustrations of how resources as well as the notions of fitting in shape the form, extent, and content of ego-centred networks. Chapter three, about Ellen, gave an example of a woman with a relatively wide circle of friends, relatives and acquaintances. Elisabeth is another example of a woman with many contacts. She may, even viewed in her own social circles, be called a network specialist, because she is more than usually active in starting up and maintaining social contacts. The circle of people who visit her in her home is wide in terms of number, age range, kinds of defining relationships (friends, relatives, in-laws, colleagues) but relatively homogeneous in terms of who fits in with whom. Her social circle is, however, less homogeneous than Asbjørg's. Elisabeth has a brother and a sister who have studied at the university for the lower degree *(cand. mag.),* and two brothers who are skilled workers. Two of her siblings thus belong to the "student" category.

Elisabeth is central in the sewing circle that forms the core group of my fieldwork network. She has been especially close friends with both Kirsten and Sissel from adolescence.

She does not, however, live in the same neighbourhood where she grew up. She lives in a neighbourhood about half an hour away by bus. There she already knew Mette, who had lived the first part of her childhood in the same area as Elisabeth. Through Mette she came to know Beate. She did herself take the initiative (by inviting her for a cup of coffee) to know Eva ("I saw that she had nobody") and through Elisabeth, Eva and Mette became friends. Elisabeth visits both Eva, Mette, Mona, Asbjørg, and Beate in the neighbourhood, but Beate is the only really close friend there. She sometimes meets Audhild at Asbjørg's place, but finds her a little too special for her taste.

Elisabeth mostly socializes with women of her own age in the neighbourhood, but she also has a few good neighbourly relations with women 10–12 years older than herself. One is Mrs. Hagen, who lives on the same stairwell. Her husband drinks, and Elisabeth and Georg tried for a period to help them out of their problems. Elisabeth also visits or is visited by a few other women at the same stairwell once in a while. It took some time, however, before she was accepted. Georg's brother drinks and is often without employment. He often came to see them while drunk, when they first moved in. Some neighbours wanted to separate Elisabeth and Georg and throw out Georg because of that. "I have forgiven most of them, but not all", Elisabeth says, several years later.

In the neighbourhood she uses different paid informal child-care solutions when she needs them, and has no difficulties in developing personal relations of trust with the babysitters. Her network of relationships in the neighbourhood is, however, altogether relatively homogeneous in terms of "who fits in with whom". Students and people who try to be high-up are not personal friends of her, nor are really stigmatized social cases. Mrs. Hagen and Asbjørg are on the borderline of a stigmatized category, but both because of the husbands, not because of themselves.

Elisabeth had the intitiative to invite home former and present colleagues, as well as her mother, old friends of her mother, and other relatives. She and Georg have extensive contact with relatives on both sides, especially parents, parents-in-law, but also siblings, aunts, uncles and cousins. They try, however, to limit as much as possible the contact with Georg's brother, who would

have been a real *slaur* if his parents had not protected him. Their contact with Elisabeth's "student" siblings is also to some extent limited by their involvement in other spheres of life. This is, however, counteracted by Elisabeth's parents being more than usually helpful and active in keeping the family together. Their summer cabin is, for instance, a meeting point for all the grown-up children and their spouses.

Georg and Elisabeth receive much help and support, but they are also able to and willing to give help and services back. When she, for instance, took her driving lessons, some of the days her mother-in-law came half an hour by bus to take care of her children. On other days Asbjørg took care of them.

Asbjørg, on the other hand, has a much more limited social network in Bergen. She was first separated, then divorced, and has three children, between one and ten years of age. Her home community is several hours' journey by boat and bus from Bergen. There she has parents and relatives. A large part of her own generation has, however, moved elsewhere. Her siblings live in different parts of Norway, one sister in Bergen. Bergen is the centre for a few specialized medical services. For that reason her parents visit her for a few days about once a year, if one of them has to go to the hospital. "Otherwise my father never would have come", she says. "He never leaves the farm, even if my brother has taken over now". Asbjørg and her siblings each get a lamb every fall when they are slaughtered. Once in a while they get a little butter, cheese, fish, jam or juice, but this contribution is relatively small. She may, however, spend holidays on the farm or send one or more of her children there. Since she has no husband and no car, it is burdensome for her to do the journey, therefore she does not go very often. "It is important for me all the same", she says, "to know that I can always come home".

Her closest relation is a sister who also lives in a cooperative apartment block in another suburb. The sister is divorced with two children, but has a steady male friend living together with them. He has a car, and they come relatively often, about once a week or once a fortnight, with the children in the early evening, to see Asbjørg and her children. The sister's children are about the same age as two of Asbjørg's three children. Asbjørg cannot go to see them so easily, because she has no car and travelling on two buses with three children is both expensive and cumbersome. When she

goes to see them, she always brings the children and sometimes stays overnight from Saturday to Sunday.

The sister and her friend also sometimes bring one of Asbjørg's children with them for shorter holidays to the farm. Asbjørg feels, however, that this can easily be "too much" for her sister. "She has her own things and her own kids to take care of."

When her sister was ill once, Asbjørg left everything at home, and went to help her. It was just before the 17th of May (the Norwegian national day). She had not finished her own preparations (the children are supposed to have new clothes for that day), but left all the same because she was more needed at her sister's place. "I just have to go and help her. She has nobody else to help her." Asbjørg brought along the smallest child and let the two eldest take care of themselves under the supervision of a friend (Audhild) in the neighbourhood.

Asbjørg's husband was a skilled printer, but lost his job because of drinking and beating it up. He has gone off to live with another woman. During fieldwork Asbjørg became formally separated and divorced. Her former husband came once in a while to see her, but never did anything for the children. He is not reliable, in her view, so she would not have trusted him if he had wanted to take care of them. Asbjørg is a little bit pitied and blamed by neighbours because she lets her former husband visit her.

After separation she almost never saw her former mother-in-law. Asbjørg was disappointed that she was not interested in her grandchildren. The grandmother gave them something at Christmas, but "nothing much". Asbjørg only asked her once during those years to take care of the youngest child during a weekend. The reason is, Asbjørg says, that the grandmother takes so little interest in the children. "If she had come here to visit me, it would have been different. Then I would have asked her more often."

Asbjørg sees her former sister-in-law more often. They sometimes escort each other to dancing places. Her sister-in-law is divorced with one child and considered a little bit "cheap" by other women, because of the places she visits and because of her looks (see also chapter ten). Asbjørg feels, however, that she does not have very much choice about friends to escort her out to dancing places. She has to use the few contacts she has.

In her first neighbourhood, Asbjørg had two friends whom she visited and was visited by, Elisabeth and Audhild. Elisabeth she

only visited when Georg was at work, but Audhild she also visited when her husband was home. "It is Audhild and my sister that I count on", she used to say. Audhild's husband helped her a few times when she needed some minor repairs, but she felt it was difficult to ask him. "I do not like asking people for help, since I can do nothing in return myself. The only thing I know is to take care of kids." Asbjørg took care of both Audhild's and Elisabeth's children when they needed it. She insisted on not receiving money, but they usually gave her money or a gift. They also took care of her children a few times, but she had less need for child care during the day than they had.

In the afternoon and the evening Asbjørg regularly uses paid adolescent babysitters from the neighbourhood. For a period she developed a close relationship with Berit, an unemployed 18-year-old girl who lived with her parents on the same stairwell. The girl got company and a place to be away from her parents. Asbjørg got relief and help with the children.

Asbjørg also has two other friends in suburbs not far away. She came to know them several years ago, through her sister. They are both from Bergen. One of them is married and does not often have time to meet, the other is divorced with only one child and with more time and need for company. During fieldwork Asbjørg moved from her neighbourhood to one about ten-fifteen minutes' walk from the first one. In this way she came closer to both her sister-in-law and this friend, both divorced like herself. She moved in order to have more social contacts. Audhild is planning to move and she does not see many other possibilities in the neighbourhood. On the same stairwell in the new neighbourhood she already knows Hanne, an unmarried mother with two children. She is the sister of Berit, mentioned earlier. The housing estate is newer then the other one, and the inhabitants are accordingly generally younger. Hanne has told her that there are many nice young women in the block. After the move Asbjørg was satisfied: "Here I do not have to sit alone almost every evening. There are several others in the same boat as me." Her problem is however not to involve herself too much with people who are considered no good. She is a lot together with Hanne, who lives on the flat above her, but tries to avoid the woman with a steady friend living next to her, because of all their drinking and parties. She feels, also, that as a single mother she is discriminated against by other inhabitants on the

stairwell who "try to be so refined". She feels that she receives many unjust complaints about her children just because she has no husband.

In these ways there are differences in the extent and the content of the social circles of the young women. Asbjørg's situation is shaped by the following factors: 1) She has moved away from the locality where she knows people and places and has most of her relatives. 2) She has no husband to do his part of the division of work both in the household and in exchanges in networks of personal relationships. 3) Because of that she has a very strained economic situation. 4) When she has paid work this is *dagmamma* work in her own home, which gives no extra social domain.

Conclusions

Several factors, some of them directly connected to occupation, some connected to region, religion, urban versus rural background etc. shape who fits in with whom. The categories of high-up people, students, social cases, those who put on airs etc. I have deduced from actions and conversations of everyday life. These categories inform their everyday life and do together make an implicit model of society. This implicit model expresses a tension in the culture between ideas of equality and the hierarchies of division of work. The egalitarian dimension is taken care of by looking at themselves as being in the middle, as the average of society. Hierarchy or conflict is expressed by their feelings of being threatened by social mobility in both directions. They may themselves lose control and become stigmatized or others may leave them behind.[6] Their implicit model of society does not, however, make an exhaustive picture of actual social groupings and life styles in society. To make a typology of Norwegian life styles one also needs data about the ways of life and categories of other social groupings. It would, for instance, be very interesting to know whether all Norwegians look at themselves as "plain respectable ordinary folk", as my informants do. My well-qualified guess is that a wide range of people in terms of life style and occupation in both cities and the rural areas would in fact say so. Those who would *not* look at themselves as plain ordinary folk, according to my guess, would precisely be two of those social groupings that my

informants have special categories for and stereotypes about; upper-class and upper-middle-class business manager, professionals etc. ("high-up people") and social workers, students, teachers and academics ("students"). Persons that my informants categorize as not respectable, as social cases, do on the contrary put forward a definition of themselves as respectable ordinary folk. Their problem is, however, that this presentation of self is in many situations not accepted. They have to live with a stigmatized identity.

Women and men belong in these ways to the same kind of people. They share some understandings about what is right or wrong and what are signals and signs for different kinds of people.[7] At the same time they also play very different roles in order to realize their values. As a result women and men are judged by different standards. Throughout the book I give a detailed picture of what it means to be decent ordinary folk for the women studied, in their everyday life.

In the next chapter I examine hearth and home, the heart of the matter of this study. Hearth and home is valued by both women and men, and they share basic ideas about what a good home is like. At the same time the home means very different things in the total life of a wife and a husband.

5. Hearth and home

Housing is an important part of the lives of Norwegians, both practically and ideologically. On the practical level housing is especially important because of the wet and cold climate. The climate simply makes it necessary that many activities that people in Southern Europe, for instance, engage in outdoors, must be done indoors in Norway. On the ideological level housing embodies the value of autonomy. Autonomy is very much a matter of being lord of one's own castle. Autonomy of the household is highly valued and expressed in numerous proverbs. Autonomy means being self-reliant and independent. This is probably a heritage from hundreds of years of peasant life in a sparsely populated country. One had to be self-reliant to survive, it is commonly believed.

The colloquial expression *hus og hjem* literally means house and home, and is a main symbol for the unity of the familiy and a frame for a whole syndrome of values. Norwegians tend to think that family life is the ideal way of self-realization for most adults, both male and female, For both husband and wife the trinity of spouse, home and children has central importance for identity and self-realization. "What a man is proud of nowadays", the women hold, "is his wife, his kids and his home". The home *(hjemmet)* is central as the family's territory and often also their most important economic asset. The ideal home is celebrated in "native theory" for its atmosphere of warmth, cosiness, peace, quiet and safety as opposed to the colder, more challenging but also potentially more dangerous outside world. Considerable time and money are inevested in it to secure those values symbolically.

Verbally the importance of the home is also indicated by the many expressions containing the word house *(hus)*. Norwegians often use the word house where in English the words "family" or "our place" would be used. The Norwegian popular expression for

a family quarrel or row is, for instance *husbråk,* a house quarrel (literally a disturbing noise in the house). One's house is ideally a privately owned single-family dwelling. Rented or cooperatively owned apartments are in many ways also treated and talked about as the house *(huset).* Women for instance often use expressions containing this word for their domestic work. "Apartment" is more a technical and legal term, while *hus og hjem* are the everyday words for the place to live.

Hearth and home thus seems to be a generally important concept in Norwegian culture. In this chapter I start the examination, which will be continued throughout the book, of the different values that the young women of this study connect with hearth and home. What does hearth and home mean in the context of their lives, and what does it mean in relation to other valued pursuits that they also engage in? The different roles of husband and wife in the realization of the values of hearth and home will be touched upon here, and examined more closely in chapters twelve, thirteen, and fourteen.

The apartments in which these young women live, are situated in different parts of suburban Bergen, in cooperative housing estates. These estates are situated in different directions at a distance of 3–12 km from the centre of Bergen. The age of the building, its distance from the centre, and the demographic composition of the estates vary. The oldest estates date from the end of the 1950s; the newest are only a few years old. In newer neighbourhoods, there are many families with small children. In estates built in the fifties and sixties, young families are a new generation among middle-aged couples with adolescent or grown-up children (who have now left the parental home) who similarly settled there when the estate was new.

The areas where they live consist of apartment blocks with three or four floors and several entrances (see photograph).[1] In between the blocks are walking paths, playgrounds covered with asphalt or gravel, and lawns. The use of cars between the housing blocks is often restricted. There is one road for cars through the area, which is otherwise supplied with walking paths. There are usually one or more grocery stores a few minutes' walk from any apartment.

Inside each entrance to the block, there are normally two apartments per floor, one on each side of the stairwell. Apartments

usually have from one to four rooms plus kitchen, hall and bathroom.Most of my informants lived in aprtments with two (sometimes one or three) bedrooms and a living room. The area of the apartment is sometimes around 60 m^2 (2 rooms) and most often around 80 m^2 (3–4 rooms).

Home decoration

Home decoration involves interests and activities for which both husband and wife are responsible. In the early stages of married life many young families have not had the time and economic resources to arrange everything according to their standards of what a nice home looks like.

When talking about their homes, most people stress individualism and independence: "We don't give a damn how other people live. We do it our way." But for an observer likeness between the homes is as striking as the differences. There is an underlying "grammar" for what a nice home looks like. Individual homes may be seen as permutations and variations on the same "grammar".

Generally a good Norwegian home has to be cosy and homely (*koselig* og *hjemlig*) and warm. The temperature is usually about 20°C. Cosiness is achieved by an abundance of furniture, small lamps, green plants and ornamental pieces (many of them are some kind of souvenir) in the living room. The kind of house and its decoration, as well as what is considered "good taste", vary between different milieus and classes.

In Norwegian homes, generally, the living room is the largest room and bedrooms are smaller. The general increase in living area in Norway after the war has mostly been used to make the living room larger. In the cooperative apartments the living room is about 20–30 m^2 and the bedrooms are about 6–12 m^2. (See drawing, page 88). One bedroom is larger than the others. This is supposed to be the parents' bedroom and is large enough for a double bed. Smaller bedrooms are for the children. The families of my study use the rooms as they are intended to be used, whereas intellectuals of the "student" culture sometimes use the largest bedroom for the child(ren) and take a smaller bedroom themselves. When there are sufficient resources, the whole apartment

is newly and nicely decorated, but often, at this early stage in the family's developmental cycle, there is a considerable difference between the appearance of the living room and the other rooms.

Typical apartment plan

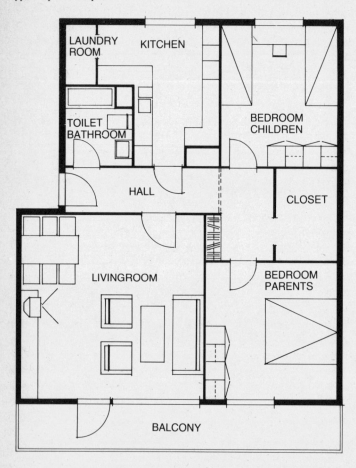

The parents' bedroom is usually about 10–12 m² and is equipped with a double bed and perhaps a little night table at each side. In addition a few objects like a vacuum cleaner, a sewing machine,

and the like are often stored there. It is furnished in a standard way. What varies is the newness and fashion of the double bed and whether the room is newly decorated or not. The bedroom is the most private room of the apartment, the one guests are least likely to enter. It is normally not used in the daytime, unless one of the parents is sick or takes a nap. Babies who sleep with their parents also have their morning nap here. The privacy of the Norwegian bedroom indicates that sexuality is considered the most private part of life. Mette once gave an example of the privacy of the spouses' bedroom when she told about the uneasinesses of having a municipal home help. While she was in the hospital once, a home help, a middle-aged woman, cared for the house and the child while her husband was at work. He did, however, put a note on the parental bedroom door, telling the home help not to clean or tidy up this room, as he wanted to do it himself. In his view she had no business to go in there. The home help had not, however, respected the note, but entered the bedroom to vacuum and make the beds. After Mette came home from the hospital and still was not well, the home help continued to come for a few days. One day she found some clothes to repair, among them her husband's pyjamas that were torn in the front. "Are you in such a hurry?" the home help had asked. "Oh well we are young, aren't we", Mette had answered, very annoyed and embarrassed. After these experiences Mette and her husband found that it is better to manage on one's own. The help received was not worth the intrusion into their privacy.

Bedrooms are normally redecorated after the living room and kitchen are done. The equipment of children's bedrooms, however, varies most between families. In some families these rooms, besides the necessary beds, contain discarded furniture from the living room and an abundancy of both whole and broken toys. In other families they are elaborately equipped with childish wallpaper and furniture.

Kitchens are small but relatively well equipped, without necessarily being newly decorated. In addition to cupboards and counters there is a small table with steel legs and a formica top where the family members eat their daily meals. Besides household utensils, tableware and food, many families keep bills and other important papers in one of the cupboards. In one of the drawers the young mothers often keep their make-up kit. They also often

keep a mirror and their handbag in the kitchen. While putting on make-up or fixing the hair they usually sit in front of one of the kitchen counters.

The living room is, as noted earlier, given priority. This room is, among other things, the room where guests are normally received , and is thereby a symbol of family aspirations and standards. It is funished with a soft and comfortable couch ensemble, which includes a matching couch, loveseat and chair, a large coffee table and a large cupboard with some open shelves. In the open shelves there are mostly ornaments. Some families also have a dining table in the living room, but several do not. The room may be too small, or they may instead want an extra pair of good chairs, a stereo-rack or a bar instead of a dining table. Wallpapers are made of textile or burlap, and sometimes an imitation of velvet which is popular. Even if a household has not been established for more than from five to ten years, several of them have already exchanged the couch ensemble for one covered with leather. They are oriented towards furniture fashions in the big stores. Fashion in the late 1970s has emphasized dark colours, fringes and large voluminous furniture, to some extent copying furniture from the last century.

The priority of the living room is made more clear by the fact that it is also kept more in order than the other rooms. Mothers try to keep the living room in order by not letting the small children play there, and especially not when they are not themselves present to control them. The mothers of children below three very often keep the door to the living room closed during the day. The children play in the kitchen, in the narrow hall, or in their own bedrooms. Informal visitors received during the day often sit in the kitchen. If the kitchen is too small or if she wants to honour the visitor, visitors are invited into the living room.

The ideal living room gives off an impression of luxury and comfort. The wood in the furniture is often polished, or made to look as if the surface is of polished wood. A dark brown cupboard may for instance be made of real palisandre or painted and polished pine wood. There is a concern for style, for instance that the different patterns on wallpapers, carpets and curtains are harmonized. Some couples use many different patterns, some have monochromatic dark brown wallpaper and/or laminated wood in their living room. A few years ago the fashion was for large patterns, now small flowers seem to be more popular. When

there are many different patterns in a room, being harmonized means that the colours are regarded as matching, and that the mix of patterns is not regarded as too loud and glaring. "Nature colours" like brown, orange and green "go together", and are often used.

Choosing furniture and decorating a home often takes a long time. There is more or less a continuous interest in home decoration. Young couples look at advertisements and coloured pictures in brochures from local furniture stores and discuss what they fancy themselves and what couch ensemble *(salong)*, cupboard *(reol)* and bedroom set *(soverom)* their different friends and acquaintances have bought. Furniture, pictures and ornaments are mostly industrially mass-produced and bought in stores. They usually buy, if not the least expensive items, then the next cheapest items in the selection.

The kind of ornamental pieces *(pynteting)* chosen also contribute to the impression of luxury and comfort that they want to give in a living room. They favour shiny, precious or brittle materials like brass, glass, alabaster, onyx and porcelain. Some ornaments, like onyx ashtrays, brass pots for the green plants or brass candlesticks also have some practical use, but many pots and figures are only for decoration and the pleasure of the eye. There is also a concern for symmetry and order in the way objects and ornaments are placed in a room. There is a certain ritual space around each ornament hanging on the wall or standing on the shelves. Mona's place is a good example, as once expressed this way by Elisabeth: "Everything is so stylish and harmonized at Mona's place. Brass lamps complement white alabaster ornaments here and beige alabaster ornaments there. She has so many beautiful ornamental pieces!"

Pictures and figures are mostly figurative and a little romantical, for instance a reproduction of a painting in a golden frame, showing a deer in front of a sunset or an embroidered picture showing a woman in rococo dress with a little dog in her arms. Some of them also have a non-figurative decoration on the wall above the couch, made of scrap metals on a burlap background.

One also tries to give the living room a luxurious character by keeping a ceremonial state of order and cleanliness. They try, as already mentioned, to keep it ready for presentation if somebody should show up. There are as few signs as possible of the daily

activities of the family members. The living room belongs primarily to the grown-up members of the familiy. They relax there after the chores of the day are over. Children use it together with their parents or on ritualized occasions, like watching the children's television programs in the evening. The comfortable furniture is there to give the family members a luxurious feeling. The room is furnished to be a nice place to relax in, relaxation meaning sitting idly chatting or looking at the television.

If one compares their homes to those of business middle-class people in Norway, there are obvious differences. Upper- and middle-class people may regard what is good taste in working-class milieus as glaring and cheap. They have larger houses and more expensive furniture. They have a lot more space and may for instance have polished wooden floors or expensive wool carpets instead of more inexpensive nylon carpets. They have real art paintings instead of reproductions. The furniture is made of expensive polished wood, like mahogany or nut wood. Some have real antiques instead of industrially made copies, and so on. But in the underlying standards, there are also striking similarities. Business people's homes can be described in terms of representativity, luxury and tradition. Tradition is thus more valued than in the urban working class. Fashion has perhaps replaced the traditions that working-class people want to get away from, traditions and ways of living which seem to be too impregnated by poverty and misery. There are thus some similarities between the standards and underlying patterns of working-class people and business-class people, but the different milieus elaborate these ideals in their own way. Working-class people seem to use advertisement and fashion as sources of information to a somewhat greater extent than upper business-class people. In this way patterns of life change, but differences between the classes persist.

The ideal "student" academic middle-class home, on the other hand, may be described not primarily by the notions of fashion, comfort, luxury or representativity, but by the notions of rusticity, activity and also tradition. They favour elements from traditional peasant life somewhat more than elements from traditional bourgeois life style and elaborate those as sign objects in a new urban context. An ideal academic middle-class living room has unpolished wooden floors or floors covered with cork, which is closer to nature and to rustic life. Furniture is made of pine and not

polished. The couch ensemble is covered with wool. The few ornaments are hand-made handicrafts. There is original graphic art or posters on the walls and books instead of ornaments in the shelves. Signs of activities do not make the living room less representative. There is an ideology of using and living in the living room. For these individuals a loom, invariably for the wife, music rack, instruments etc. are prestigious signs of an active and meaningful middle-class life, and add to the ceremonial state of the living room. Academics often express the opinion that other groups have status symbols, while they do not. A better way of phrasing it is to say that status symbols or prestigious objects differ somewhat in different milieus. Among working-class people a fashionable couch ensemble, new and impressive stereo-equipment, colour television etc, are status symbols. Among academics some status symbols are inverse to working-class and business middle-class symbols: one expresses other values than "passively looking at the television" by perhaps having only a black and white set. Similarly the kind and amount of records are more important than the newness and quality of the stereo-equipment. The kind and number of books are more important than the shelves. But also academics value technical innovations like a modern bathroom and kitchen.

These differences between classes are of course only tendencies and not absolute differences. Other classes than the working class are also influenced by fashion. Different traditional objects are for instance fashionable at different times.

Home decoration as an ongoing concern

What is so striking in this material is how home decoration is not done once and for ever, but has become a constant ongoing concern. Many households seem to be planning or doing a project of this kind at any point in time. "Last year we did the bathroom. This year we will panel the hall." The people in my study are not only changing wallpaper or giving the walls a new coat of paint, but also giving the apartment new equipment.

Beate's and Nils' home is a good illustration of the values and meanings of home decoration in this milieu, and of how home decoration has become an ongoing concern. They are admired by

friends and acquaintances for their nice home. Since they moved in a few years ago, the whole apartment has been completely redecorated. Parts of the apartment were redecorated more than once. First they did the living room and the hall. The living room has two different wallpapers in patterned red and green, and contains a dark leather couch ensemble, dark brown tables, white cupboard with drawers and shelves. There is a white bench for the stereo-equipment, brown velvet curtains, and an abundance of lamps and ornaments. An old kerosene lamp from her husband's home at a farm near Bergen, with a pot of green plants where the kerosene used to be, hangs over the coffee-table. An Italian reproduction of a crying boy, very fashionable in this milieu at the moment, hangs over the couch. Another picture is a real painting, made in Japan from a photograph of Beate's son. (A door-to-door salesman came to everybody in the block and took orders from those who wanted to have one made.)

Then the kitchen was completely redecorated. Walls and cupboards were panelled with different kinds of laminated panelling. Every cupboard and drawer was covered and framed by wooden mouldings and given new knobs. A dish-washer was installed; there are new curtains, a new dining table and new table cloth.

In the bathroom walls were covered with formica, and a new mirror, hooks and towel-racks were installed. The walls and ceiling in the toilet were painted. In the boy's room they installed two different kinds of "boyish" wallpapers (with cars and airplanes) curtains, shelves, table and bed. Lastly they did up their own bedroom. They sold the beds that Beate's father, who is a carpenter by trade had made for them (nobody in the family wanted them), and bought new fashionable beds. New wallpaper and a soft wall-to-wall carpet was installed. In all the rooms in the apartment they had installed new covering on the floors, either carpet made of artificial materials or vinyl.

In the meantime the furniture in the living room was re-arranged many times. Beate's father made them an original bar in the form of a small open wagon arranged as a man lying over a woman. The barwagon is ca. 1 ½ m long and stands on the floor with glasses and bottles. They bought new stereo-equipment in a vertical rack, which is the fashion of the day. (They got this equipment secondhand, cheaply from someone who needed the money.) They gave the stereo-bench they already had to Beate's

brother (since her father had made it, she did not like the idea of selling it to him).

Beate lost her liking for the dark patterned wallpaper in the hall and wanted lighter colours that became more fashionable in 1980–81. They plastered the walls with a white substance that gave them a rough surface and changed the frames around the doors, the door sills and the floor covering to a dark brown shade. (The fashion is inspired from Spanish architecture, from holiday hotels in Spain.) They also changed the floor covering to an imitation of tiles that go together with the white walls with dark brown frames. The next project was to treat one of the walls in the living room with this white plaster. Beate became tired of the two dark patterned wallpapers and wanted to change them also, but she did not want more than two white walls. Four white walls would have been too uniform, in her opinion. After my fieldwork was completed they also changed the couch ensemble, to a still more fashionable one, covered with oxblood coloured leather and filling the whole corner.

In this way they are continuously decorating, redecorating and elaborating their home, the frame of their life together. Whenever I asked Beate about division of work between her and her husband Nils, she answered "we do it together. We share it." After a while I learned that, practically speaking, this meant that she helps him, for instance by holding something, or handing tools to him if he works alone. She may also help him by making a good meal and keeping him company while he works. He is an especially handy man who was brought up on a farm close to Bergen, and who had also been a sailor for several years until he settled down as a repairman in an automobile repair shop. She, on the other hand, is a "typical urban girl" and does not identify with rough kinds of work. She knows how to sew and knit, even if she does not practise very much. She is proud of several silk lampshades that she has made for herself and for others. Both of them, and especially Nils, get help cheaply from relatives and friends. Because of his job, Nils is able to offer other services in return. They may also occasionally use hired craftsmen, but that is more seldom. He often (alone or together with male friends) actually puts the wallpaper on to the wall, but she is responsible for choosing the equipment and often for the shopping and paying of bills. They always go shopping for larger items together. Both want to have a say and

agree on what to buy, but she is the one who plans and administers most of the aesthetic aspects of home-making, whereas he plans and carries out the more technical aspects. She says: "He does not care whether there are one or ten pots of plants in the window. To me it means a lot." Beate takes most interest in the ornaments and in the "good taste" of what is to be installed. It means a lot to Nils to have a nice home, but he leaves much of the aesthetic planning and concern and many of the details to her. She plans, but needs his consent and cooperation. "Beate has such good taste", other women say, "and she is so determined".

Beate and Nils are particularly successful in the way they manage to equip and decorate their apartment. In my experience only Mona's home, described in chapter two, can be compared with theirs. Ellen's home, described in chapter three, is close to an average home. The reasons why Beate and Nils can be so successful at this stage of life where many other families have economic problems, are several. They receive income from two full-time jobs. In addition to that he often works overtime. They have a few hours' cleaning job together every week in the neighbourhood, paid in unregistered money. Because of his job Nils is able to offer many friends and acquaintances services and get their services and help in return. There is a lot of work and a complex economy behind their success.

Beate and Nils do, however, demonstrate general ideals in this milieu. Couples here are all striving to a greater or lesser extent to achieve the same ideals. Judging from the proliferation of shops and stores that sell materials and equipment for "do it yourself" activities, these activities are growing in importance in Norwegian society, not only in working-class milieus. In my view this is an important change in familiy life, whose reasons, meanings and consequences ought be examined further in the social sciences.

Home decoration as a central symbol

The home and its decoration are thus a matter of concern to both spouses. They both invest emotion, time and money in their home. There are multiple reasons for this concern and interest. Norwegians generally seem to emphasize economic and practical reasons. "By redecorating the kitchen, work there becomes more

practical, and also, it looks nicer", they, for instance, say. It may be argued, however, that the practical savings of time and effort sometimes seem small compared to the economic costs and the efforts it takes to plan and perform these activities. In a privately owned single-family house reparation and redecoration may be regarded as an important kind of investment, in case of a future sale. But when cooperative apartments are being sold, the authorities have up to now decided on the price and only add relatively small amounts if the apartment is well kept and nicely decorated. There is thus an economic aspect, but in my view this is only one of the reasons why home decoration has expanded.

Some of the other reasons have already been suggested. These reasons or meanings can also be deduced from the activities and the ways the young couples talk about them. The home is a comprehensive symbol for a complex set of meanings and values. Some of the meanings and values are connected to the unity of the familiy members as against the world. By decorating their home the family members symbolize their unity, and elaborate on the values of sharing and togetherness in the charged context of hearth and home. For each of the spouses their home symbolizes their identity as members of their particular independent family.

As I showed in the last chapter, the decoration of the home also symbolizes life style and social class, the kind of people that the family members identify themselves with and want to be like. A nice home, in the way it is valued in their culture, gives prestige. It is a way of presenting what the spouses are good for, vis-à-vis their relevant social counterparts. In university milieus, on the other hand, what one has published lately is perhaps as important as a sign of ability and success as the decoration of the home.

Further, home decoration implies activities which in themselves are meaningful to the spouses. Traditionally repairing house and equipment is a male task in the household. In cooperative apartments there are no fields or garden, no private house and few tools to repair. What is left of traditional male tasks is repairing and decorating the apartment and maintaining the car. Building and repairing are considered to be masculine activities which call for invention and creative energy: one sees the result of one's work (Wærness 1975). In arguments between husband and wife about division of specific household tasks, men put forward the "musts" of building and repairing against more routinized and also tradi-

97

tionally female tasks They often prefer these undoubtedly male tasks to those which are traditionally associated with female gender identity, like changing diapers or cleaning the floors. Home decoration is one of the ways many men prefer to be useful to their families. Since the home is more her domain than his, his interest in home decoration is for her a tangible symbol of his interest in her and in his family.

Home decoration also unites husband and wife in working together. Partly he exchanges these services for relief from other tasks, partly they actually plan and do this task together. She does most of the choosing, shopping, consumer-work, finds the best buy and so on. They work together as a team, very often with complementary tasks. He may feel like a man and she may feel like a woman while doing complementary tasks in a joint enterprise that they both value (see also chapter thirteen for a further elaboration on gender identity and division of work). Home decoration gives both of them, not only him, non-routinized tasks. She plans and cares for the aesthetic aspect, makes curtains and so on. For all these reasons the home represents a whole constellation of symbols and values. If the family life of my informants is compared to the bourgeois family of a few generations ago, meals were then one of the ways that the family acted out its character as a corporation. Highly ritualized Sunday dinners are remembered as occasions on which to demonstrate family unity and the ability to eat and converse in a proper way (Kirsten Danielsen 1984). In the working-class homes I have come to know, meals are less important as markers of family identity. Instead home-making, elaborating the frames of familiy life, has became a central symbol. To make a nice home is also a projection of the love relationship between the spouses. Elaborating the frames of their life together is one of the most important ways in which Norwegian families today manifest themselves as families. As products and symbols of contemporary Norwegian culture the homes are perhaps more important than banks, insurance companies, and public buildings. The culture is home-centred, and the homes may perhaps invite a symbolic comparison with, let us say, the Gothic cathedral of medieval France. They are not comparable in terms of aesthetic quality and grandeur, but in terms of being among the central products and symbols of their cultures.

Being a housewife

There is more to a home than furniture and decoration. It has to be kept clean and tidy and to have a good emotional atmosphere. Cleaning, cooking and child care have traditionally been wifely responsibilities. The Norwegian word for housewife *(husmor)* means mother of the house. Verbally motherhood is emphasized rather than marriage. The meaning of the word seems, however, in its everyday use to be more associated with cleaning, cooking and home production, for instance in these utterances:

"I am not really a housewife. I clean up and make dinner, that's all. Look at Elisabeth! She is a good housewife. She is humming and singing and baking."

"Marie is so housewifely. Have you seen how clean her place always is?"

There is a basic division of responsibilities: the wife is primarily responsible for child care, housework, preparing food, the laundry, repairing clothes, and for the good emotional ambience in the home. The husband, on the other hand, is primarily responsible for economic provision and for constructing and repairing household utensils. This basic division of responsibilities between spouses is very different from, but at the same time to some extent in line with, traditional peasant society. Women no longer have cows and the duties of tending them. Men have no fields to till and farm tools to repair. Instead of fishing they have their jobs, and instead of farm tools they have the car and the equipment of the apartment. At the same time it is relatively recently in Norway, given the late urbanization, that being "only" a housewife has become a role open to a large number of women. Depending on their personal backgrounds, young women today have somewhat different role models from those of their mothers and grandmothers. In the traditional peasant adaptations, the participation of women in production was needed, as well as their housekeeping and child-rearing. In fact housekeeping and child-rearing were subordinated to work in the fields and with the animals (Bratrein et al. 1976, Flakstad 1984, Holtedahl 1979).

The bourgeois housewife managed her servants in the house-

hold. In the first stage of industrialization the working-class mother had paid work in addition to tending children and household chores. The rise in the incomes of husbands made it possible also for many working-class mothers to "stay at home with the children". The housewife as a role model is thus recent but relatively firmly established in cities and towns. It now seems "natural"and that things have "always" been this way.

In the rural areas, the changes came later than in the urban working class; to some extent this change is still taking place. Since the 1960s, new technology often makes the farm a one-person workplace instead of keeping the whole household occupied. And only a fraction of what were farms in 1945 are today run as farms. These changes most often make the wife's position more like that of the urban housewife, but they may also make one of the spouses take paid work outside the home, if such opportunities exist.

Urbanization in the form of people moving in great numbers from the rural areas to the cities seems to have stopped, but not the local concentration in municipal centres and more densely populated areas. Many households still remain, however, in the rural areas, often with a changed base of livelihood, from farming and fishing to paid skilled and semi-skilled labour. The husband often commutes to the nearest centre. This is a way of urbanization that suburbanizes rural areas. Division of work between spouses and other aspects of life style become more like the urban counterparts (Holtedahl 1979).

In some milieus a woman is thus more accustomed to participating in production or paid work. Her routines for household chores and child care were adapted to this fact. In other places the housewife role is firmly established. The mother is primarily expected to take care of the children and the home. The picture is further complicated by persons moving from social surroundings with one set of rules to places where other rules are prevalent. Such experiences and expectations influence the responses of women to new opportunities. For instance, women with a rural background are more inclined to do rough tasks that urban women find unfeminine (Synnøve Aga, personal communication).

The women of this study do not completely conform to the housewife role, because even as mothers with small children they have some paid employment. They represent changes in Norwegian female employment which took place in the 1970s (see also

chapter eight about paid employment). To some extent they do, however, judge themselves in terms of the role of the housewife without paid employment. It sets some of the standards for what children need, for what a good home looks like, for how a good meal should be prepared. But both ideologies and practices about division of work between spouses are changing. (These changes are examined in chapter thirteen.) When, however, husbands and wives are arguing about division of specific work tasks, they still argue on the basis of such a main division of responsibility. Women have specific and pivotal roles in the fulfilment of the values of house and home.

If one visits one of the women when her house is untidy, she will excuse herself to make it clear that this is an exception, not the normal state of the home. She will for instance welcome you with expressions like this:

Come in, come in, but it's such a mess!
I haven't got anything done today.

And the understanding female friend will perhaps answer:

Oh, just relax, it won't hurt if you leave it for a bit. You can do it later, can't you?

How much work and what kinds of work are needed to keep the house in order? Most often they do their housework in the morning, if they do not go to full-time paid work. They do it before or after they have fully dressed themselves. It involves doing the dishes, making the beds, tidying up toys and clothes that are spread around, wiping dust from tables and shelves, vacuuming or washing the floors. The first chores are to be done every day; cleaning the floors is not necessarily done that often. Some of them clean or vacuum the floors once a week, but most do it more often. To clean the kitchen, hall and toilet or bathroom every day, living room and children's bedroom about three times a week, parents' bedroom about once a week, is a common ideal. In many apartments only the floors of the hall, kitchen and toilet may be washed; the others are covered with carpets and are only vacuumed.

In this way there are tasks that are done every day (like doing the dishes and making the beds), some tasks that are done every

other day, every week, fortnight or month (like cleaning windows, polishing brass ornaments), and tasks that are done once or twice a year, or more seldom (like washing ceilings and walls).

There seems to be relatively little ritualization of housework in the sense that it is done on specific days and times and with specific intervals. When , for instance, I asked them about how often they clean their windows many of them would answer "When I see that they need it". When I followed this up with a further question about how often the windows normally need to be cleaned, they would answer vaguely: "Perhaps once a fortnight". When I asked about cleaning ceilings and walls, some would say that they seldom dit it, others would answer "when I feel industrious" *(når eg e' flittig)* "when the spirit comes over me" *(når ånden kommer over meg)*. Audhild, one of the women who grew up on a farm, and whose identity is most tied to this background, seemed to have the most established routines for intervals between doing the household chores.

When the women do full-time paid work, they do somewhat less housework. Instead of two or three times a week they will for instance clean and vacuum the floors only once a week. They say that they have less time to do it, and the home also becomes less dirty and untidy when everyone is away all day – the children with a *dagmamma* (a woman who takes care of other people's children in her own home for a wage) or at a daycare centre, and herself at work. They have to do their housework when work is over, most often on Saturday morning. Before she got her full-time job, Elisabeth, for instance, said: "I never visit people who work full time on Saturdays. Then they are always busy doing the week's housework." Mette says the same thing about her mother: "I never go over to my mother's on Saturday morning, because then she is busy doing her housework. The apartment is cold and not cosy. All the windows are open and she puts every ornament from the shelves down on the table to clean them."

For the most part housework is a task that a woman does alone, or to some extent together with her husband. When a woman gets help from outside the household, it is often because she herself is not able to do it, for instance if she is ill. The other person replaces her more than supplements her.

On some occasions close female relatives or close female friends may do housework together. This is first and foremost on visits of

longer duration, for instance when Ellen's family visits the farm of her husband's cousin for a weekend. On shorter visits, it is normally regarded as impolite to do housework, both for the host and for the visitor. If the visitor sets out to do some housework, the hostess easily feels it as a criticism of herself, as a challenge to her independence as a housewife. Gro, for instance, complained that her mother often cleans the kitchen floor or does some other housework when she comes visiting. It used to annoy Gro; she felt as if her mother thought she was not able to keep her apartment in order herself. But when she learned that her mother does the same thing at her sister's place, she relaxed somewhat.

Another example is Elisabeth and Kirsten, discussing Sissel's separation after her husband Benny had fallen in love with another woman (the case is discussed in more detail in chapter eleven):

Elisabeth says that even if Benny insists that there is nothing wrong with Sissel as a wife, there must be something about her that annoys him. She recalls that Sissel has mentioned that he used to be irritated because she often forgets to pour the newly made coffee into a thermos pot to keep it warm. She also comments upon Sissel's housework: "She keeps the living room and the kitchen in order, but not the rest of the apartment. The rest is totally chaotic. For instance, when I visited her last time, Unni [her daughter] peed on the carpet in the hall. I found some paper to wipe up the pee from the carpet. The sheet of paper became totally black, and I thought, Sissel, Sissel. Here is something you ought to have done!"

Kirsten nods agreement with what Elisabeth says and adds her own experience. Some weekends ago she stayed over Saturday night at Sissel's place. They had been out to a discotheque together, and were both without children that weekend. "I saw that her brass ornaments were not polished. I am so particular about brass, you know. So I asked her if we could not do it together while we were chatting. She got so hurt that I had to say that I usually polish brass together with Marie too. This isn't true, but I felt I had to say it because she was so hurt." Elisabeth: "Yes, yes. Sissel is so sensitive. She feels the smallest comment as a criticism. Kirsten, do you remember that once I scrubbed your floor in the hall? You were pregnant and I used to visit you *(eg gikk te deg)*. Every time I went to your place I was irritated

103

by your dirty floor. I asked myself if I should dare say something or not. At last I could not resist scrubbing it clean. Do you remember?" Kirsten: "Yes, the floor got a totally different colour, much lighter, after you scrubbed it."

These examples illustrate that housework for the most part is work that is done alone, and also that cleanliness and tidiness are important for the evaluation of self, particularly for the woman's identity as a good housewife.

To the question whether there are any differences between how their mothers keep their houses and how they do it themselves, the urban women would either answer that they do it about the same way, or that the difference is that their mothers have "dust on the brain". Audhild and Asbjørg, on the contrary, answered that they themselves are more particular than their mothers. Audhild said: "When you live on a farm you just have to let the interior of the house wait until you have finished the work in the fields. *(Du blir nødt til å la inne stå mens du gjer deg ferdig ute.)*" Asbjørg answered thus: "I am much more particular than my mother. She sits quietly and relaxed with visitors, no matter what condition the house is in. You cannot do that in a city. I feel ashamed and embarrassed if a visitor finds my house in disorder."

The urban mothers of these young women, on the other hand, seem to be more worried about their daughters going to discotheques and taking paid work than by their cleaning. As regards housework, several of the grandmothers complained more about how their daughters take care of their children's clothes than about the way they clean their homes. The grandmothers' own pride, when they had small children, had been to keep them nicely dressed. They complain that nowadays there is no distinction between best clothes and everyday clothes. The young mothers, in their view, do not take good enough care of the nice clothes they (the grandmothers) give the children. A nice white woollen sweater must, for instance, be washed by hand and not be thrown into the automatic washing machine. The grandmothers are also amazed by how much more housework and child care husbands do today compared to when they themselves had small children.

Among the young women the *husband* is the closest potential team-mate for doing housework. The husbands differ somewhat in what kind of chores in a house they are able or willing to do. Some

vacuum, but do not clean. Others clean but do not cook. Some cook, but do not change diapers. Many husbands, however, are able to do most of the tasks, if they have to.

The distinction between clean and dirty (or unclean) is important in their way of assessing things, not only as regards homes but also persons and places in general. Cleanliness is one important criterion by which they judge each other, and sometimes the first criterion mentioned. When Elisabeth went with me for the first time to her neighbour Asbjørg, she whispered to me, when Asbjørg was out of the room for a minute: "Look around! See how clean she keeps her place. It is always clean here. She is really a good housewife. They could have had a very good life together if her husband had not been such a bastard." All of them, perhaps to some extent with the exception of Mette and Eva, express often and clearly that they want to keep the home tidy and clean *(å ha huset i orden)*.

There are several colloquial expressions for the state of a home:

Huset flyter. (Literally the house, or everything in it, is floating.) This is a state of disorder that the home is not supposed to be in.

Huset er blåst. (Literally, the house is swept clean by the wind.) There is no dirt, crumbs or ill-placed objects. It is only used a passive verb, not as an active verb.

Huset er sleiket. (Literally, the house is licked.) The expression invokes the image of an animal mother licking her young and is also used as an active verb.

Eg shinet over huset. (Literally, I polished the house.) The expression is borrowed direct from American, most probably through automobile care language. The image evoked is that the home is not only neat and clean but also shining. Most often used in the active form with the preposition "over", but also in the passive form.

Cleanliness and neatness are thus important cultural values. One must not, however, overdo it. There is ideally a balance to be found between dirt and disorder and being obsessed by cleanliness, "to have dust on the brain" *(å ha støv på hjernen)*. The women often hold the opinion that especially their mothers-in-

law, but sometimes also their mothers, have "dust on the brain":

"She cannot see one dirty cup in the sink without cleaning it."

"If, for instance, my father-in-law has lain down to take a nap and has left an orange peeled before he went to sleep, then she cannot wait until he is awake. She must remove the peels at once."

Having dust on the brain means that the values of cleanliness, neatness and order have become more important than sociability and good company. Other people present are made to feel uncomfortable by the obsessional pursuing of these values. The difference between themselves and their mothers-in-law and mothers, expressed by these young women, does perhaps reflect different stages in life more than different standards. The mothers of small children must adapt their standards somewhat to the disorder of small children, whereas the grandmothers have become used to having their rules respected.

The idea of good housework (å ha huset i orden) seems to imply both cleanliness and tidiness. Every object has to be in its proper place. The value of order and tidiness supports the interpretation of home decoration as having ritual overtones. Tidiness and order means that the decoration is emphasized. The house is in a mess (huset flyter) when signs of activities disturb the comfortable, luxurious and representative impression they want to give. Crumbs on the carpet and toys spread all over the place betray the play and activities of children. Ash in the ashtrays, dirty cups and glasses on the coffeee table bear witness to visitors and their activities. Dirt and untidiness disturb the preferred ceremonial state of the home. This applies not only to the living room, but also to other rooms.

The good image of a kitchen is not one of present activity, but of a place where the work is now finished. For the young mothers a nice kitchen is one where there are no dishes in the sink, and the sink, the top of the benches, and the floor are tidy and clean. The cloth to wipe benches and table with is nicely folded together and hanging on the tap. When they eat or prepare food, a few ornaments or tablecloths are perhaps removed from table and bench, and put back again when the dishes are done.

This image of a nice kitchen may be contrasted to that found among many academics. In these social circles one often finds a more romantic image of a big warm peasant kitchen with lots of smells and preparation of different kinds of food. There are also

differences between different milieus concerning the application of the criterion of clean and tidy versus dirty and untidy. Among students and academics one seldom judges things in terms of clean/unclean. Other criteria count more. One even sometimes likes to present oneself as a little "bohemian", and what is regarded as obsession with cleanliness is not the fashion in these social circles. But often this means that cleanliness is taken for granted; one presumes people and places to be clean until the opposite is evident. In this way cleanliness is important in both milieus. The difference is that in middle-class cultures the distinction is only applied when the standard is too low. In working-class culture it is explicitly and often applied, both when the speaker finds the state of affairs to be too high, too low, or just right.

Part of the reason for this difference may be that standards of cleanliness have been, and to some extent still are, more threatened in lower-class milieus. This is due both to kinds of work that make you dirty and, especially formerly, to lower housing standards. The fact that cleanliness is so explicitly an important cultural value does not mean that all the homes are up to the standard of what is regarded as clean and tidy, nor does it mean, that there is a clear and direct relationship between the "objective" state of a home or a person and the judgement made. When speaking about others the criterion of clean and dirty is, to some extent, a way of speaking about likes and dislikes. Criticizing mothers-in-law somewhat more than mothers for "having dust on the brain" is one example of this. Cleanliness or dirt is often difficult to measure. The extremes are easier to classify than the in-between cases. Beate, Elisabeth and Audhild are obviously particularly good housewives in the sense that their places are clean and tidy. Not only the living room and the top of the benches of the kitchen are clean and tidy, but also the other rooms, the inside of closets, cupboards and drawers. The others are somewhere in between the ideal of nice and clean and the stigmatized not nice and dirty. Asbjørg and Marie are also praised for keeping their places clean. Some women are blamed for not being good at keeping their places in order. One woman is often heavily criticized, for instance like this: "I would never eat anything from her kitchen. It is so dirty in her place. She never cleans the cupboards, ceiling and walls of her kitchen. She does not care." This woman is a close neighbour to one of the women studied. They have a

relationship of exchanging household equipment and services. This woman is about ten years older than her neighbour. She is divorced with two children, but she usually has a man living with her. She is also blamed for having too many parties and for having a "ravaged face". I never saw her aprtment. The criticisms of uncleanliness seem, in this case, to be associated with what are regarded as loose morals.

Mette is also often the subject of similar, but not so harsh, comments. "She has no idea about how to keep the house in order." To an observer Mette's place did not seem more dirty than most of the others, only a bit more untidy. Her home does not have the same ceremonial status as the others. Part of the disorder is chronic. On the shelves of the cupboard in the living room there were, for instance, many objects that did not "belong" there; they were not ornaments (with ritual space around them and perhaps a crocheted doily underneath). Cameras, baby vaseline, and other articles for everyday use may be regarded as displaced objects in this context. Part of the disorder was more of the moment. She did not take so much care as the others to keep the living room representative and free from signs of the children's activities. Her "disorder" thus may seem to be a different kind of order from that of her friends. They may perhaps be offended by the lack of respect for visitors that disorder *(huset flyter)* in the kitchen and the living room seem to represent in this milieu. Mette herself says: "I do not want a sterile home, like the one I had in my childhood. Every time I opened the entrance door to the apartment, I heard my mother shouting: 'Take off your shoes!' She was awful. But she has admitted it since. I do not want my home to be sterile. But I am embarrassed if people come visiting when my place is very untidy."

Those who criticize her generally hold that Mette is "trying to put on airs" and that she is "too domineering". Some relationships are strained and difficult for many reasons. To blame her for not keeping her place in order is one way of talking about these strains.

Some of the others, who are not blamed for not keeping their houses in order could "objectively" speaking have been criticized. Walls and ceilings may seldom be cleaned. In the openings of the ventilators in the kitchen and bathroom fat and dust have perhaps collected. The inside of closets and cupboards may be in a "complete mess". Bedrooms are not kept the same way as the kitchen

and living room. As long as they strive to keep the living room and kitchen in the right ceremonial state, and relationships are good, nobody seems to mind.

One disgracing sign of uncleanliness is smells *(lukt)* that should not have been there. In the crowded working-class living quarters of the central parts of town in former days the smells of poverty were sometimes difficult to avoid. Homes and clothes smelled, for instance, of the humidity, mould and fungus in the wood of the houses. In today's modern, spacious and recently built apartments such smells of poverty are easier to avoid. But they are still signs of stigmatizing uncleanliness. One woman once talked about how nice her own apartment block is compared to those of friends in the neighbourhood: "The people who live in our block are very nice people. Everybody call it the classy block *(sosseblokken)*. We decorate the staircases together with nice curtains and green plants. It isn't that way down at X's block. They have no smell in the staircases, but still . . ."

Kirsten had once worked for several days on cleaning her apartment. She had moved the cupboard and worked very thoroughly. The reason, she explained, was that there was a smell in the apartment. She could not detect where it came from, but she felt that she just had to get rid of it. On another occasion I visited a new friend of Sissel's together with her. Her friend was divorced and had two children. She lived in a similar apartment to the others. None of us had been there before. In the apartment there was a very strong smell of urine and mould that tickled the nose. Sissel seemed to like her new friend, who was also very nice and friendly. When we left the place I wondered if Sissel would mention the smell, but she did not. After some time I mentioned it casually, but she only answered "I noticed it too". She seemed to want not to emphasize the smell because she otherwise valued the friendship. From these examples one may conclude that cleanliness is important, but there is no one-to-one relationship between the degree of cleanliness or dirt and how women evaluate each other. One may be a bad housekeeper and a good friend and vice versa.

Meals

Daily meals in Norwegian cities generally consist of breakfast *(frokost)*, *formiddagsmat* or lunch (at their work-places Norwe-

gians use the English word for lunch), dinner *(middag)*, and supper *(kveldsmat)*. Breakfast may consist of slices of bread with butter or margarine, covered with jam, cheese or ham, coffee and perhaps a glass of milk. Lunch consists of coffee and sandwiches, made from similar materials as breakfast. Most people bring their own lunch packet with them to the job from home, for usually no hot meals are served at Norwegian workplaces and schools. If the firm has a canteen, sometimes hot meals but most often only sandwiches, coffee, tea and the like are served there.

The Norwegian dinner, *middag,* is served about 5 p.m., when husbands come home from work. It consists of boiled potatoes, vegetables and meat or fish, all served as one dish. In the evening people often eat a late supper consisting of open sandwiches. The timing of supper, if there is one, is not fixed.

The meals of my informants, in some contrast to other parts of Norwegian society, can be characterized as being little ritualized. The meal(s) at work and dinner are the most important. Dinner is the central meal of the day and the one for which there is some concern that family members eat together. When the husband comes home, dinner is ready. But in several cases it is more convenient that the rest of the family eats earlier, especially when the mother goes off to paid work. Also, if the husband, for one reason or another, does not come home to dinner *(middag),* the rest of the family often eats something simpler, for instance a soup or just plain sandwiches. The ideal is thus to eat dinner *(middag)* together, but according to the circumstances they modify the standard pattern.

One expression of the relatively low ritualization of meals is the fact that several families, in contrast to earlier generations, have no comfortable dining table. Instead they have a small kitchen-table and a large coffee table in the living room, and dinner is eaten in the kitchen. There is no tablecloth. (If there is one for decoration, it is carefully taken off the table and folded together before every meal and put back in place when the dishes are done.) The food is mostly served in the pots and pans it is prepared in. Water is the most common drink at dinner *(middag).* On occasion they serve dessert for everyday meals. If there is a difference between Sunday and other days, it mainly consists of better quality food, longer preparations, and perhaps a dessert. They also eat in the kitchen on Sundays, when alone.[2] When not alone they eat at the

coffee table in the living room, if they do not also have a dining table.

Everyday cooking, however, is relatively quickly done, about half an hour to make the meal. Fish, when served, is, for instance, boiled salted or smoked cod, pollack fried or baked with onions. They seem generally, however, to eat little fish except for prepared fish cakes and fish balls. Some never seem to eat fresh fish; some do it once or twice a week. Different kinds of sausages are the kind of food that is most used for dinner, for instance with mashed potatoes. The cheapest kind of sausage is a long sausage called dinner sausage *(middagspølse)*. One buys a piece of the size needed. A common way to make the sausage last longer is to chop it into smaller pieces and put them in with the mashed potatoes.

The vegetables seem to be the least important part of the meal and are more easily skipped than potatoes, meat/fish and gravy. Fresh carrots, cabbage, rutabaga and onions are often used. These are vegetables that were used all the year round in Norway before the "revolution" of air-freighted produce and freezers. People now also use frozen vegetables, usually a mixture of peas, chopped cauliflower and carrots. The selection of food in Norwegian grocery stores is both relatively limited and expensive, especially as regards fresh foodstuffs. The women in this study, however, make a more limited choice of foodstuffs than what is available. Cooking often includes ready-made products. Prepared (often vacuum-packed) sausages and fish balls are common. In addition, they use industrially made dried soups, sauces and stews. International cooking has mainly arrived through dry "oriental" stews and frozen pizzas industrially made (in Norway). With the "oriental" stews they may serve rice or spaghetti, which are also innovations. To the stew itself they add water and dinner sausage or ground meat. Neither pizza nor "oriental" stew, however, is regarded as "real food". They are mostly used for supper, when they want something extra.

Sometimes they make pizzas themselves, with ground meat, tomatoes and cheese. They are generally very sceptical about food and ingredients to which they are not accustomed, and rarely use many of the vegetables and foodstuffs that nowadays can be bought in many grocery stores. If served a stew with mushrooms, celery or leeks, for instance, they will serve themselves modestly, and some of them pick out and do not eat these pieces.

111

In addition to the ordinary meals several of them eat a lot of extra snacks like chocolate, sweets, crisp potato chips and other crisp snacks and cola drinks. Such non-nutritional snacks are eaten and given to children all day long. This practice partly explains the diminished ritualization and importance of regular meals.

They have a colloquial expression, *snadder,* (literally cackling, quacking of fowl) which is used for food that is very good but no real meal. *Snadder* is pizza, "oriental" stew, fried chicken, grilled pork bones, some bottles of beer, drinks of vodka and the like. These things may be served on weekend evenings when the children have been put to bed and the parents spend a quiet time in front of the television. This is "to have a cosy time" *(å kose seg). Å kose seg* is the best part of household life; one really enjoys homely comfortable surroundings, eating and drinking something extra *(snadder)* and relaxing after a day's or a week's strenuous work.

Late Saturday afternoons, children regularly get a bag of sweets to eat during the childrens' program on radio and TV.

People in these networks seldom eat meals outside the home, except for the sandwiches that husbands and children bring to work and school. Eating at restaurants is too expensive. When they go out it is mostly to drink and dance. When they go visiting they are mostly served coffee with perhaps (on weekends) a piece of cake or a cookie. Sometimes they are invited for Sunday dinners at their parents' home. They rarely invite each other for dinner.

Norway has never been a country famous for its cooking. There are no strong traditions of good cooking. In this respect my informants conform to a general pattern. But all the same other social groupings have given more emphasis to set tables, cutlery, china and cooking as a specialized activity. There is reason to believe that the emphasis has become less strong than it was. Wives who are also professionals, and who no longer have maids to help them, have made some necessary simplifications. Both academics and business families may today eat their everyday meals in the kitchen. But these kitchens are often larger and there is a little more concern for eating together and setting the table. They usually also have a dining table in a dining-room or in the living room for more ritualized meals. To some extent they have both other standards for the serving of meals and better opportunities to realize them than the milieu described here.

Kirsten Danielsen (Danielsen 1984) has analyzed the lives of old

widowed upper-class women in one of the former "best" parts of Oslo. They insist on being upper class despite being in a situation where their resources to maintain, and the audience to which to present, such an identity have become considerably reduced. But they have plenty of time each day of their waning lives. One of the ways they insist on maintaining this identity for themselves is to ritualize everyday life. *Middag* is bought and cooked in an elaborate way. The table is set for one person with a tablecloth, nicely folded napkin (made of cloth), polished silver, old precious china and so on. Eating in the kitchen is for these women a sign of lower-class identity. They know that other people do it, but they claim never to do it themselves.[3]

Home production

The women of this book do relatively little home production. Most of them know how to sew, knit and mend; they just do not bother to do it. When asked "Do you sew?", some answered "Very little, but I know how to sew"; and others answered "Seldom, I am afraid of doing something wrong to the expensive material". Some of them own a sewing machine and most have access to one, for instance their mother's or a friend's. Sewing is done for making curtains, making a pair of jeans tighter, and minor alterations or repairs. Several of them knit, but not much. Mona knitted sweaters for her nephews and nieces for Christmas. Mette knitted sweaters for herself and the neighbouring girl who looks after her daughter for a few hours every day *(passepike)*. Audhild has filled her living room with cushions and bellropes that she once embroidered. Some of them may mend socks and the like, but I have never seen them do it, and when I asked about it, they said they just throw away socks with holes in them.

None of them make jam or juices to any extent, but most of them do some baking of bread, cookies, and rolls. Audhild does most of these things. She gets berries from the farm where her husband grew up, and she also makes cookies and rolls every Saturday for the weekend. She has two freezers, full of products from the farm and products that she has made. To the extent that the others have a freezer, the content is for instance ready-made meat balls, buckets of ice-cream on special offer from the grocery

store, crabs bought in season, meat and sausages bought cheaply through "connections", and perhaps a few home products made by themselves or by mothers or mothers-in-law.

Practices are obviously changing from one generation to the next. But it is also a question whether part of the difference is due to different stages in life. Many of them are not yet at the stage of life where they have full responsibility for the celebration of festive occasions, like Christmas. For these occasions their mothers and mothers-in-law bake many kinds of cakes, make pickled pork, pressed into loaf shape and sliced, and so on, in addition to traditional Christmas dinner dishes.

Most of them do some of these things for Christmas, like Ellen, who enjoys baking cakes. But often Christmas preparations amount to buying or, in some cases, making the presents and making cookies shaped in human figures with the children. This dough is spiced and rolled flat. For Christmas Eve and a few of the other Christmas days they are often invited to the homes of parents and parents-in-law.

One may ask whether they will be more concerned about home production and preparing things the "right" way when they themselves are the most adult generation. The answer is probably both yes and no. They will certainly be more concerned about eating better quality food when they get older and have more time and, above, all, more money. Their way of doing things may be seen as a convenient strategy for this stage of their lives. Later they will perhaps resort to some of the peaceful and gratifying pursuits of home production. At the same time the tendency of doing less home production and using more ready-made products will probably continue. They seem to be establishing routines that will endure. Some household chores are expanded and others are reduced, as consequences of their entrance into other fields of activity. Not only are skills being lost, but opportunities to use them are also being systematically reduced.

The reduced home production may seem surprising in a region like Western Norway, where life was poor and people traditionally had to combine many resources to survive. Such a way of life is part of the recent history of the region, and is the background one-two-three generations back of my informants. Audhild is the only one who retains something of this way of life. The economic necessity of doing home production is no longer there. Now they

can buy the things they need. The quality of clothes and equipment that they buy is also such that it to some extent makes mending and repairing useless. In addition they are afraid of their children being mobbed if for instance their pants have patches on the knees. And newness is in itself valuable. Mending and repairing are to some extent signs of poverty and stinginess, identities that they do not want.

Making new things is somewhat more valued than mending used ones. They admire women who are clever at sewing and other kinds of home production, but do little of this themselves at this stage in their lives.

In the "academic" parts of the new middle class, on the other hand, both home production and the ideal of recycling material resources as well as the activities that accompany them are more popular. Buying clothes and furniture cheaply on flea markets is for instance a popular sport. In the milieu of this book, however, this activity is somewhat downgrading.

Conclusions

All in all, some activities of hearth and home seem to be reduced while others are expanding. Home decoration is expanding as an activity and as a symbol. The young mothers take less pride and interest in cooking than in cleaning, and there seems to be relatively little ritualization of meals, even as a home-centred activity. Sewing, making jam and juices, and similar kinds of home production are very reduced. The technological equipment of the homes, like electricity, running water, vacuum cleaners, automatic washing machines, fridges and so on make their work more easy. Hearth and home have become more strongly integrated in the market economy. This is one part of the explanation why young mothers are able to enter roles and activities outside "hearth and home".

6. The relationships of hearth and home: Motherhood and marriage

Closely connected to the value of hearth and home are the relationships there, ideally between a mother and a father and their children.

Motherhood

The women of this study are mothers of at least one small child each. They have, most of them, become mothers very young, some as young as 17 or 18 years of age. (See Table II, Appendix I for careers of motherhood and marriage.) Pregnancy often preceded marriage. In some cases they are still unmarried. Gunvor never married but lived in a common law relationship with a man who was not the father of her child. Beate too was an unmarried mother for some years before she married Nils. Kirsten married her first husband after their child was born, and her second husband while she was several months pregnant. A typical pattern, however, is to marry 2–5 months pregnant and then have another child a few years later.

Most of them seem to have the children they want and express satisfaction when the period of diapers is over. One woman had an operation for cancer of the uterus and can bear no more children. During my fieldwork two women had abortions because they did not want a third child. One never told her parents. First she thought she would tell them when everything was over, then she never did. The other told her mother and received strong objections from both her and her sister. She cried and wept and went back and forth between her mother and some of her friends to discuss the matter and seek legitimation for her decision. She

could not bear the thought of having another baby. Her smallest to be able to think of myself", she said, "perhaps I will want another baby later, a little pet to caress when the others grow bigger". Her husband supported her decision. Abortion has recently become freely available in Norway, but it is considered, by strong Christian groups, to involve a question of homicide. It is done in one day. The day after her abortion the young woman was caring for her own children and for the baby to whom she was *dagmanma*, as usual: "My mother refuses to help me. She is so disappointed with me. Yesterday we had to send our own kids to my mother-in,law, and the mother of the child I take care of during the daytime had to stay home from work."

Beate is the only one who wants another child at the moment. She has only one child and does not have one by Nils, her husband. They are receiving various medical treatments from a gynaecologist to achieve this end.

The practice of having two children within a short time span is part of general demographic changes in Norway, as well as in other Western countries. The number of children has, during the last hundred years (only broken by the years during and after the second World War when people had more children), decreased from an average of 5 to an average of 2 children per family.[1] This tendency is more salient in cities than in the rural areas. Few urban children today have more than one sibling. The circumstances around the births of children have also changed. In the average family, a hundred years ago, parents were older, because of higher age at marriage and longer time span between each birth.

Today children might reach their teens before their parents are in their forties. Grandparents today are often still in their forties or early fifties, and very unlike the traditional image of a grandmother and a grandfather.

During the last ten years the development towards lower age at marriage and first childbirth has stopped and changed slightly. The average age at marriage for males was 25.3 years in 1970 and 26.8 years in 1978. For women the average age was 22.8 years in 1970 and 24.3 years in 1978.

These averages do not account for class and regional differences. Among working-class people the average age at marriage is lower. The women of this study exemplify this, but even for their own class they have probably been somewhat younger mothers

than the average. Early motherhood is one circumstance that shapes and influences their way of life and the dilemmas they experience.

Child care

In daily life babies are kept inside most of the day. They are taken out for an hour or two by neighbouring girls paid to take care of children in the daytime *(passepike)*. But when children are about two years of age, irrespective of sex, they are allowed to go out alone. In most neighbourhoods cars are parked and driven. The change from being out in the care of a neighbouring girl *(passepike)* to being out alone is gradual. But still, relatively small children are allowed to play outside without organized supervision. When the mothers sit inside chatting in the kitchen, they seem to relax completely and to not run anxiously to and from the window to see what happens, as many middle-class mothers would have done. The children play outside, between the apartment blocks, "out in the street" *(ute i gaten)*. The young mothers often speak humorously not of sending the children out, but of "throwing them out" *(ungene hiver vi bare ut)*. The mothers regard normal middle-class 3–5-year-old children (like my daughter) as a kind of weaklings because they have often not learned to the same extent to fend for themselves in the street. The street *(gaten)* is actually not a thoroughfare for traffic, but the space between the apartment blocks. That space consists of paved paths and roads, lawns, paved playgrounds and a few trees and bushes. The word *gaten* for children's outdoors comes from the time when more of Bergen's working and lower-middle-class people lived densely in the central parts of Bergen. There children's outdoors are (among other things) real streets and the word is accordingly more appropriate. The symbolic classification of "in" and "out" is, however, the same.

Playing outside, in the street, means several things. It means being outside in contrast to inside hearth and home. Outside means less warmth and cosiness and also exposure to "nature" in the form of lawns, bushes, flowers, different weathers and temperatures. The climate of Bergen is usually rainy and chilly. For shorter periods during the winter there is also snow and ice. Out in

the street also means the artificial man-made environment of concrete buildings, asphalt and cars. Finally, and most importantly, being out in the street means contact with other children of different ages. All these things are thought of as challenges and experiences that teach the child about life.

Among the women of non-urban origin Eva shows the strongest resistance to this aspect of urban living. She says: "I am used to single-family houses with gardens and natural surroundings. My childhood was much freer than this. We learned everything about animals and plants directly, out in the open air. I do not want my children to have their whole childhood here."

The other women express little resistance to the practice of sending the children out into the street. In older denser working-class neighbourhoods of central Bergen (Gullestad 1979a), a few of the women interviewed very explicitly emphasized how they, in contrast to others, kept their children inside for several hours in the morning before they allowed them to go out. They emphasized that they did not leave all the upbringing to the street.

The suburban women may sometimes complain about "dirty words" or swearing that the children have learned in the street. But, as a matter of fact, they levy this criticism more strongly against organized child-minding in playgrounds than against unorganized playing in the street. It is, however, an important sign of good parenthood that the children come in relatively early in the evening. In the long light summer evenings they are allowed to stay out later. This means that light and darkness is a variable for what "outside in the street" is conceived to be. Darkness makes the outside more "out" and more dangerous.

When they play "in the street" children may be more dirty than when they go "to town" or go visiting with their mother. When they leave the neighbourhood, the mother dresses them up in the newest jeans and the newest padded coat.

The women also hold that a "bad" mother or a "bad" *dag-mamma* is one who constantly "throws them out". Motherhood is more than "throwing them out". You have to care for them. Caring for them means, among other things, to be constantly available to tend their needs. The initiative is with the child more than with the mother. While "throwing them out", the mother is still available. A balance between closeness and distance is found by being available but not taking many initiatives towards the

119

child. This makes the children independent and autonomous, and encourages the development of peer groups and children's culture. In some contrast to the children of Norwegian middle-class intellectuals of today and especially to American white middle-class socialization, they are not encouraged to be the focus of attention in social encounters with adults. Babies are more the focus of attention than older children, who tend to be quiet and moderate in claiming attention. They are not allowed constantly to interrupt the conversations of adults, the way the children of academics normally do. The different practices probably encourage middle-class children to become more persistent and innovative in relations to parents and less tied to peer groups. Working-class children are encouraged to be quiet and obedient with parents but to be independent and enterprising with peers.

The young mothers of this study live in neighbourhoods with, to some extent, a mixed population in terms of life style and social class. Other people have somewhat different attitudes towards child care. Their practices are thus ambiguous as signs. The women express themselves ironically about sending the children out into the street, when among themselves. The expression to "throw them out", is an example of this. They have a kind of solidarity over the fact that motherhood sometimes is strenuous. Often they want to chat or do other things for themselves, and not be disturbed by the kids. The practice of giving children sweets or juice when they claim attention can also be seen in this perspective. It is a way for the mother to tend to the needs of the child and at the same time to tend to her own needs. Yet they know that sweets are "bad for the teeth" and try to control this practice to some extent.

Signs of good parenthood are to be concerned about the children not being out too late in the evening, to take them for walks on Sundays, and to show concern in other ways.

Cleanliness and neatness also apply to motherhood. Women try to keep their children neatly dressed, at least when they are taking them out themselves. Many incidents show that they feel ashamed, especially if their babies are not neat and clean. If it happens, they always explain and excuse it, to show that this is not the normal state of the baby.

Concerning physical punishment, the attitude seems to be that it is acceptable to hit a child when he or she deserves it, but only on

the thighs or the bottom, never on the face or anywhere else. Most common is to shake the arm of a disobedient child vigorously, or give him/her an occasional spank on the bottom. One woman used, for a time, the cold water shower on the bottom of a three-year-old child when he had soiled his pants, to teach him to use the toilet. He was too big not to be clean, in her view. Other women, however, thought this treatment too rough.

All in all there seems to be relatively little physical punishment. There exists, all the same, some social insecurity. Asbjørg, for instance, was very embarrassed when her little son had received a black eye from falling out of bed: "People might think that I did it." (The same thing applies if a woman has a black eye. People immediately think that she has received it from her husband.)

It seems to me that the child-care practices of the young mothers may in part be derived from larger sibling groups of former times, as well as perhaps being the outcome of the housewife role of later times. They seem to be adapted to and function well in a neighbourhood that has community qualities and that is physically both safe and stimulating. They function less well in neighbourhoods with traffic and other dangers and where neighbours do not know each other well. In addition, these practices exist in a context where mother and housewife are not the only identities available to women – for women who fulfill additional roles in other domains.

Many middle-class mothers, in comparison, are more reluctant, at least ideologically, to inflict physical punishment. They also feel that they have to do more things especially for the children, for their growth and development as small individuals (Haavind 1979). Middle-class children do also play out of doors, but under a closer surveillance of their mothers. Middle-class motherhood seems to make more claims on the mother's attention, care and planning. The flow of educational and psychological books on socialization and child care have, for instance, given middle-class mothers many feelings of guilt and personal insufficiency (Kari Wærness, peronal communication).

For the women in this study children figure in their conversations, but they are seldom the main topic. Sometimes funny stories are told about the children. At other times they discuss problems of motherhood in a practical, matter of fact way. Sicknesses, skin and diaper rashes, nightmares and how to get decent dental care

are examples of problems discussed. They perceive "dirty words" and swearing as mild signals that something is wrong with the child. Lying and especially stealing are regarded as more alarming. If a six-year-old steals from his or her mother's purse, she looks on this as a bad sign for herself as a mother. When Sissel was in the middle of her separation, her son started to steal, and she imputed this to the divorce. She mentioned it in the sewing circle *(klubb)* one evening. The others gave her advice in a matter of fact way. One told her to take the child to the police station and let one of the policemen explain to him how bad it is to steal. This had worked in several cases that she knew about. Another told her to guard her money well, and tell her parents and her former husband to do the same, so that the boy would not have the opportunity to steal. And so the comments went on. At this moment I broke their unwritten rules for how to handle these matters, by suggesting that because of the divorce and the troubles that went with it, she should give the boy a little more attention and care than usual.

This was obviously interpreted as a criticism of her as mother. She became quiet; her head sank down between her shoulders. The others started frantically to talk about something else, about what seemed to be fashion in the clothes stores at the moment. There seems to be a tacit agreement about not problematizing motherhood in this way. Not only do they not criticize each other directly, they also comment little behind each other's backs. Motherhood does not seem to be the most important theme in their conversations. But this does not mean that criticisms are never made. One married woman was criticized because she and her husband for a period used to lock the door to the children's bedroom and then leave the apartment for many hours. Both the spouses were criticized behind their backs, but the mother more than the father.

Separated and divorced mothers are more subject to such criticisms than married women. Often criticisms sound like disguised comments on sex morals. Separated or divorced women may be criticized for being too interested in men. Being "too interested in men" is equated with a woman neglecting her children. Separated women were gossiped about for going out too much and thereby neglecting their children. "The kids have only one parent, so they need her to stay at home more than other kids do."

One may ask why they criticize each other relatively little as

mothers, why criticizing somebody else for being a bad mother is seldom used as a way of presenting oneself as a good mother. The reason may simply be that after some time they to some extent take motherhood for granted. They have all been mothers for at least 4–6 years. A few years ago, when they expected their first baby, and for the next few years afterwards, motherhood was probably more essentially the focus of their interest and conversations. Elisabeth, for instance, gives this reason why Rose Marie, a former friend and member of the sewing circle, broke off with them:

> She was the only one who did not have a child. Therefore she had to brag about other things instead, to assert herself. She changed furniture all the time and bragged about all the roses her husband gave her and the money he gave her to spend on herself. The rest of us did not have what she had . . . And also she never said anything when we discussed our sex lives. Several of us had problems in bed. But she just sat there listening, and said nothing herself. Everything had to appear so perfect with them!

Eva gave a similar example when she related how she lost her childhood friends the first summer when she came back on holiday after she had a baby:

> They invited us to parties and out on boat trips. They did not understand the new constraints on my life, since they did not have babies themselves. The next summer they too had babies, but then it was too late.

To the women in this book becoming a mother is a fundamental, self-evident, and "natural" part of their lives. It is so self-evident that it does not have to be explained or legitimized. On the contrary, an eventual voluntary decision never to have children would have to be explained and legitimized. Most of them had not planned the exact point in time and circumstances under which they became mothers, i.e. becoming a mother was an accident, but that they were at one point in time to become mothers seems to have been self-evident. And once they have become mothers, mothering colours and governs the rest of their lives. It is for

instance, out of the question, in these circles, for a father to have custody of the children after a divorce. Their reactions were very strong when they heard about a former classmate who had left the child with the father. The former classmate was a student and participated in other social circles where such an arrangement is, if not common, at least more ideologically acceptable. For my informants leaving the children with the father is definitely not accepted. "This is sick", "it is unnatural", "she must be insane", "a mother is fundamentally different from a father", were some of the comments. All the same, hearing about other ways of acting and thinking makes the inconceivable at least conceivable. When talking about her own divorce, and how little interest her former husband took in the children, Asbjørg once said: "What if I had done the same as him! What if I had left the children in his care, and gone away to the Canary Islands whenever I wanted!" The others present shook their heads in a knowing and resigned way, and said smilingly: "You cannot think that way. You just cannot think that way!"

Marriage and divorce

Marriage and divorce are treated more fully in chapters twelve, thirteen, and fourteen. In the following few pages I give some information about the ideas and values of marriage, to provide a background for the problems discussed further on.

Careers of marriage as well as motherhood are shown in Table II, Appendix I. Marriage is ideally the basis for establishing a separate neolocal household, away from the households of parents and parents-in-law. Practice does not, however, completely conform to these ideals. Some of the married and the unmarried women established their own households after a period of staying with parents or (for the married women) parents-in-law. Asbjørg left her first child with her parents at the farm. Gunvor and Beate established their own households in separate apartments after living with parents for some time.

Kirsten's first marriage broke up. She remarried when she expected a second child, and this marriage also broke up. During my fieldwork she separated and two different men lived with her for periods. Asbjørg was separated when I started fieldwork.

During fieldwork Irene and Sissel also separated. Sissel's marriage was resumed after a year. Marie separated after my fieldwork was completed. Ellen's sister became pregnant at 17, in the second year of her apprenticeship as a hairdresser, just as her sister did. She wanted to marry, but the father of the child did not. They did, however, set up a household and live together. After some time they married.

If the women of these social circles do not marry after having become pregnant, it is not due to alternative values, but because of emotional problems in the relationship to the father of the child-(ren) or other difficult circumstances. Anne, for instance, did not marry because she was too young at the time of pregnancy. They know that other values exist, among students and intellectuals, but do not fully understand them. Elisabeth does not for instance, accept that her brother, who lives together with a woman by whom he has two children, has never married. Their reasons are ideological, not difficult circumstances.

Marriage is voluntary and based on sexual attraction and love. After a period of being in love and "going steady" several of them have become pregnant and got married. They seem to have had, at the time, little experience and information about contraception and sexuality. Or perhaps this is not completely the right way to put it. Of the choices available to them, getting pregnant, marrying and making a home seem somehow to have been the preference.

For most of those who married, the wedding was a relatively elaborate ritual occasion. The typical couple marries in church (The Norwegian Lutheran State Church) and gives a party afterwards for close relatives and a few friends. The bride is dressed in a long white dress with a veil. Hair and make-up are often done by professionals. After the ceremony in church and before the party, the couple visit a professional photographer to have pictures taken.

The party is often held in some other place than the home. The apartments are too small for so many guests. Premises are rented or borrowed from a hotel, a firm that specializes in this, a voluntary organization, etc. A meal consisting of dinner or lunch is eaten, and after the meal there is dancing, sometimes with live music. Later coffee, cakes and drinks are served.

The women seem to retain a happy memory of their wedding.

The fact that they were pregnant *(måtte gifte seg)* does not seem to have cast a shadow over the event. They joke about the corselets they had to wear under the wedding dress to conceal pregnancy in church and what a relief it was to take them off afterwards. Mette's wedding is an example. She is proud of her wedding, because there were as many as 58 guests. 20–30 guests seem to be more typical. "We had such fun! I have been to two weddings since my own, but neither of them was half as much fun! We hired reception rooms and a man to conduct the proceedings at the party, to tell jokes and announce speeches and songs.[2] He alone cost 500 kroner. We also hired two musicians to play for dancing. It was expensive, but we also saved a lot of money because many people helped. My husband's brother brought brandy that he had obtained free through his job. A brother-in-law of my aunt is a confectioner, and he came and made all the food. We only paid for the raw materials. When the meal was over, he joined in the party." Mette still has her wedding dress. "I was lucky and got it cheap at a sale, only 120 kroner." The expenses of the wedding were shared between her father and the father of the groom. "They wanted such a big wedding, so it was only reasonable that they helped out."

A wedding, celebrated in the customary way, is expensive. The father of the bride is, according to both bourgeois and rural traditions, supposed to pay for the wedding. Nowadays, in this milieu, the young couple either seem to pay the expenses themselves (if they have had time to plan the event) or the expenses are shared between both families.

At the wedding the young couple gets some help in the form of gifts, but far from everything they need, to start the new household. Pots, pans, glasses, tableware, linen, decorative objects etc. are all suitable wedding presents. Close relatives and those who are invited to the wedding give the most expensive presents. Parents and parents-in-law may, for instance, each give one electric stove, a vacuum cleaner or a fridge. Ellen and her sister both got an electric stove from her parents as wedding presents. "But my sister got a much more expensive one, because they paid for the wedding themselves." Other guests give presents worth 2–500 kroner. When one of my informants during fieldwork was invited to the wedding of a sister, they wanted to give dinner-ware that cost 400 kroner. They were in a very difficult economic situation at the time, but reasoned that "she only marries once, and that's the

least we can do for her." That one only marries once is a doubtful truth, but the fact remains that one only marries once in this elaborate manner, and that this is usually when a woman establishes a home and often soon becomes a mother.

As in other Western or Westernized countries, the spouses promise each other, in a standardized marriage contract, to "love each other for better or for worse" *(elske hverandre i gode og onde dager)*. Sexual faithfulness is expected of both partners. Their love is mutually exclusive, and they are supposed to have a primary loyalty towards each other. The project of their love relationship is to make a home and raise children. Its realization implies, as we have seen, different things for husband and wife on the level of tasks and responsibilities. The signs of being a good husband are related to signs of being a good provider. The good husband gives his wife roses or other flowers once in a while. At Christmas and birthdays he gives her personal gifts, sometimes gold jewelry; rings, bracelets, earrings, necklaces and the like. Few of them can afford this very often, but it is an ideal. Roses, jewelry, and other generous gifts are signs of his love. Among women gold jewelry is a sign of a happy marriage or love relationship.

Other signs have to do with his showing that he prefers her company to the company of other people, that he is sexually faithful to her, shows no interest in other women and that "home and family come first". Signs of being a bad husband are going out often, drinking a lot, and not going to work regularly.

Signs of being a good wife have more to do with services than with presents. Some of these acts and their meaning are, however, intensely debated nowadays. Acts that earlier were signs of being a good wife may change meaning and become signs of an unwanted submission (from the wives' point of view). Dinner ready and the house in order on weekdays when the husband comes home still seems to be the main sign of being a good wife. "In this house it only happens once a year that dinner is not ready when Arne comes home", says Ellen, for instance. Getting up early in the morning to make the husband's breakfast and his lunch packet to take along to work are, however, more ambiguous signs. Most women have stopped doing these things. They find it unjust, since they are the ones who most often have to get up during the night if there is something wrong with the children. These services are thus singled out and charged with meaning as symbols of submission or

127

love in the spouses' debate about division of work.

The basis of marriage is love and attraction, but its functioning implies, also, a working division of labour, as well as a continuous satisfying love life. As we shall see (chapters eleven, twelve, thirteen and fourteen), their stage of life is one where marriage seems more problematical than mothering. If there is some kind of crisis, it is often the result of problems connected to marriage or other steady male/female relationships.

In the case of a marriage crisis, the husband often leaves or has to leave the home. Practices in marriage crises also demonstrate the opposition and contrast between the interior of the home and the outside world. A husband may just leave, but often, it seems, he is "thrown out". This is the same expression that the young women use about their children. In the husband's case he is only "thrown out" when there is a serious crisis, if he has done something wrong. He is thrown out so that he can regret and learn. Ellen, for instance, threw Arne out after she learnt that he had been smooching with another woman in their home when she was away. Afterwards she regretted having "taken him in again" *(tatt han inn igjen)* too early (after two days) "he should have had to stay away more, so that he really had to learn". When a man is "thrown out" he usually goes and lives with his mother. The father is not mentioned. Kirsten wanted her former husband to go and live with his mother and there show that he was able to live a steady life; to go to work every day, pay his debts, and keep away from other women. If he managed to do this, he might be able to show her that he was serious when he said that he wanted to be a steady family man. Instead he chose to move in with another single mother, and their marriage broke up permanently.

Asbjørg was, as already noted, pitied and criticized because she "took her former husband in again" every time he showed up. He is a man who "over and over again has shown that he is unable to keep a job and act responsibly towards his family". "He even stole her wedding ring and the children's silver cups that they had got for their baptisms." Asbjørg seems to care for him, however: "Every time I see him something rises inside me *(det stiger opp i meg)*. I cannot resist."

Throwing out is a temporary sanction in marriage crises and a permanent solution in separation and divorce. Some marriages break up. Divorce is a new fact of familiy life. Before the turn of

the century marriages were practically never broken up by divorce. The number of divorces in Norway has risen from 2500 in 1965 to 6200 in 1978. Today there is a tendency toward levelling out, but the figures of dissolved marriages are still twice as high in cities as in rural areas.

In the case of divorce, in this milieu, the husband has to leave. He is entitled to half of the economic assets of the family. In practice this often means that he takes his clothes and personal belongings, the car, the stereo-equipment and the colour television, if any. He is entitled to be paid half of the value of the apartment by the wife. The municipality helps out by giving her guarantees and inexpensive loans to buy him out. She gets social security payment in addition to the maintenance the husband has to pay for his children. When she has no education she gets help from the social welfare office to go to trade school or get a similar education, if she wants to. The help consists of advice, help to apply, and a place for her child(ren) in a municipal daycare centre. These places are very few and normally difficult to get. They cost half the amount of private child care *(dagmamma)*. The social security money is, however, not much to live on.

In spite of a certain number of divorces, the nuclear familiy ideal seems to be as strong as ever. When a woman enters into new love relationships, she tries to codify them in such a way that her whole life situation and that of her children resembles that of a biological nuclear family. Several of the children of my informants believe they have another father than the biological one. Social fatherhood and biological fatherhood are confused. Children often have no contact with biological fathers nor with biological grandparents on the father's side when the biological father does not live together with the mother. The mother and/or the biological father may be building up new nuclear families in such a way that it excludes former nuclear family relations. The nuclear family ideal, the way it is often applied, thus may seem to have some negative consequences; the existence of a truth that parents try to hide and that probably will be discovered one day or another may foster insecurity. The children's range of personal contacts are reduced, and the new man in the mother's life may also one day leave them. Divorce and serial monogamy is a new pattern which is not yet accompanied by a full range of established customs, ideas and practices. Trial and error seem to some extent to prevail. This

129

means new experience, production of new practices and ways of thinking about them, as well as feelings of insecurity and search for stability.

Mother is central in the home

Housework and child care give the married woman a certain control in the home. According to Norwegian urban cultural tradition, women's right place is in the home, where they are central. My informants talk for instance about *my* floors and *my* carpets when they discuss housework.[3] Women's central position in the home is the case, to a certain degree, in all of Norwegian society. But more in the urban working class than in other milieus, she *is* the home (Gullestad 1979a.) Working-class men cannot take friends home as easily as middle-class men often do. An example will show this attitude. Mette tells about the reaction of her husband's friends to the fact that they married and had a child early:

> They were in a way my friends too. I knew them like the palm of my hand. But when we married and had a child, it was as if there was a ring around us. They seemed not to dare to come here. They had so much respect for me. Then we invited them to come one Saturday evening. I told my husband to buy a case of beer, and so he bought a case of beer and put it on the balcony. Then they arrived. None of them had dared to bring something to drink. I had made a stew. "Would you like beer or mineral water with the food?" I asked. "Yes", they said hesitatingly, "we can take one glass of beer." "You may drink as much as you like", I said. "There is a whole case on the balcony." Then they cheered up. Later in the evening, they said that they had so much respect for me that they had not dared to bring anything. They thought I would not like it, now that I am a married woman and a mother. I found it strange that they, knowing me so well, should think that I would change that much. Later they came back, one after the other, and perhaps brought with them a half bottle of brandy *(en hallemann),* saying: "You spent so much on me last time, I will treat you today." They never brought anything *much,* though.

Mette's story demonstrates the fact that men do not feel completely free in the home of a married friend and with a woman

married to a friend. Once a woman marries and has a child, temperance and moderation, plus other qualities are supposed to be exhibited by that woman, and men are supposed to respect both the new image and the new woman. There is a ritual space around the couple and their home. She is thought of as being central in the values of hearth and home and the boundaries around it. (The idiomatic value of alcohol is discussed later, in chapters ten and eleven.)

Verbally the central position of the mother is indicated by several expressions. When one visits one's parents, the expression is "at my mother's" *(hos min mor)* or "at the place of my mother and them" *(hos min mor og de)*. "Them" stands for the father and siblings, if any. The parental home is also conceived of as the mother's place.

Apart from repairing, home decoration, and the like there are not so many indisputably masculine tasks in the home. The home is his place of relaxation from work. He also does other tasks, like doing the dishes or playing with the children, but doing these tasks is to some extent arranged or supervised by her. She seems to be more in her natural setting than he: her arrangements and her tools – her choices too – compose the environment. This is part of the explanation for the constant redecoration of the apartments and the corresponding importance of the car for a man. The car is for him a place to be legitimately away from wife and children, a place to be alone or with other men doing activities that are defined as masculine. There is always something to do to a car. It "must" be washed, or it "must" be repaired, and in addition it is an object for redecoration. These "needs" provide arguments that carry some weight in the negotiations between the spouses regarding taking care of everyday life household matters.

When one visits a family in the evening, one often finds the father or male live-in friend sitting on the couch watching television. On weekends he often has a glass of beer or a drink in front of him. Some of the men are well-built, heavy workers who sit heavily on the couch, their legs apart. Those who work in service occupations, may be slim and have a different physique and physiognomy. They may perhaps be seen sitting with one leg crossed over the other, more like middle-class men do. Men in general seem somehow not to feel completely at ease in their own homes. They may look ill-placed, perhaps a little bored. To some extent

the same may be true for many middle-class men. If there is a difference, it probably has to do with ideals of masculinity. In working-class milieus muscles, physical strength, practical knowledge and being handy are more important than in middle-class milieus. And somehow one does not demonstrate these abilities when sitting idly chatting in a comfortable and representative living room. Home decoration is, as discussed earlier, an activity of the home which seems to suit him more. Men want to have a wife, home and children, but this life also confines them, and is to some extent contrary to traditional masculine ideals of freedom and varied activity. Georg, for instance, used to play in a band. When they married, he had to sell his instrument to buy the eitherdowns they needed. To me, then, the image of the men's position in the corner of the sofa is a vignette that suggests symbolically, that from a social point of view they are not completely "at home" in their own homes. They are both somewhat marginal and somewhat confined. Their positon of marginality in the home is most dramatically demonstrated in cases of divorce, when the man is the one who has to leave and must find another place to live.

Conclusions

Motherhood is a fundamental identity, consisting of a whole syndrome of values and ideas. The children influence very much of what the young mothers do, even if they are not the most important figures in the talks between them. As we shall see later, other things than mothering and child care present their most important existential problems, but the way they formulate these problems are strongly coloured by the fact that they are mothers. Their child-care ideas and practices are also such that they leave room for additional activities and interests.

That motherhood is central as both role and identity is demonstrated in cases of marriage crisis and divorce. Mother is central in the home and father is the one who is "thrown òut" or has to leave.

7. Getting a home: Operating on the housing market to realize the values of hearth and home

To get a home, one has to enter the housing market. Not only economics but also other factors shape people's choices about where to live. In this chapter I examine some of these factors by asking the following questions: What possibilities do the young couples have to realize the values of hearth and home? What does it mean, economically and symbolically, to live in a cooperative apartment block? How are people recruited into such living accommodation? What are the different aspects of housing they consider important? Where will they probably be living in ten years' time? In what ways is the type of housing a sign of identity? What does it mean for young couples to live close to parents or parents-in-law? What is the social meaning of neighbourhood?

In the housing sector the State has, by facilitating inexpensive loans, contributed to the fact that a high percentage of all Norwegian households live in privately owned single-family houses. These are found both in cities and in the rural areas, but less in the former than in the latter. There is in Norway only a very small public housing sector. Instead there is, in the suburbs of the cities, a cooperative housing sector, also a product of inexpensive loans and organizational efforts by the State. Cooperative housing mostly consists of suburban apartment blocks and kinds of housing that are called terraced houses in Britain and rowhouses in the United States.

Few areas in Norway can be designated as outright slums. All the same, as in many other countries, studies have revealed that some of the worst and some of the best living conditions are to be found in the biggest cities – especially in Oslo, but to some extent also in Bergen, Stavanger and Trondheim (Aase and Dale 1979). Between city and countryside differences are complementary: wages and the labour market are better in town, whereas housing is better in the countryside. Within the city, however, advantages

accumulate in some areas, while drawbacks accumulate in others (Aase and Dale 1979).

The most advantageous areas are residential districts with privately owned single-family houses and gardens. Worst off, in terms of the indicators used in statistical studies of living conditions, are the old central parts of the city. The indicators used measure things like housing standard, WC, bathroom, rooms per inhabitant, traffic and noise in the surroundings, education, income and health of inhabitants. In between the best and the worst are many other areas with different characteristics relating to site, distance from the city centre, kinds of housing and ownership. The cooperative apartment houses in the suburbs where the women of the present study live are among the least advantageous places to live. They have also been stigmatized, through the mass media, as being places full of problems like social isolation, juvenile delinquency, etc. People are sorted and sifted into different kinds of neighbourhoods in the city by the combined effects of the economic mechanisms of the housing market and social and personal factors like kinship, length of residence, personal ability to plan ahead. But average figures also conceal some differences concerning occupation and life style existing within many neighbourhoods.

Personal histories of housing

Those young parents who grew up in the rural areas are accustomed to living in privately owned single-family houses, often farm houses. The houses are relatively big and comfortable, but electricity and running water were often not installed before the 1950s or 60s, in the childhood of my informants. Electricity and running water was a great change in the lives of their families, especially for their mothers.

Those who grew up in the city have, from their later childhood, been used to the same kind of dwelling that they now live in. Their parents moved in the fifties or sixties, often with three or four children, from very cramped and low standard rented living quarters near the centre of the city to cooperative suburban apartments. That move was the "big leap forward" in the recent history of these urban working class families. It exemplifies an important

stage in the development of the Norwegian welfare state, and in the bettering of the living conditions of the working class. They moved from one or two rooms with kitchen, no bathroom and a toilet shared with other families, to new modern apartment blocks with three rooms, kitchen and bathroom. This movement from the centre to the suburbs was partly due to a necessary decline in population density in the inner city together with rising standards and area norms – and partly to a neglect of the inner city on the part of the authorities.

The young mothers have, most of them, moved one or more times after they married or had their first child. Many lived with parents or parents-in-law during the first period after they married and had their first child, before they could establish themselves on their own. Others have lived in a rented apartment, often of low standard, in or near the centre, in a cabin or a rented house outside the city, or in another cooperative apartment in an area where they felt isolated, before they acquired their present dwelling.

The Bergen housing market

The housing market in Bergen consists of different sectors with different kinds of housing and different recruitment principles. Geographically the city is, as already noted, to some extent demographically and socially segregated. Demographically the population, on the whole, is older the closer one gets to the centre. Close to the centre live the old, a little bit further out the middle-aged, and in the newest suburbs live the young families. Socially the population is also segregated into different kinds of areas. The most attractive areas are where the surrounding hills allow a lot of sunshine to fall. Bergen South is also more attractive than the West and North. The following is a crude classification of kinds of housing. The classification is meant as a background for the discussion of the current housing conditions of the women of this study, and the possibilities open to them on the housing market.

1. Close to the centre one finds smaller wooden 18th and 19th century houses and larger apartment blocks from around the turn of the century. The city centre has burned down several times. In spite of the city being 900 years old, few dwellings are

135

therefore older than a few hundred years. Most of my urban informants, as already noted, spent their early childhood in such old houses close to the centre. Houses and apartments may be owned by the inhabitants or rented. These areas are traditionally inhabited by working-class and lower-middle-class families, partly also by the *lumpen Proletariat,* which is what my informants call social cases. To a considerable extent houses are sold and apartments rented through social networks (Gullestad 1979a). This is changing as the areas have become more attractive for the new educated middle class. The economic marked mechanism now operates more consistently when houses are sold.

2. More removed from the centre are houses with 2–3–4 apartments and gardens, dating from the beginning of the century until 1950. These are attractive for families because of the garden, and because there is less traffic here than close to the centre. Traditionally these areas were inhabited by lower-middle-class/working-class people, but are now also attractive for the educated middle class.

3. In the sunny parts, both close to the centre and up to approx. 20 km from the centre are areas with big single-family houses for upper-class and upper-middle-class people, in Wright's (1978, 1980) terminology capitalists, top leaders, and a few semi-autonomous professionals, like successful doctors and lawyers; in my informants' terms "high-up people". The closer to the centre the older the houses are. The oldest districts have the highest symbolic value as "upper class", but some new districts, especially in Bergen South are getting such a reputation. These houses may be inherited or bought for a very high price on the open market. These areas are outside the universe of my informants.

4. Suburban cooperative apartment blocks and terraced houses/rowhouses, all at some distance from the centre, but the distance varies according to age. In Norway new apartment estates and terraced houses/rowhouses are suburban. Terraced houses/rowhouses are more expensive and regarded as better housing than apartment blocks.

 In the cooperative estates live both working-class, lower-middle-class, and middle-class people, and also "social cases", stigmatized people with various problems like alcoholism and

unemployment. The cooperative housing market is outside the ordinary economic market. The entrance premium is lower than on the ordinary market, but economically it may be more expensive living there, in the long run. The inhabitants who can afford it, tend to move on. The turnover varies, but is relatively high (approx. 20 % a year) on the newest estates. More middle-class families tend to live here for a short period than working-class/lower-middle-class families do. Housing in apartment blocks is normally used for the early stage in the development cycle of those households. They tend to move on to cooperative rowhouses or kinds of housing with private ownership. The turnover in terraced houses/rowhouses is lower than the turnover in apartment blocks.

5. Privately owned rowhouses are relatively new and more modest housing than the upper-class houses, but, because they are privately owned and therefore allow for more autonomy and control, they are regarded as better than cooperative housing. The distance from the centre is about 5–12 km. Inhabitants are mainly middle-middle class, employed both as intellectuals/ bureaucrats and in business. A few working-class people and upper-middle-class people will also live in such areas. Recruitment is mainly through the operation of the market, but may partly be due to information obtained from social networks.

6. New privately owned prefabricated houses are situated 10–30 km from the centre. These are rural and/or recreational areas under suburbanization. Many, but not solely, working-class and lower-middle-class households live in these areas. Several of them are the relatives of rural people (farmers or workers), or people from Bergen with small recreation cabins. In such areas it is still possible for working-class/lower-middle-class couples to get a free or a cheap site through relatives or acquaintances, and with it the possibility of acquiring a privately owned single-family house.

Recruitment to cooperative ownership

Cooperative ownership is particularly well developed in Scandinavian cities, as an alternative to a strong municipal housing sector. It is probably also a reflection of the strong value of autonomy in

this society. Cooperative ownership, it is commonly believed, gives one greater autonomy and more reason to feel like a "lord of one's own castle" than a rented dwelling, but less autonomy than private ownership.

The way to get a cooperative apartment, the recruitment process is, in principle, by becoming a member of a cooperative association and waiting until one qualifies by right of seniority. A lesser period of qualification is needed to get an apartment in a completely new housing estate than in an older one. The reason is that apartments in older housing estates (5–30 years old) are more attractive because they are closer to the centre, cheaper, and also more scarce.[1]

Cooperative ownership means that one owns a share in the association and with it the right to occupy one apartment. From the shareholder's perspective, this is practically interpreted as if one owns the apartment, although really one only has a shareholder's rights. There are several restrictions on ownership rights. It is, for instance, not possible to sublet the apartment for more than two years, and the share cannot be freely sold. In principle the apartment has to revert to the cooperative association when one moves. The price is standardized and is smaller than for privately owned apartments. It differs somewhat according to the state of the apartment and rises with inflation, but not as much as in the case of apartments that are privately owned. The cooperative association then reallocates the apartment by right of seniority on its membership list.

Instead of qualifying by right of seniority one may get an apartment through the municipality which is allocated according to social criteria based on need. The municipality disposes of a quota of apartments in every new estate which is allocated through a municipal agency. The share must be purchased, but the municipality helps out by giving guarantees for loans. The cooperative associations may also apply provisions in their membership agreements for allocating apartments according to social criteria based on need, which may result in seniority rights being set aside to some extent.

There are also other exceptions to the usual procedure, which leave room for some manipulation. One is permitted to sell the apartment to one's parents, children or siblings. One also has the right to move by exchanging the apartment for another place to

live in. By such an exchange one may move to another kind of apartment, to private ownership or a rented dwelling. A young family with small children may, for instance, exchange their modern apartment with an old couple who have a house and garden but want a place to live in that is easier to run. In such cases there will of course be a considerable difference in price to pay.

The right to exchange may be manipulated to cover not only a direct swap, but a "triangular" swap. Sometimes money that brings the price closer to the market value is paid "under the counter", in the case of both direct and triangular swapping.

Parents and children never seem to take money "under the counter" from each other, but brothers and sisters may do so and also friends and acquaintances.

Most of the families of this study have obtained "old" apartments, in one way or another, through social networks. There is no difference between the rural and urban girls in this respect. Asbjørg got her apartment (before she moved) by swapping with her mother-in-law. She was married then, and her former husband is from Bergen. Audhild swapped with her sister.

Eva and her husband bought the apartment from his parents; he is also from Bergen. The urban girls have followed the same pattern. Irene bought her father's flat. She has later almost lost contact with him. He does construction work in different places in Western Norway and lives in a caravan. An example of another kind is Kirsten's widowed mother, who changed to a newer apartment, not on the same estate as her daughter, but close to her. Her own apartment from the end of the forties was relatively cold and damp. She both got a better apartment and came closer to her daughter.

Elisabeth got her uncle's apartment when his family moved, through a triangular swap. Mona got her apartment by acquiring her grandmother's membership number in the cooperative. As already mentioned, the cooperative associations have a provision for allocating an apartment according to social criteria. Beate is an example of this. She got her apartment in a new housing area through the municipality on social criteria as an unmarried mother. The municipality also helped her to get loans by guaranteeing for her. Then she managed, again on social criteria, to exchange to an apartment back in the area where she had spent the later part of her childhood and where her parents still live. Her

argument was that as a single mother it would be better for her and her child if she lived near her parents and could get more help from them. She lived for half a year in the first apartment. Thus it did cost her some extra work to move back. I draw the conclusion that she wished to live near her parents and in a social and physical environment that she knew was good.

Mette and Ellen provide similar examples of the value of living in a familiar social and physical environment. Ellen and her husband (see chapter three) exchanged back to the area where she had spent her adolescence by putting up advertisements in the grocery stores. Mette and her husband both grew up in the same neighbourhood. After they got married, they first lived half a year with her parents-in-law. The parents-in-law had no younger children at home at the time. Then they managed to rent an apartment in this same neighbourhood for two years when the owners sublet it and moved to another town for a period. After this they rented the apartment direct from the cooperative association. They were not qualified to buy it by right of seniority. They had to move to another newer area further away from the centre, but tried to get a chance to go back. "Everybody in the whole block signed a petition that we should be allowed to move back", Mette says. After three weeks on the new estate the cooperative allowed them to buy the apartment they had rented. The cooperative applied the provision relating to social criteria, because Mette has a bad back that often hurts and needs treatment. A doctor certified that it would be beneficial for her and her family if she could live near parents/parents-in-law and get their help when needed.

Altogether 6 of the 15 women live in the same area where they spent the later part of their childhood. (See Table I and Fig. IV in Appendix I). Sissel and her husband bought his parents' apartment when the latter bettered their housing standard by moving to a cooperative rowhouse. Sissel's parents still live in the area. Gunvor got her apartment on social criteria as a single mother.

Only a few households in this sample live in new housing estates through the municipal quota or through ordinary membership rights in the cooperative. Since my fieldwork started in an "old" neighbourhood (20 years old), there are naturally many families in the sample who live in "older" apartments. What is striking is the strong role of social networks also in the cooperative housing market. The cooperative housing market is, in principle, the most

bureaucratic and the least possible to manipulate. Earlier research has also pointed out the fact that in practice very few apartments revert to the cooperative association once they are allotted (Guldbrandsen and Torgersen 1978).[2] New apartments are allotted through the seniority list of the cooperative and through the municipality. When apartments are once allotted, they change hands, in many different ways, through social networks.

Another important finding is that many young families, also in suburban housing areas, seem to want to live near the place where one or both of the spouses grew up. This phenomenon is known from other kinds of housing and other kinds of community, but it may there often be explained by the existence of other inducements. For instance, in the rural areas, the one who builds on his father's ground gets a free site, and this is often the only possibility there is to get a privately owned single-family house or a dwelling at all. Otherwise it becomes too expensive. The suburban households of this study, on the other hand, who take the extra trouble of exchanging back from a new apartment, gain little more than the possibility of living near parents and/or parents-in-law *and* the possibility of living in an environment they are used to, both physically and, not least, socially. "Here I know everybody", Ellen, Beate and Mette say. The modes of contact that children have to persons and places in urban Norwegian neighbourboods are much freer than the ones adults have. This is why those who have grown up in a place are the ones who really know it (Gullestad 1979a).

In addition to coming near to people and places they know and where they are known, what they gained through the move was perhaps paying a somewhat lower price for the share and a lower monthly rent and getting a location closer to the centre. What they lost was the newness of the new apartment. To me it seems very clear that living close to parents and the old neighbourhood was what counted. It makes it easier to give and receive help in daily life which costs little but means a lot for the flexibility and the viability of the household.

Living near parents/parents-in-law

Living near parents and living in a well-known social and physical environment are two motivations that often, but not always, go

together. It is in my view important to distinguish between the two and not mix them up or equate the one with the other. It seems to be clear, from this material, that these motivations are often among the important factors behind the choice of where to live. Many young parents want to live close to their own parents, if the housing market allows it. There is, however, an interesting qualification. They do not want to live "too close". Most of them live some blocks away. Only Mette lives in the same block, but not on the same stairwell, as her parents and in the block next to her parents-in-law. She is also the only one who has both parents and parents-in-law in her neighbourhood. In addition she also has a brother-in-law and his family a few blocks away. When discussing the matter a woman may say that the same stairwell is too close, a few blocks away is the best. "It is better if you have to put on shoes and a coat to go there." Asbjørg once gave me a good example of what it means to live too close to parents. A woman who lived ten minutes' walk away had asked her if she would swap apartments with her. The reason why the other woman, also a single mother, wanted to swap, was to come closer to her mother. The daughter used to come over every day to let her children play outside and to talk to her mother. Her children enjoyed playing with the children there. Asbjørg and this woman, Hanne, had almost come to an agreement, when Hanne withdrew. Her reason was that living on the same stairwell as her mother would be too close. She was afraid her children would disturb their grandmother. The grandmother would never get a peaceful moment *(aldri få fred)* and relations could become strained. The grandmother lived in a household together with the grandfather and one almost grown-up sister. (Asbjørg later swapped with one of Hanne's neighbours, a divorced taxi-driver.)

Being "too close" implies that the boundaries surrounding the households may be transgressed. It may be difficult for each household to keep the desired degree and kind of independence. Cooperation and sociability are sought, but it may easily become "too much". This definition of what is suitably close and what is too close explains why some cooperative "two-generation houses" have been a failure. They are rowhouses consisting of one bigger and one smaller apartment, the smaller one on the ground floor (the basement floor). Few people wanted to live in them, partly because the two households came physically "too close", partly, I

believe, because one apartment was small and the other big. When the younger household is in a position to buy a rowhouse, the older household is today not prepared to retreat into a smaller apartment. Such an arrangement presupposes a later stage in the developmental cycle, a stage when the younger household usually is already firmly established.

It seems that a few minutes' walk (1–3 minutes) is considered the best. Several of them are not very fond of walking. They find half an hour's walk a hindrance, except on Sundays. For this distance they will often use the car, if they have one. But still, when close relations, be it parents, good friends or other relatives are located within half an hour's walking distance it is possible to cooperate for some purposes.

It is on the same stairwell that the best neighbours are most often found, speaking of neighbourliness proper. The relationship between parents and children is in itself complex and close. Different rules apply from the ones that regulate neighbourliness. Both the young and their parents have difficulties in being explicit on what living near each other involves in the way of drawbacks or benefits. A situation in which a choice has to be made like the one above, is one good indication of such feelings. Most often, at the beginning of my fieldwork, when I asked those young mothers who live close to their parents what they thought about it, they would look at me as if they did not understand. me. "I have never thought about it", they would, for instance, say, and add: "They never come over here anyway." They seemed to find my question annoying, as if I implied that they were not managing on their own as a household, that they were not independent and self-sufficient in the way it is defined here. As the fieldwork went on, I learned about the small almost daily services and contacts between such households. Children would, for instance, often eat dinner both with their grandparents and at home. Mothers who grew up in the neighbourhood or in the city generally have access to much more flexible solutions for child care and babysitting than mothers who have a rural background.[3]

There is only one example of a situation where a woman actually complained about living too close to her mother. In a very difficult stage in the process of separating from her husband, Sissel complained about her mother nagging her all the time. She sighed and said it was a relief when her parents went on holiday, and that she

wished she herself could move to the area where Elisabeth lives or to the area where Kirsten lives. But before and after that period she used to praise the advantages of living only a few minutes' walk from her parents.

On the other hand, some women who do not live near their parents say that they would not have liked to. Arnlaug, a former schoolmate of Elisabeth, Sissel and Ellen said once "I am one of those who do not want to move back". Elisabeth's husband, Georg, sometimes said he wanted to go back, but Elisabeth was more sceptical. "I would move back for a rowhouse but not for an apartment", she said.

The reasons for Arnlaug's and Elisabeth's attitude are, I believe, connected with the social milieu of a stage in their lives that they want to have done with. For some of them the old neighbourhood is associated with a wild adolescence: too much drinking and petty crime in adolescent gangs.

Where will they be living in ten years' time?

They regard cooperative apartment blocks as a decent kind of living, compared to rented apartments in old badly kept houses and other alternatives that several of them have tried before they settled here. It is "decent and ordinary living". At the same time they see some drawbacks. Many people want a privately owned single-family house, if given the choice. The main drawback of an apartment is that "you have to take account of others all the time" *(du blir nødt til å ta hensyn til andre hele tiden)*. It is seen as a reduction in the desired autonomy.

Most of the urban parents and parents-in-law of my informants live in similar cooperative apartments. Asbjørg's mother-in-law accepted their smaller apartment in exchange for her bigger one, because they needed it most. Elisabeth's parents bought a privately owned rowhouse in the same area where they formerly had a cooperative apartment. The small geographical move made the social move to better living conditions somewhat smaller than it could have been. A few other parents also moved in the housing spiral from a cooperative apartment to a cooperative rowhouse, or from a cooperative apartment to a single-family and privately owned house.

During fieldwork two of the households moved. Asbjørg exchanged to an apartment within 15 minutes' walking distance. Audhild moved to a rowhouse close to the area where her parents-in-law live. None of the other women in the study had definite plans to move, but a few were discussing it. Most of them were still paying interest and instalments on the loans for buying their current apartment. When they have paid all the instalments, they will each own a share in the cooperative and can then use this as starting capital for exchanging to more expensive accommodation. The share price for a used older 3-room apartment was about 70–80 000 N.kr. (in 1980). (Prices have gone up considerably since I did my fieldwork.) A new apartment was priced at about 120 000–150 000 N.kr. in 1980. The price of such a share has risen rather high in relation to medium incomes the last few years. The premium entry for this housing market is accordingly relatively higher for those who are trying to establish households today than for those who established themselves some years ago.

It is difficult to say what impact the straitened economic situation in the country will have on the further bettering of housing standards for these families. It seems obvious that the separated women, as long as they do not establish a marriage relationship with a new man, have few possibilities of bettering their housing standard. They have already had to share the value of the apartment with their ex-husbands. To be able to buy out their former husbands they normally get help from the municipality to obtain the necessary bank loans.

For some, but not all, of the married couples there are reasons to believe that they will try to advance in the "housing spiral", in the years to come. The alternatives seem to be the following:

1. To buy an older house or part of a house, not in the central parts of town, but so that there will be a tiny garden. This necessitates changing from the cooperative to the private housing market. This alternative is possible, but seems to be unlikely. The reason is that none of them seem to have relatives in such neighbourhoods. That means that they would have to buy the house on the open market. This implies both more money and more "cultural capital" – ability to act in this difficult market. In addition, when one owns an old house, one needs male skills for repairing and redecoration. This is a barrier to a few but not

to all of them. They are not as romantic about old houses as the educated middle class is.

2. To remain inside the housing market of the housing cooperative and swap to a rowhouse with a garden. Some of them will probably do this.

3. To build a new prefabricated house on a site relatively far away (about 15–30 km from the centre). This is about the distance where it would be possible for them to get sites. For several of them it will be possible to get such a site through parents or other relatives. Mette's parents have a small cabin on one of the islands outside the city which has recently been connected to the mainland by a bridge and is now in a process of sub-urbanization. Since her parents have promised her a free site, they were tempted to ask for permission to set up a house there. Two of Georg's uncles also live on the same island. They have offered Elisabeth and Georg a part of the garden as a free site if they are willing to move. Georg was interested, but Elisabeth hesitated. "I know nobody out there", she says. "And the commuting distance is too long for me to keep on working."

4. To build a new prefabricated rowhouse through one of the asociations for persons who intend to build their own house with their own hands. The association helps in finding sites. One couple is a member of such an association, and one couple has close relatives (the wife's parents) who are members.

The spouses think and make choices in terms of many different factors: the housing market and their specific resources in it. Their values are such that a rowhouse or house and garden is considered better than an apartment; cooperative ownership is considered economically more advantageous than a rented dwelling, but private ownership is considered the most economically advantageous. They also want to live near places and people they know.

Housing as a sign of identity

There thus exists in Norwegian cities an ideal housing career, a housing spiral. At the bottom of the spiral is the cheapest and least attractive housing accomodation, on the top the most expensive and most attractive. People are sorted and sifted to different kinds

of housing and different parts of the city according to their resources, both economic, personal and social. Cognitively, also, different areas have got different kinds of reputation. The reputation reflects not only the kind of housing, the age and degree of stability of the estate, but also specific problems or advantages.

Changing one's residence from a cooperative apartment to a cooperative rowhouse and even more to a privately owned rowhouse or single-family house has several social implications. One gets new neighbours. Geographical propinquity or distance has direct social consequences. Seen from a communication perspective, the kind of housing, like clothes or occupation, also serves as a signal for who you are or want to be, and is interpreted as such by others. To old friends, neighbours and acquaintances it is a sign of success, of becoming better, more than ordinary. This implies prestige, but also dangers of becoming "too high up". This is illustrated by a quotation:

> We do not have very much contact with my mother's family. My mother is annoyed because she is never invited to weddings . . . My mother's brother tries to be posh *(skal liksom være så fin)*, you see. They live in a single-family house at X [a middle-class area].

When someone is planning to move, the motives are often examined. If it is because one needs the space and really can afford it, it is perfectly all right. If the motive is considered to be mostly showing off, trying to become "better", it is condemned. When the women discuss their own housing and plans for the future, some of them hold very strongly that they will never move:

> An ordinary cooperative apartment *(blokkleilighet)* is more than good enough for us. I can't understand how people can afford to buy their own houses. It's crazy to spend so much money on housing. We want to live, not just to dwell. *(Vi vil leve, ikkje bare bo.)*

On other occasions they discuss the plans of friends and acquaintances:

> My sister-in-law always wants to be better than everybody else. Now she wants to move to a rowhouse. She says [imitating an

147

affected middle-class Bergen dialect]: "We just have to move. There are just not enough closets and room for what we have." She is never in tune with others *(hon e' så sløkket,* e.g she is so out of step).

Similarly, a group of women were discussing a friend, not present. Together with her husband this friend was planning to build a new prefabricated house on a site, 25 km from the centre, which they could get for nothing from her parents. Her friends doubted whether they really could afford this. They discussed in some detail what kind of furniture and equipment they possessed and came to the conclusion that "they really have nothing". "It would be much better", one of them held, "to save up for proper furniture first and then start planning a new house. As it is now, there will not be more than one chair for each room in the new house!" The others present seemed to agree fully. The family they discussed did have a furnished apartment, but the furniture was partly old and partly home-made.

The woman who brought this news to the group and most strongly criticized the decision, had herself offered her point of view, but certainly in a milder version, to the couple when they told her. Such values, and the social sanctions they imply, act to some extent as brakes on entrepreneurship. Economically it is most advantageous to build a house and make the best out of old and home-made furniture. Socially the best thing apparently is to be only a little bit better off than your friends. Better furniture and equipment do not remove one substantially, either geographically or socially. Moving may often imply geographical distance, not only from old neighbours but also from friends and relatives who live more geographically dispersed. The reason is that new housing estates are often situated relatively far from the centre. Moving to better housing means moving socially from one category to a "better" one. This gives prestige, but also introduces a difference that has to be handled carefully in social interaction, unless "everybody else" is also moving to the same kind of housing. Since my fieldwork was completed, the situation has changed somewhat in that direction. Elisabeth and Georg have moved to a cooperative rowhouse, and several others also consider moving.

Where one lives thus has do with both the ritual status of the household and the practicalities of everyday life. There is concern

about neighbours, about coming close to people one is already related to, or in some way familiar with, in addition to getting a better housing standard, if possible.

The housing market is, however, such that it is difficult to get the right kind of housing in terms of standard and at the same time be close to people one is already related to.

Neighbourhood

The women of this study have their relatives, friends and acquaintances spread over the city and the region. The neighbourhood is one domain of several in their social lives and has little collective identity. It depends on the situation and the problem at hand how one choses to define the neighbourhood. There are ever wider circles reaching from the same stairwell to the same block, to the closest blocks, to within five minutes' walking distance, to within half an hour's walking distance. Neighbours proper live in the same block and in the closest 3–4 blocks. Within this area people can be expected to recognize each other after some time. Most of my informants have at least one family on the same stairwell that are "particularly good neighbours", neighbours that they use for borrowing flour and other items from after the stores have closed, for babysitting and so on. Relationships to other neighbours are more distant.

Then there are relatives, for some of them, and friends. People one is related to by other criteria than neighbourhood, like relatives and friends, are more reachable and more important in everyday life if they live within the neighbourhood, within five minutes' walking distance, or even within half an hour's walking distance.

Most of my informants have at least one or a few friends in the neighbourhood; six of them also have parents or other relatives within 5 minutes' walking distance. These relationships are governed by other considerations (kinship, friendship) than neighbourliness proper.

The idea of cooperative ownership is that the inhabitants have shared rights and responsibilities over joint territories inside and around the blocks. The tasks of keeping these territories in order are assigned to the inhabitants. They clean the stairs and sweep

and wash in front of the entrance doors in rotation. There are also democratic organizations to take care of the common interests of the inhabitants. In spite of this, most adults do not use the space outside the private apartment very much. Children use this space freely, whereas adults feel more restricted. They go to and from their different duties through this area. There are some loci for activity that to some extent function as meeting points in every neighbourhood, like the stairwell, the laundry room, the children's playgrounds, repairing the car, going to the grocery store, and so on. Adults linger, however, very little outside the blocks. Few women, for instance, take sunbaths or meet outside to chat on nice spring and summer days. This may happen in other areas, as for instance described by Haugen (1978), and in old central neighbourhoods of the city (Gullestad 1979). The women prefer to go to the seaside or find more privacy in some wilderness to take a sunbath. They feel uncomfortable sitting outside "on display". At most they take a sunbath on their private balcony, an extension of their living room. Neither women nor men identify with the common space in the same way as they identify with their own apartment. The division between inside (the apartment) and outside seems here, where the outside is common property and has few or no other functions, to be sharper than in an old central quarter, where the area immediately outside is not common ground but public ground (Gullestad 1979a). There is less a feeling of an intermediate half-private and half-public space, due probably to the fact that the adult inhabitants are more distant and know each other less. Social relationships and not legal rules thus seem to be most important for how people feel about their immediate surroundings. The lack of intermediate space between the home and the public space is probably one more reason why home decoration has become so important. (See chapter V.) This is the territory people feel they have immediate control over and identify with.

Child care provides one of the most important integrative functions in these neighbourhoods. In addition to kinship-based child care there exist different institutionalized practices for child care outside the official market, done by "strangers" for a wage.[3] *Passepiker* are neighbouring girls from 9 to 12 years of age who take small children from 0 to 3 years of age out for a stroll every week-day after school is over from about 3 to 5 o'clock. (See also

photograph). Babysitters in the evenings are typically adolescents of both sexes from about 14 to 18 years of age. There are also grown-up women who take care of children for payment while their parents are at work *(dagmammas)*. Among working-class families there is a tendency to make such relations of paid child care personal and familiar. The existence of these different child-care solutions makes the participation of women in other roles and activities possible.

Neighbourhood, socially speaking, has most to offer those who have grown up in an area. By "knowing everybody" they have sources of information that make it easier to approach people, for instance if they need help with child care. They have access to more flexible child-care solutions and a wider range of social contacts. Having grown up in the neighbourhood thus makes it easier, also, to get away from it and exploit other possibilities of the city. On the other hand, neighbourhood means most to those who have few other alternatives and whose movements are restricted. Asbjørg and Eva, two of the three women who have grown up in other parts of the country, do not take much paid work and are most confined to the neighbourhood. The few friends they have got there thus mean a lot to them.

By comparison with these neighbourhoods, one might mention kinds of housing that sometimes have unplanned negative consequences, especially for the wife, Moving to privately owned single-family houses 15–20 km from the centre makes it difficult for her to take paid employment, and makes her isolated by removing her from old friends and acquaintances. (Solheim 1984).

Conclusions

The cooperative housing market is, in principle, the most bureaucratic and the least possible to manipulate. The findings of this study support and supplement earlier research (Guldbrandsen and Torgersen 1978), pointing to the fact that few apartments revert back to the association once they are allotted. Social networks play an important role, also in the cooperative housing market.

Another important finding is that many young families, also in

suburban housing areas, want to live close to the place where one or both of the spouses grew up, and that this is a source of strength in the daily life of these families. They want to live close, but not "too close" to parents and parents-in-law. Their definition of what is too close explains why some cooperative "two-generation houses" have become a failure.

Housing is a sign of identity. Moving to a better house actualizes the dilemma between prestige and equality. The housing market is such that it is difficult to get the right kind of housing in terms of standard and at the same time be close to people one is already related to.

Neighbourhood has in itself little collective identity. Neighbours may live in very different neighbourhoods, socially speaking. All the same the location of their places to live and the neighbourhoods provide advantages for several of them. The young mothers of this study live close enough to the centre to take paid employment if they want it. Most of them have both unpaid and paid informal child-care facilities in the neighbourhood, especially when they live close to parents, as some of them do. In some ways their neighbourhoods make possible participation in activities outside "hearth and home".

8. Visiting and other social occasions in the homes

What do people do in their free time? What forms does their sociability take? The answer is that people often meet in each other's homes. The homes are the setting for the main occasions where friendships are confirmed. Formalized occasions (outside the workplace) are relatively few, but informal visiting is extensive.

The visiting among women when their husbands are not at home is essential for the formation, maintenance and development of their friendships. At the same time the women's coffee klatches are a special case of a more general practice that also includes men and children (when escorted by adults). Women do however, both receive more visitors and go visiting more than men do. Their sewing circles are formalized versions of coffee klatches, occurring in the evening and without children present.

To go visiting, to drop in at somebody's place *(gå på besøk)* takes on different meanings depending on the occasion and who is present. Among the things that make a difference is the sex of the participants (one-sex or mixed gathering), the time of the day, the week and the year, and if there is something special to be celebrated.

In mixed gatherings (for instance two or more couples) two conversations often develop. The men discuss cars, sports, television programs, etc. The women discuss things like children, fashion, home-making and the sayings and doings of friends. When talking about these last matters women sometimes speak quietly or steal out into the kitchen and quietly close the door behind them. Both men and women try to monitor each other's conversations, and may sometimes interrupt to voice their opinion. Men seem, however, generally to be more interested in listening to the women's conversation, than vice versa. Women discuss emotional and personal matters of significance for both sexes.

(See also chapter XI about their moral discourse.) They have more information about the personal lives of friends and acquaintances. But I also heard women comment upon what the men discussed. If a wife for instance hears her husband tell a male friend that he is soon going to buy such and such car, she will perhaps interrupt by saying forcefully: "Don't be too sure of that! Have you forgotten that we agreed upon buying a new couch ensemble first!" Or she will, like Beate, silently and without commenting eavesdrop when the husband admits something about their relationship to a friend that he usually does not admit to her. She was very pleased, she told her female friends afterwards.

When the couple is visited by a female friend of the wife, the situation is a little ambiguous. The husband seems to have difficulties in balancing his dignity as a man against his desire for company. If he choses to retire (and keep his dignity) the women may sit in the kitchen while he has a nap in the living room, or he may retire to the bedroom or the kitchen if they are in the living room. If he choses to keep them company, he usually does not talk very much. He is symbolically only half present. His silence symbolizes distance and dignity. It is also a way of hiding any feelings of discomfort and insecurity he may have from being with women on their home ground. Men probably feel insecure in a women's world and sometimes cover this behind a quiet and dignified masculinity. At the same time he is present and listens to their talk. His presence restrains their conversation. They do not, for instance, confide in each other about their men and the relationships of their friends. Complaints about parents-in-law are not appropriate on such occasions either.

What happens when a male friend of the husband visits the couple, is less certain. My impression is that the situation is less constrained, at least seen from the woman's point of view. It is normally not difficult for her to be respected as the mother of the home. The home is a woman's natural environment and she has lots of tasks to do there. She may be present without losing dignity. It is more directly a question of her liking. Her presence as well as the home as setting makes it impossible for them to talk about topics that are considered degrading to women. They must behave decently. Remember also Mette's story about how intimidated the friends of her husband became when she married him and established a home.

Men like, more than women, to do something together rather than just talk. They like to look at or listen to sport on television or radio. The English football matches, on Saturday afternoon, are important foci of interest. The results decide who wins the football pools that "everybody" (men and also women) participates in. One woman gave a humorous account of her husband, sitting in front of the television with one hand around the baby son on his knee and with a bottle of beer in the other hand, watching the Saturday afternoon match. Their companionship as menfolk in this world had already started.

Women also watch these matches, but not as consistently or with the same enthusiasm as men. They are informed, but not as enthusiastic. If other women are present, they often choose to chat and just keep an eye on the match, whereas the men are totally absorbed. Their companionship often takes the form of shouting loudly together in joy or disappointment following the ups and downs of the match.

Daily and weekly cycles

Women go visiting for their coffee klatches *(kaffeslabberas)* when their male partners are not at home. For a married woman or a woman with a steady (living-together) relationship, this is the time of the day when he is at work and she is not away at paid employment (she may however be taking care of a child in her own home). Daily rounds of life are mainly governed by working hours, school hours, and child-care solutions. I should perhaps mention here that Norwegian school schedules are very different from, for instance, those of the UK. Small children in Norway go to school for only a few hours a day, whereas in the UK they go from 9 a.m. to 3 p.m. from the age of 5. The Norwegian system gives children a much longer period between school and dinner, a period that belongs to the children themselves but which also necessitates the care and supervision of a mother or another person.

Rounds of life also differ depending on whether the mother is living with a man or not, and on whether she has part-time, full-time or no employment. Different combinations of tasks have different consequences for other fields of activity. (See also chapter thirteen.)

In the following I describe one typical pattern of daily life. The husband is employed full time, and the wife works as a *dagmamma* or in a part-time cleaning job. This pattern of paid employment was the solution for several, but not all, households at the beginning of my fieldwork.

Most husbands start work at 7.00 a.m., so they have to get up at about 6 o'clock. Some husbands start at 7.30 or 8.00. A few women get up together with their husbands, and this is in some cases seen by themselves as a favour and in other cases as a sacrifice.

Mothers usually do not get up before the children claim attention, or before they have to be sent off to school or, in the case of a *dagmamma,* when the mother of the child concerned brings it. With only pre-school children, between 8 and 9 o'clock seems to be the average time for getting up. This means that small children usually wake up earlier and play by themselves for some time. It happens that they are given snacks, like potato chips, to keep them quiet a little longer. One of the drawbacks of this method, from the mother's point of view, is that it gives her more work afterwards to clean up a room with potato chips everywhere, literally speaking. Sometimes the children damage something or "rob the kitchen" while their mothers sleep. They may for instance eat up the content of the tube of chocolate spread or use it to make a mess on the floor.

The proper time for visiting is not before about 11 o'clock. When Mona once dropped in at Elisabeth's place at 9.30, Elisabeth was very surprised. "Who would ring the bell at such a time?" The reason was that Mona had passed her driving test and "was dying to tell someone". As Elisabeth herself was taking driving lessons at the same time, she was an interested and sympathetic listener. Normally the young mothers are occupied with feeding or dressing the children, vacuuming or doing other kinds of housework before eleven in the morning. Sometimes they sleep a little later and are still in bed, or they go to the grocery store at that time. Most women go shopping every day, often either before eleven or after two o'clock. Their reason for doing this so frequently is often that they like to have this walk every day. Shopping practices are also connected to ways of budgeting (see chapter twelve).

Between 11 a.m. and 2 p.m. is the favourite time, seen from a woman's point of view. This is the usual time for coffee klatches,

depending on whether and when the woman herself has to go to work. She may choose to do some extra housework, go downtown or to the nearest shopping centre, go visiting or receive visits. Not only close friends, but also neighbours and other female acquaintances of the wife may drop in at that time. The number of women is most often two or three, sometimes four or five. A woman drops in at a friend's when she has finished her own housework, or she sends one of her children with a message inviting a neighbour to come over. When a visitor arrives, she rings the bell and waits until the door is opened, unless she is expected and the key is in the lock, to permit a child to let itself in. She brings her children with her or leaves them outside. The hostess most often stops her work momentarily, if she is not in the middle of something that has to be finished. They sit down in the narrow kitchen or in the living room. The choice of place is determined by the size of the kitchen, whether it is big enough to have a small dining table with stools or light chairs, the age of the youngest child, whether the husband is present or not, how close the relation is to the visitor. The kitchen-table is for close, intimate and informal visits.

The women sit down and chat. Conversing with each other is the focus of their interest. At the same time they are available for their children. The talk perhaps begins by one woman telling what sort of a morning she has had. ("Today I did not get up until ten o'clock. The baby played so quietly in her bed.") Pieces of new equipment are good news ("Yesterday we got our new colour television set"). Home-making, health problems and fashion are among the recurrent topics. Most intensive interest is given to confidences and personal matters. (Such discussions will be analyzed in chapter eleven.) When talking about some topics, especially marital crises and alcohol, the women make some effort to prevent the children from listening. They will either encourage them to leave, start whispering, make sure that the child is sleeping (in the evening), or talk in such a way that the children do not understand. These efforts are not always successful, however. Sometimes they are so engaged in a discussion that they forget that there are children present (and the children keep quiet so as not to be discovered). When the children are suddenly rediscovered, the mothers often change the topic by saying "little pitchers have long ears" *(små gryter har også ører)*.

Coffee klatches end when the hostess has to prepare dinner or

get ready to go to work. Some part-time charwomen leave home relatively early. When she cleaned classrooms in a school, Sissel left home at 1 p.m. Audhild leaves at 2 o'clock for her cleaning job at a bank. Elisabeth left at 3 o'clock when she was a cleaner in a firm in the centre of the city. They often start their work just before the day ends in the institutions where they do the cleaning, because they want to meet, even if briefly, other people who work there.

The period before they leave is usually the most strenuous of the whole day. One reason is that they want dinner to be fixed and the house to be in order, before they leave. The other reason is that they often depend on a child-care solution that cannot fully be relied on, like a neighbouring girl *(passepike)*, older siblings and so on.

If there have been visitors during the morning, they tidy up after them. There must be no dirty dishes left in the sink, no crumbs on the carpet, no displaced objects. The husband must find a neat place and dinner ready when he returns from work. The wives make dinner, eat it themselves, and give dinner to the youngest child(ren) before they leave. The husband eats alone or with the older children if any. Audhild relates that when she comes home from her job at about 6 p.m., her husband has done the dishes and made her coffee. But he is a special case. "He is so good-natured that you can get anything out of him" *(Han e' så snill at han kan melkes)* other women say. Their husbands may not do much more than look after the children and tend their needs while alone with them at home.

In the afternoon sociability is constrained, but not made completely impossible, by different tasks. The preparation and eating of dinner *(middag)* between 3.30 and 5.30 p.m. is the dividing point in the Norwegian day. Then there is, eventually, the father's or mother's after-dinner nap (which seems to be very rare in this age group) and putting the children to bed. At 6 p.m. the only Norwegian television channel starts sending the evening's program. The first transmissions are usually for children. Therefore 6 o'clock is another keypoint in the Norwegian day. Very young children watch the programs until about 6.30; older children also watch later programs. On nice light summer evenings they stay out later, but on dark winter evenings they normally come in before 6 o'clock. From that time onwards the family usually gathers in the

living room. The youngest children are put to bed between 6 and 7 o'clock. The older ones (5–6 years old) go to bed between 7 and 8 o'clock. In the evening, when the children are (with any luck) in bed, the parents are free to relax. Some men play games (football, handball) one or several evenings a week. A few women go to jazz ballet classes, and most women go to a sewing circle one evening every other week. A few women participate in two sewing circles. The spouses may also go visiting, one of them (because of the babysitting problem) or both. Most evenings are spent at home, in the couch ensemble in front of the television set. Sometimes friends and relatives drop in. The most popular television trans-missions are markers of time. Every evening the news is broadcast at 7.30. On Monday evening there is a cinema film. For the men, football matches on Saturday afternoon and the sports-reviews on some weekday evenings are events that they do not want to miss.

Just as the morning is the visiting time par excellence for women, the weekend is the visiting time par excellence for couples (Friday and Saturday evening) and whole families (Saturday after-noon and the whole of Sunday). At weekends people feel they can relax from their jobs, because they do not have to get up early the next morning. Saturday morning (until 1 p.m., when the shops close) is more used for shopping than visiting. Sunday morning and early afternoon, from about 11 a.m. to 3 p.m. is visiting time, but to some extent also from 6 p.m. to 11 p.m.

At the same time as the weekend is the time one most looks forward to, it is also the most stressful period of the week. Sunday is the most difficult day in many families with small children, the day of feeling nervous (literally have nerves, *ha nerver*). "I start feeling nervous when we light the first cigarette and drink the first cup of coffee after breakfast and it does not stop before we have decided to visit some friends or relatives, or some of them have dropped in here", one husband said once. And he added: "The best time of the week, really, is the last work hour on Friday, because then I look forward so much to a whole weekend off."

Sundays are the days for family life, but it is difficult to decide on activities that satisfy family members of different age and sex. Some Sundays are also days of having a hangover.

Friday and Saturday evenings are the times of the week when people give parties, when visits turn into parties, or when the couple simply relax on their own, eating tasty food and drinking

some bottles of beer or glasses of vodka. Friday or Saturday evenings are also days for "going out" to discotheques or other dancing places, especially for the single (unmarried, separated or divorced) mother, but also for married spouses. (See next chapter about the excitements and dangers of going out.)

When somebody comes visiting, the expected procedure is to serve coffee. If the coffee is not made or served relatively soon, the visitor may jokingly ask for it. "Where is the coffee? I'm dying of thirst." Very often the coffee is already made and poured over into a thermos pot (so-called TV-pot). People drink a lot of coffee during the day. Most coffee is drunk when visitors turn up. The amount of coffee used every day is a measure of the number of visitors and indirectly of popularity. "I use 1/4 kg (half a pound) of coffee every day!" Mona once said proudly. It is not necessary to serve anything with the coffee on weekdays. During weekends or if the visitor has come a long way, a little something may be served (a piece of cake, a sweet biscuit, etc.). If the woman does not have anything to serve on such occasions, she will excuse herself. "I'm sorry, but there's nothing to go with the coffee." If the timing of the visit has been agreed upon beforehand, she will make sure she "has something in the house".

In the evening a supper consisting of a few slices of bread with a sandwich spread is sometimes served. During the weekend, especially on Friday and Saturday night, alcohol is usually consumed. Visitors, at those times, often bring along half a bottle or a whole bottle of brandy.

People generally encourage those that they want to come visiting when they meet them. Their farewell remark is often: "Come and see us one day!" *(Ta deg/dokker en tur en dag!)* If it is the evening one has in mind, one often adds: "I/we just sit around anyway." *(Jeg/vi sitter nå bare her.)*

Informal visiting is not always completely reciprocal. There is, however, especially between friends of about the same age, a certain concern about reciprocity. The visitor makes more effort and shows more concern than the person who receives the visit. Therefore, symbolically, the one who receives visitors gains most in terms of feeling popular. Mona is proud of all the visitors coming to see her. Once, when speaking about some old school-friends who "make out that they are better than they are", she adds: "I am fed up. When they come here I talk to them just like I

Typical Norwegian cooperative suburbs. None of the pictures in the book are of the neighbourhoods or the homes of the young women studied. (Photo: Reidar Kvam.)

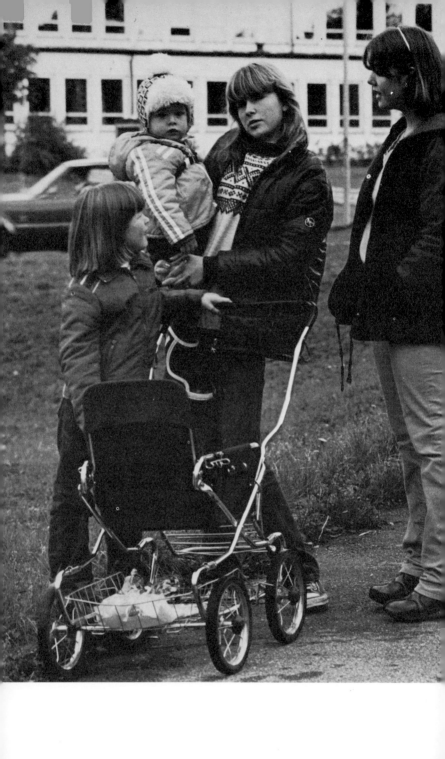

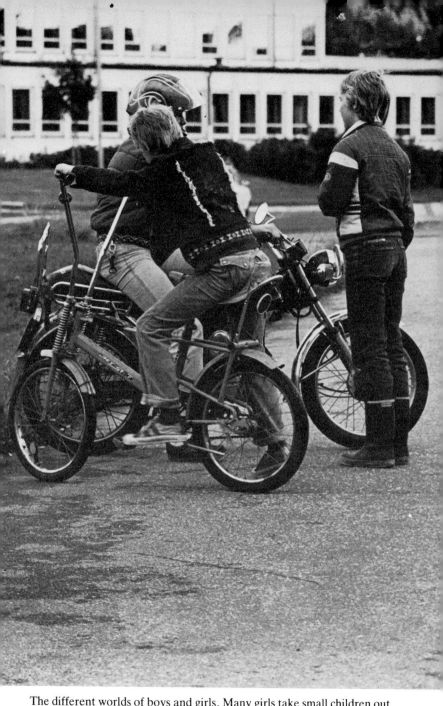

The different worlds of boys and girls. Many girls take small children out for a stroll in the afternoon, for a wage. (Photo: Marianne Gullestad.)

Playing "out in the street". The space between the apartment blocks consists of paved paths, roads, parked cars, lawns, playgrounds, and a few trees and bushes. (Photo: Reidar Kvam.)

The process of socialization to being good care-takers and members of kitchen-table society starts early. First they play with dolls, then they take care of small children. (Photo: **Marianne Gullestad**.)

Residents take it in turn to clean the stairs and sweep and wash in front of the entrance door. (Photo: Marianne Gullestad.)

Those who have grown up in a place are the ones who really know it. Children use space more freely than grown-ups. (Photo: Marianne Gullestad.)

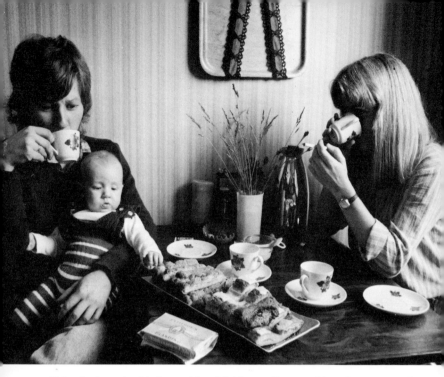

Friends sit at the kitchen-table, drinking coffee, smoking cigarettes and conversing with each other. (Photo: Reidar Kvam.)

The narrow hall.
(Photo: Reidar
Kvam.)

One of the corners of the living room. Symmetry and order are important.
(Photo: Reidar Kvam.)

The living-room is the show room where guests are entertained. This is an average home in terms of decoration and furniture. (Photo: Reidar Kvam.)

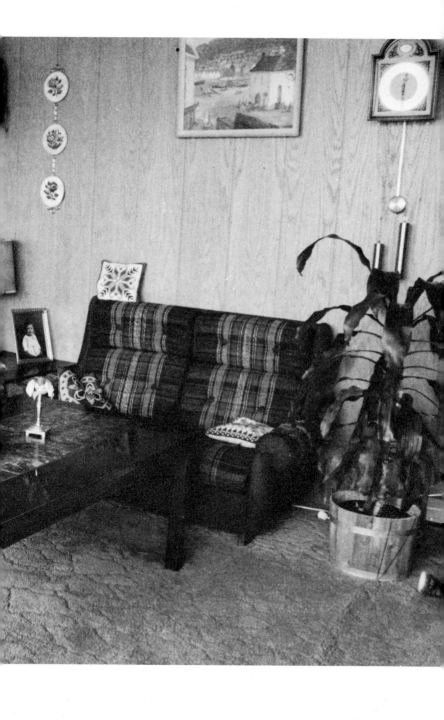

Every living room has a cupboard (*reol*). (Photo: Reidar Kvam.)

The kind of ornamental pieces chosen contribute to the desired impression of luxury and comfort. They favour shiny, precious or brittle materials. (Photo: Reidar Kvam.)

Possessing a piano is rare in this milieu. (Photo: Reidar Kvam.)

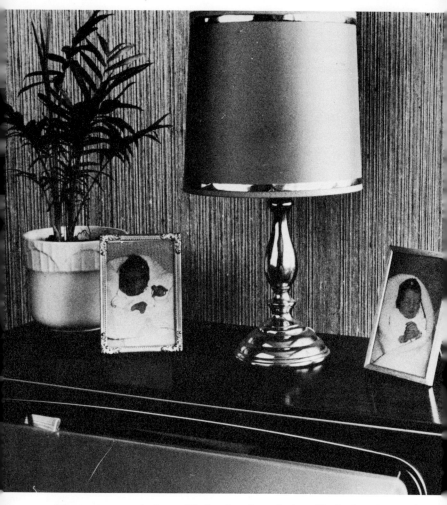

More ornamental pieces. Notice the silver ducks, gifts for baptism, and the two baby pictures taken at the maternity clinic. (Photo: Reidar Kvam.)

The bedrooms are given less priority than the living room. Children play in the hall, the kitchen and, like here, in their own room. (Photo: Reidar Kvam.)

The parents' bedroom is the most private room in the apartment. (Photo: Reidar Kvam.)

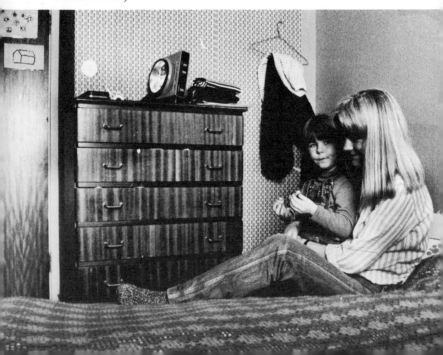

talk to you, but I never go to see them any more." Not returning visits is a sign of the relationship cooling off. Elisabeth was angry, several times, because Kirsten or Beate had not been to see her for a long time. "I cannot go over to her all the time. If she wants to see me, she has to come over here." If somebody one cares for stops coming, one easily feels "not good enough any longer". Close friendships have constantly to be confirmed by sociability and visiting.

There are also other dimensions to the question of being a visitor or the one who is visited. Some women seem most often to take one of the roles. Ellen is in a period when she is so tied up by her own small children and the children she is minding that she cannot take them along, but has to encourage friends to come and see her. Mette usually brings her children over to Eva's place, but when she becomes a *dagmamma,* Eva and her other friends have to come and see her instead. She complains about it: "Being a *dagmamma* ties you down. You can't bring along three kids so easily. And then everybody comes over here, messing up the place and stopping me from doing everything else."

"We just sit around anyway". (What it means to relax.)

Besides the serving of coffee, there are other typical characteristics of informal social encounters. One is that almost everybody smokes. Visits and coffee klatches are the occasions, par excellence, for smoking. Mostly they do not use ready-made cigarettes, but roll them themselves, by hand. People bring their own tobacco, but someone who has run out of tobacco may easily ask another for some of his or her tobacco and paper.

When friends or relatives come visiting, the hosts will, if possible, immediately put aside anything they may be doing. They sit down together with the guests, drink coffee, smoke cigarettes and chat. During the day the women postpone any housework. In the evening the couple normally relax *(slapper av)* anyway.

When people come visiting in the evening the television is often on. There is only one channel in Norway. The sound is turned down on programs they find uninteresting, and turned on again when a film or something else to their liking starts.

Friends and relatives sometimes fill in the football coupons

161

together on Tuesday evening. Sissel and Benny, for instance, used to visit another couple every Tuesday to fill in the coupons. Either he went alone or they went together. Elisabeth and Kirsten often fill in their coupons together.

Other kinds of handiwork are normally not done when visitors arrive. Women are more constrained than men, it seems. Men may decide to go out and have a look at the car together, but women normally do no knitting, sewing or mending. Even handiwork that may easily be combined with chatting is put aside, for instance easy sewing and knitting that does not need constant counting.

This pattern may again be contrasted with the traditional female culture of poor rural areas. Women were clever at recycling materials and at using every possible moment to knit, sew, mend and do other kinds of handiwork. Old women tell how they used to knit even while walking to and from the fields (Flakstad 1984). In the urban working-class milieus of today, on the other hand, it seems to have become of particular value not to do any sort of work during social encounters. Visitors easily feel unwelcome if the hosts do not put aside work, if they can. One woman, for instance, was very annoyed by her friend knitting the whole Friday evening when she and her husband unexpectedly came visiting: "Isn't she silly! We went over to see them and even took along half a bottle of brandy. There she sat knitting the whole evening! It was no fun at all! We just did not feel very welcome!" I asked her if the knitting was so complicated that it stopped her friend from chatting or drinking. "No", she said, "but it just was no fun. It changed the whole atmosphere".

The symbolic value of the knitting seems to be that it contradicts the sociability of visiting. The contradiction seems to be particularly serious since it is 1) evening, 2) Friday evening, and 3) they had suggested a "party" by bringing brandy.

On other occasions I heard women tell how they made use of tasks in the house to shorten an unwelcome visit.

One young mother complained about two of her friends. "They try to freeze me out", she said. "Every time I go over to one of them, they are always so busy." "I have to do the dishes", or "I have to clean the floors", they always say, but when they come over to my place, and I want to tidy up a little, they say: "Don't stress, come on, sit down and relax."

162

What handiwork and knitting there is, is mostly done in the family. It is one way that the boundary between households is marked. I only observed a few exceptions to this rule. Once, for instance, Mona's mother was knitting at a morning coffee klatch at Mona's place. Elisabeth and I were present. Mona's mother has both grown up and lived parts of her grown-up life (as a sailor's wife) in rural areas. She was knitting a costume for one of her grandchildren. "Who knits for you?" she asked Elisabeth. "My mother does not knit very much", Elisabeth answered. "She has been ill so often. But she has bought a lot of clothes for the children."

Sociability through visiting thus seems to be regarded as totally engaging, as a specific activity that excludes everything else. This means that women seldom work together. There is sociability in women's cooperation and help with child care and in men's repair work, but not much work-activity in sociability proper. The constraints apply more for women than for men. The home is her main workplace and his place of rest. Besides she seems to be more responsible not only for the state of the home but also for the proper treatment of visitors. She is the master of ceremonies. Men are, in these matters, regarded as more irresponsible and excusable by women.

The contradiction between visiting and handiwork is related to the idea they have of what it means to relax. To relax *(å slappe av)* is a much used expression. To relax means to do nothing useful; it is the opposite of work. Urban industrial society implies a division between work and free time for the workers. To relax is the opposite of the drudgery of paid work. The meaning is slightly more activity-oriented when talking about holidays. But the main social implication of relaxing is to sit down and do nothing immediately useful, preferably in good company and, during weekends, with a drink or two. It is connected with the activity of sitting and preferably talking. (Relaxing is of course also connected with lying down, sleeping or resting, but such activity is more solitary than social.)

The exclusion of work from social encounters with friends has some exceptions. Good friends may, for instance, go to each other's place to borrow the sewing machine to make their pants tighter or to mend something. Other things they do together is, for instance, to borrow each other's nail polish and decorate their

163

nails. Or they may try to fix each other's hair. Once I saw Irene and Sissel trying to fix (without result) the taps in Sissel's kitchen. This was improvised on the spot and did not last longer than a few minutes.

Since housework is mainly done in the morning, they have to strike a balance between duties towards husband and family and sociability with friends and neighbours. With increasing familiarity in the relationship they may sometimes do a certain minimum of work even after a visitor has arrived. When I came visiting the women in the morning, they were often doing their housework. Ellen might, for instance, be doing the dishes. When I arrived she insisted (against my protests) on sitting down with me at once. She left the dishes unfinished, made coffee on the coffee percolator, and sat down at the kitchen table with me, rolling herself a cigarette. After an hour or so of chatting in this way, she would perhaps get up and finish the dishes (and if necessary do some preparations for dinner) while continuing the talking. In this way she expressed both that she enjoyed my coming to see her (by leaving her work) and some familiarity in our relationship (by resuming work after some time).

If the women were vacuuming, they would sometimes ask me in an apologetic way: "I have just one room left. It only takes 3 minutes. Do you mind if I finish this first?" When the room was finished they would sit down, drink coffee, smoke and chat. Most things that they have planned to do they postpone, if possible, when they receive visitors, for instance cleaning the whole apartment or washing and curling their hair. One thing that cannot be postponed is doing the laundry in the common laundry room. Some women have private automatic washing machines in the apartment, others use a common laundry room. Then they have to book specific hours and use the machines then. They try to avoid making appointments on these days, and if somebody turns up, she will have to wait while they go up and down to the basement to put the clothes in and out of the machines.[1]

The main activities of their coffee klatches are chatting and taking care of children. Being available for the children structures their contact and sociability with each other.

More formalized events in the homes

If a visit is agreed upon beforehand, the serving is more elaborate, but still the event most often has an informal character. On Friday and Saturday nights a visit often turns into a party *(fest, gem)*. A meal consisting of sandwiches, rolls, a stew, a soup, cutlets with potatoes and vegetables etc. may be served. But what really makes the difference is the consumption of alcohol.

Most elaborated are special occasions and anniversaries *(dager)*. Birthdays are celebrated, especially when one turns a round number of years. In some families a few guests are invited, in other families nobody is invited but "everybody" turns up. The timing is often late afternoon (about 6 o'clock) or evening (8 o'clock). Nicely decorated open sandwiches are served with a good tasty morsel, like roastbeef, ham, smoked salmon and scrambled eggs. A (ready-made) marzipan cake is served after the sandwiches. Both the sandwiches and the cake are bought from a good bakery. The marzipan cake is called "white lady" and is an important element of local Bergen culture. They serve coffee and perhaps liqueur to drink. Afterwards long drinks and fruit may be served. This ideal pattern is often modified in the early stage of life when they have a strained economy.

Sometimes anniversaries are celebrated with dinner and dancing in a restaurant, especially by the parents of the present sample, because this solution is more expensive. The hosts have to pay all or most of the expenses. Beate's parents celebrated the combination of their wedding anniversary and her mother's 50th birthday by inviting a few people to dinner at one of the best dance restaurants. The guests included their two children with their spouses and some of their best friends, two couples. Altogether the party consisted of 10 persons. Neither Beate's mother's nor her father's siblings were invited. "I will put it in the paper that I am going away *(bortreist)* on that day". (In Norway there is usually a little notice in the newspaper about everybody who has a round number birthday from 50 to 100. Prominent persons get more text and a photograph.) "I am not interested in inviting my brother. I have very little contact with them. Last time I saw my brother was a year ago."

The hostess will pay for a cocktail, full dinner, and coffee "with

a drop of something". Any long drinks afterwards the guests will have to pay for themselves.

When Nils, Beate's husband, celebrated his 30th birthday, they did it a bit differently. Sandwiches and cake at home, dancing and drinks at a restaurant, and then *nachspiel* back home, with stew and beer. What was consumed in Beate's and Nils' home was paid for by them. What was consumed in the restaurant was paid for by the guests.

Sissel and Ellen invited only close family and in-laws for their 25th birthday. One of them served coffee and ready-made sandwiches and marzipan cake. No drinks. The other prepared the sandwiches herself and also made the cake herself.

Birthdays, both for children and grown-ups, are more fully celebrated than marriage anniversaries. A marriage anniversary seems primarily to be the concern of the couple themselves, and perhaps close lineal relatives, unless it is a 10–25–30–40–50 years' anniversary, which may be celebrated by giving a party. Children's birthdays are celebrated with parties for children in the afternoon. Sometimes adult relatives and friends also participate.

On birthdays the guests bring presents. The presents are important. "What did you get for your birthday?" is as appropriate and natural a question after such a day as the question "What did you buy to take home?" is after a holiday abroad, or "What did you get for Christmas?" is after Christmas. Material objects play an important role in social relationships, both as gifts and loans. A greater number of objects seem to be exchanged here than in the middle-class circles that I know of. The young women often borrow both clothes and household utensils from each other. Especially for big occasions, like a wedding or an anniversary, objects are given and borrowed. A woman who is invited to a wedding may, for instance, borrow a long dress or accessories from a friend.

The circle of relatives, friends and neighbours who are potential visitors is relatively wide. Those who come regularly and often are fewer in number.

On birthdays and great events in the life cycle: baptism, confirmation, weddings and funerals, the core group consists of close relatives plus a few friends. The bond between parents and children is close and enduring. Bonds to grown-up siblings and other relatives are somewhat more a matter of choice.

166

The sewing circle

Sewing circles (with or without sewing or other kinds of handi-work) apparently occur more often, it seems, in Bergen than in other Norwegian cities. In some regions they have voluntary organizations, like women's missionary organizations, which, in addition to an idealistic purpose, have some of the social functions of a sewing circle. The Norwegian word for sewing circle is *klubb* or *syklubb,* which means club or sewing club. The *klubb* in Bergen is a circle of female friends who decide to meet at regular intervals, for instance one evening every other week, in each other's homes. The purpose is just good company, getting together. Participants number from 5 to 8. Often the sewing circle is started by childhood friends or friends from adolescence when they marry and settle down in different parts of town. When there is no longer a com-mon institution that brings them together (school, neighbourhood etc.), they create one, to be able to meet and continue their friendships. The practice exists in both upper-class and lower-class milieus. I do not know when this practice developed. The word does perhaps suggest that this is an upper-class practice that has spread to wider social circles. Sewing circles and similar practices of everyday life are, unfortunately, not the kind of topic historians until now have written dissertations about. Sewing circles have, however, existed for at least several generations. I learned, in my earlier fieldwork, that going to the sewing circle was one of the few self-centred leisure activities a wife could legitimately lay claim to. Once every fortnight she had the right to "get away and chat" with her friends. The self-centredness of the activity resides in the fact that it is not combined with and structured by child care. She had the right to be replaced (by husband or relatives) for this activity. The handiwork that was often done while chatting was one way of modifying the self-centredness, of making the occasion somewhat more "useful".

Providing a context for meeting old friends after having become a wife and mother may be one possible origin of the practice of the *klubb.* But this is not the only way a *klubb* may be established. A *klubb* can also be established to create new relationships rather than to provide a context for the maintenance of old ones. Two women may, for instance, decide to create a *klubb* and each bring a few friends, sisters or sisters-in-law. Sisters and sisters-in-law

may be added to an existing *klubb*. Some *klubbs* last a whole lifetime with no change in the membership; others lapse completely or the membership changes over the years. Most of the urban mothers of the young women participate in one or (in one case) two *klubbs*. They differentiate between *klubbs* of childhood friends, *klubbs* of cousins *(kusineklubber)*, *klubbs* of sisters and sisters-in-law, and *klubbs* formed by the wives of the husband's buddies. In this way not only women who have grown up in the city but also those who have moved into it often participate in a *klubb*.

The *klubb* I participated in during fieldwork was originally one of adolescence friends. Elisabeth, Sissel, Ellen, Kirsten and Rose Marie all went to school together and decided to create a *klubb* when they started to marry and have children. After some years Rose Marie decided to quit; she was "frozen out" when the relationships between her and especially Ellen and Sissel deteriorated. They were neighbours at the time and visited each other often for informal coffee klatches. Now Rose Marie is in a new *klubb*. A new member was added to the *klubb* by Elisabeth. She had found a good friend in her new neighbourhood, Beate. Beate came to know the others through a few private parties and was allowed to join them. During fieldwork Kirsten quit the *klubb* for a period, because of a conflict between her and Sissel. Later Ellen left the *klubb,* partly because of the difficult working hours in her new job as a waitress, and partly because of a conflict between her and Sissel.

In this *klubb* nobody ever did any handiwork, but I heard both other young women (Mette, Mona, Audhild) and older women say that in their *klubbs* they sometimes do handiwork, sometimes not. Handiwork is not economically useful in the same way as before; it has become more of a hobby. And it does not seem as necessary as before for a woman to gloss all her activities in terms of their usefulness for her family or for other people (charity).

The members of the *klubb* meet at fixed intervals in each other's homes. They follow a rotation system, so that all members are hostesses in turn. Tuesday and Wednesday are typical *klubb*days. Women dress up a little for going to the *klubb*. They arrive in a nice and tidy home and are served a meal. What is served depends on the life style and the traditions of the particular *klubb*. There is often a concern not to make the meals too expensive. The stereotype of a bad club is one where "they do nothing but gossip"

and where the members "assert themselves by serving better and better quality food, driving the expenses up."

In the *klubb* I became familiar with there was one serving of food that consisted of sandwiches, a warm stew, meatballs or the like, along with coffee and water or juice. After the main course, a dessert or cake was served, and then some snacks, for instance potato chips, sweets and fruit. In other *klubbs* soda water is served instead of water or juice, and the dishes may contain meat instead of ground meat and sausages. Wine and other kinds of alcohol are normally not served in working-class women's *klubbs*.

Like the morning coffee klatches the sewing circle provides a forum for women to talk and develop understandings of their own. Some of their strength in relation to their husbands derives from being able to talk things over and arrive at common points of view. If the *klubb,* for instance, decides to go out to a discotheque or a dance restaurant together, it is difficult for a husband to object.

*Klubb*friends are also expected to care about each other's well-being. This means for instance giving gifts on great occasions like childbirth and sending flowers when in hospital. In the *klubb* in which I participated only close friends, not *klubb*friends *per se,* gave gifts on birthdays, but on childbirths they pooled together money for a present. I know about old women in Bergen whose most faithful visitors in hospital are old *klubb*friends. In "my" *klubb* flowers were sent off several times when one of the members was in hospital. Kirsten went to hospital twice during my field-work. The first time she only got flowers from one individual *klubb*member but not from the *klubb*. She found this very disappointing. The reason she did not get flowers the first time was that Christmas came in between one *klubb* evening and the next, and she was thus forgotten. She told Elisabeth (who had given the flowers), and the next time she was remembered by the whole *klubb*.

A *klubb* is an organized group with limited and, at any point in time, fixed membership. The *klubb* is a whole "package" of friends, some close, some less close. What happens in the *klubb* is to some extent shaped by the relationships its members have outside the *klubb*. Some of them are "real" friends in the sense of being close, seeing each other often, and confiding in each other. In my *klubb* Elisabeth had a key position, since she was close friends with both Beate, Sissel and Kirsten. Ellen's position was

more marginal, since she was only a close friend of Sissel's, and when this relationship lapsed, she became even more marginal. One of the others said: "Ellen has never been a friend, only a *klubb*friend. We met in the *klubb,* that was all." This quotation illustrates the idea of "real" friendship. "A real friend is somebody you can confide in, who does not repeat what you have told her."

Who become friends?

Close friends are important for sociability and company and for emotional support. Friends belong to the broader category of people who "fit in" with each other. (See chapter four.) Women choose their female friends on the basis of likes and dislikes. Friendship is a voluntary, personal and dyadic relationship between two partners. Some stages of life, domains and occasions are however more favourable for the formation of friendships than others. And not all friendships are chosen in dyads. Some come in a "package", like a neighbourhood clique or the members of the sewing circle, who are not all equally close. Adolescence is one stage in life that seems particularly important for the formation of friendships in Norwegian society. Several of the friendships between the women of this study date from this period. The women with a rural background have had to leave their friends and start anew. Friends, neighbours and other acquaintances from childhood and adolescence seem to give the urban women a larger pool of people to draw on. Most recent comers do, however, have a few initial relationships to draw on. Both Asbjørg and Audhild, for instance, have sisters in Bergen, and Asbjørg and Audhild themselves are adolescent friends who happened to meet again in the same neighbourhood.

Friends are also recruited from different fields of activity, like neighbours, colleagues, people one meets when "going out", schoolmates, relatives and the like. They also seem to have a limited age range. One's friends are generally of one's own age, plus or minus five years. Relatives and "very good neighbours", who sometimes join in the coffee klatches, may be older than that, but generally friends are of one's own age. This is an expression of a generational gap. The women of this study have to cope with

different problems from the ones of their own mothers. There is both closeness and concern between the generations, but also distance and avoidance of certain matters. The young mothers cannot speak freely to their mothers about choices that they make concerning, for instance, abortion, "going out" (see the next two chapters), or taking a new job. In the beginning of my fieldwork I was often amazed by all the activities that I heard some young women did together with their mothers, just as if they were friends. Taking driving lessons together, going to a weight-watchers' course, and going to the movies together are a few examples. After some time I was, however, struck by how little the mothers visited their daughters, and how little they figured in the daughter's conversations. Complaints about mothers-in-law are more common than talk about mothers. At the most they would sometimes sigh a little: "My mother is nagging me all the time these days" *(min mor maser sånn om dagen)*. And then somebody would answer "Is yours nagging too? So is mine!" I understood that the daughter visits the mother more than vice versa. There are both strains and loyalty in the relationship. The mother's avoidance of her daughter's home seems to have several reasons. One is not to threaten the precarious autonomy of her young household. Another is that the mother wants to avoid her daughter's friends. Several mothers complain about all the friends gathering at their daughter's place: "I can never go over to her place. The place is full of people and the air is so polluted by cigarette smoke that you could cut it with a knife." *(Huset e' fullt av folk og luften e' så full av røyk at du kan skjær 'an.)* The kitchen-table society of friends is, to a large extent, a generation-specific social organization for the solving of generation-specific problems.

Another question is whether there is stability or a high turnover in friendship circles. Stressing the importance of friends from childhood/adolescence makes the picture more static than it is. There is a characteristic mixture of stability and flexibility in their friendship patterns. In the core of the friendship circle of any person there are always several persons who have been there for years, often from childhood or adolescence. That is the stable part of the pattern. At the same time there will be one or several persons who have not been friends for very long. One may quickly get on intimate terms, if conditions are favourable. There is not necessarily a long stage of slowly getting to know each other. In the

beginning of a friendship there is sometimes some instrumental reason. Beate, for instance, got a *dagmamma* for her son in the neighbourhood. She knew about the woman beforehand, but did not know her well. Now that she is the *dagmamma* of her son, she has become an important person for the family. Beate likes to talk to her after work. When Beate had her 25th birthday party, she invited a few relatives and old friends plus the *dagmamma* and her husband. She has thus entered the inner circle. Time will show if the relationship they develop will survive after she no longer takes care of Beate's son.

Sissel and Elisabeth both developed a few new intense friendships at the trade schools they went to. Kirsten became for a while very good friends with one of the young employées at the daycare centre attended by her children. The young girl was childless and unmarried and for a period often went out to dancing places together with Kirsten.

The women in this study meet two and two together and also in larger groups of five or six. Their fora and social occasions explain to some extent the structure of relations and the flow of information. There is a certain tension between close intimate friendship and gathering in larger groups like the *klubb* or neighbourhood cliques. The *klubbs* play a crucial role in the way networks are connected and the kind of information flow and information control that is thereby possible.

Each individual has her own circle of friends, childhood friends, neighbours, colleagues, drawn from different periods of life and different domains. The *klubbs* create clusters in ramifying social networks and a tendency towards partly overlapping friendship circles of different individuals. Social networks are relatively loosely knit, with some clusters and overlapping membership.

As between a mother and her daughter's friends, there is some tension between a husband and the friends of his wife. Husbands know the best friends of wives and vice versa. But since they participate in different fora, they do not know all each other's acquaintances and friendly relationships. Men in this milieu seem more easily to lose friends (other than own relatives and workmates) as a result of a divorce than middle-class men do. In middle-class milieus more of a couple's circle of friends are often organized around his profession, and she is often the one who loses friends in the case of divorce. By contrast, in the milieu described

in this book, if several couples are mutual friends, the wives often stick together and the men disappear in the case of divorce. Elisabeth's Georg, for instance, complains about losing his buddies when they divorced, because the women stick together. "Since they come here their former husbands won't." This is one demonstration of the crucial role of women in these domains of life. The women influence very much of the family's social networks and style of life.

Just as friendships may start quickly, they may also cool off quickly. Many friendships cool down and lose importance in a quiet and undramatic way because the partners get new interests or the comon interests that have united them lose importance. Sometimes one of them may feel "not good enough any longer", sometimes they both have other things to do. Once in a while a friendship may cool off more dramatically, because of conflicts and disagreements. Some conflicts lead to a permanent break, others to a more temporary cooling down. What creates problems and conflicts in a friendship is related to what is considered its good and satisfactory functioning. A bad friend is someone who is not loyal, who is not supportive, and who repeats what you have confided to her. (I'll come back to conflicts later, in chapter eleven.)

Some problems in friendship relations are related to the dilemmas between prestige and equality, between individuality and community. A woman may be "frozen out" because she is considered "too domineering", she "tries to assert herself too much". Such criticisms are very often heard: "If you have been ill, she has always been more ill. If you have achieved something, she has always achieved much more. If you have had your first driving lesson, she has been driving privately for years!" Certain direct ways or asserting oneself by comparisons and by claiming prestige are banned. Asserting oneself is communicating "being better" where one should have communicated equality as sameness. Joviality, not self-assertion, is expected in personal relations.

Another way of not acting according to the unwritten rules is to be clinging *(innpåsliten)*. The clinging one does not know the balance between closeness and distance, she violates the autonomy and ritual space around each person and thereby becomes difficult. People may sometimes seem rather merciless in the way they treat individuals considered assertive or clinging. They are

"frozen out" *(frysse ut)*. To "freeze out" is to exclude from close social relationships.

Conclusions and comparisons

Informal visiting and more formalized occasions in the homes set the stage for much sociability between friends and relatives. It is on these occasions that the home is displayed to persons outside the family that lives there. The importance of visiting in the homes is thus one more factor that explains the importance of home decoration, of having a nice home. The visitor shares the warm, cosy, comfortable atmosphere of another home. At the same time the ritualizations and routinizations of visiting are markers of boundaries between families. The woman has the ceremonial responsibility for receiving visitors properly, but this task is relatively simple compared to more formalized representative upper-class sociability.

The visiting among women at the times when their husbands are at work provide them with fora and occasions to form and develop friendships and thus to form and develop some shared understandings and strategies. Several factors may explain how the women's visiting patterns come about. Sociability is highly valued. They do not look down on chatting in coffee klatches as many middle-class women and also some older working-class women do. Their socialization techniques and housekeeping standards do not prevent them from combining child care and sociability with friends. Having mostly part-time paid employment, they have the time and occasion to meet when their husbands or male friends are at work. Those who work full-time in paid employment see their possibilities of meeting female friends outside work reduced (but often their possibilities for sociability with colleagues become much better). On separation or divorce, opportunities to receive visits from female friends increase. When there is no man in the household, a women disposes of the home more freely at all hours.

Normally visiting between women involves few activities other than a combination of taking care of children and talking. But talking is important and has numerous meanings and functions. Talking is an exchange of information that makes some exchange of goods and services possible. Talking is emotional support and

negative sanctions. Talking is intellectual work and creation of culture. In later chapters the moral dimensions of women's talking will be more thoroughly examined (chapters eleven and fifteen).

Informal visiting, especially in the evenings and at the weekends, may be compared with other kinds of leisure-time activities. Informal visiting as a social practice seems to be more important here than in other social circles. Generally Norwegians and Northern Scandinavians are known for their love of nature, both when going for walks in the "wilds" and when working in the "tamed" nature of their gardens.[2] Our royal family provides a good illustration of this. A new monument of King Olav V, for instance, shows him out on skis with his dog beside him. Such foci and occasions for family life during weekends play a greater role for middle- and upper-class people than for the people of this milieu. The long family Sunday walk in the woods, a typical urban Norwegian institution, is, for instance, to some extent a middle- and upper-class pattern. My informants often take shorter walks, in the suburbs rather than out in the open terrain. Both status group and stage in the family life cycle (having small children) explain the difference. It is not as easy to take the children on long walks when they are very small. The urban parents of the young couples are somewhat more active lovers of nature than their grown-up children. Several of them have small cabins with tiny gardens. But they are not as active as some upper- and middle-class Norwegians.

The generation of their parents also seems to be somewhat more active in different kinds of organizations. Participating in organizational life is also connected to status group and stage in the family's life cycle. These activities lead to much social contact.

The importance of informal visiting and other occasions in the home is also one more reflection of the home-centredness of Norwegian culture. Public fora to meet friends and relatives are few and far between in the neighbourhoods. One mostly finds public fora in the centres of the cities. People often find it too expensive to eat or drink in such establishments. Taxation and labour laws make eating and drinking out expensive. But since wages are also relatively high, this cannot be the only reason. The relative scarcity of public fora like pubs and restaurants is probably caused by late urbanization, as well as the home-centredness of Norwegian culture, and pietist religious attitudes.

Discotheques are, however, a new kind of commercial public fora which seem to be expanding and growing in importance in the cities. In the chapters to come I examine different fora outside the home, first paid work and then going out to discotheques and public dance places.

9. Paid employment

In today's western urban setting, a household's main income comes from paid occupational work. Normally one or more of the members have periodically to go "outside" the home and work in order to provide money for the family. This applies especially to households with an adult male. Households without a grown-up male may, in Norway, live on social security payments provided by the state. In terms of paid employment for women, Norway has until recently been one of the countries in industrialized Europe with the lowest participation of women in the paid work force.[1]

During the last decades considerable changes have taken place. According to Social Survey, 1980, the percentage of employed females was 53% in 1972 and rose to 65% in 1979. (All persons who have at least one hour's paid occupational work in one specific week are recorded as employed, together with those who are temporarily away from work and those who are registered as unemployed.) The number of persons employed has, however, risen more than the amount of work hours. The tendency is to divide occupational work between more persons. Part-time work for women has risen. In 1979 43% of the employed women worked 30 hours per week or less. (Social Survey, 1980.)

The labour market is segmented, and most of the women in the labour force have unskilled and low-paid occupations. It is generally easier for women to find paid work in larger cities than in other places. Paid employment for women is highest in the largest cities, Oslo, Bergen and Trondheim, where 71 % have some kind of (mostly part-time) paid employment (Social Survey, 1980).

Participation in paid work has risen for all married women, but less for young mothers with small children than for other age groups (Social Survey, 1980).[2] The women in this study confirm this tendency of rising employment for women. Being in the youngest age group and having the youngest children they may be

177

regarded both as pioneers in their age group and as illustrations of general tendencies.[3]

All the women of this study have, at least periodically, some income from their own work. Both men and women have paid work, but its content and meaning vary between the two sexes. One reason is that men and women operate on different segments of the labour market.

In Appendix 2, page 337, I have listed an inventory of occupations. The occupations of both the young women themselves, their husbands or steady male friends, their fathers and their mothers are listed. From this inventory one learns that the young women are today employed as *dagmammas,* charwomen, home-helpers, office clerks, waitresses, sales girls and the like. They all have more or less unskilled or semi-skilled work in service occupations. *Dagmamma* work (child care) is paid, but not a part of the ordinary labour market. It exists on an unofficial labour market, the wage is not registered, and it is done in the home, literally an extension of work at home. The other occupations can, however, also be described as extensions of the housewife role: cleaning, serving and selling of food, and care taking. The occupation of an office clerk is a little different; it necessitates some training, but it is also firmly established as a typical female occupation. The women all have typical female occupations. They enter a segregated labour market where the jobs they get and look for are gender specific: the gender of the incumbent is more or less implied in the definition of the positions. These are often assistant jobs in an occupational hierarchy. No women are foremen or self-employed (if one does not choose to call being a *dagmamma* a way of being self-employed). After fieldwork was completed, however, one woman became a self-employed delivery truck driver for small goods, using a small station wagon.

The variations in men's occupations are considerably greater than those between the women's. They are both skilled and un-skilled, mostly unskilled, in traditional crafts, industry, service occupations, and self-employed as truck- or taxi-drivers, manual blue collar workers, and white collar sales clerks, foremen and not foremen. These distinctions do not make too great a difference in the networks of friends and acquaintances, in the status group aspect of their lives. What is similar between them (and this goes also for the women) is a relatively low amount of schooling; similar

178

educational level and occupations that correspond to this level along with income and the life style that the income allows for.

Between women and men there is an important distinction between working full time or part time. Men always work full time (or are unemployed), whereas most, but not all, of the women work part time. And men generally shift place of work less often than women at this stage of the family's developmental cycle. Because women's wages generally are lower, and because they work fewer hours, the women earn less than their men. The men earned (1979) from 5 000 N.kr to 7 500 N.kr per month before taxation. Some did not earn the same amount every month. The women earned 4 000 N.kr per month as full-time office clerks, 1 500 to 2 200 N.kr gross per month (depending on number of hours) as part-time cleaning women. The *dagmammas* earned 800 N.kr per month for taking care of one child on all workdays.

Men and women have had different careers since they finished the 9th obligatory year of school. After about the same amount of schooling, the women have become mothers very early and in most cases got married. Their men have gone through apprenticeship or a "trial and error" period on the labour market and then found a (more or less) stable adaptation to the labour market or become drop-outs, social cases. The women have to combine work and motherhood and thereby adapt differently to the labour market. They generally change work often when the children are small. From the point of view of employers, this may seem unstable. From the point of view of home and social network it may be seen as flexible. Some examples of occupational careers will further document these differences between men and women:

Harald is a painter. After 9 years' schooling he went into apprenticeship with a big firm in town. After apprenticeship he changed to another firm and has worked there since (approx. 7 years).

Kirsten, who was married to him, worked for a few months as an office delivery girl in a journal after her 9 years of obligatory school. She did not like office work, so she changed to sales work in a grocery store. She did this for half a year, but quit because they did not allow her to weigh or touch the cash register. Then she was at home for some time to help her

widowed mother. Her father died and her mother was very depressed. Then she worked one year as helper in an old people's home, until she had her first child. After her child was born, she was asked by the friend of a friend to be *dagmamma* for her 3-year-old boy. She did this for one year. Then she moved to the suburbs. She was without paid work and stayed home for two years because she remarried and had a second child, "... walking restlessly back and forth in the apartment *(jeg gikk bare og slang i dørene)*. I tried to get paid work, but could only get cleaning jobs. I wanted something that gave credits to get into the one-year nurse assistant school." She has applied for the nurse assistant school for many years, without being accepted. Finally she got a part-time job as a cleaner in an old people's sanatorium. Cleaning, when done in a sanatorium, used to give qualifying points for the one-year nurse assistant school. After half a year of cleaning, she was allowed to do assistant nursing. She did this for one year, but had to quit because it was shift work with very difficult work hours. Her husband was a locally famous sportsman, so she could not count very much on him at weekends in the season.

Then she separated from her husband and had a part-time job as home help for old people. She worked from 10 a.m. to 2 p.m. four days a week. Her children had been accepted at a nearby daycare centre, because she was a single mother. She still wanted to go to school to become an assistant nurse, but they have lately changed the rules, so her practice counts even less. If she is to be accepted, she will have to do half a year of domestic economy first. She will probably do this. As a divorced mother she has income from social security. Her social security payments are reduced somewhat because of the wage she earns as a home help, but her total income is higher. Going to school will reduce her income somewhat. Since she is alone with the children, having a job in the daytime did not change her social life with female friends. Female friends may come and see her on the day she does not work and all afternoons and evening.

Georg had 9 years of schooling. Then he started an apprenticeship as a carpenter. When one does not take the vocational school training, one has to have five years' apprenticeship. He did not go through all the five years, so he has no certified qual-

180

ifications. Next he worked in a transport firm, then in construction work, and now for the last 4–5 years he has worked in a small industrial concern, the last year as a foreman. He is satisfied with the organization of work – they work in self-directed groups. He also has a relatively good wage. But what he really wants, he says, is something more creative.

Elisabeth. Elisabeth is married to Georg. After the nine years of obligatory schooling, she went to trade school, but quit after a short time. "I believe I got tired of the whole idea of schools." Then she was an office girl in a private firm before she changed to industrial sewing. (Bergen and surroundings have several textile industrial concerns.) She did this until her first child was born. Then she stayed home for one year before she started cleaning an office from 4^{30} to 8 p.m. She went to work every day a little before her husband came home from his job. She did this for 4 years, with little more than the paid leave of absence (3 months, now 4 months) one is allowed for childbirth, when her second child was born. In addition to this she also often worked in periods as a child minder when a friend or a neighbour asked her. At the end of this period she got a gastric ulcer and attributed it to the stress every day when she had to leave before Georg was home. She had to trust a *passepike,* a neighbouring girl of about 12 years of age, with the child care. She also wanted the home to be absolutely spotless and dinner ready before she left.

Before she got the gastric ulcer she also went to an evening class for typing once a week, after doing her job. She had started to think of getting a full-time job as an office clerk. She quit the cleaning job after a period at home because of illness. She then applied for several jobs as an office clerk. It proved to be difficult. Through one of her mother's connections, she was admitted to a half-year course for office workers administered by a state agency. After this course it was still difficult to get a job. She had no practice. At last she was employed full-time for a short period by a state agency. The period was extended and extended again. After a year she was given a permanent position. She types, answers the telephone, keeps the files in order, and so on. She will probably stay in this agency and perhaps advance inside it. She thus seems to have passed the

shifting but flexible period of child rearing and found a more permanent adaptation to the labour market. Her social life has been changed by getting a full-time job. There is much less time to attend coffee klatches with friends. This part of her life is obviously impoverished. Instead she has acquired colleagues of both sexes and with different positions at the workplace. Her social surroundings are more varied. She has learned more about society through the organization of work at her workplace. At the job there are sometimes parties, and she also, once in a while, has to go out of town for several days to take special courses related to her job. This gives legitimacy, in relation to her husband, to acting on her own in new ways, and a new extra focus of her life.

Asbjørg. Asbjørg grew up on a farm in the countryside several hours' journey from Bergen. She has eight years of schooling. Then she worked for one year as a maid in a smaller town closer to her home. She did not like the job. "She, the lady of the house, was, let me say, a little bit pedantic." Then in one year she had two different jobs as maid in another smaller place. She liked the first job but not the second. Because she had a female friend in the nearest city she moved over there, and was a maid for four years in one family. She liked the job very much.

When she was with them, she got pregnant with her first child. She did not marry, but quit and went home to the farm when the baby was born. After half a year she left the child on the farm and went to Bergen. The first 1½ years she worked in a spinning factory, threading the machine making crimpelene material. Then the company went bankrupt. For a period she was without employment and stayed home at the farm. Then she got a new job in Bergen, in a factory, making paint. She labelled the boxes. "The work was boring, but not too bad. It was nice to work together with men instead of women." She quit a few months before her second child was born. At about the same time, eight months pregnant, she married and also brought her first child from the farm over to her new home. After this she has only had a one-month cleaning job. "I did not have the conscience to leave the kids, because my husband, who was supposed to look after them, used to disappear and go drinking downtown." A third child was born and the husband left her to live

with another woman. She and her children now live on social security money. Once in a while, when somebody asks her, she is a *dagmamma* for periods. The benefit of this income is that it is unregistered and not taxed, nor is the social security payment reduced. The drawback for her is that "you need a lot of energy to do that when you have three kids yourself to take care of."

Asbjørg's former husband is a skilled printer, who lost his job because of drinking. He worked some time in different jobs as a welder, but lost these jobs too and is now unemployed. He has a child by the woman he lives with.

These occupational careers show that there are some occupations that the women had before or shortly after their first childbirth, that they do not take up again. There are also some career differences between the urban and the formerly rural girls. Some of the urban girls have been office girls as their first jobs. The two rural girls have worked as maids and then as industrial workers before they became mothers. To be a maid is confined to status as a single person, and also, to a large extent, in today's Norwegian society, to adolescence. To be an office girl or boy is also clearly an entrance job for adolescents to the labour market. None of the women are looking for industrial work at the moment. The urban girls, with the exception of Irene, have only done sewing. The (formerly) rural girls have done varied kinds of industrial work. Industrial work is better paid than the jobs they now have. The reason that they do not seem to consider industrial work as an alternative is only partly because few of them look for full-time work, but mainly because industrial work, with the exception of sewing, is considered too rough. The urban girls seem to be more reluctant to do industrial work than the rural girls. Their role models for femininity seem to imply less rough work than the rural models of mothers who also did farm work. This interpretation is supported by Synnøve Aga's labour market research, (Synnøve Aga, personal communication), which suggests an "office clerk complex" among urban working-class women.

Irene, the Marxist-Leninist art student, is not really "one of them". She has worked at several places as a full-time industrial worker and been fired because of political activities that "disrupted the workplace". She has also worked as an electrotechnician. Her case is an exception and a contrast, because she took up

this work for political reasons. During my fieldwork she audited for one year at an art school, and this also clearly makes her different from the others.

Part-time cleaning seems to be the most important re-entrance to the labour market after becoming mothers. Those who can will try to get jobs they consider better, for instance as canteen helpers, serving food in hospitals and so on. There seems to be an ideal succession in the kinds of employment they have, from cleaning to work as office clerk or assistant nurse.

How jobs are passed along through personal relationships

What characterizes very much of the women's paid work is that jobs are to a great extent passed along through personal relations. In this milieu *dagmamma* jobs are mainly arranged through the social network, and more seldom through advertisments in the newspaper. When a mother wants somebody to take care of her children, she looks around in the neighbourhood, talks to friends about their connections, and then asks a woman about whom she has at least a little bit of information. This is contrary to the mass media image of *dagmamma*. In the media's image she is recruited impersonally through advertisement, as if to imply how poor a substitute she is for a mother. But more working-class than middle-class women work as *dagmammas;* so middle-class people without connections in the working class often have to recruit somebody to take care of their children in this impersonal way.

In this milieu not only *dagmamma* jobs but also other jobs are arranged in one way or another through networks of personal relationships. Charwomen, for instance, are almost always recruited by one woman asking on behalf of or leaving her job to the next. Mona got her job as a cleaner through her mother, who was already working in the same institution. Audhild got her job when her sister left it for an even better one. Women tell each other about their jobs and act as employment agencies for each other. Often they are also recruited through men in their personal networks. This recruitment is most often from one person "on the floor" to the next. They give each other information about possi-

ble jobs, and whom to address. In some cases they ask on behalf of each other. It also happens that personal connections are in a position to recruit, like the owner of a small grocery store.

There are also several examples of men recruited in this way. Men inform each other about jobs and speak for each other. But it does not seem to happen to the same extent as for women. The reason seems to be that men's careers have a stronger dynamics of their own, which to some extent overrides possibilities through networks of personal relations.

This means that the work of these women is placed at the point of intersection between personal social relations and the labour market. They enter the labour market in a personal way, and are often asked instead of asking or applying themselves. The reason is not, in my view, a question of passivity, because most of them are really interested in and looking for paid work. Rather, I believe the reason to be that they feel uncomfortable with the impersonal "bureaucratic" way of applying. It is a culture they are not fully familiar with. Elisabeth, before she had taken the half-year course, expressed her feelings before applying for a job this way: "It is so strange. I always become so modest and discouraged. You know all the questions they will ask: 'Have you got any qualifications?' And then there is no answer to give but 'no'." In the more limited context of her own social network she is active and enterprising. In formalized social situations like this she becomes timid, "muted" and powerless.

There is even more of a barrier if one has to make a written application. Working-class culture is partly a way of managing that avoids bureaucratic impersonal contractual relations and the use of written language (Gullestad 1979a).

There are two problems connected with getting employment mainly through the channel of personal relations. One is that those who do not have many personal relations and also feel unfamiliar with bureaucratic culture are at a disadvantage. Two of the women who have moved into Bergen from some distance away (Asbjørg and Eva) have the least amount of paid work. Both have, though, sporadically *dagmamma* jobs, which they were asked to take.

The second problem relates to the fact that not all kinds of employment are obtainable this way, and more choice depends on being able to use all the channels on the labour market. The most

prestigious and desired jobs, as office clerks, require ability to write an application. Beate and Elisabeth both tried many times before they got their current full-time jobs as office clerks. They have both gone to half-year or one-year trade school. Mona got her current part-time job as an assistant serving food in a hospital by making a written application after she learned about the vacant job from a neighbour who already worked there. Mona then asked an aunt, who was an office clerk, to help her write the application.

Identity from paid work

Paid work means different things to men and women, Inside the household economic provision is the man's responsibility and, to some extent, a woman's choice (see also chapter twelve about the meanings of money). It is fundamental for his worth and identity that a man manges to keep a decent job. These are fundamental premises for engagement in paid work and shape the greater importance paid work has for his identity than for hers. In addition to these premises, the content of work determines its meaning for the individual worker. Sociability with colleagues and/or clients, clear standards for evaluating the work, and confirmation when a good job is done are among the factors shaping feelings of one's own worth and identity. Jobs are different, and this makes comparison difficult. There is reason to believe that generally men's paid work gives more such confirmation than women's paid work. Men talk about their work in social encounters. They like to present themselves in terms of their work. Work, cars, and sport seem to be some of their favourite topics.

Paid work is, however, also a part of the identities of the young mothers. When they talk about old friends, for instance, reference is always made to their paid work. How many children, if she is married and with whom, where she lives (what kind of housing), and where she works and what kind of work are the four dimensions usually mentioned. They talk about their workplaces in social encounters, but not as much as men. When they talk about paid work, it is often about relationships to colleagues or clients. One woman may, for instance, tell funny stories about the nice old lady she is cleaning for as a municipal home help, about the nice old-fashioned Bergen dialect she uses. She also tells about the

fantastic handiwork the old lady is doing. Another woman may tell about a colleague office clerk and how many sweets and cakes they both eat during a working day. She may also tell about how embarrassed she was to be the only one smoking at a table in the canteen where one of the directors was also having his lunch.

The women, also those who work as charwomen, usually have some colleagues. That jobs are passed along through social networks means that they sometimes have a relative or a friend at the job. As a matter of fact, only a few, as for instance Ellen, had a really lonesome job. She was cleaning a whole branch bank by herself and had no colleagues. Most often they work in larger institutions with many cleaners. Each has her rooms or a floor to clean, but they usually seem to find some opportunity to meet and chat, for instance by arriving a quarter of an hour earlier than is strictly necessary. These minutes of chatting and being sociable are important for them. Other jobs, like cleaning and serving food in hospitals, cleaning for old people, being a waitress etc. are valued, among other things, just because of the possibilities of sociability with patients, clients or customers they offer. When asked about their wishes, many women want a job "that has to do with people, to help people." They want to interact with people, not only with empty offices or classrooms. The frame of the inter-action does, however, count: few grown-up women today fancy cleaning and cooking as servants in other people's homes. This work profoundly contradicts egalitarian premises of personal social interaction among Norwegians. It is better to be a home help employed by the municipality. Then one is a helper for a disabled individual and not a subordinated servant. The work is to some extent the same, but authority relations and interpretations of the tasks have changed. It is also considered better to be employed as a charwoman at the bottom of a formal hierarchy than submit to personal subordination as a servant.

My informants value assistant nursing and serving food in institutions because this work is less physically hard and more interesting than cleaning.

A job as an office clerk often represents several advantages in this respect. One often has more colleagues, also male colleagues and superiors. Office clerks dress nicely, better than they do at home or as cleaners. They get more time and occasion to have sociability as an aspect of their work. Their work has low rank

within the organization, but it is not necessarily monotonous. It may consist of varied tasks, like answering the telephone, keeping the files in order, a little typing, etc.

There are also fringe benefits like parties and stays at nice hotels to participate in courses in, for instance, "telephone culture", paid for by the employer. Part-time cleaning women do not have such fringe benefits.

Depending on the kind of workplace, men are usually invited once in a while to parties on their job or to courses. Several men seem to have more sociability and get more confirmation as good workers at their workplaces than women (except for the office clerks). There are clearer standards and a public to appreciate what is a nice hair cut or even a nice piece of industrial work than for cleaning classrooms. Cleaning is most often remarked on when it is not done, not when it is done. But since men's work is so varied, their work conditions vary also. Some have a rich social life (including confirmation as a good worker, flirting, exchange of news); other men work in noisy surroundings and relative isolation, with few pauses with colleagues. It did, for instance, strike me in social encounters that men in certain service occupations have an obvious interaction resource because of the information they get at their place of work, both about ordinary people in their own social networks, and about well-known personalities of the city. Cutting hair or repairing cars for other people are activities that engage the service worker in kinds of interaction where information is given both intentionally and unintentionally.

The kind of identity that paid work represents also has to do with prestige. Being an office clerk is a relatively low ranking occupation in society, but a prestigious occupation among friends and acquaintances in this milieu. If one is so clever and lucky as to advance to be a secretary, one has really made it. There are important nuances of evaluation, and many dimensions enter into such evaluations. Cleaning is considered to have the lowest status. This is expressed in different ways. One woman who does not clean says that she cannot understand her friends who work as cleaners. "It is not that I find it humiliating, but I would not like to go off to work when my husband comes home from his work." Some time later this woman got a job at a hospital. She tells her friends that she has become a doctor's secretary. But her friends learned from her colleagues that what she actually did was to clean

the instruments. She is no secretary, she too is a cleaner! They dislike very much what they interpret as trying to put on airs.

Mona had another way of presenting herself when she was a cleaner: "When I go out to discotheques and dancing places and people ask me what I do, I answer charwoman *(vaskekjerring)* or cleaning assistant *(rengjøringsassistent)* as the name is nowdays. I am not embarrassed to tell people that I am a cleaner. Cleaning does me no harm. I like cleaning. I do not feel that it does me any harm!" She also has incidents to tell about other friends who "feel too good to clean" *(de e' for fine te å vaske)*.

In some situations cleaners may talk humorously about their work: "I met Anne Lise from our school class today. She is cleaning, too. She said: 'God help me, everybody in our class has become charwomen *(vaskekjerringer)!*" Cleaning work is thus an ambiguous source of identity. It is decent honest work and a way of "getting away", but also heavy and monotonous, and has a low status among the workers themselves.

Connected with the identity derived from paid work, with the workers' realization of self, is the value of the work for the worker. In this respect too cleaning has fewer potentialities than work as an office clerk. Different kinds of work give different possibilities for learning, for expanding abilities and knowledge. Beate, for instance, became organized in the trade union and also took a course in German, after she became an office clerk. Through the work she developed an interest in learning more and taking on more responsibilities. Most of their paid work, however, and especially cleaning, is too routinized and monotonous to be inspiring and make them develop an interest in the work itself. The barriers to entering other kinds of professions are high, as shown for instance, in the case of Kirsten, who has tried for years to become an assistant nurse.

Conclusions

As we have seen, there are differences of both prestige and potentialities for self-realization in different kinds of occupations. Some differences between kinds of occupations, however, that are traditionally regarded as important do not seem to play a crucial role here as regards the extent to which people have personal relationships outside the workplace and regard each other as equals:

1) The distinction between manual blue collar work and lower white collar occupations.
2) The distinction between industry and service as kinds of work.
3) The distinction between wage labourers and self-employed (with only oneself or perhaps one more person employed) "petty bourgeois" persons.

The common denominator between them seems to be a relatively low level of schooling and not too great differences of income and consumption profile. Income may vary within certain limits, but if the differences in consumption become too great, relationships become more strained (see chapter four). With higher income a family might, for instance, move to better housing and thereby give off signs of being better off (chapter seven).

There are also typical differences between men's and women's integration in the labour market. Men work full-time (if they are not unemployed). Women have different adaptations. Most work part-time, a few work full-time, and a few have no or little paid work. Their occupations differ in terms of possibilities for self-realization and the interest they thereby take in the work itself. Work as an office clerk or being a student (at a trade school) seem to give most in terms of realization of self and getting a new additional focus in life. When they take a real interest in the work itself, they tend to work full-time. Most other kinds of work is part-time. (Being a *dagmamma* is full-time in terms of work hours, but part-time in terms of combination with other activities.)

There are also interesting differences of style at work between the spouses of a marriage. The wife is, for instance, a cleaner while the husband is a salesman, or the husband is an industrial worker while the wife is an office clerk. The ethos and interaction style for the office clerk at work in a private commercial firm are, for instance, very different from the ones of workers on the floor of an industrial concern. The differences between women and men in terms of occupation seem, however, to be smaller than they sometimes may be among, for instance, top leaders, where the husband may be a company director and the wife may have been or is a secretary (but her father is probably also a top leader). When the wife is a cleaner and the husband a hairdresser the difference between them is in some ways analogous, but not so great, as the

one between the company director and the secretary. The difference between an office clerk wife and a blue collar manual worker is also interesting. Being in a service occupation she can be expected to learn and apply more middle-class ways in their life together.

The main conclusions of this chapter are that in spite of the expectations that mothers of small children stay at home, most of them have some, mostly part-time, paid employment; their adaptation to the labour-market at this stage is flexible, considering their other responsibilities; the kind of employment they have is often ambiguous as a field for self-realization and a sign of identity, but also the differences between husband and wife in terms of the class position of their own paid employment are relatively small compared to some other status groups in Norwegian society.

In the next chapter I will examine discotheques and other public dancing places as important fora for the young women studied.

10. Going out: Excitement and moral danger

Going out: The struggle for visibility

Going out dancing in public places is an activity of their own choosing that several of the young working-class mothers of this study engage in. Giving parties and going out to restaurants create variation in their lives, therefore they very much look forward to such occasions and talk about them afterwards. Drinking and dancing also take place in the homes. Going out to discotheques and dance restaurants does, however, especially highlight some general tendencies, since the forum and the roles that go with it are more specialized and anonymity there greater than at parties in the homes. In Norwegian cities the combination of motherhood and participation in public dancing is a new one. Or, to be precise, it is relatively new that women who have borne children go unescorted by men in any numbers to public dancing places. Upper middle-class women married to (or formerly married to) business men or professionals do not usually go to public dancing places without male escort. It is somewhat more common for students and academics who have borne children to go out on their own to public dancing places, but to a large extent this is, so far, a working-class and lower middle-class pattern.

In this chapter I examine what discotheque life consists of, what it means to them and the dilemmas it creates. To visit a discotheque or a restaurant is called "going out" *(å gå ut)*. A discotheque is a place to dance, drink and perhaps eat. The music is "disco" records played by a disc jockey. The place is dark, often without windows. There is often a show of changing coloured lights over those who are dancing. The discotheque is an innovation that arrived in Bergen some 15 years ago, and there are about 8–10 discotheques in Bergen at the moment. In addition there are a number of dance restaurants and dancing bars with live music. The main difference between dance restaurants and dancing bars is that you are obliged to eat in the former whereas just buying

drinks is enough in the latter. Customers of discotheques generally are somewhat younger and have a more youthful style in dress and manner than customers of dance restaurants.

With one exception all the discotheques and dance restaurants are situated in the centre of Bergen. The one exception is a huge new discotheque situated in a suburb containing mostly cooperative apartment blocks and rowhouses.

Codifications of what it means to frequent discotheques, dancing bars and restaurants vary somewhat from one milieu to another and from person to person. As mentioned previously, some Norwegians, especially on the west coast around Bergen, look on both dancing and drinking as temptations of the devil. They never visit such places and never engage in such activities. Among the women of this study there are some variations in attitudes towards alcohol, giving parties and going out. None are teetotallers, but a few, like Audhild, are more restrictive than the others. Audhild says that she and her husband drink, but never very much, and that they seldom go to parties. "We do not like drinking and party-going and such nonsense. We like to have a cosy time at home." *(Vi likar ikkje festar og dill dall. Vi likar å kose oss heime.)* These variations exemplify general variations in Norwegian working-class attitudes. Most of the women of this study and their friends and relatives do, however, hold more positive views of restaurants, discotheques, dancing and alcohol. I give the following description of their attitudes and activities knowing that not all working-class people of Bergen are like them, but that they represent what seems to be a typical and growing trend. New discotheques are constantly being established, even in the suburbs where families live, and they do not seem to lack customers.

Most of the mothers of this study thus visit discotheques, dancing bars and restaurants once in a while, and some use them more often than others. Motherhood, marital status, and the content of the marital relationship seem important in explaining the variations. Unmarried, separated and divorced men and women, if they do not have a steady girl/boyfriend, can be expected to use such places most often. Some go out as much as two or three times a week, several go once a week, for instance every Saturday or every Friday. Married people or those having a steady relationship go more seldom. It is more legitimate for unmarried, separated and

193

divorced women to go out than for other women, and among them more legitimate for childless women to go out than for mothers.

Couples may go out together or each on their own. Gunvor was engaged to Harald, not married, but they lived together. There were constant quarrels and troubles between her and her fiancé. Friends and acquaintances attributed this to their going out on their own "too much". Gro seldom went out on her own with female friends because her husband did not like it. Elisabeth would have liked to go out with her friends once in a while, but accepts not doing so because Georg "does not allow" her. He never goes out alone himself. Sometimes they go out together, but not so often because it is expensive and they do not feel they can afford it. She does, however, go out a few times with the sewing circle *(klubb)*.

Nils and Beate go out, sometimes together, sometimes alone. Once she discovered that he had lied to her and had been out. The next evening she went out herself, "just to show him". If one of them goes to a party on the job, the other often goes out to a dancing place.

A woman just separated from her husband was advised by her friends not to go out, but to go visiting, if she wanted him back. "If you go out you may put him off *(skyve han fra deg)*. If you go visiting he will understand that you do not just sit at home waiting for him to come back."

Mona sometimes goes out very often. Her husband does not like dancing and is often the babysitter. He complains about her going out so often, but she argues that he sees so many people in the canteen at his workplace, that he does not need company in the same way as she does.

Going out is expensive and it may provoke jealousy. But this kind of commercial amusement exists and expands, not only for unmarried customers but also for those who are married or divorced. They hear about other couples or persons who go out often. People talk about their experiences in social encounters. A woman who did not go out two years ago may do it now, for a period. A woman never goes out alone; usually she is escorted by one or several female friends. If a husband is very resistant, the whole *klubb* (sewing circle, see last chapter) may decide to go out together, for instance once a year. It is very difficult for husbands to resist when the project is planned by the *klubb*. The group

behind it gives it more legitimacy. When a woman goes out with her husband, her activities and the excitement are often more restricted than when she is escorted only by one or more female friends.

Husbands also go out on their own, both alone or with a (male) friend. They do not always have an escort the way women feel they have to. But wives seem both to be somewhat more interested in going out and in fact go out more than husbands. The reason is perhaps that it is more difficult for husbands to legitimize going to dancing places. It does not sound very masculine, in these social circles, when a man says that he "loves dancing". On the other hand, leaving the home and engaging in various activities together with buddies is a traditional ideal of masculine freedom and autonomy. One woman expressed the difference between women and men this way: "You know men! When they go out they like to drink. Then they usually become quarrelsome *(krakilsk)* and sock somebody *(drar te en eller annen)*."

A few men do, however, often go out on their own (Harald and Atle). Others go out once in a while and some never do. The men in the discotheques are to a certain extent other women's husbands and to some extent separated, divorced or unmarried men. Some of the married men are probably sailors, travelling salesmen, fishermen, men taking a course in Bergen because of their jobs, in other words men legitimately away from their homes and feeling more free to go out. The city of Bergen is a port and a regional centre. The selection of men may thus be drawn from a wider region than the city itself. My informants, however, seldom spoke about having met men from outside Bergen. The men they meet seem to live in Bergen, and often they are able quickly to trace links to common friends or friends of friends when they meet a new man. My impression is that part of the demographic picture is also made up by some men (mainly unmarried, separated and divorced men) going out more often than separated and divorced women.

Since women never go out in this way alone, a woman who wants to go out may sometimes have trouble finding a friend to escort her. She may not have friends who are allowed to go out by their husbands, or who are able to go out on that particular evening. Separated or divorced women have this problem, since they go out most often. They form alliances with other women in the same situation, but also with younger unmarried women.

Separation often leads to new friendships or to somewhat changed emphasis on old ones. Many separated women form friendships with younger unmarried women for going out and for talking about it afterwards. In this stage (separation, divorce) adaptation to men (free women) seems more important for the formation of new friendships than motherhood.

Asbjørg, divorced mother of three, goes out every Friday. There are four places that she alternates between depending, it seems, on what (female) friend is escorting her. "I *have* to go out", she says. "Being at home all day I *must* go out to meet people". Going to dancing places is the only alternative that she perceives which interests her. She does not, for instance, as some educated middle-class persons would have done in the same situation, consider singing in a choir. It may happen that she goes out twice a week, but this is easily codified as "too much", both by herself and others. A woman, and especially a mother, is stigmatized as "no good" if she goes out too often. People will react against her in different ways; free men are not subject to similar reactions. If they want to, they may enjoy restaurant life more freely.

When they go out the women dress up, but the way they are dressed and made up is not very different from usual. The difference is that clothes are clean and newly washed, that they change clothes, put on make-up, and give their appearance a little more care than usual. The style of dress is international youth fashion. In 1978–79 they often put on tight jeans and a cotton blouse with lots of pleats, perhaps a belt around the waist, and obligatory high-heeled boots. In 1980 sweat shirts were the fashion. On top of this, when outside, they would wear a tweed sports jacket.

This is the same kind of outfit that they used in the home, for going to work as cleaners, or for going to the grocery store. Working clothes do not exist, it seems. The only difference is that they save the newest jeans and the newest blouse for going out, but this is not necessarily so. Hair and make-up are prepared every day, but a little more carefully for going to parties, discotheques or the sewing circle.

Another part of the preparations for going out is drinking. If the babysitter problem is solved in such a way that they can leave before the children are put to bed, they usually gather to have a few drinks. This is called a *vorspiel,* a pre-party, and most often takes place in the home of one of them or in a bar downtown. The

intention is to warm up *(fyre)* with a few bottles of beer, or a drink of vodka and cola. The drinking is done to get in the right mood, "get a fair breeze" *(komme i stemning, få fin bris)*. They normally become more and more cheerful, but the right mood is often conceived as finding peace, or, rather, as finding "the peace" *(finne roen)*. This expression is used in many other contexts too, both by men and women. In the present context it means to assuage and calm down all the little everyday anxieties of life and also to calm down anxieties about changing from one kind of forum and role (home, wifehood and motherhood) to another that is both more exciting and more dangerous. Finding peace is to be able to act in an easy and poised way, and to endure inactivity, if necessary to wait patiently to be asked for a dance. The anxiety and excitement have to do with meeting men and other women and being evaluated, primarily by men but also by other women.

The choice of dancing place depends on background, personal taste, and the wishes of the escorting friend(s). The dancing places in town are known to have different kinds of customers. The main variables seem to be age, kind of occupation (or school), place of origin (some places are known to have many "rural" people from the islands close to Bergen as their customers), and degree of respectability. All places have something of a reputation as pick-up places, but some more than others. A few places also have a negative reputation for unpleasant drunkenness and fighting. To be a regular customer in one of these places is somewhat stigmatizing.

Asbjørg for instance, has a friend who is somewhat stigmatized by the way she looks and by her being a regular customer in one of the "worst" places. "Look at the way she looks!" Asbjørg says. "She has bleached hair with a high hairstyle that was fashionable a long time ago. Her make-up is overdone, and everything about her is so exaggerated. She goes out almost every evening. She does not seem to care for her poor child." Asbjørg criticizes her friend, but goes out with her all the same when she has nobody else to escort her. "What can I do? I have so little choice of people to go out with", she says. "And I must see people once in a while"

The way you look, that is what clothes you wear, the perceived degree of cleanliness or dirt, the kind of hair style and make-up, the places you frequent, all are signs of what kind of person you are. Then comes your way of life and the signs it gives off. Some

activities and events are potentially stigmatizing events.

People are thus somewhat sorted and sifted according to the different places they frequent. They like to use one place more or less regularly. Not only the place, but also the day of the week determines who will be there. Some go only on Fridays, others on Thursday and Sunday, and so on. In this way some of the uncertainty of going out is reduced. By being (more or less) regular customers one can expect not only to know many people in the crowd, but also specifically that he or she probably will be there. I remember once, when sitting at a table in a discotheque, together with a happy crowd of women, one of them looked unhappy and did not say a word. "She is newly separated", another woman whispered to me. "She has not gone out very much before and knows nobody here." She imputed the unhappiness not so much to the fact that she was newly separated as to her not knowing anybody and not being used to discotheques.

In addition to the hope of knowing some of the other customers, the differentiation of dancing places also means that one is a little more likely to meet unknown persons of one's own kind, people that one "fits in with" *(passer inn med)* and with whom one has perhaps common acquaintances. The practice of being more or less regular customers, or at least going irregularly to the same places, is a device that reduces uncertainty in urban social life.

When they arrive at the discotheque they choose a nice table, if one is still free. A nice table is one where one is both seen and can oneself see the dance floor and the rest of the place. There they will drink and talk to each other until somebody asks them to dance.

They most often go out to drink and dance, and not to eat. Eating out is expensive and is mostly done on special occasions with a husband or a boyfriend. At discotheques, however, if there is an entrance fee, something may be served for the ticket. They mostly pay for their drinks themselves, but do not refuse when a man wants to treat them. To let oneself be treated with a drink or two does not imply a promise of "something in return" *(noe mer)*, as they see it.

Som of them drink carefully one or two beers, mainly because they cannot afford more, but the main pattern is to drink several (4–5–6–7 pints of beer). They mostly drink beer, vodka and cola, or gin and bitter lemon.

198

They shuttle back and forth to the ladies' room and to the bar (if drinks are not served at the table) to be seen, to get an overview of who is there, and to chat with people they know on the way to and from. Good friends go to the toilet together, sometimes not only to the main room where the mirrors and wash basins are, but also inside the smaller closets. The toilet is a place to chat in whispers about what has happened so far and what this means. I asked one of them once if she only does this with very good friends and she answered "Oh, no, if there is a very long queue I will ask almost anybody in the queue if I can go inside with her." Going to the toilet together may thus both shorten any queue there may be and create a backstage with a confidante. Peeing together in public toilets is, in comparison, a kind of physical intimacy that middle-class friends of the same age do not engage in after childhood. Going to the toilet together is one way of maintaining and signal-ling female solidarity and some distance to men in the discotheque situation.

Women normally wait until asked to dance, and only use indi-rect means of catching attention. They do not dance with another woman. That is a way of catching attention which they do not seem to consider. A woman may, however, ask a man she knows well at the same table to dance. Dancing and going back and forth to the dance floor are ways of seeing and being seen. Discotheque life is a struggle for visibility.

When asked about her reasons for going out a woman, whether married or not, will answer that it is to dance, to have fun *(ha det gøy)*, to see people *(treffe folk)*. To have fun and meet people imply a range of different kinds of activities and relationships. It sometimes means singing, shouting and joking in groups, a "let ourselves go" definition of the situation, helped by alcohol. At other times meeting people means personal confidences, not only between women, but also between a man and a woman. When drinking, people talk more easily, and a discotheque visit (or a party) may therefore lead to exchange of more information than usual. Women and men may act out friendship relations to each other, not only sexually loaded relations.

The most important thing however, when going out, is to catch the attention of attractive men. This gives exciting feelings and confirmation of her identity as an attractive woman. She is excited and anxious through not knowing who, if anybody, will ask her to

dance, or if somebody she cares for will show up. She feels her identity as an attractive woman confirmed if a man, whom she considers attractive, shows some interest, and she seems to enjoy it when such a man holds her tightly during the slow dances. These anxieties and excitements are what having fun and meeting people are about, in this context. A nice evening out means that she has met one or several persons that she considers attractive and feels herself both attracted and confirmed as being an attractive woman. Singing, shouting and laughing in a group is fun and also, often, confirmation of the attractive woman identity. A bad evening is when nothing happened, when she received no positive confirmation, or perhaps even something unpleasant happened. In this context getting no positive confirmation means, to some extent, getting negative confirmation.

The attractive woman identity is a way of summarizing an aspect of persons that has important consequences for social action and interaction, without necessarily being talked about directly. When they talk about other women, they often indirectly focus on their attractiveness by discussing their looks; face, figure and way of dressing. They use positive expressions like fine, stylish *(fin)*, pretty *(pen)*, tidy *(nett)* and negative expressions like cheap *(billig)*, dirty *(dritten)*, rough *(grov)*.

The expressions used indicate that there are strong moral dimensions involved. And such dimensions there certainly are. A woman does not only want to be considered attractive, but also morally responsible. There are limits to how much a woman may enjoy the excitements of going out. To search for attraction and romantic feelings is a dangerous playing with the fire. Dancing cheek to cheek in the discotheque is allowed, but when the place closes up at about 12.30, the married woman has to go home. The separated, divorced or unmarried woman may go to a late night party *(nachspiel)* but she should not bring a man home just for the night. There is in itself no moral difference between bringing a man home or going with him to his place, if she has no responsibility for children that night. (They might for instance be with their father.) Most often there will, however, be no choice. Single women who are mothers have homes and children to tend, whereas single men in discotheques sometimes do not have their own homes and seldom have children to tend.

Because of these moral attitudes, women have mixed feelings

about going to discotheques. It is both good and bad. Often it is described as an obsession, as something that "gets into your blood" *(det går deg i blodet)*. "If you start going out, it gets into your blood. You just cannot stop. I remember a period when I went out as much as three times a week", one woman once said. When she used to go out she was an unmarried mother. Now she is married and only goes out once in a while.

Another example of the perceived obsessional nature of going out is when separated mothers who go out say: "Now I will not go out so often any more. I have found peace. *(Eg har funne roen)*. Now I prefer to relax at home". They may say this the day after a particularly hard evening out, with too much drinking, which resulted in a terrible hangover or perhaps in something really unpleasant happening, like a visit to the police station because the driver of the car was drunk, or an attempted rape by some man. To find peace, in this case, means that the restlessness and need for excitement have calmed down.

Going out is thus exciting, but involves dangers of losing control, of slipping over into a stigmatized and downgrading way of life. Their mixed feelings reflect that what they seek by going out involves temptations that conflict with other values and interests they also have. They want monogamy and faithfulness as well as excitement and confirmation of their identities as attractive women. They want security as well as new experience. They want good morals as well as testing out the rules. This implies that they follow "a strategy of chastity in an environment of non-chastity" (Anne Rasmussen, 1969, 1984)

To seek, in this way, excitement and confirmation is dangerous. Careful management is necessary if one does not want to get a "bad reputation".

Moral practices: What produces a bad reputation

The women want both excitement and good morals, and this combination gives them some intellectual problems. In the following pages I examine their informal rules about sexual morals. These are not rules in the strict sense of the word, but informal prescriptions for action, based on some common understandings. These common understandings and prescriptions are constantly

debated and somewhat changed (see next chapter about their moral discourse), but the central dilemma between excitement and good morals remains the same.

Public dancing places are not the only occasions for excitement, confirmation of the attractive woman identity and temptation. Parties in private homes or at the place of work, situations at work or in the street are other examples of encounters between men and women that may have sexual overtones. But only parties at the workplace can really be compared to public dancing places as occasions for temptation and excitement. Private parties occur in the homes, there are fewer guests, and for those who are married the spouse is present. But at private parties, too, often, "something happens". Public dancing places are, however, the most specialized fora for this excitement.

Moral practices prescribe sexual faithfulness in marriage and not to have loose morals when one is unmarried, separated or divorced. Separation means, in legal terms, that one is still married and not supposed to have sexual intercourse with anybody. In folk terms, however, separation means that one is free to enter into new relationships. Not to have loose morals, to be morally responsible, is to make love to a man only after having known him and had a steady relationship with him for some time. If one does otherwise, one might be considered cheap *(billig)*. For mothers children are considered as an extra obstacle to sex. Motherhood and sexuality have to be separated into different times and places. This is so in marriage and even more so outside marriage. It means that children are not supposed to see any other person in their mother's bed than their father, or a very steady permanent new man in their mother's life, who is more or less willing to take on the responsibilities of a father. All single mothers express this view very clearly. One woman says: "I do not think it is right that the children should see another man in my bed unless it is something permanent. I am not so much of an animal *(dyrisk)* that I must have a man every night. I do it when the children are away with their father." Another woman who is seldom without her children says: "Sometimes I should like to invite a man home for a cup of coffee. Just a cup of coffee, nothing more. I do not do such things [i.e. sleep with men] since I have children around."

A third woman is full of remorse about the first time she brought a man home a few months after her separation. This is what she

related, a few days later, about the incident and her feelings: "I was drunk and he was so nice to talk to, and so good-looking. I did not intend making love to him, but suddenly it all happened." The next morning she woke up very early, and very, very ashamed of herself. Most of all she was afraid that the kids (aged 6 and 2) should discover anything. She seemed to think that they would be negatively emotionally affected not only by seeing him in her bed, but also by seeing him half dressed in the living room or even fully dressed in their apartment at this private part of the day and the week (Sunday morning before twelve). Degree of dressing (from naked to fully dressed), room in the apartment (a man is not supposed to stay in mother's bedroom at all), and time of the day and the week (the most sexually loaded time is early in the morning), are all signs of sexuality/asexuality. A man is in principle only fully acceptable in the living room or the kitchen, fully dressed at normal visiting times. The woman seemed to think that her children had the same interpretations of events as sexually loaded as she has herself. She stated very clearly, when she afterwards spoke about those events, that such experiences are in themselves dangerous to children. And, she added, "What won't my son, later on, when he himself is grown-up, think of his mother if he has seen one guy after another in my bed!" This was also given as a reason on other occasions, for instance when she did not let a male friend (who was "only" a friend) sleep on the couch for a night "because of the children". In addition to the anxiety for the children's feelings came the fact that the older one (6) was able to bring this information to other fora, especially the woman's own parents. Since she was ashamed of what she had done, and her act was potentially stigmatizing, she wanted to keep some information control.

What she did, that morning, was to wake up very early and sit in the kitchen, smoking, drinking coffee and waiting for the kids to wake up. They slept in a separate bedroom close to the kitchen. When they woke up, she helped them dress, gave them breakfast and later on, sent them "out in the street". All this time she guarded the closed door of her own bedroom, where her lover slept peacefully. "They did not see him before four o'clock", she later said. She was thus successful in keeping apart her roles as mother and lover, in not letting the children experience even the slightest signs, as they are here defined, of her sex life.

But when the lover woke up, she still had a problem. She was ashamed of what she had done and was anxious about what he might think of her. Therefore she tried to correct the impression she feared by giving him information that put her acts in a new light. She told him how unhappy she was, how ashamed she was, and that this was the first time she had brought a man home like that: "You probably think I am a cheap whore *(itt billig ludder)* since I brought you home the first evening we met, but I am so ashamed, and it is the first time I ever did this." In this way she tried to change the interpretation of her making love the first evening from a degrading one ("a cheap whore") to both an accident, a mistake that could not be taken as a sign of her way of life ("I feel so ashamed") and a special favour ("I never did this before"). The contradiction inherent in this effort is typical and general as a variation of the trap all Western women are caught in between the images of whore and madonna, between whore and old maid, between lust and decency.

There is an additional dimension to the interpretation of the cultural meanings of this incident, and the values and codifications that are expressed. The opposition between home and discotheque, between inside and outside, between warm cosiness and exciting moral danger was also confounded. Part of her fault was to have brought home an unknown man from the outside, without an intermediate stage of getting to know him, his background and his motives, to tame him, so to speak, to fit into the context of the home.

Not only mothers, but all women must somehow relate to informal moral prescriptions that regulate sexuality. They have to manage their erotic life carefully in order not to be saddled with a bad reputation. Jealousy in marriage (and to some extent in other stable relationships) is a special case of this general regulation. There is more at stake when a wife makes love for a night with a man other than her husband than when an unmarried, separated or divorced woman does the same thing. Sexual monopoly is an integral part of love, and this seems to make jealousy an integral part of marriage and steady-going relationships.

The separated woman who brings a man home on the first evening may discover that social sanctions aren't very strong. It isn't catastrophic, after all. She did perhaps get negative reactions from her mother or a friend or indirectly by rumours coming back

to her, but nothing very dramatic. If she continues, however, "to take one man after the other home to her bed", her reputation will slowly change and she may, depending on the seriousness of the case, have difficulties in finding a steady lover and building up a steady relationship. She may also have difficulties in establishing the friendships that she wants, if the category changes from respectable and ordinary to "a cheap whore". She will no longer fit in with the same people as before.

The married woman or man, on the other hand, who stays out all night, is the cause of more acute drama. Adultery threatens the whole existence of a marriage. According to Norwegian law, one may be divorced in court, without the normal one-year separation period, if adultery can be proved. She may even lose the parental rights over her children. This provision is, however, seldom used. But its existence reflects the importance commonly ascribed to sexual monopoly and faithfulness. Adultery threatens marriage, and marriage is the foundation of the household. Marriage and household make up the frame for a syndome of supreme values that profoundly affect spouses' feelings of identity and of their own worth. It is thus most serious when a married woman has a love-life of her own (with a man other than her husband), but such behaviour is likely to give women a bad reputation irrespective of marital status. The words used are *hore og ludder,* meaning whore or tart. These words are used interchangeably by both men and women, not in the literal sense of offering sex for money, but about a woman with what is considered loose sex behaviour, who violates moral rules about how sex and erotics are to be managed and handled.

There is a similar word that is used for men with loose sex morals, *fittetjuv,* literally a "cunt thief", cunt chaser. This word is very derogatory, and reserved for men particularly disliked for Don Juan habits. Sometimes a woman may use this word directly to the face of a man, to show him what she thinks of him. If a man is told that he is a *fittetjuv,* however, he will consider it as half severe criticism and half compliment, even if the woman only meant it as a severe criticism. He will laugh sheepishly, whereas a woman becomes deeply offended if a man calls her a whore in a similar situation. She will protest, defend herself, and often begin weeping. The different attitudes of women and men are illustrated by how men are codified as being basically conquerors or libertines.

What threatens women's identities as being morally responsible, then, confirms men's identities as being conquerors. Their identities are complementary, but mutually threatening.

Generally, then, sexual behaviour defines women in ways different from those in which it defines men, both for themselves and others. The way men are defined means that a man is not restrained by moral rules in his sex-life in the same way as a woman is. But, as I will discuss later, inside marriage he too is relatively more confined.

An example of an incipient bad reputation happened once when a father tried to give his daughter some advice. He came over to his daughter and told her that he did not like it that she, a separated woman, often went out with a specific girl friend, also separated. At his workplace there were several younger men who often went to the same discotheque as his daughter's friend. They had discussed this friend at lunch time several times, saying she was a real whore, *(itt ekte ludder)*, "who brings home a new man every time she goes out." His daughter later told me what her father said and what she had answered. "I just answered that I had never heard about this and that it must be very exaggerated." I asked her what she herself thought was the truth and she said: "I know that some time ago she often did take men home to her bed when she went out, but I am sure she has stopped doing it now." This incident did not lead to a change in the friendship between the two women, who were at the time both separated. But several months later, when they had a serious quarrel, this information was used to revenge and to hurt. In the situation she said "I know how they talk about you down at X (the discotheque). They call you a tart and a whore *(ludder og hore)!"*

This example illustrates how women protect each other against men. In this case it was a father, in most other cases it is against husbands and steady boyfriends. At the same time as they may violently criticize each other among themselves (see next chapter), they often try to conceal disturbing information about friends from husbands. The example also illustrates how the bad reputation has to be relatively serious before friendships lapse, that other issues are more important to the rise and fall of friendships. But, as noted earlier, sometimes a reputation may be so bad that old friends disappear and new friends are difficult to obtain, at least new friends that are not also stigmatized.

The role of alcohol

Drinking alcohol is an integral part of going out. Moral dilemmas about sexuality and erotics are connected with the use of alcohol. Alcohol is also consumed in the homes. People normally drink at weekends, both at home, at parties and when going out. The use of alcohol is an important part of the lives of most of my informants. There is, among them, almost no conversation where the use of alcohol is not mentioned, in one way or another. People do, for instance, tell how drunk they were and all the silly things they did last Friday or Saturday. Or they might say the opposite: "Saturday was peaceful and quiet. Nobody was drunk."

According to the statistics, drinking in Norway has increased drastically in the last decades. From the middle of the seventies the curve has levelled off. The consumption of alcohol per head is moderate compared to other European countries, like Belgium or France,[2] but is regarded as high in Norway, as appears for instance, from the way the figures are discussed in the media.

Average figures of alcohol consumption cover, however, different milieus with very different use of alcohol. Attitudes of total temperance have a strong hold in Norway, especially in the rural areas of Western and Southern Norway. Wine and liquor are only sold in cities, in a few state monopoly stores. Because of heavy taxation wine and liquor are not only difficult to get, but also very expensive. Quite a few households, both in the rural areas and in the cities, make their own brandy, which is illegal.

For the social circles of my informants, the importance of alcohol is verbally indicated by the variety of vivid expressions for different shades of being sober or drunk, for alcohol itself, and for the activity of drinking it:

Edru	Sober
Klinkanes edru	Stone sober, literally "tinkling" sober. A tinkle is the sound made when tapping the glass. At Norwegian formal dinners, a person taps his/her glass in this way if he/she wants to make a formal speech. A similar English expression is perhaps sober as a

	judge.
Lunke	Take the chill off.
Gå å lunke	Slowly warm up a little.
Ha en liten lunk	Get a little warmth.

These expressions stand for drinking just a little, to become more uninhibited.

Fyre	Light or stoke a fire.
Vi satt og fyrte	We sat and stoked the fire.

These expressions mean to drink steadily.

Lett bris	
Liten bris	A little breeze.

Fin bris	A fair breeze.
Brisen	In a breeze.

These expressions stand for the state that they explicitly want to achieve by drinking: becoming uninhibited in a nice way, becoming a little tipsy, to blow free, be sailing along. Etymologically the expressions may be connected to blowing on a fire *(å brise)*. Most people do, however, associate them with the blowing of a breeze.

Pussa	Tipsy.
Full	Drunk.
God og full	Good and drunk, quite drunk.
Godt i gassen	Well-oiled, literally with plenty of gas.
gas.	gas.
Fin i farten	Full speed, i.e. going fine.

This expression means having a

little more than "a fair breeze".
One is drunk and happy, even if
one is also a bit loud; quite merry.

Renne over	Running over. The image is one of a glass that is more than full.
Kanon full	Literally cannon-drunk.
Helt kanon	Now one is really drunk, canned or plastered.
Kanon	The word cannon evokes images of loudness, explosions, the possibility of scandals.

Møkkandes full *Møkkanes* *Drita full* *Dritings*	Literally these expressions mean muck-drunk and shit drunk (cf. "pissed"). *Møkk* refers to the mixture of shit, dirt and straw on the floor of a stable. *Drit* refers to dirt and faeces. They stand for being out of control, clothes in disarray, being dirty from having fallen, etc. etc. These expressions also contain the idea of a person showing his or her more unlovely sides by being in that state.
Døddrukken	Dead drunk, unconscious.
Drink	Drink.
Dram	Shot. In Scotland they have the same word, dram, for a shot or a swallow.
Pillehytt	Affectionate nickname for a drink or a shot.
En tynn en	A weak one.
En stiv en	A strong one.
Mannabrus	Beer (or sometimes drinks of other kinds of alcohol), i.e. men's lemonade (as opposed to chil-

	dren's lemonade).
Helemann	Nicknames for a bottle of brandy.
Heling	
Hallemann	Nicknames for half a bottle of
Halling	brandy.

Drinking patterns vary between social circles. Parts of the urban upper-middle class have more liberal "cosmopolitan" attitudes towards, for instance, drinking wine for dinner. My informants exemplify to a great extent the typical Northern Scandinavian drinking pattern of drinking heavily once in a while (instead of drinking moderately more often). They almost never drink wine (only strong wine) and drink mostly beer, brandy, vodka with lemonade, and liqueur. Together with food they drink coffee and liqueur, beer, brandy or just lemonade. The combination of drinks is often according to what is available and what tastes one likes best and not according to upper-middle-class standard drinking patterns.

Drinking is not unproblematic in these circles, for many reasons. Alcoholism is a realistic threat, and is, in many ways, uglier and more difficult to hide than in middle- and upper-middle-class milieus. When the normal drinking pattern allows for heavy drinking, excessive drinking becomes more socially disturbing than when the normal drinking pattern consists of moderate drinking. The threat of alcohol is to lose one's identity as a decent, respectable human being.

All my informants have some relatives or friends who are alcoholics and who have lost their jobs or are about to lose them. Some are also criminals. Kirsten's older brother for instance, has been "in and out of jail" for years, because of minor crimes for gain, mainly to get beer and tobacco. Georg's brother is a good artisan when he works, but has lost one job after the other because of drinking. Now there are few firms in town willing to employ him. "He needs a woman to take care of his money and control his drinking", Elisabeth says. The line between a decent ordinary life and a stigmatized existence is sharply drawn but easy to cross. The way one uses alcohol is one sign of which category one belongs to.

Michael Thomsen (1981) has described the way of life of a stigmatized group of people in Bergen. They live in badly kept

municipal dwellings, do not follow a stable working pattern, and live to a great extent on money from the municipal welfare office. From my informants' point of view they are social cases. Within this neigbourhood use of alcohol is a particularly clear marker of identity. Either one does not use alcohol at all, or one misuses alcohol, which is stigmatizing, also within the neighbourhood. Identity as a decent human being is so precarious that it does not allow for the use of alcohol at all.

The stigmatized way of life of the people studied by Thomsen is a real threat to my informants. This is one of the life styles they immediately compare with their own, and that they know personally through some friends and relatives. (See chapter four.) Their own identity as decent human beings is however more secure and allows for a different meaning and use of alcohol. They insist on a stable decent existence while at the same time drinking heavily, once in a while. Even if one is drunk on Saturday, one still always goes to work on Monday. Georg's drinking pattern is a typical example. "I drink something, just to relax, every weekend", he says. "And once in a while, about once a month, I am completely sozzled *(skita full)."*

Drinking is, however, even among them ambiguous as a sign of identity. It may signify a stigmatized life style, and it may signify being "one of us", depending on the context. Their particular drinking pattern is one element of their way of life that distinguishes them from other reference groups of society. The ambiguity lies in the delicate balance between being "one of us" and being "decent ordinary folks", the danger of stigmatization by people with other life styles. Their drinking pattern may sometimes give off the wrong signals to an outsider. This ambiguity is illustrated in the following examples:

Ellen once explained how they came to know Jacob, the bachelor physician of their own age living in the apartment next door. The apartment is owned by the hospital. "Doctors are not normally part of our circle of acquaintances. But then he came over one evening and asked if we had a few bottles of beer. We at once understood that he is of the same kind as us. He had a whole bottle of brandy, but he fancied beer that evening. He gave us the bottle of brandy."

211

This was the beginning of their relationship. They used to visit each other informally, once in a while. But when he once invited them to a party, they found an excuse:

> We did not want to go. We do not know these people. They talk about things that we do not know. We went over to my father-in-law instead.

Not drinking, on the other hand, is often regarded as anti-social, not being "one of us". After a party at the trade school, for instance, several women were disappointed because their favourite teacher did not drink anything but soda. He excused himself because he wanted to drive home. (Legal rules are strict in Norway. If one is caught driving with a blood alcohol content of 0.5 pro mille or more (i.e. 50 mg alcohol per 100 ml of blood), one gets 21 days in jail and loses one's driving licence for one year.) Not drinking has the same effect as not laughing at jokes in social encounters; it creates social distance and makes it difficult for the rest to sustain a happy, "let ourselves go" definition of the situation.

They know that other people have different life styles from themselves, also concerning drinking habits. Letting oneself go too far, especially in a large gathering (for instance a party arranged by the school or the workplace) is fun but may also be embarrassing. Other people might codify the fun as stigmatizing. The nuances of interpretation are fine. The following utterance is by a woman who is very disappointed because two of her friends try to "freeze her out", as she sees it. Her husband is a salesman. Their husbands are manual workers. She would have liked to be together with them more, but relations are difficult:

> I believe the reason is that the two of them are more alike, that I am a little bit different from them. They are better off financially. They can buy more of the things they want. And then there is their way of going on at parties. We may bring a whole bottle of brandy *(en helemann)* and only drink half of it *(en hallemann)*. But then they will say "My goodness, what a tiresome party you must have been to!" We also let ourselves go, but not in the same way as they do. For instance, several of them always go to sleep in the middle of the party. And then there is

always so much quarrelling. You sit there, and you know you are right, but it is impossible to say anything. Sometimes all the girls go into the kitchen or the bedroom and talk as if they were in a *klubb,* while the men remain in the living room, talking about cars. No, after all, it's not to my taste!

As a single divorced mother, on the other hand, Asbjørg is concerned about not getting involved in potentially stigmatizing events (see also chapter four). She has a close neighbour, in the apartment right beside her on the same floor, who wants to have more contact with her. The neighbour is divorced, but lives with a man. Asbjørg says:

She is nice, but there is too much drinking and party-giving in their apartment. They seem to drink every evening. They often invite me over for a drink in the evening, but I always say no. I am afraid they will start coming over here when they are drunk, that I will never have a moment's peace *(aldri få fred).* If she had come over to sit here with me in the morning, it would have been otherwise.

In this case having peace means controlling accessibility to her apartment, guarding autonomy, the desired degree of privacy and respectability.

What is regarded as too much drinking? One sign is drinking too often, and at the wrong times of the day and the week. Drinking in the morning or the afternoon is a very definite stigmatizing sign. Not only being obviously intoxicated, but also the smell of brandy on one's breath is heavily stigmatizing at such times of the day. At weekends this is slightly less serious than on weekdays. Some people make it a rule not to start drinking before 2 p.m. on Saturdays. Drinking in the morning and drinking every day are signs of danger, even if it is moderate. Excessive drinking is also bad. One should get "a fair breeze", i.e. get a bit merry, but not become dead drunk. The state of drunkenness is measured by its social consequences. Joking, laughing and singing loudly is fun. To break glasses or furniture, quarrel and fight violently is not fun.

The women's drinking pattern is not very different from the men's, as far as overt drinking behaviour is concerned. Just as with driving and smoking, this is a field where they have become more like men over the last decade. In my fieldwork among working-

class families in Bergen in the beginning of the seventies, I observed that when the men were served beer or brandy at social gatherings, women were often, automatically, and without being asked, served soda. At that time too, several restaurants in the city served half-litre glasses of beer only to men. Women had to drink beer out of smaller glasses. The reason given was that it did not "suit a woman" to drink beer from half-litre beer steins. I believe the difference is one of time and not primarily one of milieu. Today, in the present fieldwork, both men and women may be heavy drinkers and enjoy the effects of a "fair breeze" *(fin bris)*. But it is still regarded as a more ugly sight when a woman is really drunk. Women probably also generally drink somewhat less than men. Drunkenness does, as I will show below, excuse her less than a man. She has to keep kontrol of herself, even when drunk. Drunkenness does, however, excuse women's more "innocent" wrongdoings and stupidities. A woman can rely on other women's support and identification if she tells about an incident where she has been drunk, if nothing more serious has happened. She may, for instance, tell about how embarrassed she was the day after a party at the job when a colleague had to take her home because she was staggering.

In addition to controlling herself, she also sees it as her responsibility to control her husband. The implicit assumption seems to be that he is more irresponsible. This is wonderfully illustrated by the following example from my *klubb*. Ellen and Sissel are clearing up a misunderstanding that has arisen earlier the same day. What happened was the following:

Arne called Sissel in the middle of the day from his job and asked her to buy him two (2-pint) bottles of beer. (He can telephone her but not Ellen, his wife, since they do not have a telephone.) Sissel replied that it was OK by her, because she was going to the grocery store anyway. She then went to the grocery store, but happened to meet her mother there. With her mother nearby, she did not dare to ask for the two bottles of beer. "She would never have believed that it was for him. She was so angry the other day because I called her when tipsy *(brisen)*. She said that if I continued like this, she would have nothing more to do with me. She would surely have believed that I intended to drink the beer myself."

214

When Sissel came back to the apartment blocks, she asked Reidun, one of the neighbouring girls (the *passepike* who looks after her youngest child) to go over and ask Ellen to buy the two bottles of beer for Arne and one bottle for Sissel herself. Ellen misunderstood the whole thing. She thought Arne had asked Sissel to do it so that she should not know. She became furious, went over to the telephone kiosk, called Arne at his job, and shouted: "I am the one who buys that beer!" Arne answered uncomprehendingly: "Yes, but that was my intention, after all." "I then understood that I was wrong", Ellen later said, in the *klubb,* "but I wouldn't admit it, so I continued to rage." Sissel tells Ellen in the *klubb* that it is her fault because she should have explained it more thoroughly to Reidun, the messenger. Reidun had overdramatized the whole thing. "I should have explained better to her or gone down to tell you myself." Ellen then told the *klubb*-members the reason why she became so upset: "Arne and I had agreed not to drink beer this week. Therefore I could not stand him buying beer secretly. We agreed upon this because of all the drinking and beating it up last weekend. It was too much. We were drinking heavily both Saturday and Friday. (….) The worst thing I know is when they start drinking on the sly. What is to be consumed in my house is to be consumed on the top of the table, so that I can observe it. I want to control completely what goes down. That's why I was so furious today. I thought he was trying to conceal this from me."

"I do not tolerate drinking on the sly *(smugdrikking),* either", Elisabeth then said. "I discovered some time ago, that Georg drank in secrecy on Sundays. He is always most nervous on Sundays. He is full of remorse, especially over stupidities he has committed when drunk *(bondeanger).* Mondays are his worst workdays. Often he is not even able to eat lunch together with his colleagues. (….) When I discovered his secret drinking on Sundays, I became so angry. I told him clearly that I was not going to stand all this drinking of his any more. This weekend we had bought 3–4 (2-pint) bottles of beer, nothing more, nothing less. Friday evening he drank half a bottle of beer. Saturday evening we were not at home. Sunday almost all the beer was still there. He went out to the kitchen and opened a bottle, then came in again with the cap in his hand. (Elisabeth smiles when telling this.) Then he said, in an anxious voice "Is it OK that I

opened a bottle?" (She imitates his looks and voice.) It demonstrates, after all, that he has respect for me, which makes me glad. I was myself ever so thirsty *(sugen)* for beer that day, but I did not want to open one. It is not right to drink yourself when they, the men, are not allowed to drink."

Drinking is thus nice and sociable, but dangerous; it has to be controlled. People drink to relax, to find peace *(finne roen)*, to have fun and to "let oneself go". They drink alone with a spouse and in good company, mainly at weekends. Sometimes they just relax with a few bottles of beer; sometimes they let themselves go and drink heavily. Drinking reduces stress and nervous tensions and drinking creates social variety in a routine life. Sometimes drinking is discussed as an alternative to tranquillizers and sleeping pills. Sometimes it is considered a way of having fun. There is both a parallel and a connection between sex and alcohol: the limits for what is morally right are constantly tried out. Testing out rules about sex morals is done on occasions where alcohol is also consumed. The use of alcohol creates occasions that are different from the routine of everyday life, both in the home and outside the home. Drinking and going out are ways of breaking the routines and boredom of everyday life.

Talking about attractive men

Sometimes, especially about unknown men in public places, women talk about men as sex-objects in an unproblematic and humorous way. On such occasions their talking in this way resembles what I believe is men's way of talking about women among themselves, but the words used are different. The occasion may, for instance, be two women together in a public place (a street, café, bus, discotheque) with unknown attractive men around. Then one of them may, without turning her head, only by using her eyes and perhaps elbow, call the other's attention to a particularly attractive man in the surroundings. The accompanying whispered words may be these: "Look at that sandwich spread!" *(Se det pålegget!)* Spread is processed food on the top of a slice of bread. The sexual connotations are obvious to the participants. Other

metaphors used for attractive men are also drawn from the semantic realm of processed food:

Pålegg	Spread.
Matpakke	Lunchpacket made of sandwiches (slices of bread and spread). The whole lunchpacket stands metaphorically for the sandwich spread.
Snop	Local Bergen word for sweets.
Snadder	Literally snadder means cackling, quacking of fowl. It is a slang word for snacks, good food but not a real meal.

I once heard a man use *snadder* for an attractive woman. Looking at a nice young lady on the television screen he smacked his lips saying *"Mmm, snadder!"* The other metaphors I have not heard used by men. There is perhaps an interesting partial contrast between women's use of metaphors from processed food and men's use of metaphors from the realms of birds and wild game.

Women also have other less objectifying ways of talking about men they find attractive. The adjectives they use describe both looks and manners at the same time. They use, for instance, the words *skjønn, en skjønn fyr,* which means a cute, good-looking, lovely, nice guy, (these words do not quite capture the playfulness of the word *skjønn*), *stilig, en stilig type* which means a classy, stylish guy, and *flott, en flott fyr* which means a generous, smart, good-looking guy.

They like "real grown-up menfolk" (*voksne skikkelige mann-folk*) as opposed to "babyfaces" *(babyfjes)*. Husbands or friends are judged positively in terms of being "real grown-up menfolk". A "real grown-up man" is well-built with broad shoulders and muscles. But the expression stands for personality attributes as well as for his physical features. He is able to fend for and defend a family. It is connected to autonomy and individuality. Beate once told a story that demonstrates the content of the real grown-up man ideal:

A fortnight after our wedding my former fiancé suddenly rang the bell. I opened the door, but was too afraid to say anything. Then Nils came to the open door. He had no shirt on, just a singlet, which showed up his impressive muscles. He almost filled the whole opening. "What do you want?" Nils said in a brusque voice. "I only wanted to congratulate you", the other said, meekly. He saw that Nils was a real grown-up man *(et skikkelig voksent mannfolk)* and did not dare to say anything more.

Other positive qualities in a husband are to be "peaceful and quiet" *(stille og rolig)*, often expressed in utterances like this: "Mette has a very nice husband. He is peaceful and quiet." The persons praised in this way may have both a lively temperament and a sense of humour. Being "peaceful and quiet", in this context, means not drinking too much, not fighting, going steadily to work every day and, above all, it means enjoying staying home and not running about to bars and restaurants. "The family comes first", for a man that women consider a good husband.

In the ways they talk about men one may detect slightly different emphasis on what are considered attractive male qualities and what are considered good husbandly qualities. Attractive men are handsome, stylish, generous and real menfolk.[3] Good husbands are real menfolk but also peaceful and quiet, tamed to the context of "hearth and home".

Conclusion: Reconciliation of conflicting values

This difference between attractive male qualities and good husbandly qualities resounds with the tensions between excitement and the values of hearth and home. Discotheques and other public dancing places offer opportunities for acting out and having identities as attractive women confirmed. Participating in the discotheques' struggle for visibility is one way of proving oneself to be capable, to be able-bodied, to master one's life as an individual. They thus express individuality by acting out identities as attractive women. As long as they do not violate informal moral rules, going out supports marriage and hearth and home, not by ideology but by consequences. It gives them a valued change from the

boredom of everyday routines, experiences that give them confirmation and a feeling of mastering their lives. But moral rules are constantly violated, and this brings out the tensions between "going out" and "hearth and home". "Hearth and home" is conceived of as the warm and cosy inside. When one goes out it is to colder, potentially demoralizing but also more exciting surroundings. One also leaves the home for other reasons – for instance to go shopping or to do one's paid employment – but these activities are not, however, "going out" in the same way. All activities that lead a woman into other fora and role-relationships than the home somehow widen the range of social experience. But some activities can more easily be seen as extensions of life at home and are thereby legitimized in home-referenced terms. Shopping and dealing with banks are mainly household activities. Paid employment is undertaken both because of the wage, but also to get away from home, to have some change. Its primary legitimation, however, is found in the money earned and brought back to the household (see also chapter thirteen). Visiting friends and relatives, going to replicas of one's own home, is also an activity that in several ways can be seen as supporting the values of hearth and home.

Combining family life and the discotheque, on the other hand, accentuates the oppositions between individuality and hearth and home by calling upon a different form of togetherness. Hearth and home, primarily, but not completely, stand for community as monopoly and faithfulness, warmth, cosiness, safety. Discotheques stand for individuality, being attractive to many, excitement and danger. This contradiction provides them with some constantly debated moral dilemmas. In the following chapter I examine their way of discussing these vital moral dilemmas.

11. Women's moral discourse and its consequences for female solidarity and conflict

When women sit together in the morning drinking coffee, smoking and looking after their children, or meet in the *klubb* (the sewing circle with or without sewing) in the evening every other week, they talk about a whole range of different topics connected with their lives as wives, mothers, employees, customers, daughters, daughters-in-law, etc. Some anthropologists have for a long time taken an interest in such everyday talk, which at first glance might seem trivial, and have shown how it expresses important ideas and values in the culture. Max Gluckman (1963), for instance, pointed out how gossip serves to create and maintain agreement about crucial values. Ulf Hannerz (1969) analyzed the talk among black men while drinking as 'street corner myth making'; a way of developing and elaborating an alternative ghetto-specific masculinity to the white mainstreamer male role (Hannerz 1969).

In this way the women's talk when they are together may be analyzed as a moral discourse about what is right and wrong. Their talk includes rightness and wrongness in child-rearing practices, in division of labour between spouses, in relationships with parents and parents-in-law and other relatives, issues surrounding work, issues raised in films on the TV or picture magazines, etc. A substantial part of the data presented in this book has been retrieved from the different matters that they converse about. Some themes, however, seem to engage their interest in a particular way. Their relationships with men are the focus of an intensive interest, and as we shall see, the cause of the most dramatic incidents at this stage of their lives. Talking about relationships with men includes issues related to sexuality and proper domestic and extra-domestic relationships between women and men. Because of their strong interests in these issues and the existential dilemmas they reveal, I have chosen to concentrate my analysis in this chapter on this particular theme, while at the same time stating

clearly that this is not the only theme of their discourse. First I shall give some examples of their talk and analyze their implicit ideas and values. I shall then extend the analysis to an examination of the consequences of their moral discourse for both solidarity and conflicts between female friends.

Moral discourse[1]

In the preceding chapter I reported the gap between moral rules and the application of them in practice that often occurs. They stick obstinately to some ideas and rules that do not quite work, but are all the same important to them. Attraction and love between men and women is a conflicting experience. They stick to values of monogamous love and faithfulness while at the same time testing the limits of these rules. When chatting they make constant intellectual efforts to harmonize opposing values and conflicting experiences. This debate takes many different forms, from criticizing others' misdeeds to admitting one's own. In the following pages I give a few examples, some of them dramatic, of the moral discourse concerning love and attraction. The examples are, some of them, about marriage crises. The most violent emotional reactions have to do with jealousy in marriage. By focusing on dramatic incidents, I run the risk of making their lives seem more dramatic than they are. The reader is asked to keep this in mind. The advantage of the approach is that in a crisis rules and resources become particularly visible. By analyzing such cases it is possible to make explicit some of the informal rules, notions and assumptions about male/female relationships.

The first example is of a more theoretical kind. Two women discuss what they would have done 'if something happened':

Example 1
Mette and Eva and I had a morning coffee klatch at Eva's place. At first they discussed an incident in the neighbourhood. A woman had run away with a younger man. Then the discussion continued about adultery and jealousy in their own lives and in general.
Mette: "Oh, all the things about adultery Kåre and I have discussed so many times. I mean, what is the definition of that

word? His view is that women and men are different, that menfolk may have a lay, get an orgasm, and that's the end of it (*mannfolk, de kan ha seg et nummer, få utløsning og ferdig med det!*), – and that womenfolk, they are more serious about it. But I feel that if he turns to somebody else, then it is my fault. Then he has not got all his needs satisfied with me. Then there is something wrong in our marriage. I might have accepted it, I do not know, if it had happened on a journey, if he had been drunk and if he did not know her name and where she lived. But if he knew her, and if he had met her several times, it would have been completely different." *Eva*: "I don't find that drinking is an excuse. They ought to know themselves what the limits are (*hvor grensen går!*)". *Mette*: "Yes, I don't know what I would have done. We have talked about it many times, because we are very open about such things. (. . .) I once read an article in *Vi menn* [a picture magazine for men], about three men who explained why they frequent prostitutes (*horer*). Purely business-like relationships like that preserve their marriages. I can understand them, but I would not have accepted it if it had been Kåre. I believe I would have put him into *Klorin* [a very strong commercial bleach]. I believe it would have affected our sexual life, I believe I would have thought about it . . . "

Eva: "Oh dear, yes . . . (*Uff, ja*)".
Mette: "And if he had had a real affair with a nice woman, on the other hand, I would have got an inferiority complex . . . "

Mette perceives adultery not just as something wrong with the relationship, but also as something wrong with her as a person. Adultery threatens her self-esteem. It is unclear whether drinking is an excuse, but the possibility is left open. She also, to a limited extent, leaves the possibility open for somehow judging actions in terms of context and motives, whereas Eva is more strict. But since this is only a theoretical discussion, it is difficult to know how Mette actually would have reacted.

The next discussion is about the interpretation of incidents that have actually happened to one of them.

Example II
The members of the *klubb* were chatting together during a gathering. Beate related that she had not been to work for a few

days. She pointed to her face and asked the others if we could see something. She had carefully made up her eye to cover a black eye and was very concerned about whether it showed or not. "Everybody believes at once that Nils (her husband) did it. That's unavoidable. But, it wasn't him, it was my brother. I can't manage to lie about it either." The others asked how it happened and she said: "I'll tell you, but I am going to make a test case, I will test what you think."

She then told them about the party on her birthday the previous Saturday. "The party was such fun, the nicest party I have ever had. Only two persons did not drink because they were driving. One of them was Berit, my brother's fiancée. [She has two children and has been married before. She has lived with Beate's brother for years.] She did drink a few weak drinks in the beginning, and then she stopped drinking. Nils and Berit have often flirted before. For instance, once, in a restaurant, they were playing footsie under the table. They know I don't like it. I especially don't like him to flirt with her. The reason is that once, at a party 3 weeks before we married, she danced with him almost all the time. I haven't forgotten it. Well, at the party on Saturday she was in the kitchen helping Nils make the soup for a midnight snack. I went out in the kitchen and saw her cuddle up to him (*var bortpå han*) first once, and then once more. I became furious and screamed. I was totally hysterical. My brother came in and pushed me aside. I fell. That's how I got the black eye. A plate broke and I was bleeding. Berit found a piece of cloth to help me wipe away the blood. I was so angry at her for what she had done that I pulled her hair; but I had forgotten that. It was all her fault, in my view. She was sober, Nils was drunk." Elisabeth (who was one of the guests at the party and who had obviously also discussed the events before) said: "Berit should have pushed him aside and said 'I'm going in to Beate now. Beate surely needs help.' It is OK to give a hug, but when they start kissing with the tongues (*tungekjøssing*), that's too much!" Beate answered her: "I am not sure they kissed with their tongues, but anyway, I saw enough. I don't want anything of that sort when I am present. I readily admit that I may give somebody a hug at a party at my job, but I never do it when he is present." Elisabeth: "A hug, yes, but not tongue kissing!" Beate made no further comment on this. She

emphasized once more that Berit was sober whereas Nils was drunk. She continued to tell what happened next. The next day her brother and Berit visited her parents. "They told them everything. I don't think that was the right thing to do, but they did it. Yesterday my parents (e.g. my mother and they; *min mor og de*) came over to us for coffee. They sided with them. I wasn't able to say very much. I kept myself more anonymous. My brother called Nils the day after and said he was sorry to have pushed me. He could not call me as I was not at my job. But he said that Berit expected an apology from me. This was my parents' (e.g. my mother and they; *min mor og de*) opinion too."

At this point in her story Beate looked at the other women present: "Now comes the test. What would you have done if you were me?" The others seemed to hold that she should not apologize. Berit was sober and should have known better. Then Beate told: "I have called and apologized. But she was cold. She said she did not know if she could accept my apology. She wanted to wait and see. I slammed the receiver down. I am glad I did call her. I am finished with her. Now I hold the trump card. I am not nervous any longer. I was really nervy (e.g. had much nerves; *hatt så mykje nerver*). I stayed in bed for two days, not daring to show the black eye. I could not go out or anything."

She then told more about her brother and Berit: "They are not jealous. They go out to restaurants together. At the restaurant they each find another person for the evening, and then they go home together. They are not married, after all. . . . She has a beautiful face, but her figure is nothing."

Ellen supported Beate: "I understand you very well. I would have done exactly the same thing. I am especially jealous of Erna. She and Arne were smooching (*lå og klinte*) on our bed once, when she was highly pregnant. We had a party, only girls. We drank beer, but not a lot. Erna was lying on our bed when Arne came home. She did not feel well and therefore I allowed it. Arne was drunk, the way he used to be at the time. He saw his chance and went into the bedroom. I got an impulse and went out on the balcony to hang up clothes. They were lying there, smooching. (*Der lå de og klinte.*) I saw them through the window. I went back inside and over to the open door to the bedroom. I threw all of them out. Erna cried: 'Forgive me,

forgive me. I am so fond of you.' Later on, they have done the same sort of thing many times. I am especially jealous of her because of that event. Every time she and Jens are together with us, something happens. Last time was some months ago. Arne sat there rubbing her. I talked to Jens. He saw nothing. I saw Arne's hand moving up and down her ribs. Suddenly it stopped . . . I flared up, furious, and slapped their faces with my palm. Arne became rather meek. Jens supported me: 'She is right. I do not accept this,' he said."

The case clearly demonstrates how strongly they feel about sexual faithfulness. (This is so for both men and women even if it is not demonstrated here.) Spouses seem to belong to each other, and signs of the spouse's sexual interest in a third party is threatening. The meaning of events seems to be discussed in terms of actions and not in terms of motives. Motives seem to be taken for granted, action is what counts, because certain actions are perceived as breaches of important norms. Motives are also not immediately known, and norms are not completely clear and fixed. There is an escalation of danger and importance from hugging to intercourse, but people are insecure about how to codify each specific act. This could indicate that purpose or motive is also given some weight, but to me it seems that what people are insecure about is not motives but rather exactly when actions take on a new meaning, from being innocent to being dangerous. Over the years the specific codification of actions change, but the focus on actions seems to persist. The specific codifications of when it really matters, when actions take on a new meaning, is constantly debated. The fact that there is a hierarchical *ranking* of actions is more permanent than the degree of danger imputed to each act.

Beate seems to be insecure, since she makes her story into a test case. She does not fully want to stand up for her rage and anxiety. There is an implicit disagreement, which they do not pursue, between Beate and Elisabeth. Elisabeth codifies tongue-kissing as the limit when acts take on a new meaning. Beate is not sure whether they did in fact go as far as tongue-kissing.

By using alcohol as an excuse, the moral conflict is defined as being one between the two women, instead of being between husband and wife. She is mad at the other woman, not at her husband. Drunkenness, which dissolves boundaries, excuses him.

225

Men are defined as morally irresponsible in these matters (in fact, this is what they often say: 'Men are so irresponsible!'). That the actions took place in Beate's presence, makes the offence worse. There is thus not a unilinear scale of action (dancing, hugging, kissing cheeks, tongues, lying together, intercourse) but a three-way relationship. The reason seems to be that when Beate is present her self-esteem is more offended. This could also mean that if they kiss in her presence, they will have intercourse in her absence. To me self-esteem seems however to be most at stake, because the kisses are seen to be stolen from her. Beate's self-esteem seems in fact to be more offended than the relationship between her and Nils, in this case. Jealousy is very much about self-esteem.

The other couple, who are not jealous of each other, exemplify variations of codification. They allow extensive flirting including "playing footsie" and "tongue-kissing", but "they always go home together". They too stick to sexual faithfulness as a principle, after all.[2]

The next example is also from the *klubb*:

Example III
In the *klubb*, one evening, some interest-provoking events were discussed. Ellen had been out one evening some days ago, and did not come back before half-past seven the next morning. The event was already known by some of them. This is probably the reason why she chose not to keep silent and forget about it, but to give her own version before she was asked for it. She made the story into a funny self-ironic revelation about how drunk she was and how she lost track of time, but did not do anything sexually wrong. She went out to buy two pairs of jeans with a friend. Afterwards the two of them went to have a couple of beers, and then one more, and one more, and one more . . . until they were rather drunk. Some men had been talking to them, and Ellen herself went with one of them to another restaurant, and left her friend behind. When this place closed up, she went to a late night party (*nachspiel*) with the man she had met. ("I was so drunk, I didn't know where I went.") She must have fallen asleep, and did not wake up until the next day. She rushed downtown and found a taxi without knowing what time it was.

The other women listened to her story with somewhat

shocked and unbelieving faces. Sissel said: "I could never have stayed out all night. Benny [her husband] would have killed me." The story-teller answered: "Arne [her husband] has done the same thing himself. I only had to point to that fact." The others seemed to be shocked because she had left her friend at the restaurant, and because she does not know where and with whom she has been at this late night party (*nachspiel*). She had to answer questions about this and about what happened when she came home:

- 'What did Arne say when you came home?'
- 'Where have you been, you whore?' 'The whore, that was me!'
- 'How did you look?'
- 'I looked terrible. My hair was streaming down because of the rain the day before. My cheeks were red because of all the drinking.'
- 'What did Arne do?'
- 'He nearly sent the taxi back to find out where I had been.'
- 'But why did you stay so long?'
- 'I was drunk, you know. I fell asleep.'
- 'Did you fall asleep? Where did you wake up?'
- 'I was lying in a chair.'
- 'In a living room?'
- 'Yes, in a living room. I told you I hadn't done anything wrong.' (*Eg hadde ikkje gjort nokke galt*).

Her husband had been awake all night. The next evening he went out, but came home early, drunk. The women ask some more questions but did not offer any more opinions or evaluations direct to her face.

Some days later I had an appointment with Elisabeth to go and visit Kirsten. First Elisabeth and I talked about these events, and then the discussion continued at Kirsten's place. Both are members of the same *klubb*. First Elisabeth told me what Kirsten thought about the incident: "What do you think about Ellen!! Do you know what Kirsten says? 'This is what I call whims of a whore (*horefakter*)', she says. 'You and I, Elisabeth, we have been sozzled (*skita fulle*) many times, but we have always known how to get ourselves home. You are never

so drunk that you do not know where you are and who you are with'."

Elisabeth agreed with Kirsten's views. When we arrived at Kirsten's place the discussion continued: Kirsten gave her views herself: "I almost told her in the *klubb*, but I was afraid she would cut my throat. Why on earth did she do this? I cannot understand why she did it. It is a long time since Arne did the same thing. She has already forgiven him a long time ago. She cannot revenge herself now. Nothing good will come out of this. He will be so suspicious. And then he will want to revenge himself. And she who is so jealous! (. . .) She was sitting there trying to justify herself. I would never have told the *klubb*, exposed myself the way she did. If she had said it was a mistake (*en glipp*) it would have been different. Because that is after all what it was, a mistake. No, such things I call nothing but whims of a whore (*horefakter*). And I say this even if I am divorced myself. I have done this once myself, and I have regretted it many times (. . .) A woman is called a whore when she does such things, but a man is not called anything."

I asked Kirsten if she does not think this is unjust, that there are different rules for men and women. "Yes", she answers, "but we care more for the kids. Somebody has to care for them. A mother must be with her kids when they wake up. You are never so drunk that you cannot drag yourself home to the kids."

Ellen's version of what had happened to her was further questioned by both of them. They believed that she had done something wrong, e.g. been to bed with somebody and tried to cover this up by saying that she had slept in a chair. "She told us nothing about the party, and that is probably because she was alone with a man." "She has surely 'forgotten' where and with whom she was so that nobody shall ever find out what really happened", they said.

Ellen's story starts off with an innocent buying of two pairs of jeans. The act is self-centred. Individualism and acting on one's own is not in itself wrong. What matters is what specific actions one engages in. She becomes detached from her friend and attached to a stranger. The actions do escalate, but the way Ellen describe them they never lose their original innocence. She describes the escalation of events as being automatic. One event

leads automatically to the next. Their content, however, was innocent. (She did "nothing wrong".) Implied in her account is a view of herself not as a motivated actor but as "naturally" following her desires and urges. One act naturally explains the next one in the sequence of events that she constructs. As in the last example, there is all the same implicit morality of action rather than a situational morality, because what is most important to her to state is that she did "nothing wrong", that is she did not go to bed with this man.

Her friends are shocked. They stress different aspects of what happened. They question her account of the substance of what happened and also the form of actions. Staying out all night is in itself, whatever happened, a wrong thing to do in relation to a home with children. Their norm is that one should not go on to a late night party (*nachspiel*), while she stresses what she actually did there (nothing wrong). For them going on to a late night party is in itself a main sign of being loose, being a whore. They stick, in their interpretation of this event, to a normative line between excitement and danger that is drawn between a public place and *nachspiel*. What is wrong seems not to be acting on one's own, but to be inconsequential, random. Her problem is to establish that despite all she was consequential and thus not "wrong", but actually "right". (She did not go to bed with the man and she stayed so long because she was drunk.) Their discussion focuses on relationships between actions, conceived here as things, and not on motives. Both Ellen and her friends seem to presume one meaning for each act. Ellen's argument is unconvincing because her "forgetting" is not believed. In this way they negotiate the meaning of the event. Ellen's defence lies in the relationship of actions creating the automatique of the escalation.

Her friends are also, in addition to questioning the form of actions, concerned about what really happened. They demand more information ("You are never so drunk that you do not know where you are and who you are with"). Whore-ishness seems to be loose behaviour. One does not necessarily need to sleep around to earn the title, it seems. Being in control is what matters. Control keeps the danger at bay and is self-confirming. Thus, Ellen, has represented her behaviour as following a natural automatique and ultimately as being controlled, to resolve her dilemma. Her problem is to make that interpretation stick.

Her friends do not accept drunkenness as an excuse. Motherhood should be stronger than any drugs. A woman should know when to "drag herself home" because she is a mother, because that is where she is a mother and where the kids need her. They do not emphasize so much her position as a wife. The husband is the one who has reason to be jealous, and this is implied rather than expressed. Motherhood is the explicit reason given for women having to be morally responsible. In fact women, the way they see themselves, are the morally responsible ones, in contrast to men who are conceived of as being morally irresponsible in sexual matters, as well as in other aspects of personal relationships.

What would have happened if Ellen had done "something wrong" and if she had admitted it or if it had been possible to find out? There would have been a relatively high possibility that it would have resulted in a serious marriage crisis. Her husband would have become very unhappy, and it could perhaps have cost her her marriage, thus leading to rather drastic changes in her life. If she and her husband had been able to work this out, the result would probably have been a relative loss for her in the power balance between the spouses. Some of women's power and influence in the marriage rest on their responsibility and respectability.

One may ask, if she had done "something wrong", could she then have confessed it to her friends and denied it to her husband? Beate (example I), who admitted her insecurity, got support, but Ellen, who is believed to be covering up for herself, is met with disbelief and moralizing. The answer is that such a solution is possible but more improbable. Beate's act was not dangerous. She felt offended and did perhaps over-react. If Ellen had done "something wrong", this would have been more dangerous. By confessing such a thing, a woman might perhaps get pity, not necessarily support.

A woman gets support when she feels offended, not when she breaks important rules. Since women regard themselves as morally responsible, they are, among themselves, their own most severe judges. Direct to Ellen's face they use expressions that show that they do not take her story at face value. Their strategic questions also imply that they do not believe her. But they, like Kirsten, make no further explicit comments or evaluations when she is present, because "she would cut my throat". The result would be a broken friendship. Friendship is often taken for

granted in a case like this. Ellen has offended husband and children, not her friends. Friendships break when a friend feel personally offended. Therefore their criticisms of her acts do not result in breaking off with her. And they do not convey their criticism and disbelief further to her husband. It is to some extent a kind of internal justice and internal moral discourse.

But a woman cannot completely count on friends not conveying information back to her husband, her family (of origin) or to other persons where it might do harm. They make an effort to keep some information control, but it is seldom completely effective. Also, in the case of serious conflicts with one or more of her female friends, such information might be added to their grievances against her and thus spread. Women "stick together", but there are limitations to identification and support. The next example from the *klubb* also expresses the importance of being in control and what organizational and spatial arrangements can secure it.

Example IV

Sissel says: "I have stopped being so jealous. But it is a problem that he is so jealous. When we went to the Canary Islands he followed me wherever I went. I could go nowhere without him. I feel like being in prison. I feel like he stops me, that he wants me only to be interested in him . . . In my childhood I had a severe upbringing. I always had to be home in time."

Ellen: "Me too!"

Sissel: "And now I have married someone who continues the same thing!"

Kirsten reminds her of a party once: "You danced with one of the other husbands, and Benny went home, very upset, because of that. Everything happened in this one living room. He had total control, but he still became upset."

Sissel: "I have never done anything wrong . . . "

Ellen: "The best medicine for him is that you continue to dance with others, even if he does not like it. I had to accept that, and it helped. What happens in the same room is not so dangerous. There you both have total control."

This example demonstrates several of the same points as the first ones: strong moral commitment to sexual faithfulness, strength of feelings of jealousy, insecurity about the exact codification of

specific acts, and a willingness and ability to debate to find ad hoc solutions of interpretation, to establish the norms. Control is a key word. Spouses have to control each other. Attraction seems unavoidable. It is better to face it and control it. If one is not present it may get out of hand, if one is present it may be controlled.

The following case also concerns Sissel and happened later. This time doing "something wrong" led to marriage crisis and separation. Actions that some Norwegians perhaps might regard as relatively innocent are interpreted as extremely dangerous and important. The case shows how cumulative and accelerating meaning is ascribed to these acts.

Example V

Sissel and Benny had been married for almost 6 years. They were both about 25 years old and had two children aged 5 and 2. Benny was a sales clerk. Sissel cleaned classrooms in a nearby school every afternoon. They seemed to have a happy marriage. One day something happened that changed everything. Sissel called me early one morning from a telephone booth. "I need somebody to talk to. Benny has found himself another woman." I went to see her, and she told me the whole story:

"I have felt for a long time that something was wrong. There has been something in the air. My stomach has been upset. Yesterday I made a lot of fuss (*maste veldig*), and he admitted it. He is in love with somebody else. It has lasted one month. He has not gone to bed with her. Benny is not the kind of man who only wants one thing. They have been kissing and smooching (*kline*) in the car. He says that he does not know which one to chose, me or her. He wept yesterday evening and this morning. We sat up and talked until five. Then he went to sleep. I was sitting here, smoking and thinking. They have decided not to see each other again until after Easter. He says that I am much prettier and have a much better figure than her. I believe she is married too. I looked in his notebook to find out, and I found a telephone number on a cigarette paper, put away under the cover. (. . . .)

The worst thing is that this has happened before, 4 years ago. I found a love letter to a 17-year-old girl. She was not in love with him, however. My father was so angry, then. So I do not want to

tell my parents this time. It took such a long time before they forgot. They were so curt when talking to him. (*De var så korte*). He was so embarrassed.

He said yesterday that he wanted to relax and see how things arrange themselves during Easter and then perhaps choose me. But I was thinking when he slept . . . I must have some pride. I must show him that he can't do whatever he wants to. Therefore I said this morning that he has to move over to his mother's (literally to his mother and them, *moren og de*). I packed his suitcase and told him to choose her or me, and change his place of work. I do not want this to happen over and over again. He started to cry. What if he was not allowed to stay with his parents? I could not put him on the street. (*Eg kunne ikkje sette han på gaten.*) He said he is so fond of me. He patted my cheek and asked me to lie on his arm in bed.

I am so anxious about how things will work out for me alone, what money we shall live by. He said he would give me money, but . . ."

Benny actually moved over to this parents' place that day. He gave Sissel 300 kroner before he left in the morning. When work was over he went to his parents.

The day after I went to see Sissel again in the morning. At her place I found Tore, the husband of Benny's sister. He was unemployed at the time and had come because he was in the neighbourhood to apply for a job. When he arrived, Sissel had asked him to babysit for half an hour with the little boy who was sleeping in his room. He was smoking and drinking coffee in the kitchen. He is a heavy and muscular man, medium tall. Both body and face are roughly built. He looks and acts like a manual worker. "Sissel has just gone on an errand with Ellen", he explained. "She will soon be back." Since he did not know if I was informed, he did not say any more. (Ellen is Sissel's neighbour, childhood friend and *klubb*friend. They live in two apartment blocks opposite each other.)

Soon Sissel and Ellen came back. They had been away to talk to the woman Benny is in love with. Through a friend who was a client of Benny's, they found out her name and where and when she usually worked.

The first thing they both exclaimed is that "she looked shabby (e.g. rural, *strilete*). She was not very pretty (*ikkje nokke fin*).

Her coat looked like a sack. Her pants were too wide and too big for her. When she sat down there were lots of pleats over her bottom. She had no make-up at all on her eyes, and her eyelashes were completely white."

Ellen and Sissel are themselves both pretty and fashionable. Both are relatively tall and slim. Sissel has long dark hair, big grey eyes and a pretty face. Ellen has short, dyed, blond hair, blue eyes and a pretty face. Both use make-up on their eyes and perhaps a little lipstick and rouge on the cheeks. They wear very tight blue jeans, fashionable blouses, tight tweed sport jackets, and high-heeled boots.

They then proceeded to tell what happened. When they arrived at Benny's workplace, Sissel herself approached the other woman and asked her: "Are you Kari Nilsen?" The other woman nodded. "I am Benny's wife", Sissel then said. "We are about to be separated. He has moved over to his mother's. My little boy is very upset because of this. He cries and trembles because the father has moved." "My goodness", Kari answered. "Has it gone that far!" Then she had told them that she and her husband had had a crisis, but had now found out that there was, with two children, too much to lose. Sissel had then asked her not to see Benny any more, to come to her work after Benny had gone home. "I think I did the right thing", Sissel said to us afterwards. "Now I have all the best cards. What matters now is to play them well."

"I would have wrung her neck", Ellen said. "I admire you for being so calm. You two looked like the best friends in the world!" "But she was nice", Sissel answered. "She seems to be very straightforward and honest. One cannot deny that."

Benny, the husband, had seen Sissel talk to Kari. He had shaken his head and said to Sissel "My Goodness, how crafty you are!" (*Gu' kor utspekulert du e'*!)

Around the kitchen-table they continued to discuss what else Sissel ought to do. Ellen condemned Benny's acts: "There is no excuse for Benny's acts. He deserves not to get things too easy." Tore fully agreed: "He knew what he did. He has gone into this with his eyes open. I have also had many opportunities, but I have never used any of them. As long as I get what I need at home, it isn't necessary." Ellen said that her husband, Arne, pities Benny. "He has done the same thing himself, and he pities

Benny because he is so stupid. He does not see the consequences that these acts will have." Sissel protests against the most negative evaluations of Benny: "Nobody must say a bad word about Benny. He is kind, (*han e' snill*) whatever you say."

Tore and Ellen strongly advised Sissel to separate officially from Benny: "You must secure the kids and yourself economically. You cannot be dependent on him giving you money. What if he one day just says he has no money for you?" (An official separation implies certain rights to support and services from the welfare state, and regulated support from the ex-husband to the children.)

In the middle of the discussion we saw, through the kitchen window, Sissel's father coming. He worked on shift, and this was one of the days he worked evening or night shift. (Sissel's parents and two younger brothers live in an apartment in the neighbourhood, 4–5 minutes walk away.) When she saw him, Ellen asked Sissel! "Should I leave?" "No, no", Sissel answered, "you just remain seated". When the father arrived he and Sissel went into the living room to talk in privacy. We remained seated in the kitchen. Tore said to us, while we were waiting: "I do really hope that her father puts some sense into her head (*får litt vett inn i skolten på hon*), that he advises her to separate officially. If they should come together after a month or two, no harm will be done by that."

They judged Benny severely: He knew what he was doing. "But", Tore said, "marriage should not imply being completely hooked up, either (*du ska'kje vere lenket heller, fordi om du e' gift*)." He told about some of his wife's friends who were not allowed by their husbands to go out and dance, a whole group together. "That is not right, either. There is a long step from going out, meeting people and dancing – to going to bed (*legge seg ner*)."

Sissel and her father came out of the living room after about 10 minutes. He exchanged a few words with us in the kitchen before he left. He seemed to feel embarrassed. He said that Sissel's mother was in despair. She wept and wept. She had an appointment with Benny at his workplace today and had to joke and pretend knowing nothing, because Sissel had asked her to pretend not to know. Sissel's father was especially worried because this was the second time Benny had done this. "It may

happen over and over again." He was afraid that Sissel would become nervous again (*få nerver igjen*). She has been very nervous before.

Tore wondered what his parents-in-law would say about his being here now. He was afraid they would get angry because he was here and supported Sissel. Therefore he had at first thought of not coming. "They will have difficulties in defending Benny. There are no arguments that support his acts." "But", he said, "a case always has two sides, and I do not know the other side yet."

Sissel's father left, and after some time the others left too.

The next day I arrived at Elisabeth's place just after Sissel and Ellen had been there. (Elisabeth lived in another part of town than Ellen and Sissel. All three were members of the same *klubb*.) Sissel and Elisabeth were good friends and saw each other often. Elisabeth and Ellen did not usually meet outside the *klubb*.

Elisabeth was, that day, a bit disappointed that Sissel had also brought Ellen, and that she had stayed such a short time. Georg worked late, and she had expected Sissel and her children to stay for dinner, to have a long afternoon together.

The crisis between Sissel and Benny was her main interest: "What do you think about it?" Elisabeth asked me. Her own opinion was that Sissel is making far too much of it (*tar det altfor voldsomt*). "She listens too much to Ellen. Ellen is so vengeful. I do not think, as Ellen does, that it is necessary to separate officially, with all the bureaucracy that this implies. I am afraid this will make him angry and then he won't give a damn for his family. It is better to wait and see if he brings money or not."

Elisabeth also wondered about the reasons for Benny's acts: "I wonder what is wrong with Sissel. Something must be wrong, since Benny does this. The only thing I can figure out is that she is quick-tempered. But Benny is quick-tempered too, so that does not make any difference."

In the ensuing period Benny stayed with his parents (and a younger sister who still lived at home). His parents have more than usually strong moral convictions against divorce. They felt a great moral burden. Partly they blamed their daughter-in-law. ("She is not a competent mother." "Her children are dirty and badly kept.") Partly they solved the problem by helping Benny

to find a new, smaller, apartment. When he was no longer under their roof, they felt less responsible for his acts.

The happenings that led to Sissel and Benny's separation demonstrate how some relatively innocent events (from an outsider's point of view) quickly escalate into a serious crisis. The seriousness lies in the different interpretations given and the consequences that follow from them.

Both Benny and Sissel codified the situation as a crisis. Sissel's perception of crisis seems to some extent to be derived from Benny. He has experienced strong emotions of being in love and is insecure about what these emotions mean and what he ought to do about them. According to the rules of marriage, such feelings should be reserved for one's spouse. They should simply not exist outside marriage. He therefore, according to Sissel, immediately feels that he has to choose between his wife and the new woman. The choice is between the two women. That he eventually loses home and children at the same time as he loses his wife is implied but not expressed by Sissel. He wants, however, some time to reflect and think things over, she says.

Sissel is concerned about what the kissing means to Benny. To her it is a clear sign of his being in love and that she herself has lost his love. The seriousness of the matter is such that it allows her to break ordinary rules of conduct; she permits herself to read his private papers. It further adds to the gravity of the case that this has happened before, and therefore can happen again. How can a man who has twice lost control ever be trusted again? Her view is more absolute than this. She cannot accept the ambiguity of the situation. Since he does not choose her on the spot, she cuts off their relationship. Cutting off their emotional bonds means that they cannot live together in the same home. The emotional bond to her is his *raison d'être* in the home. His parents are his closest relations, e.g. "his mother and they". In his case (for shelter and warmth) the mother is stressed. In her case (for defence of her rights) her father comes over. He is afraid that they might not accept him. Benny tries to soften her by appealing to her emotions for him. In the symbol septem of his discourse the alternative to the (warm cosy) home is the cold inhospitable street. The implication of his argument seems to be that one sends children out into

the street during the daytime, but one does not send a husband out at night.

Sending Benny home to his mother is a spatial dissociation that seemingly is intended to make the situation less ambiguous, but is actually setting the stage for a greater crisis, since Benny's moving out is seen more as preliminary than as temporary.

Sissel calls on allies and confidantes to help her sort things out more. One of the first things she does is to approach the other woman direct, to find out about her interests and present her own. She presents herself as Benny's wife, and brings in the feelings of the children. In a way Sissel makes the other woman responsible for the tremblings of her son. Kari must keep away, not give Benny any more temptations. She is Sissel's adversary in this contest for Benny's love. The other woman has different interests, but Sissel obviously counts on her being the same sort (a woman) and thus on her ability to identify with her own situation. She does not approach her alone, but together with a confidante, a witness and moral support. The other woman reacts exactly the way Sissel hopes. She recognizes Sissel's problems. She has the same problems herself, and has chosen marriage because of the children.

Sissel has turned the problem into a conflict between adversaries who are equal and identical. It is an honourable conflict, where the adversaries are able to identify and recognize each other's good qualities and different resources. Attractiveness is one kind of resource. The first thing Ellen and Sissel report on, when they come back, is her attractiveness (beauty, decoration, fashion). What they see does not threaten Sissel's identity as an attractive woman. Ellen's comment ("I would have wrung her neck") suggests that less honourable conflicts are also possible. In this situation Benny is a helpless onlooker to the women's discussion. For him the situation has got completely out of hand.

Sissel's allies offer their different views on Benny's acts, views that to a great extent focus on actions, not on motives. The interpretations of Benny's acts and their social consequences are taken to be self-evident, but are actually interpretations of the situation. The usual consequences, then, of doing specific actions are used as a basis to speculate about motives. The interpretations in terms of acts and not of motives also add to the gravity of the case. Ellen does not really criticize his motivations, but his social intelligence. He knows the usual consequences of such acts, so he

should have known better. Tore's argument somehow implies a view of man as associated with nature. If he himself had not got what (sex) he needed at home, then perhaps he would have used some of the opportunities . . . He does not, however, suggest that this might have been the case with Benny. A happy love life between Benny and Sissel is taken for granted in the discussion. Such matters are probably too private and thereby too offensive to be suggested.

Sissel insists on Benny being kind, not evil. In their view Benny's identity as a man is not separated from his identity as a husband, which seems to be why the case goes from an atmosphere of tension to a crisis in a single step, and why Sissel's strategies take the "all or nothing" form they do. There is a concentration on the wholeness of persons, rather than a view of persons as bundles of roles.

The emotional bond is closely related to the economic bond and to the legal bond as it is defined in Norwegian law. Ellen and Tore advise her strongly to separate officially, i e. bring Benny's wrong-doings into the legal and administrative field of the authorities. The matter will then not only be their private concern, but also a concern for the authorities, and accordingly more serious. They advise her to give priority to her own independence. The value of autonomy is thereby brought inside the household. (See also chapters thirteen and fourteen for a further analysis of this theme.) Their reason for suggesting that she should prioritize her independence is that they judge Benny not trustworthy. When he lacks control over his emotions, how can he control his money? Autonomy and individualism are better than dependence on a man who has proved to be out of control. Also inside marriage the value of autonomy thus makes itself felt. When a crisis happens one easily thinks of dissolving the corporation into two autonomous units. Very quickly their whole marriage and communal household are at stake, and Sissel is at last left with the choice between very radicalized alternatives.

There are, however, slightly different views among her allies. In cases like this parents are expected to side with their own adult child. The visit of the father excludes other confidant(e)s. A practical solution is found by a physical separation. He is concerned about Sissel's mother being somewhat out of control (weeping) and Sissel perhaps becoming out of control (nervy).

239

Losing the man in the household make boundaries unclear.

Tore expresses a dilemma of divided loyalties. It is implied that he is sure that the separation will automatically be codified as a conflict and that the two families will take opposite sides. Married to Benny's sister, he takes the side of Benny's family. At the same time he is only an in-law, and this makes his position ambiguous. This is probably why he has visisted Sissel today. His ambiguous status makes him one possible channel of information between the families. (Another person is Benny's sister, who is also Sissel's friend). Tore keeps the possibility open for changing his point of view. He has only heard Sissel's version, and "there are always two sides".

Elisabeth, on the other hand, tries to see both sides, even if she has only heard Sissel's version. She does not disagree with the codification of Benny's affair as serious, but she disagrees with the degree of danger and seriousness imputed to it. In Elisabeth's view Ellen has advised Sissel to escalate the crisis too much. Revenge is not the proper reaction, but suitable tactics. A man has to be handled with care, otherwise you risk completely losing the necessary control over him. (This was, in fact, Sissel's view too, but she concentrated her tactics on the other woman, to control him through her.)

Elisabeth also tries to see things from Benny's angle by figuring out what reason he has for doing this. They focus on actions and the usual consequences of doing certain actions and have to guess at motives, what reasons he had. The implied assumption is that, in the case of a crisis, there is something wrong with the persons involved. Elisabeth diagnoses disturbed relationships as something wrong with persons, hence with the "victim" too. Elisabeth does not express a guess at an unhappiness in their love life together. She only mentions Sissel's quick-temperedness, but since Benny is quick-tempered too, this cannot be the reason. In this way Elisabeth manages to look at things from both Sissel's and Benny's viewpoints, without saying anything bad about Sissel, her best friend. Elisabeth's loyalties are also divided. Her ability to see things from Benny's angle is a measure not only of her friendship with Benny as Sissel's husband, but also of her loyalty to Georg, her own husband. They have had time to discuss this the evening before. As a man he identifies with the other man.

Benny's parents try to use Sissel's being a bad mother (in their

view) as an explanation for their son being a bad husband (in everybody's view, to a greater or lesser extent).

In the period that follows they have a long and emotionally disturbing, but also, by bringing new experiences, thought-provoking separation. Sissel has both ups and downs in this period. Seven month later, on a particularly depressing day, she expresses these reflections:

> *Example VI*
> "I feel depressed. I am fearful because of all that happens . . . I have gotten into such a mess (*Eg har rotet så veldig*). When I feel depressed I wish I had the security I had when I was married. I feel I could have written a book about everything that has happened these seven months. People would not believe me if I told everything. Now I will stop drinking and stop going out so much. I am afraid and frightened when I see what this life brings along. I am afraid of slipping (*skli utfor*). I feel it is so easy to slip. It is easy to be just like Kirsten, and that I don't want. 'Don't give a damn' (*Gje faen!*) Kirsten always says. 'Don't give a damn!' When I was married, I always said to Kirsten that I could not understand how she managed to live the kind of life she is living. Now I understand how easy it is"

Sissel did not write a book about everything that happened. Her utterance demonstrates, once again, how important being in control is. Control is related to autonomy, losing control is losing independence.

The next example demonstrates both continuity and change. During a morning coffee klatch at Mona's place where Mona, Jannicke (one of Mona's neighbours), and I are present, she told us about the party they went to at New Year's Eve:

> *Example VII*
> Mona had for a period been going out very often to discotheques with female friends. Her husband, Edvin, does not enjoy dancing, so he had mostly stayed at home as babysitter. For some time the two of them had been discussing jealousy. Edvin had held very strongly that for him it was impossible even to think about other women than her. Then at New Year's Eve, something happened. Mona tells the story: "Edvin was sitting on the

couch, kissing a girl. There were lots of people in the party that we knew. Edvin has earlier, before we married, been going steady with several of the girls. He had also been going steady with the one that he kissed. He was drunk and she made herself available to him, nicely served up on a plate. (*Han fikk det ferdig anrettet på itt fat for seg.*) I was not jealous, instead I laughed. I know these girls so well. Perhaps I would have been more jealous if they had been really pretty. When I wanted to go home, Edvin wanted to stay longer. I told him that it was perfectly OK with me, if he only escorted me to a taxi first. But then he went home with me. I wouldn't have minded if he had gone to bed with her. I am glad that for once he did something against his principles, that he understood that it is nothing but nonsense to say that he cannot imagine making love to anybody else than me. It is a part of life that you can imagine making love to other persons. I have told him that I could very well imagine both kissing and going to bed with some of the men I meet at the discotheque. He did not understand that. But I have not done anything wrong. He did more wrong things in 5 minutes than I have done in all the evenings at the discotheque. I am glad that he has discovered that he may also become interested in some-body else. He had to admit that this is a part of life. First he did not remember anything from the party. He was drunk, he said. I had to remind him. "Why did you want to go back?" I asked him. "There were some bottles of beer" . . . he mumured. I laughed loudly. Then he had to admit it.'

Mona is less jealous in this situation than what is expressed in several of the other cases above. Part of the reason is that she knows these girls so well and does not see them as a threat. Edvin had already, several years ago, left them for her. Part of the reason is also that she does not only consider acts but also their motives and contexts. This makes her different from the women in the other examples. She has more of a motivational ethic than the others. She does not see this context as threatening ("I know them so well", "He was drunk", "she served herself up on a plate") but recognizes that it may be different in other contexts ("perhaps if she had been very pretty . . . "). Most of all his acts support her arguments in a continuous discussion between them. In this discussion he used to be the moralist (he cannot even think of being

sexually interested in another woman). She goes out to disco-theques and holds that "it is a part of life" to be interested in others. By his acts the moral positions have changed. She has got legitimation for going out and being interested in others ("it is a part of life", "he had to admit it"), *at the same time* as she has seized a position as morally the more responsible one in the relationship ("he did more in five minutes than I have done in all the evenings at the discotheque"). After all she sticks to a morality of action. It seems to be self-evident what actions are "wrong". Now he cannot complain about her going out. She forces him to recognize its legitimacy. At the same time moral rules of sexual faithfulness are confirmed ("I had not done anything wrong"). She has, at least for a while, succeeded in reconciling not only both excitement and confirmation as morally responsible, but also con-firmation of being morally the more responsible of the two. Mona, who seems to have made the leap into motivational thinking, really hasn't at all. She has her categories firmly in hand, resolved so to speak, with a grip on what the other cases do not really convey.

Moral support from female friends

When together on their own, the young women develop informal common understandings about how to handle their lives, including their husbands or menfriends. They support each other, but also give each other warnings and apply sanctions. The shared under-standings that they develop are the source of some strength in their relationships with their husbands.

Their moral discourse demonstrates some of the basis for iden-tification and conflict both between women and between women and their husbands/boyfriends. During a crisis friends are mobil-ized and informal rules are made more explicit than in everyday life. There are similarities and differences between segments of Norwegian society in the way such crises are codified and solved, by routinized practices and solutions. In the social circles described in this book women are very influential concerning moral matters and the family networks. The husband/wife relationship is ideologically dominant (Hsu 1971).[3] "The husband comes first", then the friends. This is symbolized by always

finishing coffee klatches in due time to tidy up the house and fix *middag* (dinner) before he is home. The *middag* is the most compelling reason for finishing a coffee klatch. They reduce visits and revisits when the husband is at home. Both time and place are more private and more sacred then. The tensions due to conflicting loyalties are reduced by some separation in time and space, by some avoidance between the husband and the friends of his wife. While the husband is ideologically dominant, loyalty to husbands in this milieu is not such that it prevents the wives from seeking advice and support in some matters.

Through their discussions and sociability women get more "private" information than men. They tell humorously how their husbands try not to show how eager they are to hear the latest news when, for instance, they arrive home from the *klubb*. They try to hide compromising information about their own best friends from their men, even if they criticize a friend among themselves for the way she has behaved. A husband might use this information as an argument in discussions: "See what she did. Therefore I don't want you to go out alone!", or he might just feel their marriage threatened. Information control is not completely effective, however. Part of the reason is that they do not conceal information about acquaintances, women with whom they are not particularly close friends.

Female friendships are thus ideologically secondary to marriage, but at the same time expectations of loyalty are extremely high, and disappointments over disloyalty equally strong. "How could a woman friend (*en venninne*) do such a thing!"

There are, however, limitations to moral support. The women of this study keep, to some extent, secrets from their men, but they do not give each other moral support to break moral rules that are regarded as important. One cannot confess and expect support about having a lover. One may at most confess that one is in love, but not that one is doing anything about it.

Approaching rivals

Not only are expectations of identification high towards friends but also, to some extent, towards rivals. Sissel approached her rival direct, expecting to develop together with her a common

understanding of the difficult situation. Later in her separation process, Sissel approached Kari once more:

Example VIII
There were numerous difficulties between Sissel and Benny during the period they lived apart. One day she met him and he was particularly nervy and desperate. Sissel understood that he still cared for Kari, the other woman, but that he had not seen her for a long time, and that he was insecure about Kari's feelings for him. Sissel decided on the spot to go and talk to her, to find out. She went alone, by car, to Kari's home. Kari lived in an old cabin, some 10 kilometres from the centre. When entering the garden, Sissel saw a couple of small children playing. "I rang the bell", Sissel related. "Nobody opened. I knew that she was inside, since I had seen children outside. She had probably seen me coming. I shouted that she should open the door, I would make no trouble. Then she opened the door. And then we sat one whole hour and chatted in such a friendly (*koselig*) way. She even made coffee and rolls for us. She said that she regarded her relationship with Benny as being over. She did not want to see him any more. She found it difficult to tell him direct, however, because this would make him feel so miserable. She and her husband had had such a good time during the summer holidays. She thought that they needed this, because they have had so many problems. He was the kind of man who did nothing at home; he used to stretch out on the couch as soon as he came home from work. She functioned (*gikk der*) as a maid and a mistress, she said. But now, after all this had happened, he had changed. They have not talked about Benny during the whole holiday. She does not want to see him any more. She just wants to let it pass quietly. She has been in love with Benny and still feels a twinge in her stomach because of him. (. . . .) I pitied her a little bit. I almost told her that in just the same way as she used to live with her husband, I too used to live with Benny. But I did not want to say one bad word about Benny. It could so easily have been misunderstood. That was not my reason for going to see her."

The next example is one where a confidante actually contacts the rival:

Example IX

Marie is married to Atle, a man who goes out "too often". They have two children. Atle is a driver for a private company. Marie has had different kinds of part-time work, mostly cleaning and work as a saleswoman. Marie also goes out to discotheques and restaurants, but she never goes on to late night parties (*nachspiels*). She goes to different places from her husband. Her friends think she is a nice woman and a good housewife. But they pity her, because her husband is, in their view, no good. "It is only restaurants and womenfolk with him", they say.

Once, after she had been away to visit relatives with the children for a week, he did not come to fetch them as promised. She tells the story herself:

"A few days later, when one of the boys needed a box for his glossy coloured prints, I found a lady's name and telephone number on a recent ferry schedule in one of their father's boxes of airplane equipment. (He is an eager amateur pilot.) I later asked Atle about it, but he denied it. I threatened to call her. The same day I went to a telephone kiosk together with Kirsten. Kirsten called up the number, while I stood beside her. When a woman answered, Kirsten said she was the friend of the wife of Atle Berentzen. She told that I had found her name and telephone number and asked her what she knew about Atle. The woman replied she had only met him and talked to him one evening at P dancing place. He had told her he was divorced, that he was a pilot by profession, and that he was building a house with his parents at Q island. Kirsten told her the realitites: he is married, a driver on a delivery truck, and planning to build a house with his wife and children on this same island. The lady was very disappointed to hear this, because she had got such a good impression of him. She is herself divorced, has three children, and lives in another suburb of cooperative apartment blocks.

When Atle came home from work I teased him with what we had learned: "Is it really true, that you are building a house with your parents?" He became furious, because he understood that I had called her. He had thought that I would never dare to do it. He screamed: "Now you have made a fool of me for everybody at P (dancing place)!" Now they will sit there and point at me saying: "there he is, the guy who has three kids and whose wife

checked up on him and so on and so forth . . . " Now he seems to have calmed down a little, but he does not talk to me. He does not talk and is sulky when he is home (*han bare mulker når han e' heme*). He waits for me to start talking, but I am dead sure I am not going start this time. I am not the one who is in the wrong!"

The husband had separated roles and fora and played out what are conceived to be incompatible roles towards the two women. His role-playing was based on their not knowing about each other, on segregated fora. The case demonstrates that even women who do not know each other and have opposite interests in a man, may expect each other to be able to identify with a rival, to develop common understandings to protect marriage and good morals. The alternative to identification is to be regarded as having loose morals.

Sketching some contrasts to friendships in middle-class social circles

In some middle-class milieus loyalties to husband and children are such that it is sometimes difficult for women to have close female friends at all (Holter, von der Lippe and Haavind, 1982, Haavind 1982). If they have friends, there may be limitations to what they can talk about and discuss. Broaching marital problems is easily interpreted as an improper public "washing of dirty linen" (*skittentøyvask*). Such matters are to be kept inside the family. At most they are confided to one good friend. One description of an extreme milieu in this respect is given in Marilyn French's (1977) novel *The Women's Room*, from the United States. The suburban middle-class women she describes in the first part of her book meet in the morning, and talk endlessly about children, clothes, cooking and homemaking. The husbands are always, figuratively speaking, in the background, but they are seldom explicitly mentioned. When they are mentioned it is often in ways like this: "Paul likes his coffee strong, so I make the coffee strong and put water in mine", "Norm does not like pork", "Hamp will not touch a diaper".

Such cognitive boundaries around marriage also seem to exist in Norwegian middle- and upper-class circles. Measured against this

background, the creed that the personal is political which was put forward by the new (mainly young educated middle-class) feminists of the seventies was a considerable change. In feminist student and academic milieus moral problems in relationships with men are now more openly discussed. The lines between loyalty and disloyalty to husbands are differently drawn than before. It became possible to tell about marital problems without being regarded as disloyal, at least by the female friends. These students and educated women are now perhaps to some extent doing what working-class women have done for a long time. But life situations have changed in the different classes, and this may rather be the reason. Relationships with men imply other problems today than one or two generations ago. The need to discuss has perhaps become greater because old roles have changed and new roles are emerging.

In some ways, limitations to moral support may be smaller among young educated women, who to some extent have more liberal motivational ethics. It may in some circles be possible for women to have solidarity about testing out moral rules by breaking them. Combining confession and secrecy (from husband or a steady-going friend) gives both some freedom of action and moral support at the same time. Such middle-class marriages may thus seem to be both more privatized and to be less protected than the working-class ones described here.

The differences may be explained both in terms of the importance for working-class women of being regarded as morally responsible, and in terms of the structure of female friendship relations in different milieus. If there is one or a few particularly strong friendship relations, (a pattern of having a best friend and confidante), confessing is easier. When there are many friends, and a tendency towards network density and overlapping friendship circles (a clique pattern), as in this milieu, confession becomes more difficult. Dense networks are usually not characterized by intimacy and exclusive information, but rather by a tendency of levelling out information.

As far as I know, an educated Norwegian woman would not approach a rival direct to protect her marriage. In a similar situation she would try other solutions, count more on talking to and fighting things out with her husband. The reason is perhaps both that their norms about marriage and adultery are more liberal and

less strict than in the milieu described here, and that they have more confidence in men's ability to understand and less confidence in the sympathy of unknown women. They also do not in the same way have a view of men as needing to be controlled and of themselves as needing to control men. Because the working-class women have these views of themselves as women and of men as men, controlling their husbands does not damage their images of them. It is a "natural" part of their roles as women to control men. In more liberal marriages, however, such solutions seem to be more unsatisfactory. In these social circles motives and emotions are the main problem. Stopping his opportunities by allying with the rival is therefore no real solution. On the one hand this opens up more flexibility and less risk of an escalating development to a crisis point. On the other hand there may be a tension between an intellectual focus on motives and an emotional focus on "what really happened".

Conflicts

Some conflicts in the friendships of the young women in this study are intimately related to their moral discourse in an intriguing way. Friends do not break off with each other because of what is considered morally irresponsible behaviour. In the last chapter we saw how Ellen was criticized without her friends breaking off with her. Friends get on bad terms with each other when they feel directly offended in their relation to each other. The cause for quarrelling is, however, sometimes activities and interests in relation to men. One obvious cause is when two women are rivals for the attention of the same man. The second reason is more important but also more indirect. "Whorish" behaviour may affect friendships, not by friends breaking off with the "immoral" one, but on the contrary, by her breaking off with friends because of rumours of what they say about her coming back to her.

Some examples of conflicts between close female friends help to document these statements:

Ellen and Gunvor had been close friends since they were three years old. There were, however, sometimes cool periods when they did not visit each other, but "only met outside, saying hi!"

One of these periods lasted for almost a year. The reason was that a famous sportstar and married man moved in with Gunvor, in the apartment she had as a single mother. Ellen told Gunvor that she should not let him do this, and Gunvor became angry with her and would not speak to her. Ellen was very sad because of this, as long as it lasted.

Kirsten and Anne came to know each other because Anne's father had a relationship with Kirsten's neighbour, a divorced woman. First Anne's relationship with her father's friend deteriorated because she told him how his girlfriend was giving parties and taking in other men when he was at sea. He dropped the girlfriend and she dropped Anne, because of that. But Anne continued to visit Kirsten and drink coffee with her almost every day for more than a year. Their relationship was also terminated definitively (it seems) when Kirsten had marital problems and Anne let Kirsten's husband stay with her for a weekend. When she learned this, Kirsten immediately went over to her and scolded her (*tok hon*, e.g. "took her"). After this Kirsten did not want to have a close relationship with Anne any longer, but they continued to "say hi" when they met out at discotheques.

Kirsten and Marie live close to each other, only a few minutes' walk apart. They came to know each other some years ago while working in a sanatorium. They often had coffee klatches together and escorted each other to discotheques once in a while. One day Kirsten became very upset, because she heard from other friends that Marie had talked unkindly about her to them. She had revealed things to them that Kirsten had confided to her, and had criticized Kirsten for being too interested in men and thereby neglecting her children. When this had happened several times, Kirsten decided that she was finished with Marie, that she could not take any more of this, and stopped going to see her for a while.

Sissel was extremely disappointed and angry with Kirsten once, during her separation period. The reason was that one night Kirsten had taken home a very attractive man that Sissel had an almost steady-going relationship with. When Sissel found out, they had an heated argument. Sissel screamed that Kirsten was a whore who took one man after another home to

her bed. Kirsten wept and said that she knew she had acted awfully (*jævlig*), that it was awful to do such a thing to a friend, but that Sissel had no right to call her a whore. The day after this incident Sissel said that she was much more crushed by the fact that a woman friend (*en venninne*) could do such a thing to her, than by what Benny did to her by falling in love with another woman. The relationship between Sissel and Kirsten was, however, resumed after some months that did not lack other dramatic incidents.

The sanctions used in cases of conflict are varied. Besides stopping visits, another sanction is to "measure" (*måle*). This sanction is used mostly for acquaintances but also for friends. To "measure" (*måle*) is to look the other person up and down, from the face down to the feet and up again, with a condescending look, and without speaking to her (or him). The idea seems to be to demonstrate how (figuratively speaking) small and disgusting a person one finds the other to be. Ellen's sister "measured" a woman working in a bank who used to flirt with her boyfriend. Ellen had a conflict with Sissel once, because she thought Sissel "measured" her. Sissel thought Unni, one of Kirsten's friends "measured" her once during the period she and Kirsten were not on speaking terms.

Spreading rumours

"Spreading rumours" is both a reason for conflict and a sanction in case of conflict. There is a constant concern about controlling information and stopping rumours. Rumours are in this context always perceived as negative, as leading to a bad reputation. Women's talk may be examined from many different perspectives. It is concerned with the creation and defence of cultural standards. It contains the giving and receiving of emotional support. It provides confirmation or rejection of an identity as morally responsible, as not loose and whorish. It sometimes contains gossip and the making and "spreading of rumours". By rumours "coming back" one understands that one or several friends have criticized one's behaviour "behind one's back", in other fora. This leads to disappointment and feelings of distrust.

When discussing dramatic incidents in other people's lives the participants pool their pieces of information, so that the group's knowledge about the incidents increases. They also provide evaluations of these incidents. Folk wisdom says that "when people speak two by two about an incident, things are constantly added until it is not possible to recognize the original story". Information about incidents and evaluations of them are constantly spread by such talking. Information is revealed, processed, spread. And information can be dangerous, dangerous for creating "a bad reputation", and for having one's claims to an identity as a morally responsible person rejected.

The process of "spreading rumours" is one where friends and friends of friends talk about and evaluate an incident or a person in different fora. One of the persons may bring the "rumours" back to the one concerned, and recount what others say about her. Such processing of information may become extremely complicated. The one who retails the rumours may, for instance, only tell what the others said, not what she herself said in those situations. The person addressed then becomes very disappointed over the disloyalty of those friends or acquaintances who have talked unkindly about her, and she may try to "stop the rumours" by approaching those who have talked about her and defending herself. Men as well as women participate in spreading these kinds of rumours. The difference is only that men have somewhat less access to confidence and personal information than women. Spreading of rumours is more likely to occur in some network constellations than others. With several clusters of friendship circles, people with opposite interests or personal animosities, and some overlapping membership of circles, those who have double membership have, structurally speaking, key positions for unwanted spreading of rumours.

It does, however, matter who the person with overlapping membership is. People differ in their interactional style and their ways of handling delicate information. A few are considered as having a "poisonous mouth", or simply as "talking too much" (*maser for mykje med kjeften*).

"Spreading rumours" is spreading information that may harm the reputation of the person concerned. The information may go to particular persons who can misuse it, or to wider circles of persons: "Everybody down at X (dancing place) knows . . . " or

"Everybody at Y" (cooperative estate) and even "the whole town knows". One standard expression is "a rumour in town" (*et rykte på byen*). Georg once told me that a particularly funny incident that happened at my place was now "a story going around town" (*en historie på byen*). By that he meant that he had told so many persons about the incident that it now had a life of its own going around town. This reflects perhaps that Bergen is a relatively small-scale town where one may sometimes have the feeling that "everybody" knows, even if that is not literally so.

Another expression is "you have been noticed in town" (*du e' observert på byen*), meaning that one has been observed downtown (at a dancing place or restaurant) in a compromising situation. The speaker does not want to reveal the source of the information. She or he may also say "A little bird told me that . . . " (*eg har hørt en liten fugl så kvitret . . .*).

The problem of "spreading rumours" is the back side of the medal, so to speak, of their moral discourse. There is a certain conflict between partaking in these discussions about matters vitally important for them and loyalty to friends.

The tension between loyalty and talking is also revealed in the standard jokes about sewing circles: the members always talk about the one who is not present. But there is more to the question than this. This kind of gossip means different things for the two sexes. Women are more vulnerable to accusations of bad sex morals than men. An interesting parallel to the present milieu is a study made by Sigurd Berentzen about the young boys and young girls of some ghetto streets in Philadelphia, USA (Berentzen 1981).[4] There are some striking similarities between "spreading rumours" in the present case and "sending messages' between young adolescent girls in the ghetto. Berentzen points to the different kinds of groups formed by boys and girls as a result of the different values that they have. Boys form larger groups; their values are such that they can easily rank themselves in terms of bodily strength, being a good leader and so on. Because of their relational values, the girls do not form larger groups; they form dyadic friendships and small shifting groups. They are all the time concerned about "sending messages", evaluating each other behind each other's backs and fighting and straightening things out when the "messages" find their way back to the one who was talked about. Berentzen analyzes these processes in terms of

ranking and prestige, arguing that the relational values of the girls explain the dyadic relationships, the small groups, and the problems of ranking. "Messages" are about rank. In my view this is not wrong, but unidimensional as an analysis. The girls are to some extent seen in terms of what they lack (larger groups, clear criteria for ranking) compared to the boys, more than in terms of what they are up against themselves. He does not take account of the cultural values and dilemmas expressed and the identities they want to have confirmed.

In the present chapter I have examined what spreading rumours is about, their cultural and moral content in this particular Norwegian context. Spreading rumours threatens a woman's identity as a respectable decent person, and is thus connected to rank. But they do not talk and thereby spread rumours primarily to make internal rank hierarchies among themselves. They talk and debate these issues to solve existential value dilemmas that they have. Moral discourse and "spreading rumours" are about value dilemmas. Moral discourse is related to female solidarity in the same way that "spreading rumours" is related to their conflicts. Solving (for the time being) contradictions between being an attractive woman and being morally responsible creates new problems, of "spreading rumours" and conflicts between friends, a circuit of contradictions which is only temporally and never completely resolved.

Conclusions

The moral discourse of these young mothers is characterized by being very concrete and personal. They never discuss moral problems *in abstracto*. General problems are discussed through concrete events, in a verbally very eloquent way. The women of these examples are not taciturn country folks, but verbally eloquent urbanites.

All the examples I have given are in one way or another about the rights and wrongs of how to express sexuality. They give each other warnings, support, sanctions, advice about how to handle their sexuality. Sexuality is important to them, and they are at the stage of life when one is sexually most active. They are also relatively young and do not feel as confident about love, sex and attraction as they will perhaps later become, with more experience of life.

While they are in some ways both concrete, direct and out-spoken, it is worth noting that some matters are not talked about or only problematized in certain ways. The personal feelings of love, attraction and sexuality remain basically very private, and each person is left alone with her eventual feelings of insecurity.

Their ethic seems to be more of a normative ethic than a situational one. Actions and their relations to each other are examined, whereas motives are to a large extent taken for granted. Their ethic is one of norms and assumed consequences of breaches of norms, presuming, often, one meaning for each act. Mette and Mona are, to some extent, exceptions to this in that they express the idea of taking the motives of their husbands into consideration.

Their dilemma is, to some extent, to reconcile two different worlds – hearth and home and going out. Female friends may in many ways be seen as mediators between those two worlds, as both escorts, allies and as confidantes. The women in this study are in a fundamental way striving to create an integrated whole of their lives, to integrate diverse and conflicting roles and experiences. In so far as they insist on pursuing conflicting interests, they also work hard intellectually to integrate these interests. Life as an integrated whole is the ideal, not life as a hotchpotch of different colourful roles. Contradictions and ambiguities are not accepted. They constantly try to solve the contradictions inherent in pursuing both identities as attractive women and identities as decent and morally responsible persons. The ideal of being whole, integrated and autnomous persons seems to be a specific theme in Norwegian culture.[5]

Connected with these underlying ideas about the whole and perfect person is their way of viewing problems in relationships in terms of there being something wrong with the persons involved. What is at stake in cases of jealousy, then, is to some extent, self-esteem. This is the reason why some of these cases are so emotionally disturbing and dramatic that relatively innocent (from an outsider's perspective) actions escalate into a crisis and a choice between very radicalized alternatives in one single step.

Their concrete way of discussing moral problems is connected with their position as working-class women having relatively little formal education. The image one gets of women trying to control their own and men's morality confirms other descriptions of strong working-class mothers, both from Norway and from England, for

instance Young and Wilmot (1957). Control is one key concept here. The emphasis of control is related to identities as "decent ordinary folk", as stable working class as opposed to different stigmatized categories, and to women's particular role to achieve this for her family. A man needs a woman who controls that he goes to work regularly and who keeps his urges for women and alcohol at bay. Being morally responsible is an important part of female identity, it means something different for them than for men. There is a cognitive division along gender lines between "them" and "us". "We think of the kids. We drag ourselves home." "Men are so irresponsible." "Men are so egoistical. They get things so easily." "Men are really like big children", are common refrains. The fact that women have shared understandings about men being irresponsible does not necessarily mean that men agree with these understandings, but the ascriptions are certainly perceived by them. The ideal perceptions men, in these circles, have of themselves are often connected with physical strength, economic responsibility as providers, practical knowledge and being handy, a ritual purity/impurity complex where they see themselves as pure (and women as somehow impure), freedom as an ideal etc. There seems to be a mutual ascription of attributes between women and men. Women find men irresponsible. Men, on their side, find women fussy, gossiping, nagging and so on.

Men are probably not less moral than women, but they apply more of their energy to different realms of life than personal relationships. They talk about other things when together and do not in the same way debate personal relationships. To some extent women have understandings of their own that are not shared by men, and to some extent they are the ones who are debating, maintaining and changing cultural ideas and values about love and personal relationships. In these realms of life men are the ones who to some extent appear muted and women are the ones who appear articulate and influential.

12. Married life: Some meanings of money

The examination of one part of the moral discourse of these young women has shown how husbands and boyfriends constitute a central topic in their talk. This discovery motivates a closer examination of married life. The separate home is as we have seen one important dimension of the way in which Norwegian native theory defines a family-household. Common budgeting is another important dimension that marks off a family-household as against the world.

In this chapter I examine some meanings of money. Money has many meanings besides the more obvious one of enabling its possessors to buy the necessities of life. In the context of a welfare state one might say that it is not survival, but "what life is for" that is threatened by the want of money, and this makes the meanings of money more important. There are differences between status groups not only in how much money they have to spend, but also in spending patterns, consumption profiles, ways of talking about money and ways of calculating. Within marriage too, attitudes are changing, especially in the ways money relates to the roles of husband and wife, to corporate versus individual spending and budgeting. Money is a part of social relationships. In no status group do people act in terms of purely economic rationality. This does not mean that they are irrational, only that they also apply considerations other than purely economic ones. By the ways in which he or she uses money a person signals something about him or herself and something about the actual relationships. The way the young spouses in this study handle money may be looked at in the light of both their relations to others in society and their relation to each other.

257

First a few remarks on householding

On the level of resource management money is one of the main resources of an urban household. What defines a household to the members themselves, together with sharing a place to live, is common budgeting. Somehow the money available has to be allocated to satisfy the different needs. In the management of money, as in other domains, there is an ideal of being autonomous. For a household being autonomous means being able to manage its own administration. Autonomy does not mean that the household members never get any help from outside in money, in services or in kind, but rather that a household may be helped only on specific conditions. There are limits to the kinds of help, in what fashion it can be given, and how such help can be codified. Autonomy thus requires that members of a household have to manage their own affairs, and be able to tend their own needs in the way this is here defined. To obtain money and use it well is a central concern in their independence. Money can be obtained in different ways. The most common way is to earn money by the paid employment of one or more of the household members. Another way is the various social security payments by the state to the unemployed, to the disabled or to single mothers.

A third way of contributing to the resources of the household is by doing different kinds of informal work, from unreported "black market" jobs to more subtle reciprocal exchanges among friends and relatives. All these different kinds of resources or the lack of them have to be taken into account to understand the economic viability of a household. In what follows I shall, however, limit myself to the question of how they think about and handle money.

These young families are at a stage in the developmental cycle of the family where needs are great; they are not fully established, they are relatively inexperienced and expenses are relatively high. At the moment their expenses are especially high because they are still paying for the apartment (not only running charges but also interest and instalments on loans) and they are also paying instalments on some of their household equipment, for instance the couch ensemble or the colour television, if they have one. (See also next chapter about economic needs at this stage.) There are, however, notable differences between them. Some are better off (like Beate and Mona) and some are worse off (like Asbjørg) than

the average. Most of them do, however, often have too little money.

Small calculating and lavish spending

The terms I use, administration and budgeting, mean that money is allocated to different ends, not necessarily by detailed and careful planning. When asked about how the money is administered my informants usually say: "First we pay the bills, and then we use the rest." What they mean is that every payday, they first pay off the bills that have piled up since last payday, and then they live on what is left. The bills are the charges for the apartment, interest and instalments on loans, the electricity bill, insurance on home and car, and so on. Most wages are paid monthly, but some are paid every fortnight or every week. The more often the wages are paid, the more difficult they find budgeting, because the more often the wage is paid, the smaller is the amount to pay bills from. When the wages are paid monthly the easiest bills are those that come every month. Most of the regular bills are monthly, but some bills arrive every third month, like the electricity bill, or every year, like some bills for the car. The bills that come more seldom, like the electricity bill, are for large amounts of money and often cause anxiety. Kirsten, for instance, was not able to go on holiday one year because a large electricity bill, which she had not planned for, arrived. When they find such bills in the mail box, they often inform each other and discuss the amounts. "I got the electricity bill today, it showed 600 kroner", one says. "Then I will probably get mine tomorrow. I don't think it will be more than yours", the other perhaps answers.

Saving is done in several ways. Few of them have the extra resources to save money every month in a savings (interest) account at this stage in life. The main way, at this stage, is indirect, by paying interest and instalments on loans for the apartment and for objects bought on an instalment plan (a car, a couch ensemble, a colour TV). These payments form a substantial part of the bills. Interest and instalments on loans on the apartment are mostly paid every third month, but the bank often automatically deducts money due when wages are deposited every month. Betting (*tipping*), if one is lucky, may perhaps also be regarded as a kind of investment.

Their way of adapting to scarce resources at this stage of life is different from that of other status groups in society, and may seem irrational to some. When one has little money, the general pattern is to use all the money every month until there is no more money left, a hand-to-mouth administration. This means, however, that one limits expenditure by not using any money when there is no more left, and thereby one is able to pay high mortgages. These practices are due not only to scarcity of money, but also to culturally specific ways of thinking about and handling money.

There are little or no reserves to meet unexpected expenditures. When they are out of money, they may borrow one or two hundred kroner to cover the most necessary expenses, but mostly they will adapt by not using money in such periods. For instance they often say something like: "I saw these very nice boots in a shop in town yesterday. Next Thursday, when I get my wages, I'll go down and buy them". When Kirsten once was out of money when it was her turn to be hostess for the *klubb*, she insisted on postponing it for two weeks, until she "had money" (*hadde penger*), in spite of the fact that the others volunteered to lend her the necessary money. The rhythm of her income seemed directly connected to the rhythm of expenditures. She did not, for instance, reason as middle-class persons like me would have done: "As I will have to pay for this *klubb* entertainment anyway, and as I can get a loan free of interest, I might as well pay for it now". Instead she thinks that it is awful to start a new month with too many loans. This gives her a feeling of hopelessness, even if the expenditures are the same.

Kirsten is one of several who has stopped using a cheque account. "With a cheque account it is too tempting to buy more than you can afford. You feel so rich. You buy one pair of jeans here and a pair of padded pants for one of the children there. And when the day for your next wage arrives, you have already used it up".

The immediate connection between income and expenditure makes it very important for them to be paid wages or social security money exactly on time. One typical source of conflict between a *dagmamma* (woman who takes care of one or more children for a wage in her own home, see Appendix II and chapter nine) and the mother of the child, especially if there are class differences between them, is that the wage is not paid exactly on time.

A middle-class mother may not understand that the *dagmamma* has planned a lot of expenditure when her wage is paid, and so may easily let a day or two go by. For her, it often makes no difference if her own wage is delayed a day or two, as long as it is paid. The *dagmamma* finds it difficult to ask for the wage, and therefore the mother of the child will often never know the irritation she causes.

Not directly connected to the rhythm of the income, but a part of this way of thinking about money and expenditure, is a way of apportioning expenditure. In some contexts they make expenditures seem smaller by a process of apportionment. An example of this is an incident when Elisabeth and I were sitting in her kitchen looking at recipes that she had cut out of coloured magazines or obtained in the grocery store. She asked herself which recipes should be used for the meal at her next *klubb* meeting (sewing circle). She showed me a recipe for Waldorf salad. "This is really very good", she said, "but the ingredients are so expensive. You need blue grapes, walnuts and a lot of other expensive ingredients. But perhaps I can manage if I buy one ingredient now and one ingredient then, so that when the day for the *klubb* arrives there is not so much left to buy". This way of making expenditures seem smaller by buying a little at a time, I encountered often and with different persons. At the time Elisabeth spent about 50 kroner a weekday and 200 kroner before the weekend in the grocery store. To pay 100 kroner for the *klubb* on one day seemed too much. If she could spread the sum over several days and perhaps economize a little on the items she bought for her family each day, it would not only seem less but also become less.

Paying for driving lessons is a similar example. One may choose between paying every month or paying after every lesson. Most choose to pay after every lesson "because it seems less when you pay for each lesson. It easily becoms too much when you pay every month". For a person with other ways of budgeting this may seem strange, since the amount of money is exactly the same. Seen through their way of budgeting it is reasonable. "Paying the bills and using what is left" means that large bills are a worry. At the end of the month there is nothing left, and when the new wage arrives, there are other new bills to pay.

Their way of budgeting makes paying in advance difficult. A married woman was once genuinely interested in an advertisement of a beginner's course in electronic data-processing. However, the

course was organized in such a way that one had to pay 2500 kroner in advance and then 80% of the costs would be reimbursed by the State. Since this was not done until the course was completed (after half a year), this was a real obstacle to her. "Who has 2500 kroner to pay out?" For her the costs were 2500 kroner because she had to pay in advance. She found it almost unthinkable to borrow money from a bank for such purposes. It is also questionable whether she would have been granted a loan by a bank. If she had obtained a loan, the real costs of this course, calculated in purely economic terms, seem to be 20% of 2500 kroner plus interest on a 2500 kroner loan from a bank for half a year, about 625 kroner. Another reason for her to be careful was probably that she was afraid that she would not be able to complete the course and thereby not get the 80% of the costs back.

Another telling example of how money enters into calculations other than purely economic ones is provided by an episode with Sissel:

> Sissel was separated and had been going out to discotheques for some time. "After all", she said, "I do not find 100 to 150 kroner for an evening out to be so bad. I find it rather cheap, actually." "But", I answered her, "when you go out every Friday and one Saturday a month it costs you between 500 to 750 kroner a month. That is as much as the monthly rent of your apartment." Sissel gave me a quick look and said firmly and definitively: "Yes, but I do not count that way!"

What was the difference between Sissel's way of calculating and my way of calculating in this situation? An answer in line with my comment could have been something like this: "It is a lot of money, but I need to go out and deserve it after a whole week of hard work, school in the daytime and children in the afternoon and evening. Besides, I have figured out that I can afford it." But note that Sissel does not say this. Sissel does not compare necessities and going out and she does not make rationalizations on the basis of such comparison. Instead she looks at each evening out, the fun and recreation it gives her compared to what she pays for it.

Sissel's unwillingness to make comparisons may be explained in relational rather than economic terms. In all milieus money is a part of social relations. Some comparisons are not made because

they would make social relationships difficult. In this case money for going out may be seen as a kind of ceremonial fund, an investment in social relationships to friends and acquaintances.

Sissel's way of reckoning is an example of something more general in their ways of spending money. In addition to the apportionment (mainly done by women) of daily household items of expenditure, there is a pattern of large scale spending in public places for instance in restaurants. Especially men, but also women, voice the opinion that they do not consider going to a restaurant or on a holiday without having plenty of money. "It is not nice to have to sit there and ask yourself if you can afford it for every drink you buy." Having to calculate detracts from the pleasure. The pleasure is to have enough, not having to reckon. Generosity is highly valued in these situations.

Persons who have very obvious and apparent reasons for being careful in their spending patterns are excused, but careful spending is easily interpreted as meanness, as exploiting one's friends, and thereby detracting from their pleasure. To think too strictly in purely economic terms makes the maintenance of social relationships difficult.

The thingness of money

To my informants money does not only seem to be the means to an end, in the way they approach it, but has thingness as an important symbol and as a kind of commodity, because money is in itself a good thing and worth striving for. They talk extensively and often about money, about "having money" and also, to some extent, about not having money. Money makes one able to lead an easy life and to possess valued objects, symbols of being able-bodied, especially for the man of the household, but also for the woman. Money is one important symbol of how people manage their lives. It stands metonymically for a whole range of values.

Being ostensibly short of money, then, becomes embarrassing, because this state of affairs contradicts the image of an autonomous household able to manage on its own. Part of the reason is probably that the gap between just being short of money and not being able to manage at all is much narrower among my informants than in middle-class milieus. Not to be able to manage at all

means becoming a disgraced social case. The transition to a stigmatized category is short and is therefore a real threat.

The embarrassment of being short of money makes people expect each other to over-communicate success and under-communicate failure, to hide shortcomings. The following situation illustrates how being short of money is especially embarrassing for the husband. Mette, Eva and I are chatting together. Mette does most of the talking. She tells us about her worries for Christmas:

> Christmas implies so many economic worries. It isn't nice at all. Earlier I liked Christmas, because of the gifts and everything, but after I married, Christmas has become nothing but worries. Especially Kåre (her husband) feels ashamed. Last year we celebrated Christmas Eve at my parents-in-law's (*hos min svigermor og de*). We had not bought anything for ourselves. We could not afford it; moreover we had decided to save money for a new couch ensemble. My two sisters-in-law were sitting there, each with a golden neklace that their husbands had given them. They asked me "What did you get?", "What did you get?" We were so embarrassed. We just had to say that we could not afford anything. We could not say that we were saving for a couch ensemble, for that was supposed to be a surprise for my mother-in-law. Kåre, is, as a matter of fact, much more ashamed than I am. He is the economic provider and feels responsible for us having enough money. But I feel the difficulties of giving away all those presents. It is problematic, I feel, to buy a present that costs 20 kroner, even if it is a very nice thing, when you know that you yourself will get a present that costs 40 kroner.

Mette's friend, Eva, nods and agrees that Christmas brings economic worries. Mette continues, turning to me: "It is so good that Eva and I can talk together about everything. We can, for instance, admit to each other that today we have no money, so there will be no dinner today. Between Kåre and Eddie [their husbands who are also friends] it is more 'hush, hush'. They do not talk to each other about money."

That it is shameful not to have enough money may lead to interpretations of disagreements in social relationships as due to

shortage of money. A couple disagree with the husband's brother about the sharing of some expenses. Nils' brother and wife do not want to pay their share. Beate's interpretation, "they probably did not have the money, but would not tell" is very common. Another example was experienced by Ellen's mother once when she was in hospital. A nice woman was lying in the bed next to hers. When the woman had to get up and dress to go home, it turned out that she had worn and unfashionable clothes. She excused herself by saying that she did not have time to change before she went to the hospital. Ellen's mother, however, interpreted it in her own way: "She probably didn't have any better clothes. This was just her way of putting it." The basis of such an interpretation is that one appears miserable if one is short of money, and that material objects, like new fashionable clothes, are signs of having enough money and thereby being autonomous and self-sufficient and thus valuable as a human being.

People also to some extent expect others to brag about what is not really true. Events are interpreted with this in mind, for instance once when a couple had got a nice new car. They said it was their own. Friends and acquaintances asked themselves how this could be true. "They cannot afford a new Opel any more than we can." It soon turned out that the car was in fact owned by the firm where the husband worked.

People may, however, also be regarded as brave and open if they admit not having money in contexts where their general ability and autonomy are not questioned. Beate, for instance, told us about some friends who were planning to build their own house. "They were frank and open, too", she said, a bit surprised. "They admitted that it will perhaps be difficult to manage economically." In this context admitting was praiseworthy because this showed they were not "trying to be better" in spite of being able to build their own house. In such contexts admitting to being short of money is acting in an egalitarian idiom in spite of having something to brag about. Beate's surprise indicates that bragging about economic ability is not unusual.

Borrowing money from friends and relatives

Since the autonomy of the household is important, and since "having money" is a sign of managing well, it is somewhat prob-

lematic to borrow small amounts of money, one or two hundred kroner (17–34 dollars) to carry the household the few days until the next wage or social security money is paid.[1] The act of borrowing these small amounts of money is especially embarrassing for the husband. Borrowing money is least embarrassing between close friends, because they know that everybody may be short of money once in a while and the borrowing is perhaps mutual over time. In some ways it is easier to borrow money from friends than from parents or grandparents. Parents or grandparents often have a dilemma or mixed feelings about how to codify the exchange and the kind of reciprocity it implies. Especially when the parents are manifestly better off than the children, they may insist on generalized reciprocity, on not letting the grown-up children pay the money back. The grown-up children may also have mixed feelings. Not paying back is both a threat to their independence and an advantage they can exploit.

Among friends the balanced reciprocity when borrowing money is strict. When one asks to borrow money one at once specifies until what date. "Can I borrow 150 kroner until Friday when I get my wages?" Then the lender expects to get the money back on exactly that date. Both borrower and lender are strict about keeping the date. If the borrower turns up on Friday and says "I haven't got the money for you, does it matter?" it may not matter if the money is promised on another specified date and if the borrower has enough money until then herself. But if the borrower does not pay back the money, there will be sanctions. Even if there is no other sanction, she will, in any case, certainly not be able to borrow money from that person again. Next time the friend will answer "I'm sorry, but I'm a bit short myself."

An impressionistic comparison to middle-class milieus

A middle-class person typically (but not necessarily) has a somewhat higher income, more knowledge about how to handle banks and bureaucratic organizations, and thereby more savings and better access to loans. If one has savings and loans as reserves, it is not necessary to postpone unavoidable expenses, or to make small apportionments of expenditure, and a smoother rhythm of the expenditure, not so immediately connected with the rhythm of the income, may thus be possible. It is also cheaper to save by putting

money aside and taking up regular loans than by buying on the instalment plan.

Among academics, one does not talk as much about money in social encounters as in the social circles described here. Other things are more important. Money is more of a means to valued ends. Money is however more indirectly discussed by discussing the costs of valuable objects. Money seems often to be associated with unacceptable materialistic values. One example that might be mentioned is paying for child care in personal relationships with money. To pay grandmother for being *dagmamma* for her own grandchild is almost inconceivable for a middle-class person. Such things are too important to be calculated in money, is an attitude sometimes voiced. Among academics, to be short of money does not seem to be shameful in itself. People freely use the expression "we can't afford it". Such statements may be interpreted in two ways. Complaints about lack of money may be used as a moral justification for an abundancy that is often under-communicated. The dilemma between prestige and equality is present among academics too. In other situations the utterance "we can't afford it" seems to express a more deeply felt need or privation. Such a felt privation may be due both to an early stage in the life cycle and to a relative loss in wage and status of the intellectual middle class.

Especially among academic leftist persons, who explicitly work for one of the political parties to the left of the Social Democrats, and who thereby "identify with the working class", it is more shameful to have money than not to have it, and therefore consumption profile matters a lot. Some ways of using money, like buying big houses, expensive cars and polished furniture, are despised. These are ways that the business-oriented members of the upper and middle class value. Other ways of using money give prestige among the academic leftists, like for instance travelling, concerts and meals at gastronomic restaurants. That the leftist middle class, which explicitly identifies with the working class, inadvertently despises most strongly the values of the working class is thought-provoking. Their values are expressed in a consumption profile; it is consumption profiles that capture their attention, and alternative ones thus take on the significance of alternative values, from which leftist intellectuals are themselves alienated. Meanwhile working-class people identify with consumption profiles of the business class which the leftists reject – so

they must also reject working-class ways of life.

By comparison people in the "business" section of the middle and upper classes seem to appreciate money and what can be bought for it more directly and openly. In this respect too there are some profound similarities between them and my working-class informants.

Husband, wife and money

The household is the decision-making unit for budgeting and allocation of money. As when talking about other activities of hearth and home, the women often emphasize togetherness and "sharing" when they are asked which of the spouses deals with the money. What are the social and cultural realities that are covered by these statements? First and foremost I find it important to distinguish between the role of economic provider and the role of economic administrator and consumer. In urbanized areas the role of economic provider has become firmly established as the responsibility of the husband. The wife's part-time (or full-time) paid work is more and more being recognized as part of the process of making economic provision, and this gives her new legitimacy and arguments in the debate about the changing division of work between spouses. (See next chapter.) But the main responsibility for making economic provision is still with the husband. The changes in women's paid work and the meaning it is given only slightly change the fundamental division of responsibility. Under the umbrella of "sharing", the fundamental division of responsibility still exists, together with some change in practices and ways of thinking about them.

Several codifications exist, side by side, depending on the situation and context, and a considerable intellectual effort is required to harmonize them. This is also a part of their moral discourse. In some situations the women argue that "I work just as much as he does and therefore . . . ". On these occasions the arguments of sharing and sameness are used. In other situations they emphasize the husband's main responsibility by, for instance, attributing to their own wage another meaning and use than to his wage. In these situations they feel that their wage is something extra and special. Their main responsibility is with home and children, and

268

occupational work is something additional. Numerous examples show the co-existence of different codifications. Mona, who had a part-time job, related, for instance, how every month she bought ornamental pieces (alabaster figures, brass pots or candlesticks, porcelain plates, bowls and figures) a lamp or similar luxury items. "I buy something extra for the home to show that I am doing paid work" (*for å vite at eg går i arbeid*), she used to say. Beate said something similar: "I am buying myself more clothes now that I work full time. You want to see some results of your work, don't you?" (*Du vil jo gjerne se litt igjen for at du går i arbeid.*) Since the woman provides the luxury items, what she earns may thus be made "equal" to the husband's income, though much smaller in quantity.

Beate also emphasized that her paid work is as much a part of the process of making economic provision as her husband's, by insisting on a way of calculating its worthwhileness whereby their expenses for child care were not subtracted from her wage. She paid 800 kroner a month to the *dagmamma* for child care. This, in her view, was covered by the contribution of approx. 250 kroner she got for the child (the father is not the man she is married to) and by the approx. 600 kroner a month they earned by cleaning stairs and corridors a few hours a week. In this way she could take home unreduced the total wage of 4000 kroner (gross) a month from her regular job.

By ways of calculation and by consumption they give their paid work meaning and value. Some of the money they earn may thus be used for consumption that symbolizes their work more than daily expenses do. Most of what they earn is, however, used for the common household expenses. These different tendencies in how they think about their wages as both "my" money and "our" money correspond to different codifications of paid work as shared responsibility or his responsibility. It expresses an unresolved tension between individuality and jointness, and between similarity and complementarity. The women are constantly debating this tension. They constantly try out solutions to the dilemma.

Often, when women sit together chatting, they correct each other's use of personal pronouns about money and each other's ways of expressing how money is allocated to personal needs. Sissel for instance once complained: "I had to use all my money to pay bills this time". Beate corrects her by saying: "You must not

say my money, but our money. You may say my wage, but it is our money." On another occasion one woman complains about how awful it is to have to ask her husband to be allowed to buy a new pair of jeans and a new sweater. A friend's answer to this was: "You should never ask 'may I have a new pair of jeans?' You should rather say 'I need a new pair of jeans. Is there money enough for that this month?'."

To sum up this far: making economic provision is the main responsibility of a husband, but the wife's paid work is considered a part of this process. His wage is joint money. Her wage is joint money but at the same time some kind of special money.

When it comes to the actual administration (saving, investment and spending) of money, it can be divided into several different tasks: 1) buying groceries, 2) buying children's clothes and small items of household equipment, 3) buying larger items, from a couch ensemble to a car or a flat, 4) paying bills and putting money in and out of bank accounts and lastly, but not least important, 5) keeping a certain overview over how much money there is left and what expenses there are to come, to control income and expenses.

In the analysis of economic administration, a distinction should be made between rights to spend money and duties to be shared. In the negotiations between spouses different parts of economic administration are dealt with on different terms, and these terms are changing. These days the first two kinds of tasks listed are often considered duties, whereas the next three are considered more in terms of rights to have more influence. (One of the grandmothers, however, looked at paying bills and having the responsibility for the overview as duties she was glad not to have.) Keeping the overview and thus having the ultimate responsibility may be regarded as the key task of economic administration, because the one who keeps this overview has most influence on decisions about expenditures in the family.

As already noted, bills are largely paid from month to month. Planning often consists of decisions about what larger items to buy and when one will have the money to buy them whether in cash or on the instalment plan. More important than budgeting expenses in advance seem to be the constant control of expenses and the constant knowledge about how much money there is left to spend. When the income is in cash, this control is a simple and direct one. When income is paid into cheque accounts, as it often is these

days, control and overview becomes a little more complicated.

Below I list some examples showing the variation in methods of economic administration in households with both an adult man and a woman.

Beate and Nils put both their wages into the same cheque account. But they have only one cheque book, which is kept at home. If one of them needs money, he or she takes the cheque book; if not, it is left at home. Both of them write up how much they use. This system facilitates overview and control for both. They always ask each other, however, about expenditures amounting to more than about one hundred kroner. He or she will say: "I need a new pair of jeans. Can I buy them today?" Or he might call her from his job, asking her if they should accept an offer he has got from a colleague, to buy cheap meat for the freezer.

Elisabeth and Georg sit down together some evenings and decide what is to be paid and bought. She carries out their common decisions. Her wage was paid in cash, whereas his was paid into a cheque account. They may both write cheques, but he seldom does. He gets money from her for his personal needs. "I like to control the money", Elisabeth says.

Audhild and Olav each have a cheque account for their wages. Both pay bills. She cannot use his account, but he writes cheques to her when she needs money. The final overview thus resides with him, because he earns most.

Mona and Edvin. Here she is the one who controls the money: "He has an ordinary account for his wages and we have each a card to draw money on it. But he does not use much money. He buys his tobacco, betting slips and perhaps a magazine. That is all. Then we have a separate account for the loan on the apartment. Instalments have to be paid every six months, but money is drawn from the other account every month. My wages are paid by mail. In addition to this he earns money on private jobs. I am the one who pays bills and who saves. As a matter of fact, he really does not know what he has. (. . . .) We are very well off economically. I can go out and buy a lamp for 500 kroner without asking. But if I want to buy something more expensive, I have to ask him. But he always

agrees. He is not so interested; it does not matter that much to him what furniture and ornaments we have. But he is always satisfied when we finally have brought some new equipment home. (. . . .)

At the moment we are saving up to buy a car. I have got the apartment decorated and furnished the way I wanted it. Now I am helping to save for a car. After this I want a new couch ensemble. But that will not be realized until three years from now."

Mona is one of the few who is to some extent saving in advance. They are better off than the average. But she also buys expensive items on an instalment plan, so that the saving is done after the item is bought, by monthly instalments.

Ellen and Arne. His wages are paid in cash every week. He gives her some money and puts the rest into a bank account. He pays the bills, "because he is in town anyway". They try to save to pay the 4000 kroner in mortgage payments and the interest on their loans every third month. She uses her wages for the daily expenses.

Sissel and Benny. When they were still living together Sissel used to receive her wages in cash by mail. She put the money on the top of their best plates behind the glassdoors of the cupboard in the living room. She drew from this money to buy food and pay other expenses. When there was no more money left, Benny used to give her money from his wage. He received his wages on a cheque account, but he never used the cheque book because he was anxious about using too much money that way. He used the bank account card to cash money when needed. He gave her 100 kroner at a time. "It often happened that I asked him in the evening to leave me some money because I had none left, and then, the next morning, he forgot it. Then I often had to go down to him at his job to get money."

Benny used to put all their bills in a black wallet that he always carried in his pocket. They had only the one bank account. Interest and mortgage payments on the apartment were charged every month. Besides they were always paying something on an instalment plan. At the time of separation they still had 4000 kroner to pay on the couch ensemble.

"I always asked Benny first, when I wanted to buy something for myself and the kids. I used to wait until I got my own wage, though, but I always asked him if I could. I knew that we owed

three months' house rent when we separated, but not that we owed as much as six months' rent. I was so shocked and unhappy. Benny has been very irresponsible. He knew this, still he bought stereo-equipment for the car for 1100 kroner and a season ticket to the football matches this season, which cost 320 kroner. (. . . .) He demanded to have the control over the money. I asked him several times for a change. He is used to this way of doing it from his home. There the father decides everything. At my parents' it is my mother who controls the money. But they each have a cheque book, just as Elisabeth and Georg have."

Conclusions and comparisons

The conclusion I draw from these examples is that when they talk about "sharing" decisions about how to use money this term has some real meaning. Both spouses have a say in how wants and needs are to be prioritized. Often the final overview and control resides with one of them, the wife as often as the husband.

A smooth working of the decision-making and budgeting process presupposes cooperation and good feelings between the spouses. There are several examples showing that economic budgeting fails in a marriage crisis. One or both of the spouses may cease to care and consequently use too much money.

In spite of the pattern of relative sharing in decision-making, ideas of manliness and power connected with money still exist. Kirsten once gave a very expressive illustration of this. She was still married, and after a crisis she wanted to do her best to save the marriage. Her strategy did not work, however. This is what she said:

Earlier I made him put all his money on the table. The evening he got his wages he almost had to walk on his hands over the doorstep so that I could see what he had in his pockets. Now he carries the money himself. I have learned. I was far too domineering. He feels more like a man when he is allowed to carry the money in his own wallet. He gives me money when I need it, and enough money for the weekend. I pay the bills, because his work is such that he cannot leave it. But he is really not able to handle money. If he had been responsible for paying

the bills, he would have thought "Shit, I'm not going to pay the house rent this month, we can pay it next month." I am not like that. If the bills are not paid I worry *(går eg og gnager)*. I must know that they are paid.

A wife is always responsible for the administration of some of the money. If the overview and control lie with the husband, she nevertheless controls some of the consumption. The notion of housekeeping money *(husholdningspenger)* seems now more or less to have gone out of use in this milieu. The housekeeping money was the part of the husband's wage that the housewife received to buy groceries and other items for consumption on a day-to-day basis. He kept the rest of his wage for paying bills, saving and/or personal consumption. The notion implies a firm *division* of his wage into at least two parts. In the mining town described in *Coal is our Life* (Dennis, Henriques and Slaughter 1956) the notion of "the wife's wage" is used for housekeeping money. In this fieldwork among young women I mostly heard this notion made fun of, as, for instance, one Monday morning when Ellen met Gunvor on her way to the grocery store, carrying plastic bags containing, no doubt, empty bottles to be changed for cash. Ellen laughed loudly and said: "Do you get your housekeeping money that way too? How many times haven't I got my house-keeping money on Monday morning in empty bottles!"

Some of their mothers, however, use the notion of housekeeping money *(husholdningspenger, kostpenger)* for the money their husbands give them regularly.

The wives buy the groceries on weekdays. Sometimes husbands may do the shopping for the weekend on Saturdays, alone or together with their wives. The reason given may simply be that it is their "turn", since the wife does it the rest of the week, or that they want more beer and since it is somewhat stigmatizing to buy beer, the wives may order them to get it themselves. The reason given may also be that he buys sweets and snacks more generously than the wife.

Clothes for the children and minor household equipment are bought by the wives. Big items, like a stove or a couch ensemble, are bought together (but often according to the wife's taste). The price of items that can be bought by each of them without previous agreements varies between approx. 100 kroner and in some fami-

lies up to approx. 500 kroner. In these latter cases it is the wife who buys such items (for the house, the children or herself), and she has at the same time full control over the economy. Men seldom buy expensive items without previous notice. In contrast to my earlier fieldwork in Bergen I did not see any dramatizations of the provider role of the kind that the man brings home an expensive item, for instance a colour television, as a surprise.

The findings are consistent with other studies of economic administration in different status groups. In middle-class milieus the husband often seems to have the final overview and control, whereas in working-class milieus, control and administration may reside firmly with one of the spouses, as often the wife as the husband (Oakley 1974). Among working-class families in the inner city of Bergen I found, in the beginning of the 1970s, two contrasting patterns (Gullestad 1978, 1979a). In some families economic administration was definitely part of the husband's role. These differences seemed to be connected with where the spouses had grown up, in the city or in rural areas around Bergen. The wives who had grown up in the rural areas seemed to see economic administration as part of their responsibility, and this gave them access to a wider range of activities, roles and experiences and also more influence on household affairs and their own life situation.

In the suburbs 8–10 years later, some variations are, in a way, still here, but distinctions seem to be blurred, and there are no longer two contrasting poles. The variations are not connected with an urban/rural distinction. The alleged sharing of economic responsibility seems to cover a reality, a reality still being negotiated. Seen from one point of view one might say that nothing new has happened, as some working-class women have always administered the family economy. Seen from another point of view, however, a lot seems actually to have changed from one generation to the next, in these families.

13. Married life:
Negotiating division of tasks

The way economic administration is allocated between the spouses illustrates general tendencies in the division of other household tasks. We have seen how the division of basic responsibilities is a traditional one, where he is responsible for paid employment, maintaining, repairing and redecorating home and car – and she is responsible for the ceremonial and aesthetic state of the home, and for housework, meals and children. At the same time ideologies, as well as practices are changing. What the informants themselves emphasize is change, the one they want and the one they have achieved. The young mothers want sharing and togetherness with their spouses. The women answered 'we do it together, we share it', to almost every question I asked about household tasks in the beginning of my fieldwork. This was a considerable change from the old inner city neighbourhood that I studied 8 years earlier. There tasks were more clearly segregated, also ideologically. When I came to know the informants of my new fieldwork better, I realized that practice seldom conformed completely to the "we do it together" ideology. But still, obviously, something has happened in the direction of less segregation between the spouses. They express strongly the value of sharing, and its effects may be detected in the ways the spouses actually organize their life together.

Let us first look once more at former generations of working-class women in Bergen, to get some basis for comparison. Judging from my earlier research, it seems that the stereotypic housewife role has only partly applied in the working class: many married women have always had small part-time jobs, especially as cleaners. Few were ever "only housewives". Compared to them, the young women described here represent some change. The period they stay home with no paid work because of small children has become shorter. In addition, they now have fewer children, with a

short time span between them, which also makes this period shorter. Several of the young mothers were not home more than a year or two before they took up part-time cleaning or *dagmamma* work (paid child care). They do not represent all young unskilled urban women, but a growing trend (see chapter eight on paid employment).

The mothers of these young women represent the adaptation of their generation. Most of them have not been, at least seen in a career perspective, "only housewives". Audhild's and Asbjørg's mothers worked on the family farms. They had to subordinate housework and child care to the needs of the farm. The urban mothers "stayed home when the children were small", but took up part-time work when the children grew bigger. At the present time several of them work more hours than the daughters who have part-time jobs, but shorter hours than the few who have full-time jobs. Those who have paid work seem to have stabilized at about half a full job or a little less. A few receive disability benefits *(uføretrygd)*, because their work as charwomen has given them bad backs and arms.

These urban grandmothers sometimes seem to be proud of their daughters and sometimes to deplore the extent to which they take up paid work. Their attitude depends on the solution of child care and the perceived economic necessity. If working is seen as the only way to get a decent place to live, it is difficult for them to object. But sometimes I heard them urge their daughters to stay home when the children are small, or least not take up "too much" paid work.

Part of the reason for such a disagreement is probably that the grandmothers feel some pressure on themselves to help out with child care if their daughters work long hours. Their resistance to paid work is all the same less than their resistance to other activities of their daughters, such as going to discotheques or spending the mornings in coffee klatches, chatting with friends.

The grandmothers themselves insist on presenting a version of their lives that says: "I stayed home when the children were small." The daughters may sometimes challenge their mothers. Mona once said to her mother: "I remember you went off to work and I had to put my little sister to bed. She could not have been more than three years old!" In other situations she says the opposite: 'My mother was always at home when I came home from

school. I don't know what I would have done if she had not been. I believe it is a child's right to have its mother there all day."

The impression one gets is that the grandmothers have often worked at odd hours, for instance before the rest of the family got up in the morning, to realize this ideal, to be at home and available when the children needed her. It also seems that in some cases opposition from her husband was a reason for choosing such hours. She could not expect help from him and therefore had to choose such hours. In the study mentioned earlier, from another part of Bergen working-class society, I found, as already noted, striking differences between couples regarding degree of segregation in division of labour. These differences followed an urban/rural distinction. The division of labour of some couples who had grown up in the coastal and rural areas around Bergen implied that the wife managed the whole income, her income was not used separately, and she formed a team together with him for decorating, building and repairing. On the other hand, several spouses had both grown up in the city. Their division of labour implied that he managed his income, while she used her wage separately, and that he formed a team together with his buddies (including relatives and in-laws) for construction and decoration. In these urban families the woman's part-time work was not defined as part of the regular economic provision – that was his role – but as something "extra". Therefore she could only take paid work "if it did not affect anything", if children and husband did not suffer.

In the lives of the young mothers of this study such distinctions are now blurred and blended under the forceful ideology of "togetherness". There are differences between couples, but altogether their practices are closest to the spouses with a rural background from some years ago, not only concerning administration of money, but also in the division of other household tasks. The wife's paid work is regarded as a help in providing economic support. Thereby she can legitimately use this as a basis to argue for more help from him, in contrast to the urban mothers who were only allowed to take paid work if it did not affect anything at home. Women's paid work has to some extent become a sharing of the provider role, even if the man still has the main responsibility for providing economic support.

The wife's paid work as an economic necessity

There are both organizational and cultural reasons that may be put forward to explain how these changes have come about. Organizational changes lead to new ways of thinking and codifying, and these are, as we shall see in the next chapter, reinforced by general Norwegian ideas and attitudes, as well as by those of the coastal culture surrounding Bergen. In this chapter some of the organizational reasons are discussed. My hypothesis is that there is a gap between cultural standards of living that have become firmly established and the means to realize them at their stage of the family's developmental cycle. It has become very difficult, given the current standards of living, for a family to manage on one worker's wage in the larger cities.

What does this gap in living standards consist of? When the young spouses compare themselves with, for instance, the way their own parents live now, they see considerable differences in living standards. The parents have experienced, during their life time, great changes in Norwegian society and the living standard of working-class people. They are now still an active generation, around 50 years of age. Most of them work, a few live on disability benefits. They do not have responsibilities and expenses for small children. They are often in their best years in terms of income and ability to do paid work. The urban husband has a full wage, the urban wife works more hours than her daughter, often half-time. Their apartments have been paid for, and that means that they have lower housing expenses. They have all the necessary household equipment and are also able to change to more fashionable designs. Many of them own a little cabin in the countryside where they can go at weekends. On longer holidays they can once in a while afford to go to the Canary Islands, to Mallorca and similar places that function as the sunshine resorts of Norway.

The parents are thus often in a better economic position than their grown-up children. They are established and when they have one and a half incomes instead of only one, they are fairly well off. One exception to this is for instance Kirsten's mother, who is a widow. Together with an adolescent son she lives on her little pension and half a job as a canteen helper. She has not been able to renew her first furniture.

In Norwegian society relatively high standards of living have

thus become established. There has also been a change in the notions about *when* in life one should expect the good things. "Today young people want everything at once, right away", the parents say. The ideas about life cycle consumptions have changed and also become more confused. At the same time it is more difficult for young people to attain the high standards of living. The "entrance ticket" to the cooperative housing market has risen much more than wages. Families with small children are at a stage of the family's developmental cycle where the "needs" are greatest but the means are smallest. They are not fully established with regard to housing and household equipment. They have managed to buy a cooperative flat, but since they had to borrow most of the money, they pay interest and instalments on loans in addition to the ordinary rent. They also need household equipment and furniture. It is expensive to make a home in accordance with the current standards. I have described the meaning Norwegian families attach to "hearth and home". To a large extent they are willing to work hard for the realization of these goals. At the same time Norwegian moderation applies. One should not overdo it. "Money is not everything. People today only think about buying, buying, buying", they will also hold, in some contexts.

The difficulties of managing on one wage in accordance with standards that seem "natural" and taken for granted, I see as one reason for the women's willingness to take paid work when the children are still small. This reason has the greatest legitimacy, that is, when it is not defined as overdoing it but as necessity. The couple see how difficult it is to manage on one wage, and they are both interested in augmenting the total income. This makes it easier for the wife to define her job as a necessity, as part of the basic economic provision for the family, more than as something extra, a hobby of hers. The changed definition of her work again makes it possible to argue for his assistance to accomplish a viable combination of home and occupational work for her.

But this is not the only reason. There is a pull from the labour market in the sense that there exist specific work possibilities for unskilled women of their kind, and there are also other incentives arising from the woman and her household than economic necessity. When the women themselves talk about their work, they also express reasons other than economic necessity. "I am the kind of person who cannot stay at home all day, I have to have

something to do outside home." "I become bored and restless when I have to stay home all day." They want something more than being wife and mother.

Paid work is thus ambiguous. It belongs both to the domain of sharing and togetherness in the family, and to the woman's acting on her own. Its legitimacy lies, however, in its economic necessity.

Solving the problem of child care

In addition to the definition of the wife's paid work as necessary, its timing and the child-care solution found seem to effect changes in the division of work between spouses. Of the different household tasks, care of children is the most difficult task to combine with employment. Children need someone to look after them and care for their needs at all hours. This task cannot be postponed until paid work is over. Keeping mother at home and sending father off to work is one way of adapting to these conditions. For both parents to be able to take up paid employment, they have to solve the puzzle of child care. The care for each child or group of siblings can be seen as a chain, consisting of all the personnel, fora, and relations that are involved in taking care of the children (Gullestad 1979b). The advantage of being herself a *dagmamma* (taking care of other people's children for a pay) is that a mother can look after her own children and do her housework at the same time. She does not have to leave the home. The problems and costs of finding suitable care for her own children are saved, but her eventual needs for variation and change, for "getting away", are not met.

Some of the women have access to different kinds of public child care. One kind is daycare centres that are open the whole working day, with trained personnel and many facilities for children. There are very few of these centres, and mostly unmarried, separated or divorced mothers get assigned places for their children there. A place in a daycare centre makes it possible for a mother to work normal hours, either full time or part time. A place costs from 300 Nkr to 800 Nkr a month. Most places in municipal daycare centres cost about 450 Nkr a month in 1980. This is half the price of a *dagmamma*. Some single mothers get a free place.

There also exist 4-hour play-schools run by the municipality or by different voluntary organizations. None of the mothers used

281

these possibilities, probably because there were none close by, and because it costs money without giving the mother free time that can be used for paid work.

Another kind of public child care are playgrounds in the neighbourhoods with no or very primitive indoor facilities. The playgrounds are fenced, and children are minded by relatively untrained personnel. There is a larger number of children for every woman than in the daycare centres, about 2 women to 40 children. The playgrounds are open from 10 am to 2 pm in summer and from 11 to 2 in winter. It costs about 200 Nkr a month (1980) and it is easier, but not uncomplicated, to get a place. These playgrounds are mostly used by mothers who stay home, either as *dagmammas* or without paid work, but sometimes working mothers find a child-care solution that combines the playground with a *dagmamma*. Elisabeth was for instance *dagmamma* for Beate's son when Beate was still an unmarried mother, going to a one-year trade school. Elisabeth took care of the boy for two hours in the morning before the playground opened and for a short time after it closed in the afternoon.

When a married mother in this milieu takes work on the ordinary labour market, two patterns of child care seem, however, most common. One is part-time work at hours wholly or partly after the husbands' work hours, when he can take care of the children. This is often combined for some of the time with the use of a neighbourhood girl (*passepike*) (Gullestad 1979b).

This solution of child care for parents who shift between home and employment saves first and foremost monetary expenses of child care but gives also less feelings of guilt for not being available and reachable. The father is thought of as a better replacement for the mother than an unrelated woman. Some mothers have relatives that are available for child care during the daytime. Mette, for instance, occasionally worked as extra help in the same store where her mother is a saleswoman. Then her mother-in-law looked after the children. Generally it seems, however, that shift care between parents is a common solution for part-time work in this milieu. Most grandmothers have their own jobs, and if they are available for regular child care during the daytime, their work is often codified and paid for as *dagmamma* work.

Father's care is as already noted often combined with that provided by a neighbourhood girl. The *passepike* is an established

institution and not thought of in negative terms, unless the child has also been away the rest of the day. It is for instance criticized if a mother every day first delivers her child to a *dagmamma* and then to the care of a neighbourhood girl *(passepike)*. That is, *passepike* and *dagmamma* are alternatives but not legitimately combinable to increase the amount of time parents can be away from their children beyond the normal working hours. In the evening, however, when the children are in bed, both young neighbours who are paid and relatives who may or may not be paid act as babysitters (Gullestad 1981).

For full-time work both the use of a *dagmamma*, replacement by spouse, or using a daycare centre are different solutions that may be combined. After Ellen got a full-time shift-work job, she was replaced by her husband at hours that overlapped his free time from work, and by neighbours at other hours. Elisabeth and Beate had about the same working hours as their husbands. They both had a *dagmamma* in the neighbourhood to look after their children. When Sissel started trade school, she got a place in a municipal daycare centre for her youngest child. The 6-year-old boy was looked after by a *dagmamma,* a friend in the neighbourhood.

The reasons for the child-care solution found, at any point in time, are thus varied. In the case of small children there can be no "missing links" in the daily child-care chains (Gullestad 1979b). For the parents it is a jigsaw puzzle of putting people, place, time and children together in a way that solves the puzzle and makes the chain complete. Different solutions found for these tasks do, however, have different consequences for family relations. Some of these consequences of different solutions may be separated from their immediate reasons.[1] People do not always have the foresight and overview over all the consequences of their choices. Three adaptations may be differentiated in terms of the consequences for division of work between the spouses:

(1) Part-time work during the working hours of the husband. Then persons outside the household help out with child care. A similar adaptation in terms of consequences is full-time work at home as *dagmamma*. The wife takes care of the children herself.

(2) Part-time (or full-time) work wholly or partly after the husband's work hours. This means that the husband has to help out, wholly or partly, with child care.

(3) Full-time work with more or less the same working hours as the husband. Other people or institutions help out with child care. If the spouses have very young children, tasks must somehow be divided between them, sine both housework, preparations of meals and child care have to be done in the husband's and wife's free time. With older children paid work may just be added to a wife's other responsibilities.

Solution number one has the least change potential. When the wife works fewer hours than her husband, it easily becomes an expectation that she does most of the work with house and children, plus the hours of paid work. Paid work is added to her other responsibilities, and does not necessarily change them very much.

Solution number two implies most potential for change. This solution has at some stage been chosen by several families of these networks. Husband and wife work "shift work" at home. There is a difference between being a father when the mother is there all the time, and being a father alone with the children. If she is there and "something happens", she takes care of it. For instance, if the children hurt themselves, they will automatically turn to her. If he is alone, he has to take care of things. Something nappens with his feelings and capacities as a father if he is regularly alone with the child(ren).[2] The mother still has the main responsibility for child care, but she delegates it, in these periods, to him. Men say they feel a special relationship to their child(ren) because they "have had so much to do with them" *(har hatt de så mye)*. They also develop capacities in doing certain kinds of housework and cooking. But at the same time they also find it lonesome to eat dinner *(middag)* without their spouse every day, and they find that their free time is very constrained, depending on when she is back. Men have no traditions in combining child care and sociability with buddies, as women do. I believe this is an important point that should not be underestimated. Child care is more of a hindrance for men than for women. Elisabeth for instance complained to me once about how difficult it was to arrive at an agreement with Georg on Sundays for leaving the home with the children and going for a walk or visiting friends. She ended her complaint by

saying: "These menfolk are always so slow. Imagine, Marianne, if you and I instead had been living together, with our children, how much more fun we would have had! Having children does not stop us from getting around!" First a full day's paid work and then taking care of children at home thus tend to isolate men from buddies and other activities.

Solution number three may have change potential under certain conditions. Working full-time "just as much as he does" entitles her to ask for his help. With very young children some of the tasks have to be divided between them at home. One person just cannot do all the tasks at the same time. When the children are older, the wife may do both paid work and the household tasks. The women of this study with full-time work have earlier had a shift-work combination between paid and unpaid work with their husbands. This means that they have developed some routines and practices of more sharing of the tasks. These routines are useful in the new combination of paid and unpaid work.

Negotiating the sharing of tasks

It seems to be easier for the young women to expand their roles to include activities like driving, taking up paid employment, going out, than for men to take a serious interest in those activities of hearth and home traditionally most closely associated with women.

On the simplest level of analysis, "sharing" for the young women means that husband and wife form a team for sharing household tasks. Mona and her husband for instance clean their apartment together every Saturday and polish the brass together about once a month. He is also the only man in the block who goes to the common laundry room with the laundry. Not all men do as much as he does, but most men once in a while team up with their wives for some household chores.

More typical than working together on the same tasks, however is to divide between them the multiple tasks that household life consists of. Today men do more of what is traditionally regarded as women's work than their fathers did, but there are some typical priorities, lines of argument, and interpretations of what it means to "share". The following anecdote, for instance, is illuminating:

Elisabeth relates how they spent last Sunday: "Before dinner he worked in the bathroom. We have started to paint and redecorate it. I fixed dinner. After dinner there was a pile of dishes to do. At the same time the baby had soiled her diapers. 'Now you choose', I said to him, 'either the diapers or the dishes.' He chose the dishes."

That both dishes and changing nappies are basically her responsibilities is demonstrated by her having to engineer his participation. He gets a choice, while she has no choice. She can, however, determine the choices open to him. Another example shows how the mothers generally put their husband's play-contact with the children before cleaning:[3]

Eva has only a very small paid job as *dagmamma* for a few hours a day. When her husband is home she does no housework. "I leave the dishes from dinner till the next morning, because I do not like to use the little time we have together for cleaning and washing. But if he sits down with a newspaper after dinner, I first clear my throat, and then, if this does not work, I argue: 'I have been home with the children all day. That too is work. Now we have to share looking after the children.' "

When discussing division of tasks between the spouses one cannot look exclusively at each task in isolation. One should rather look at the combination of household tasks. Women argue for more help from their husbands and in some contexts even challenge the justice of a division of work that makes these tasks mainly, if not solely, their responsibility. Elisabeth, for instance, after she had worked full-time as a clerk for almost a year, related this incident one evening in the sewing circle:

My mother-in-law came over the other day. She told me that my windows were dirty, that I ought to clean them. "Why don't you tell your son", I said. "I work full time, just as much as he does." *(Eg går i fullt arbeid, akkurat som han.)*

The sharing of tasks is restricted, as already mentioned, by the traditional basic division of responsibilities and by the spouses' preferences. Each prefers some tasks to others. Their preferences are connected to gender identity.[4] By tradition different tasks have accumulated symbolic value as belonging to one gender or the

other, and this makes changing the division of tasks much more than simply a practical and organizational matter. The extent to which changing the division of tasks is not just a practical and organizational matter is, in my view, generally underestimated. He, for instance, prefers washing the car to changing diapers. She knows that he prefers some tasks to others and tries to act on that. In addition she prefers him to do some tasks more than others.

For a man there are some activities that are traditionally male activities and that he often prefers, if he has the choice: 1) work overtime at the job, 2) maintain the car, 3) redecorate and repair/ build things in the home, 4) engage in sports like football and handball (these are not work activities. I include them because they are sometimes accepted as legitimate excuses for not sharing household tasks in the husband's free time).

Of these possibilities sport is not an activity in the common interests of the household but a pastime of his own. This activity is the least interesting to a wife, unless he is so good as to be more or less a local celebrity. If that is the case she says "I knew what I got when I married him" and accepts "taking care of everything at home". To be a good football player is a prestigious masculine identity. Several men train for football or handball about once a week, a schedule that the wives seem to find acceptable. Eva, whose husband for a period went training very often, was pitied because of that by other women. She was also the one who had the least paid work and therefore, probably, was generally in a weaker position vis-à-vis her husband than the average.

Overtime work is another activity that may be seen as an alternative to sharing household tasks at home. Overtime work is a constant topic of disagreement in a few families. His argument is that it brings more money to the home. Her argument is that he sees the children too little and/or that she is tired of being so much without him. Some kinds of overtime work is not done at the regular work place, but is "blackmarket" work for unregistered payments. This work often includes sociability with buddies and is also for this reason valued by husbands.

Like sport and overtime paid work, repairing and maintaining the car are indisputably masculine activities. Being clever at different kinds of repair work is, in this milieu, prestigious and masculine. The car "must" be cleaned, waxed, repaired etc., and these arguments carry some weight in the negotiations between spouses.

287

As a curiosity one might mention that Norwegian cars, on an average, seem to be better kept than, for instance, French cars, and the cars of working-class Norwegians seem to be better kept than the cars of typical academics. Academics have, to some extent, both other ways than working-class men of demonstrating ability and masculinity and other ways of withdrawing from the claims of their spouses.

Maintaining the car implies a legitimate activity that continues the traditional division of tasks applied to a new object. But even more than maintaining the car, redecoration of the home is satisfying for a wife. The car is his domain (repairing it, not driving it, since she also drives). The home is more of her domain. By redecorating the home he (for the time being) avoids her claims about changing diapers or cleaning floors, and gets a nice home. She gets a nice home and her husband's company. (See chapter five). Men expand the scope of some of the traditionally male tasks (those which are most satisfying for the wife) and thus avoid some of the sharing of the traditionally female tasks.

What has really changed is, as already noted, that most men have accepted the legitimacy of women's arguments for more sharing of domestic tasks. To achieve more sharing women do, however, as noted earlier, to some extent have to plan for and engineer the husband's participation. Some Danish feminists have dubbed the changed definition of a good husband and father "women's new burden", because it is the wife's responsibility to make the husband into such a person. In her research Hanne Haavind (1979 and personal communication) also demonstrates how women have to engineer and plan the father's relationship to his children. She brings to light important unspoken premises. I would add that the situation may not only be regarded as problematical for women, but also for men. That the woman ultimately has the responsibility for the traditionally female parts of household tasks is not only an expression of subordination but also an expression of power in that context. By the new emphasis on sharing household tasks, men are, to a certain extent, put into a subordinate position in their households. In the sharing of housework, as in moral matters, women are to a large extent the ones who set the rules. For them, "men are so irresponsible, they are like big kids really". Their view of their men oscillates between the images of "real grown-up menfolk" and "big kids".

For a woman sharing and togetherness is a lot more and some-thing other than doing the dishes or changing diapers strictly in turn during the husband's free time. Sharing and togetherness have to do with love, care, and understanding what needs to be done without being asked. These ideals and expectations are, however, diffuse and difficult to put into words – and even more difficult to put into practice. The activities of changing diapers or doing the dishes have become symbols of something that is really not about diapers and dishes at all. They have become symbols of a real sharing of responsibilities for home and children.

These diffuse expectations are seldom fulfilled. The wife feels the responsibility for home and children and is anxious about the consequences if she relinquishes control over how things ought to be done. The husband is not socialized into responding to all the claims of child care and performing traditionally female tasks in a home. For a man there are two different kinds of problems con-nected with doing some of these tasks (not all, since being a father and a husband always have implied some involvement). One problem is connected to gender identity. Some of these tasks are strongly contrary to masculinity, the way masculinity has been defined in these circles. In many ways women's expansion of their tasks and roles is easier than men's. Women take up activities like driving cars, going out to discotheques, having paid employment, and dealing with banks. These activities imply more independ-ence, control, and a wider range of experience – and may therefore in certain ways be associated with traditionally masculine ideals. But none of these activities are in themselves contrary to feminin-ity, as femininity is defined in these social circles. When learning to drive, they take a serious interest in learning about the functioning of the car, and how to act competently in difficult unexpected situations on the road. But driving does not necessitate their regularly having to put on overalls and get grease on their fingers and face, which perhaps, in terms of gender identity, may be regarded as the equivalent of men's changing dirty nappies.

On the labour market the kinds of work available to them are gender-charged, it is part of the definition of the job that the incumbent is a woman. They avoid "rough" masculine work, and gender neutral jobs are largely inaccessible to them.

Gender identity is thus one aspect of the changing division of tasks. Another aspect, seen from men's point of view, is that

participating more in child care and housework restricts their time for socializing with buddies. Thirdly there is the dimension of control and subordination involved. Sharing tasks in his free time puts him to some extent under his wife's supervision and administration. Instead of being the household head as against the world and leaving the internal matters to her, he is drawn into the internal matters as her assistant. Consequently traditional male ideals of freedom, control and personal autonomy become more difficult to realize. One of the reasons why being alone with the children for periods seems to be so successful for fathers is probably that the wife is not there to influence and direct his way of doing things.

The irreversibility of routines

Even with these modifications and nuances about what realities are covered by the terms of "sharing" and "togetherness", both realities and ways of speaking about them have, all the same, changed. Some child-care solutions lead to changes in the division of labour in the household, and to some changed symbolic value of domestic tasks. It is, for instance, no longer considered impossible for a man to push a pram. There are considerable differences between these marriages and marriages in the same milieu entered into only 5 or 10 years earlier. There seems to be a dividing line before and after the middle of the 1970s. As I will discuss below, not all the young women in this study are as successful in realizing their new ideas about sharing and togetherness. They make comparisons both among themselves and between themselves and neighbours and relatives who are older and who are "not allowed to do anything"; the power balance between the spouses is different from the one they have achieved or want to achieve.

As well as by age and "changing times", these differences may also be explained in terms of some irreversibility of the choices concerning division of work made by spouses early in their marriages. They develop routines and ways of dividing tasks that are not easily altered later, even when circumstances change. Ingrid Rudie (1969/70) has made a similar point about households living by combined fishing and farming in Northern Norway. In the present case the young families have developed new routines

because the women had paid work when the children were small, and because of the child-care solutions found. Something happens when the husband is alone with home and children.

Conflicts

In most Norwegian marriages, there are conflicts and disagreements as a normal part of life. There are, however, great differences between marriages. For women a bad husband is one who is an unsteady worker, who drinks often and heavily, goes out often, involves himself with other women, and beats up the wife regularly. No man in this study does all these things, but some do some of them. Asbjørg's former husband drank heavily, lost his job and was unreliable. She was pitied by other women because she could not resist him. Gunvor, also, had a problematical relationship with her fiancé. She complained for a period that her fiancé beat her. She was very much in love with him, but he did not seem to be equally interested in her. He went to restaurants more often than she did. Gunvor was pitied by her friends: "He tries to trample on her as best he can". They also blamed her for putting up with him. Marie's husband was also blamed for constantly going out to restaurants and involving himself with other women. Both Gunvor's engagement and Marie's marriage broke up after the end of my fieldwork.

Another example is Elisabeth's neighbour, Mrs. Hagen, aged about 40, and married for many years with two children. One of her children used to be Elisabeth's babysitter. Mrs. Hagen had been beaten up for years, a classic case of wife beating. She used to come down to Elisabeth's kitchen and complain when she felt too miserable. Once she wept because her alcoholic husband had beaten her up the evening before. The apparent reason was that she had bought some new wallpaper and equipment for the house without asking him. Elisabeth's explanation was that "her husband is of the old-fashioned kind who needs total control over the wife. If she does something on her own, he feels that he loses control and then he beats her up." Elisabeth blamed Mrs. Hagen for not leaving her husband. By staying with him she became in a way responsible for his acts. There is thus a social pressure to

divorce in such cases. Husband and wife do not have separate reputations, but a common reputation,[5] reflecting the values of sharing and togetherness, but also reflecting similarity between them. Each of them has to live a decent stable life for the other not to be stigmatized.

Not all of those who "should" divorce do, however, actually divorce, and couples with no such apparent and obvious reason do in fact divorce.

Since wife-beating and violence in the home have been much debated in the media lately, I should expand a little more on their attitudes in this respect. As regards physical violence, there seems to be an important distinction between being occasionally hit and being more or less regularly beaten up. There are several examples of women being occasionally hit by their husbands or male partners while quarrelling, especially in connection with the use of alcohol. This seems to be regarded as less serious, as excusable accidents. In some cases the man is blamed by (male and female) bystanders, if any, and in other cases they agree that "she asked for it by the way she egged him on". Being beaten more often, however, is regarded as very serious, and a reason for divorce. As we have seen, however, not all women in such circumstances do in fact divorce.

Wife beating and conflicts in marriage are not new phenomena. That being a paterfamilias and a provider generally threatens male ideals of autonomy and freedom is a common myth. In addition the new ideas about togetherness and sharing imply changes in power relations. Some men have difficulties in adapting to the new situation. The extreme cases, either of men trying to control every step their wives take (Mrs. Hagen's husband) or of men being reluctant to give up their absolute freedom and autonomy (Gunvor's fiancé, Asbjørg's former husband, and to some extent Marie's husband), demonstrate more clearly than the average cases what values and emotions are involved.

Comparisons and conclusions

Division of work between spouses is thus obviously changing, even if the change is more ideological than practical. The changes become even more striking when these households are compared

292

to traditional peasant, working-class and bourgeois culture. The traditional rural household, as described by anthropologists and ethnologists (for instance Bratrein et.al. 1976, Flakstad 1984, Frykman and Løfgren 1979, Holtedahl 1978, 1982, Saugestad Larsen 1980), was based on spouses being different and complementary kinds of persons. They had different assets and performed different but complementary tasks. Solidarity in the household was achieved by having some common goals and a common estate. Men and women lived segregated lives. They sat apart from each other in the rural church. Men associated with other men and women associated with other women. They seldom participated in mixed gatherings without their spouse. Romantic feelings, in the specific cultural meaning of that term, were ostensibly absent or had at least few organizational consequences. Marriage was based on division of work and economic cooperation. In the mixed economy of Western and Northern Norway women had great influence and autonomy in the household while husbands were away fishing or doing other kinds of work. The wife was accustomed to rough work, as she tended the farm in his absences.

I have several times earlier in this book compared the lives of these women with examples from my former study of working-class families in central Bergen (Gullestad 1978, 1979a). Working-class people in Bergen used to live very densely in one or two rooms plus kitchen. Social life and work life were also to a great extent segregated according to gender. Many married women, however, seem regularly to have had to take paid employment, even during the 1950s, when the housewife role was most firmly established. Neighbourhood contact was extensive, compared to modern new suburban apartment blocks. There were informal customary ways of dealing with closeness and density, more density and direct flow of information than wanted. Such informal practices were a way of guaranteeing autonomy and "peace and quiet" in spite of density.

The bourgeois way of life in 18th century Sweden is described by Frykman and Löfgren (1979). According to the stereotypes of this life, marriage was based on romantic feelings as well as economic factors. The complementarity and contrast between women and men was intensified. The wife supervised activities in the private home. She was refined, angel-like, freed from all mundane activities and not really supposed to enjoy sex. The man's life was

public, the woman's private; he was strong, she was weak; he was active, she was passive, and so on. The biological contrast was reinforced and became a romantic attraction between the sexes. In addition to the togetherness of marriage and family, bourgeois men expressed their individuality through different kinds of public life, including sexual relations with prostitutes.

In the lives of the women and men of this study, it is possible to trace similarities with and contrasts to both traditional bourgeois, peasant and working-class culture. That romantic feelings and attraction are important seems to be a bourgeois heritage. In bourgeois families, however, marriages were to a great extent arranged, based on economic considerations. Romantic feelings have accordingly even more extensive social consequences today than in classic bourgeois family life. Romantic love does thus not exist as a heritage because of a time lag, but is, on the contrary, a theme that is further developed and expanded upon.

There are also similarities between today's women and traditional peasant adaptations. Tasks have changed, but the basic division of responsibilities in the household follows the traditional division of labour among both peasant and urban working-class families. The most fundamental contrasts to these milieus are firstly that both men and women participate in more public arenas outside the household, and that several of these arenas are mixed, not segregated. In bourgeois culture only men participated in such gatherings, without their wives. In traditional peasant society both men and women participated in public arenas, but these were segregated. The claims for emotional "togetherness" of today develop in a situation with less overview over each other's lives.

The second contrast is the fact that the division of tasks is negotiated. Justification and lines of argument have changed, and these have to be distinguished from formal similarities. A family-household implies boundaries against the world and an internal division of tasks. We have seen that the main areas of responsibility for husband and wife inside the household persist, while at the same time tasks change character and spouses help each other out more. Practices have changed, but what has changed even more is the way of thinking about the division of labour. "Togetherness" *(vi har det felles)* and "sharing" *(vi deler det)* between spouses is a new way of expressing and codifying the unity of the household. At the same time as women seek fulfillment in other roles (as

urban men have always had to do), "togetherness" is brought forward as the value of the relations of hearth and home.

The facts that influence changes in division of tasks and ways of thinking about it can be summarized in this way:

(1) The cultural traditions in the region surrounding Bergen, in which women have been relatively responsible and influential. They regularly tended the household and the farm when husbands were away.
(2) A gap between established cultural standards of living and the means to realize them, in their status group and stage of the family's developmental cycle.
(3) Because of this gap the wife's paid work is defined more as a necessity, as part of the process of providing economic support, than before.
(4) Taking up paid work when the children are relatively small and timing paid work and child-care solutions in such a way that the husband is regularly alone with the immediate responsibility for the children and the home. Something happens to a father when he is often alone with the children. Because of the irreversibility of routines established early in marriage these changes become to some extent permanent.
(5) The division of household tasks between the spouses is a symbol of something else and much more than just a practical matter, having to do with both gender identity, love and care. Sharing and togetherness are terms for something deep, important, diffuse and contradictory. They are terms for expectations, longings, visions and dreams.

In addition to the factors examined above, the rising divorce rate might be mentioned as influencing the content of functioning marriages. Divorce is more often initiated by women than by men (Moxnes 1981 and personal communication). There are new kinds of divorce which may be contrasted to the traditional stereotype of the middle-aged man divorcing his middle-aged wife for a younger woman. To some extent divorce today may be seen as a sanction in the hands of women. The reasons and consequences of divorce will be more thoroughly examined in the next chapter.

14. Reflections on the data: Being a woman

After having described different aspects and activity domains of the young women's lives, one after the other, I now examine these activity domains together. I ask what the totality of their lives looks like, and put forward a hypothesis that may explain the findings. The hypothesis is deduced from observations in several different contexts. Its merit is to provide "the last piece of the puzzle", making observations into a consistent pattern.

When one looks at the social organization of their lives, it is indeed striking to what extent the young mothers of this study actually participate in domains of society other than the family and the household. They are not confined to "hearth and home", but enter other fields of the larger society.

In an advanced industrial society most tasks are such that both women and men can do them. There is no necessary gender division of work in terms of technology and organization of work. Theoretically women may do almost any task and there are often some singular examples to show its feasibility. Norway had, for instance, in 1980 one of the few women prime ministers in the world, and the second one in Europe. Still, the labour market is strongly sex-segregated. The young women of this study do not have access to gender neutral jobs, like for instance a professional career. To be a woman is to a large extent a part of the definition of their different occupations such as office clerk, charwoman, waitress, and so on. They operate on the labour market to earn money and to "get away". The jobs they have often give them relatively little in terms of confirmation as good and capable workers, companionship and experience in general. It is not so much the job itself, as the fact of bringing home money that seems to interest them. In addition to that, paid employment is a necessary, if not in itself sufficient, condition for the changed justification of the division of work between spouses. The lack of self-fulfillment in

work is more true of work as a charwoman than work as office clerks and canteen helpers. Students of female employment have made the observation that office workers in their breaks seldom talk about work but mostly talk about "private matters". Talking about private matters provides an escape from the problems of the workplace (Aud Grandaunet, 1981).[1] Perhaps it is the other way around, that they talk about "private matters" because this is what their lives really are about, this is what matters to them. It is in private life that they find opportunities of expressing individuality and crucial identities as good wives and mothers, decent, morally responsible and attractive women.

The kind of work they have often does not seem to offer such possibilities. Seen from this perspective, paid work belongs to the sphere of "hearth and home". That's were they get the pay-offs from its drudgery.

Being a customer at discotheques and other dancing places, on the other hand, is a role they actively seek for its opportunities of expressing their identities as attractive women and having them confirmed. These activities, which they pursue in their free time, are thus also highly gender-charged and not gender neutral. There seem not only to be "pulls" from society – discotheques exist and expand as commercial amusement – but also "pushes" from the other domains where they are active. Paid work does not, as noted above, offer a lot in terms of fulfillment and self-expression. Hearth and home, on the other hand, is the central domain for the realization of important values. It is my hypothesis that there are fundamental contradictions within hearth and home and the relationships there which pull the women out of hearth and home and thereby explain part of the meaning of going out.

The tension between sameness and sexuality

Let us examine the marriage relationship, step by step. A marriage relationship has many dimensions, not only division of work, but also parenthood, love, friendship and sexuality between the spouses. As we saw in the last chapter, the ideas of togetherness and sharing are gaining ground in the lives of my informants. This change is both ideological – comprising new kinds of justification and justice – and practical, whether directly or indirectly.

297

The ideas of togetherness and sharing are connected both to feelings of closeness and intimacy and to ideals about equality between the spouses. The closeness and intimacy between spouses includes sexual intimacy as a central part, but rests most of all on the meaning of equality. Doing things together and sharing the household tasks have become signs of a desired equality between the spouses, and signs of loyalty and love. By togetherness and sharing their relationship is confirmed as being one between equals. Equality, in this culture, means that the total relationship between the spouses is ideally symmetrical and equal and not asymmetrical and hierarchical; it means natural equality, being and doing similar things. Equality as similarity is related to unity and jointness between spouses. The terms in which the division of tasks is argued and negotiated between the spouses have changed from complementarity and segregation to unity and jointness, conceived of as being opposed to segregation and complementarity. Arguments like "I work full time just as much as you do, and therefore ..." or "I have been home with the children all day and that's work too, so therefore ..." are, as we have seen, most forceful in such negotiations.

These changes are in accordance with cultural changes in society at large. The women's movement in the 1970s had its strongest hold in the educated "student" middle class. It has been characteristic of the Scandinavian debate about sex roles that women, when changing their roles, claim the husband's help with home and children in addition to help from state institutions. In several other countries women generally have claimed more extensive help from society not only in the form of nursery schools and day-care centres, but also in the form of hot meals in schools and workplaces, municipal kitchens from which one can fetch good inexpensive meals, and so on. This, in my view, is not only another reflection of the home-centredness of Scandinavian culture, but also of the new ideal of husband and wife as a team for housework and child care.

Working-class women generally do not identify with the women's movement, but many ideas articulated in it have obviously gained ground in other milieus than the women's movement, through television and magazines. Or, rather, I believe, it is the other way around. These ideas are in accordance with deeply held values in Norwegian society, and this gives them some of their

force in different milieus. They are, however, more forceful in some social circles than others. There are structural similarities between lower-class women with no education and professional women with high university education which I will discuss below. Here it suffices to say that a general way of thinking, regarding equality as similarity and sameness, is applied to a context where it has not been applied before, the family. The strong egalitarian ethos in Norway lends force to changes in negotiations between the spouses. Spouses become more similar, because both have paid work and because they have more free time together where tasks are divided with some reference to the ideas of sharing.

At the same time as the idea of equality as similarity gains hold in the marriage relationship and the family, the Norwegian (or Northern Scandinavian?) ideal of individualism as independence is also gaining hold there. Independence is logically connected to equality as similarity because the relationship between the spouses is built on loyalty more than dependence. These two values, equality as similarity and independence are thus not conflicting.

Traditionally, the autonomous unit is the household. The household has to be independent and self-sufficient as against the world. Equality as similarity between the spouses brings the ideal of independence inside the household. Doing and being the same as opposed to difference and complementarity implies independence and self-sufficiency of individual members. Equality is based on and by itself produces autonomy. It makes the family into a firm in which the spouses are supposed to increase their emotional investment ("togetherness" and "sharing") but which also has a higher incidence of competition than before, and thereby provides the organizational base for an easier splitting of the unit into two independent units. Not only men, but also women want to be autonomous individuals as well as members of a household. Along with "togetherness" and "sharing", the value of independence thus also develops inside the family-household. When women go out to discotheques (and signal femininity to other men), they at the same time signal independence to their husbands. Sharing and togetherness go together with more autonomy for the wife and perhaps less autonomy for the husband, whose role is traditionally defined in the most autonomous terms.

According to my hypothesis there is some tension between the values of equality as similarity and independence, on the one

hand, and on the other hand, romantic love and sexuality between the spouses over time, because sexuality and romantic love imply some complementarity and dependence. During the last decades there have been considerable changes in the sexual mores of Norwegian society as well as of other Western societies. Mores are not only changing, sexuality also seems to become more and more important. One might mention the number of books, films, and magazines on the subject, as well as rising living standards, with the money and leisure and ways of dressing that make it possible for wider groups (in terms of social class and age) to act out identities as sexually attractive persons. Western society has to some extent become sexualized, impregnated by sexuality. Sexuality and attraction are, however, if one is married, only legitimately consummated within the marriage relationship.

In their erotic relationship to each other spouses are, in some ways, legitimately different and complementary persons. Sexual love implies a biological contrast and complementarity, and this contrast has also accumulated extra symbolic reinforcement. In these activities spouses are not similar. It may be debated to what extent the symbolic reinforcement of biological complementarity is unnecessary. But as things are, spouses marry because of love and attraction, because they, in some ways, are complementary. But other functionings of the household are, as already noted, more and more also based on sameness, doing and being similar. The tendency is to define tasks in gender neutral terms, thus making the household a gender neutral arena, at the same time as it is the most legitimate (and highly charged) sexual arena.

The wives' ideal is that spouses should divide tasks between them as a team of equals, that the relationship is symmetrical, and that she does not have less rank and authority than he, all of which are connected to what seems to be a central dilemma: the marriage relationship between husband and wife is largely acted out in the same setting as the household, and the household trivialities provide the immediate context for their love relationship as well as vice versa. They may, among other things be used as sanctions for each other. What happens over the dishes is a sign of the quality of their love relationship; the different activities and relationships are interwoven in complex ways.

My hypothesis is that equality as sameness between the spouses within the household makes the expression of gender identity

problematical when it occurs in a society that stresses both sexuality and monogamous "romantic" love. There seem to be tensions between sexuality and gender neutral division of labour, between attraction and household tasks. This tendency results in what may, in its extremes, be called (by the anthropologist) a household of peers or a sibling-like marriage. The husband is associated with the warmth, security and cosiness of the home as opposed to the excitement and danger of the outside world. The analogy of siblings should connote that the spouses are close (in this case as coparents and running a household together), that they are different (of different sex), but that they are in some fundamental way also the same. Siblings are close because of common childhood, but they are not supposed to have sexual feelings for each other. Their relationship is per definition close but asexual. In the case of the sibling-like marriage the partners do become too close through similarities in their activities to be able to maintain much in the way of erotic attraction for each other over time.[2]

Direct empirical evidence to defend this hypothesis is scarce. Common to my informants (and to most Norwegians) is the factor that sexual love is the most private part of life, as indicated by the parents' bedroom being the room that visitors are least likely to enter.

Children, except for babies, generally sleep in another room than their parents. There is thus obviously the *space* available to separate the erotic from the other different activities that go into a marriage. It seems, all the same, that it may sometimes be difficult to separate the love relationship of marriage and the household tasks that have to be done, to separate contexts and relationships sufficiently to forward the element of attraction and difference between spouses. It is difficult not to carry eventual disappointments or other dimensions over to erotic life, to create a world of erotic play, completely independent of the trivialities of the day.[3] The stage in life when the couple has small children is particularly stressful because demanding household tasks have to be done.

Not only is the bedroom the most private room, sexuality is also the most private topic of conversation. The young women talk about their bodies and about sexuality in a very direct way (compared to Norwegian middle-class practices). At the same time they seldom talk about personal feelings of sexual love.

From this one could of course conclude that my informants are particularly confident regarding love and sexuality. This is not, however, the impression one gets. During the fieldwork I was struck by how differently these women of the same milieu seem to relate to their own bodies and to male partners. I also got the impression that sexuality and love seem to be extremely important while at the same time there is for some women much insecurity hidden behind what is too private and personal to be talked about. They talk extensively around erotic love, not about it.

In addition, an eventual erotic disappointment in the marriage relationship seems to be a kind of non-event. There simply is nothing to tell before the consequences eventually make themselves felt in the form of, for instance, a jealousy crisis. Such crises are extensively debated, and, as we have seen, self-esteem is very much part of what is at stake in these situations.

Disappointments about division of work, on the other hand, seem easier to categorize and name, and can more legitimately be put forward. They do not to the same extent involve feelings of personal worth.

Owing to the relative lack of evidence, however, my hypothesis is a kind of inspired guesswork. On the basis of data and analysis I launch a hypothesis that explains why the young women are pursuing conflicting roles and values. They do this to solve the tension in marriage, and are thereby solving one problem by creating others elsewhere. They are looking for something that is difficult to find because of its inherent tensions. The only relationship where sexuality can legitimately be consummated, if one is married, is the one that tends to be defined in gender neutral terms. This tension explains the emotional intensity of their discourse. Integrating conflicting roles and experiences is vital to their practical daily life and to their identities as valuable human beings, as good wives and mothers and attractive women. (See chapter eleven about moral discourse.) Some fail, however, to achieve this integration. In the search for integration and wholeness the most fundamental relationship in their adaptation as women seems to be the "weakest link" of the chain. Marriage crisis and divorce cause the most dramatic incidents in the stage of life of my informants. Divorce has become a normal statistical, if not cultural, fact in the lives of Norwegians.

Divorce

According to my hypothesis the tensions between sameness and sexuality do not make either profound long-term love relationships or married life impossible, but they represent tensions that all married couples are affected by, and that some of them find more successful solutions to than others. Solutions can be of many different kinds, for instance the ability to create separate erotic "play worlds", lower expectations towards sexuality, lower expectations towards monogamy. All the same many marriages break up, and in my view this can to some extent be explained by the tensions between the basis for a marriage and its functioning in the context of a household and the wider society.[4] Their relevance for the understanding of divorce may be summarized as follows:

(1) Women and men are looking for love and attraction. Romantic love is the basis for marriage, for the decision between a man and a woman to make a household together. The value of romantic love is, among other things, revealed in the importance of being in love *(være forelsket)*. A good marriage relationship that works right solves the contradiction between self-realization and jointness and between sexuality and equality as similarity.

(2) Sexuality has become more and more important in Western society. Sexuality and attraction are related to togetherness in marriage and to self-expression outside marriage. Attraction has become one important way of seeking self-fulfillment and confirmation as a valuable and able-bodied human being. The sexualization of society is then one main condition for the rising number of divorce cases. People have very high expectations of marital erotic love, and since these matters are the most private and least talked about, it is difficult to get real checks on those expectations. There seems to be much personal insecurity about sexuality and love. To some extent, people do not have words and concepts to express their feelings, and, to the extent that they have words and notions, these feelings are seldom revealed in direct ways outside the actual love relationship.

(3) Norwegian culture is home-centred, which means that the spouses spend most of their free time together in the home,

both performing household tasks and relaxing in each other's company. Norwegians generally also seem to be reluctant to create secondary "play worlds" (Tord Larsen, 1982). In addition the stage in the family developmental cycle when the couple has small children is the most stressful in terms of tasks and needs. All these different aspects of their life situation intensify the tensions between household trivialities and erotic love, by making it difficult to separate the one from the other.

(4) There is a loss of self-esteem if the partner is attracted to another person. The context for life-long monogamy is the nuclear family household. Claims for emotional intimacy and closeness between spouses have become stronger. They also more and more express their life together and the division of work between them in terms of unity and jointness as opposed to the complementarity and segregation of, in different ways, both traditional peasant society, urban working-class society, and early bourgeois society.

(5) Difficult and stressful relationships tend to be codified in terms of something being wrong with one or both of the persons, rather than with the relationship, both by the spouses themselves and by persons who know them. This reflects the elementary nature of the notion of the individual, and it means that if marriage does not work, one easily thinks in terms of changing the person rather than changing ideas and dreams about love. The persons filling the positions may change while the idea of stable long-term monogamous relationships persists. The nuclear family ideal is strong and not fundamentally disturbed by divorce. Mother and child form the most enduring social relationship, and this is reinforced by divorce.

(6) When the relationship becomes strained, the attraction of divorce depends to some extent on how much one loses by choosing this alternative. Women in some class positions seem to have less to lose by divorce than others. Another way of putting it is that men have more to offer in some social milieus than others.

This last point departs partly from the themes of equality, autonomy, and the tensions between similarity and romantic love, and needs therefore some further explanation. Being able to survive economically and culturally without a husband is a factor that

supplements the other factors outlined above, leading to divorce as a solution to strained marriages. The working class women of this study are helped by state and municipal services to cope with a situation as divorced mothers. In fact some, like Sissel, get a new opportunity to acquire an education that they would not have got as married women. Firstly, there are from the beginning relatively small differences between men and women in class terms. Secondly, the welfare state makes it possible to survive as a single mother without a husband. Separation and divorce create a whole range of economic, practical and emotional problems in this as well as in other social milieus. It is still somewhat stigmatizing to be a single mother, but, with a rising divorce rate, less so than before. All these problems, however, do not stop young mothers from trying out this solution when emotional difficulties are great. And divorce becomes less stigmatizing the more women are "in the same boat". If one is young and pretty, one is optimistic and believes one will soon "find a nice new man and start a new life". According to the statistics most divorced men and women in this age group do in fact remarry.[5] In the long run, however, single divorced mothers with children are the new poor of the welfare state. The woman who does not take a job becomes isolated and more or less confined to the neighbourhood. Social security benefits are too limited to live what is considered to be a decent ordinary life. When the children get older they need ever more equipment and clothes. The woman who takes a job often does not earn enough alone to make a "decent ordinary life" for herself and her growing children. Her economy is one of mere survival.

Sine most men and women remarry, however, a working-class man has less to offer a wife for staying married than for instance, a typical business man. A business man often builds up his career together with his wife. She pays for the high rank of being his wife by subordinating herself to him in marriage. His career is the concern of both. Their relationship is more of a real partnership, if a partnership is defined by the partners having different roles. In such a marriage they have different but also unequal gender roles. He has the prospects of promotion, of bettering their kind of housing, the kind of people they meet, the resort places they visit on holidays, and so on. The difference between them in class terms is greater. Her class position is to some extent "borrowed", so she loses most by divorce.

Middle-class women with a relatively well-paid profession of their own are both different from and similar to the working-class women of this book. Since they have a profession, they too are able to run a household on their own without a male head. Two professionals with a solidaric community of consumption are much better off than a single person with children, but the differences are often not great enough to keep such a woman from divorcing, if the emotional strains of marriage are heavy. There are thus some similarities between women with the least and women with the most education in this respect. The adequacy of this analysis is reflected in the divorce statistics. In Social Survey 1980, page 106, one finds the following passage (my translation):

> The risk of divorce varies with the education of the spouses. Both for men and women divorce is most common for those who do not have any education above primary school, less common for those who have education on a university level, and occurs a lot more seldom for those with education on a secondary school or junior college level. For the period 1971–73 the number of divorces per 1000 marriages was 8 where the husband had no education above primary school, around 4 where he had education on a junior college (*gymnas*) level, and 6 where the husband had education on a university level. The greatest number of divorces, however, occurred in marriages where the wife had a university-level education, with 10 per 1000 in the same period. These numbers must be interpreted with caution. Many other factors are connected with education (income, place of living, employment and the like) and we do not know what factors are really at work here.

These figures, except for the last one, are about the education of the man in the marriage. Since women generally marry men with higher education and better positions than themselves, it seems that included in the category of men with university education is also the category of those married to women with university-level education. If one accordingly excludes these marriages from the category, then the divorce numbers of men with university-level education married to women without such education will become smaller, and the differences even more striking. There are good reasons to believe that men with only primary school education are

married to women with the same level of schooling, and that women with university-level education are married to men with the same level of schooling. The categories with most divorce are thus those where the differences between the spouses in terms of education are smallest.

There are also reasons to believe that it is among women with most education and among women with least education that one, for different reasons, finds women with paid employment. This hypothesis is also, to some extent, supported by statistics (An-Magritt Jensen 1981). Working-class women work mainly because the rising prices relative to the established cultural standards of living and the developmental cycle of the family have made it an economic necessity, but also to "get away". Highly educated women work primarily because they find accomplishment and self-fulfilment in their work as well as because of the wage.[6]

Women with high education and women with low education live in different social and cultural universes, with some barriers of communication between them (see chapter four and other chapters of this book). In class terms, strictly speaking, their positions are closer. Following Wright's categories (Wright 1978, 1980) educated women often work in semi-autonomous professions, in contradictory class positions close to the proletariat. The structural similarity between women with the highest and women with the lowest education is, however, rather based on their relative equality with their own husbands and, as already discussed, the intervention of the welfare state, which helps single mothers survive. State and municipal help is greater in a working-class context than in a middle-class context, because the economic needs are greater there. In those middle-class contexts where the wife has a "borrowed" status, the needs after divorce may be smaller in terms of mere survival but perhaps greater in terms of cultural and social survival. In other words, what she has to live on after divorce may be more than a working-class woman has to live on, but her drop in living standard is greater.

On this basis one may venture the following hypotheses for the differences in divorce numbers:

(1) The greater the difference between husband and wife is in terms of education, occupation and class position, the more stable is the marriage.

307

(2) Marriages are more stable when wives are housewives and do not have any kind of paid employment.

If these hypotheses hold true, divorce may be explained as (a) the result of moral contradictions and problems, and (b) a problem solution chosen by the women most similar to their own husbands in terms of education, class and paid employment.

It is also important to note that not only are rates of divorce differentiated between different categories; functioning marriages are probably also different. The potentiality of divorce is to some extent a new sanction in the hands of women. In working-class milieus divorce is the threat behind the sanction of "throwing out" in the case of a serious offence, and lends force to the arguments for change in the division of tasks between the spouses.

"Sharing" and "togetherness" are thus related to divorce in an intriguing way. Sharing means, in the milieu studied, equality as similarity or sameness. In milieus with great differences between husband and wife, (he is, for instance, a prospective company director and she is a former secretary), marriage may be expected to be somewhat more of a real partnership, but a partnership based not only on complementarity but also hierarchy. Where the differences are greater, men have more to offer in return for a more hierarchical marriage. The trend in the direction of "sharing" as sameness seems, however, to some extent to be ubiquitous. Norwegian women want more equality in decision-making and division of work in the household. In different social milieus they have different resources to achieve their ends. "Sharing" as sameness is valued inside marriage, but pursuing this value leads in some cases to divorce, and divorce stresses difference rather than similarity. The women continue to run the household alone. She is a mother, and fundamentally different from a father. Sharing and sameness within marriage are thus related to a growing tendency to matrifocality by divorce. Because of the instability of family life, the potential for change in the roles of father and husband implied in sharing becomes less prominent.

Going out

Going out may thus partly be explained by the tensions in marriage and household. They actively seek excitement and attraction, but as we have seen, control is the key word for the handling of female sexuality. Their way of thinking about sexuality seems, among other things, to be informed by the pietism of Western Norway. What is, ethnographically speaking, so striking about the material I have presented here, is the concurrence of a relatively strict morality and seeking out roles and arenas where this morality is maximally threatened. This part of the material is, as noted earlier, to some extent parallel to Anne Rasmussen's study of young unmarried girls at a harbour café in a Norwegian city in the 1960s. In her terminology they followed a strategy of chastity in an environment of non-chastity, as a self-organized rite to achieve womanhood, to overcome the difficult balancing between whore and old maid (Anne Rasmussen 1969, 1983). This pattern was found in the lower classes of a port. One is, however, reminded of descriptions of the practice of "night courting" *(nattefrieri)* of some communities in rural Northern Scandinavia described, among others, by Eilert Sundt (1855) and Frykman (1977). Night courting was organized by the young people of the community themselves, and consisted of young men being allowed to visit young women in their sleeping quarters. They were not supposed to have sexual intercourse. The custom gave young people an opportunity to get to know each other and test out manhood and womanhood, maximal freedom under moral constraints. Night courting did not exist in Southern Scandinavia. Northern Scandinavia was characterized by being less stratified, more socially homogeneous than Southern Scandinavia. In Southern Scandinavia parents, if they owned land, decided on who were to be the spouses of their sons and daughters, and it was a matter of very careful choice. In Nothern Scandinavia young people did to a large extent choose their spouses themselves, but needed the consent of their parents.

It is tempting, if perhaps far-fetched, to suggest a relationship between night courting in former rural Northern Scandinavia and urban working-class women wanting both good morals and fun, balancing between opposed norms. What is today an urban lower-class pattern may or may not be rooted in practices of the more

homogeneous rural Northern Scandinavia, but the similarities of the practices and the female dilemmas involved are striking.

Such practices may be seen as a version of more general Norwegian ways of handling social life, combining a strict morality with maximal freedom. Child-care practices encouraging children to play outdoors on their own is another example. The young women also see themselves as responsible for controlling both their own and their men's sexuality and use of alcohol. Like most Norwegians they attend church at baptisms, weddings and funerals, otherwise they seldom speak about religion and perform no other Christian rituals. In spite of being secularized, their thinking still seems to be somewhat informed by the ideas of pietist Christianity. Drinking and dancing are activities that in themselves are very contrary to pietist Christianity. But the way the young women think about drinking and dancing seems to be closer to pietism. In Norway pietism has a particularly strong hold in the southern and western parts of the country. Pietism seems to survive without Christianity.

The women of this study are not, however, young girls but mothers and, to some extent, married women. One might say that after some years of motherhood they have picked up their adolescence where they last left it, but that would not be a correct interpretation. What they do is fundamentally coloured by the fact that they are mothers and have a home. One aspect of going out may be a trial and error of new practices adapted to the fact of divorce. Going out is a way of trying out one's chances of forming a new relationship and a way of setting the stage for new courtships. Most importantly, going out is a way of being confirmed as an attractive woman.

Some of the absoluteness of their views on moral issues may perhaps be attributed to their youth. The mothers of the young women that I know all struck me, in comparison, as women whose life experience had taught them a great deal of wisdom and tolerance, although their ways of thinking were not less absolute than those of their daughters.

At one level of analysis going out is, as already noted, opposite and contradictory to the values of hearth and home. But as long as they do "nothing wrong", going out and seeking confirmation of their identities as attractive women from men other than husbands is a way of trying to solve the tension between sexuality and

sameness in marriage and household. Having gained such confirmation they can then return reinforced by it to marriage. As long as it works, they somehow manage to have their cake and eat it too. When marriage breaks up, going out is a way of finding a new relationship, "a nice new man to start anew with".

In both ways going out leads back to the relationships of hearth and home, and this is what I call the magic circle of their lives. By trying to find solutions to the dilemma between, on the one hand, gender identity and sexuality and, on the other hand, similarity, jointness and unity, they maintain, confirm and intensify those same values. Both working life and social life lead back to and confirm the values of hearth and home. The values and activities of home and family relationships are reinforced as well as modified in the process.

The attractive woman identity

The "attractive woman" identity is a generalization I have derived from the data about natural conversations and observed behaviour, which summarizes the meaning of a whole range of activities, notions and ways of thinking presented in earlier chapters. The attractive woman identity is not a new identity. On the contrary it is, in its most general sense, as old as womankind. What is new, in this urban Norwegian context, is the way it is connected to individuality and, also, some of the fora for acting it out. Seen from one perspective, the range of alternatives and experiences of the young mothers in this study may seem poor. Seen from another angle, they are extremely forceful, enterprising and creative, making a lot out of the limited means at hand. One may ask to what extent the importance of being confirmed as attractive women is peculiar to women of this social milieu or general for most Norwegian women. In my view the attractive woman identity is important to women of all classes and in most places at this stage in their life cycle. Let us continue the argument from the last chapter by using contemporary urban Norwegian women from other social classes as contrasts.

One contrast is the housewife married to a business man. Mette Jørstad (personal communication) has written an interesting sketch about an upper-middle-class milieu in the city of Bergen in the 1960s. The husbands were top leaders or capitalists. The wives

had got some, but not very much education, secretarial school and a year abroad, an education designed only to be used before marriage and not after. They were restricted in the roles they could take in addition to being wives and mothers. They received generous housekeeping money, but had no overview over the family's economic situation. They were expected to participate in charity organizations, not in the labour market. They could go to expensive lunches with their women friends at noon, but not visit bars together with them in the evening. They participated in large mixed parties with their husbands, but were not expected to put themselves forward. The men did the talking, the women embellished the men's surroundings. The women were experts on an upper-middle-class life style, of how to do things elaborately in the "right" way to give off signs of the standing of their families. When reading this material one easily calls to mind Henrik Ibsen's *A Doll's House*. The "right" way is very often a matter of elaboration of form, or taking some extra care by, for instance, setting a dinner table nicely or in making the ice-cream oneself instead of buying it ready-made as most other Norwegians do.

Consider then again the woman with a well-paid profession. Like the working-class woman she participates to a considerable extent in domains outside hearth and home. But in some contrast, especially to the charwoman, her profession and organizational life may give her a feeling of identity and accomplishment by doing good and satisfying work. She also has more sexually neutral ways of expressing individuality. Professional activities often have dynamics of their own which does not entirely lead back to hearth and home, but instead also provides her with a second point of gravity in her life. In addition, professional activities also provide fora for meeting men and having the attractive woman identity confirmed, like courses, seminars and conferences. Social contexts are not specialized for that identity, the way discotheques and public dancing places are. She has thus more choice of fora in which to act out this identity, not as the main identity but as an adjunct to doing other tasks at hand.

Compared to the upper-class housewife and the professional woman, the women of this study are both more restricted and more free.

The professional woman has her work, and both the professional woman and the upper-class housewife do perhaps join organiza-

tions and attend cultural events. At the same time the working-class woman has a wider range of activities and fora than the wife of the business man. She has a job, her loyalty to her husband does not stop her from having close relationships with friends, she has a say and some overview in economic matters, and she "goes out". Middle- and upper-class woman do not go out to discotheques and dancing places without male excort the way working-class women do.

A closer social grouping, in terms of stratification, is the middle middle-class families in Oslo, described and analyzed by Hanne Haavind (1979). Her families all have one child aged four and perhaps also other children. The husband is typically some kind of functionary and the wife may have a part-time job "if it does not affect anything at home". From Haavind's data it seems that each nuclear family is turned inwards on itself. The ritual boundaries around the family are sharper. Women long for a good female friend, but not everyone has one. The values and activities of marriage, motherhood and hearth and home are such that they, to some extent, seem to prevent women from developing female solidarity and expression of individuality outside the home. It is more difficult to find justification for participating in roles and fora outside hearth and home. They have accordingly fewer fora and occasions to express identities as attractive women. More of their life seems to be circumscribed by the home.

In addition to having more direct and specialized roles and fora for acting out the attractive woman identity, working-class women do perhaps also have more direct signs for expressing it, in dress and behaviour. Dress is, for instance, a complicated system of signs. In a historical perspective the young women exemplify a version of unisex dress because they wear jeans and tweed sport jackets, traditional male dress. But there are also elaborate female signs. The jeans are tight and reveal their figure. Compared with Norwegian student and academic women they wear tighter jeans, higher heels, more make-up, more jewelry and so on. Compared with women associating with business men the picture is more complicated, since these women more often wear skirts, dresses, and other feminine attire. These differences belong to the general differences between classes. When middle-class women act out identities as attractive women, it probably shows less because their signs are more indirect. For this reason it is easy to overestimate

the importance of the attractive woman identity for the women of this study, relative to women of other classes.

There are, however, more arguments emphasizing class differences about where, how, and to what extent the attractive woman identity is acted out. For working-class women glamour, beauty, being attractive represent a traditional path to success in life. They seem perhaps to have more positive views on beauty and glamour than (especially academic) middle-class persons, and identify more with upper-middle-class women in style. For working-class men and women there have always been a few traditional shortcuts to success that did not necessarily need any education. Men may become famous sportstars and popsingers, while a woman may win beauty contests or marry a rich man because of her beauty.

Summa summarum, the variations considered here may be seen as variations of (a) the social contexts for acting out the attractive woman identity (the young women I have described actively seek specialized fora outside the home), (b) the specific and detailed ways of signalling attractiveness – there are more or less direct ways of acting out this identity, and (c) the alternative identities available. Working-class women have fewer alternatives than professional women.

Conclusions: The magic circle

To have a good relationship with a man is connected to a whole constellation of values and relationships that are important to women irrespective of class: the trinity of home, husband and children. A few other studies, though on another level of analysis, might be mentioned here. Nancy Chodorow's (1974) hypothesis about personality differences is often cited. She proposes that, in any given society, feminine personality comes to define itself in terms of binding and personal relations to other people. Masculine personality defines itself more in terms of how men organize their relationships through material objects. She points to the central importance of the mother-daughter relationship for women, and to the conscious and unconscious effects of early involvement with a woman for children of both sexes. Boys are in her view less submissive than girls because they early have to repudiate the authority of the mother and identify with the father and the peer group. Sigurd Berentzen (1980, 1981), in his studies of children

314

and adolescents, contrasts a relational orientation in the case of girls to boys' orientation towards achievement and material objects. Anne Solberg (1982) has made the same interpretation of her data about children's work. In a study at two teachers' colleges Kjellaug Waage (personal communication) has found that for female students relationships with men, in the sense of attaching oneself to one particular man, is given priority to their lives as professionals.

These findings add some generality to the intensity of the dilemmas discussed by the young women of this study. There seems to be a profound sense in which searching for the one particular man and having this relationship "work out right" is a high priority goal. This would permanently resolve the dilemma of community and independence. To be able to handle one man implies, however, that one is able to handle men in general. They express independence and individuality by relating to men. In this way love and attraction are central values in these women's lives.

The rising divorce rate does not contradict this statement. It may be argued that divorce occurs because people have increased expectations and require a relationship that succeeds in combining cooperation about running a household with love and attraction. In the course of this search for love, individual marriages are lost. If one relationship does not work, one may start searching for another one.

Being a mother is linked to love. Children are ideally a product of a good and satisfying love relationship. Those who divorce want to find a new man who is willing to take on the responsibilities of a father. Children are fundamental for women, but to some extent they are taken for granted, and men are the focus of the most immediate and problematic interest for the women of this study. There are probably some contrasts to other milieus in this respect, for instance to the kind of milieus described by Hanne Haavind (1979) mentioned earlier. One might argue that the women she has studied seem to tie more of their self-expression to their children. They seem to have different ideas both about the needs of children and spouse and about how to create well-being for their families, than the women described in this study. Family values matter to both the women of this study and the ones Hanne Haavind has described, but the relative weight of different relationships inside and outside the family varies slightly.

The relative weight of relationships outside the nuclear family versus relationships inside it also seems to vary. The women described here have friends. But relationships with men are to some extent what female friendships are about. Marriage and family are not about female friends, but female friendships are, among other things, about marriage and family and their integration into society. Men in general and the husband in particular have in these specific ways priority to female friendship. Female friendships can be seen as a mediator between family and marriage and the outside world, because here many of the conflicts and dilemmas of integrating diverse roles are discussed. Women give each other permissions, support, sanctions, warnings and interpretations when taking up new roles and activities. The content of and boundaries around the private world of the family are changed by women taking on other roles, and by their discussions of the integration of marriage and family and these other roles. Friends, then, support the relationships of hearth and home by trying to solve the contradictions there. This again leads to the conflicts in female friendships about spreading rumours (described in chapter eleven).

The lives of the enterprising and culture-building young mothers of this study are circumscribed by their class in all the specific attitudes of their lives: child care practices, the importance of cleanliness, what is considered "good taste", attitudes towards money, and the degree to which a strict morality is combined with maximal freedom. A strong orientation towards family relationships and the home is combined with actively seeking relations and fora outside the home. At one level these activities contradict the values of home and family, but on another level they lead back to it, by being efforts to solve central dilemmas in family and household. Likewise they experience the dilemma between prestige and equality in a specific way that ensures, to a certain extent, the parallel change of their lives. Working-class life, as well as life in other classes, undergoes economic, social and cultural change. There are some similarities between the underlying patterns of business-class and working-class life styles. Cultural and social boundaries, however, seem to persist, even if their content and the way they are drawn are changed.

Secondly the young mothers are Norwegian in the ways they pursue independence, peace and quiet, and equality. They are

also Norwegian in the secularized pietist ethic of their discourse.

Thirdly these are typical Norwegian (or Western?) female lives in the way individuality is strongly connected to love and attraction and how being mothers colours almost everything else that they do. The trinity of home, spouse, and children is important to most Western women. At the same time the magic circle is a metaphor that characterizes the female lives described in this book particularly well. They seek ways out of hearth and home more actively than the middle-class housewife does, and their activities lead more directly back to hearth and home than the work of the professional woman. The magic ring of love gives meaning to life, but keeps them also in a vicious circle. The central importance of close relationships partly explains the dramatic inequality of women in domains like paid employment and politics. (Other parts of the explanation are connected to communication barriers and discrimination in these domains.) Yet, in some domains, the women in this book are both strong, enterprising and culturebuilding. They play a crucial role in creating and maintaining family networks and family life style.

15. Reflections on the data: Being Norwegian

The representativeness of the material

Do the few women of this study represent only themselves, or are the patterns examined typical of larger populations? What is the generality of the material? Do they represent Northern Euro-peans, Northern Scandinavians, Norwegians, Western Norwe-gians, people living in the city of Bergen, working-clases culture, young unskilled or semi-skilled women who early became mothers, or something else? The answer is that they probably in some ways represent all of these things, but that I cannot really tell which they represent the most. Notions about gender, class and ethnicity are abstractions that merge together in real life, shaping both life situations and ways of thinking about them. Our concepts are unidimensional, whereas life is multidimensional and not ade-quately portrayed by using one notion at a time.

In the preceding chapter I examined what the data tell about what it means to be a woman, and I could not do this without discussing the influence of time, region, social class, etc. In this chapter I examine what the data tell about Norwegian culture, both in a more general and in a more specific subcultural sense. In the same way as with gender the examination of culture cannot, in my view, be done without taking into account differences of gen-der, class, region etc.

First of all I should like to make a few methodological remarks. One reason why it is difficult to answer questions about represent-ativeness is that Norway is a complex society with numerous institutions and life styles, while at the same time the number of main informants in this study is relatively small. Anthropologists usually work with a limited number of main informants, often a smaller number than I have used here. But because the social universe is (or seems) easier to delineate *a priori,* and because other societies are less privatized and home-centred than Norwe-

gian cities, they often have a larger number of secondary informants. Participant observation in such societies also provides data that are more comprehensive in terms of settings, tasks and social occasions than the data I have been able to collect. Moreover, census data from those kinds of field situations usually cover one or several localities completely. In spite of these differences, however, one might argue that there is some problem of representativeness, whether one works in New Guinea or in Norway. To reduce this problem my method throughout the book has constantly been to make comparisons and contrasts by adding what additional information about Norwegian society I am aware of.

One needs, however, more ethnographic knowledge to locate the way of life described in this study properly in the context of Norwegian culture and society as well as in the context of women's studies. It is my hope that the present study will stimulate further research along these lines.

What I have portrayed is a subculture and women's culture within a subculture. Methodologically one finds the subcultural variations first and more general values last. What one records as a fieldworker is in one way or another subcultural. More general values are found through analysis, and through comparison with additional ethnographic material. I have tried to record, in one domain after the other, the notions and concepts people use to give actions meaning. On the basis of such information, when I have found similar ways of thinking in different contexts, I have summarized these ways of thinking by characterizing them by means of translating them into a comparative language. Autonomy or independence is, for instance, one such summarized generalization, based on observations of behaviour related to different domains and listening to how people talk about and judge actions, especially in situations of conflict. 'It is best to be one's own master' *(rå seg sjøl)*, 'Everybody has to struggle for themselves' *(Enhver får kave for seg sjøl)*, 'Everybody has problems of their own' *(Hver har jo sitt)*, 'It is best to keep one's options open' *(Det er best å ha ryggen fri)* are expressions often used, in different contexts, to interpret, explain and advise. What is normally interesting about anthropological finding is, however, not primarily the general and often more abstract formulations of ideas, but their complex specificity and their circumstantiality. It is the specific codifications of independence – what it means, for in-

319

stance, for a young couple not to live "too close" to parents or parents-in-law – that have consequences in social life.

Analytically one may see the problem the other way round: general values are codified through different life situations and possibilities (shaped for instance by regional traditions, people's position on the labour market, the sex of persons, etc.). These codified values, clothed in specific circumstances, are the substance of subculture. It is through specific codifications and behavioural routines that people usually learn the overarching general values and ideas of the culture; general values and ideas overarch subcultural variations. Specific value dilemmas reflect general values. Such general values are not necessarily contradictory and conflicting in themselves, but may become so in contexts that bring them together and make them conflicting. Value dilemmas are to this extent organizational dilemmas. In their conversations the young mothers express some of their value dilemmas. To solve these dilemmas they develop specific informal rules, role solutions and routines. These role routines may be seen as subcultural. They are models or patterns for coping. It is easy to reify the different levels of such stratified view of culture. I do not see each level as a complete and fully integrated system of symbols and values. Instead I think in terms of degrees of generalization and specificity. Role routines and ideas about them are specific versions of something more general. More general ideas and values only indirectly generate subcultural practices and routines, since they are constantly modified by local and life situational circumstances. The identification of such ideas is the last step of an analysis. One identifies such values through the analysis of role-dilemmas and routinized role solutions. The relationship of values to each other is not directly reflected in value dilemmas, because, as mentioned above, these dilemmas are to some extent organizational. One has to look at different domains of life in order to discover such ideas and values. The distinction between actions and ideas is in many ways difficult. We cannot conceive of one without the other. There are no ideas without actions to codify, and people's perception of actions is shaped by the ideas and values that they have. One might say that values and ideas are prior to actions but are given meaning and modified, over the years, by actions. Making economic provision may be primary, but once ideas and values are there, they get a force of their own,

which modifies the development of the mode of production. The relationship between economic base and superstructure follows a complicated dialectique; one is not merely reflecting or cannot merely be taken as an index for the other. Specific ways of thinking and doing are more easily changed by changes in circumstances than are more general ideas. The women of this study have, for instance, easily taken up smoking and driving cars. But they do not as easily change fundamental conceptions and notions about reality.

Identifying cultural themes

In the chapters of this book I have shown, in one domain after the other, how some fundamental notions about the social person and about social relationships exist in several domains of life and form fundamental premises for how social relations are constructed. These ideas are taken for granted to such an extent that almost no experience will make a person change them. Over a larger time span, however, counting time in centuries rather than decades, primordial ideas do also develop and change.

The ideas and values I have identified have to do with homecentredness, independence,[1] peace and quietness, being in control, and equality as similarity. One way to describe Norwegian culture is in terms of characteristic dilemmas between independence and community. The way autonomy is a fundamental cultural premise in Norway makes Norwegian neighbourhoods very different from, for instance, Italian neighbourhoods. Being autonomous and able to close the entrance door seems to be a fundamental premise for social contact and cooperation.[2] Pursuing autonomy to extremes, however, makes one completely isolated, and that's no good either. One has to be autonomous and sociable in the ways defined by this culture.

The ideas of independence, peace and quietness, of being in control, and of equality as similarity are related to each other. Independence is related to community in a way analogous to the way prestige is related to equality. Being in control is related to being independent, because maximum freedom (independence), together with strong normative ethics, necessitates being in control. Peace and quietness are related to noise, restlessness and

321

conflicts, in the way being in control is related to slipping, losing control.

The reader will now probably object by saying that such ideas are not Norwegian or Northern European, but universal. To that objection my answer is both yes and no. When seen out of context these may reflect universal human problems which, in the processes of codification of the Norwegian context, seem to have been turned into particular cultural themes. Other cultures elaborate other universal dilemmas as cultural themes.[3]

In Norway equality as similarity is a cultural idea that informs action in different domains of life, and informs women's lives as well as men's lives. It gives them, in the context of specific situations and domains, characteristic dilemmas to solve. These dilemmas concern the management of differences. There seems to be, in different domains, a contradiction between being equal and being different. The hierarchical dimension of equality versus inequality is tied to the horizontal dimension of sameness versus difference. For a Norwegian it is problematic to handle difference and hierarchy, especially outside the context of formal organizations. Within formal organizations, like industrial corporations, respect for specialized knowledge legitimizes the hierarchies related to the division of labour (Barnes 1978).

In personal and informal relationships difference is easily codified as unwanted hierarchy that repudiates the premises of having personal relationships. Conceiving equality on the basis of difference and complementarity is almost impossible in the personal relationships of Norwegian culture.

In this study I have traced the specific and concrete transformations of the egalitarian dilemma: the dilemma of having an egalitarian ethos in stratified capitalist class society. Among friends there is a dilemma between prestige and independence – and community and equality. Between spouses there is a contradiction between sexuality in marriage and the sharing of those household tasks that have accumulated symbolic value for gender identity. The different domains of their lives may thus be seen as connected to each other by their efforts to solve the basic contradiction and the value dilemmas and personal identity problems it creates. Solving, or attempting to solve, this contradiction, has consequences for the roles they pursue, the role routines they develop, for personal careers, household careers and friendship careers. This again cre-

ates new problems to solve.

In its abstract form the theme of equality as similarity is logical and not empirical. Thus it is codified differently and has different consequences in the lives of different classes, for women in contrast to men, and in different domains for one individual. In its most abstract version equality as similarity is thus common to women and men of the Norwegian society. In its concrete versions, clothed in specific circumstances, it has different consequences for women and men, for women of different classes and for women in cities versus women in rural areas.

Portraying a subcultural way of life

First of all it is the concrete specificness of one way of life that I have wanted to portray and analyze in this book. The young women call themselves decent, respectable ordinary folk. In the hierarchical terms of the social scientist they are, broadly speaking, working-class or urban lower-class people. They have most of them (both women and men) relatively limited expectations of "making a career" in the middle-class sense of the word. Many of their dreams and expectations are connected to hearth and home. The home is a frame for a whole constellation of symbols and values, resulting in, among other things, home decoration as a constant ongoing concern. Family life is contrasted both to the drudgery of paid work and to the excitement and danger of commercial city life.

The home is in different ways also important for other groups of the Norwegian society, resulting in different patterns of home decoration (chapter five).

Several of the characteristics of this subculture are contrary to current stereotypes and beliefs. In social science research, for instance, the way working-class people spend their leisure time is often regarded as passive compared to the way upper- and middle-class people spend theirs. I have shown in this book how they are not more passive, but do different things. They go to discotheques when others go to concerts. They visit relatives and friends when others go walking in the woods.

According to other current "armchair" stereotypes in the social

sciences, mothers with small children in cooperative suburbs are isolated, each in her own apartment. The young mothers described here are not isolated. Even Asbjørg and Eva, who actually feel most lonesome, have friends in the neighbourhood whom they see more or less daily. Their social milieu may to some extent be regarded as limited in terms of the age of the participants and the range of activities they engage in, but it is certainly active and live. Isolation in cooperative suburbs seems to be more of a problem for recent immigrants than for established urbanites, and more for middle-class than for working-class women (compare the women studied by Hanne Haavind, 1979).

For the women described here female friends are important as mediators between the home and the outside world. Friends are escorts, confidantes, allies but also each other's most severe judges. The kitchen-table society of female friends is also to some extent a generational society. Friends are usually of the same age. One exception to this is some of the neighbourhood relationships. A middle-aged woman may be one of the very good neighbours, and younger girls take care of children and sometimes listen to the talking. Another exception is that separated or divorced women will go out with younger unmarried women. My main reason for calling it a generational society, in spite of these exceptions, is that the mothers of the young women are generally not included. There is extensive help and advice between parents and children, but the mothers of the young women avoid their daughter's friends. The daughter needs friends to cope with those problems and challenges that the mother does not have and does not fully accept. Other studies support this finding. In a suburbanized local community of Northern Norway, younger women turn to each other to face problems the older women do not understand (Holtedahl 1979, 1982). Studies in industrial sociology have found that there often are conflicts between unrelated women of different ages (Lie 1982). The generational gap is another way of expressing the basic value of individuality as independence. To be a grown-up person in this society, it seems, one has in some ways to draw a sharp boundary towards the former generation and their ways of perceiving problems.

The young women are strong, active and enterprising in some domains of life, and equally weak in others. The domains of family and friendships are the ones where they apply most of their cre-

ative energy. Let us look at some strengths first. Many different reasons may be put forward to explain their strength, and it is difficult to measure their relative importance:

1) Sociability with friends is regarded as positive and not as a waste of time. This may be connected both to subculture and to their stage in life.

2) Their paid work is to a large extent defined as economic necessity (chapters twelve and thirteen). For this and other reasons Norwegian notions about equality as sameness are gaining ground inside the household, between spouses. Husbands, in principle, agree with the claims of their wives for more "sharing" of what are traditionally her tasks in the household.

3) Social changes have made possible an expansion of their range of activities (for instance driving, "going out", paid work) – and these activities are not contrary to female gender identity. Whereas women expand their range of activities, the realization of sharing to some extent seems to mean that men restrict their range of roles and relationships.

4) They have (or have had) child-care solutions of "shift work" at home between the parents. Something happens to the father when he is regularly alone with the responsibility for children, and there seems to be some irreversibility of routines established early in marriage (chapter thirteen).

5) Most of them have, or have had, a timing of paid work that makes possible sociability with friends at hours when the husband or male partner is not there (chapter thirteen).

6) Their subcultural child-care practices and routines make it possible for women to combine child care with sociability with friends (chapter six).

7) They have less education, less income and a more modest living standard than some other groups in society. Also, the difference between spouses in terms of education and income is smaller here than in some other social circles. For these reasons state support systems make women economically independent of husbands, at least in the short run (chapters nine and fourteen).

8) The rising occurrence of divorce makes it more legitimate as a

solution to marital problems and a sanction in the hands of women (chapter fourteen).
9) There is a marked difference between those women who are recent migrants and those who can draw on different kinds of support from parents and friends in the neighbourhood. Having close lineal relatives and friends in the neighbourhood or, secondarily, in the city, thus gives strength (chapter seven).
10) The young women in the study might perhaps be more gifted than the average population in regard to beauty, intelligence and enterprising abilities. Given the small sample, such personality attributes might perhaps play some role.

While the young women are relatively strong in relation to the personal relationships of their own social circles, there are also domains of life where their position is extremely weak. In relation to the labour market they have a very weak position in terms of education, seniority, income, support systems. On the labour market they get the lowest paid and most routinized kinds of work. During fieldwork I saw, for instance, how Elisabeth and Beate to some extent added a dimension to their lives by becoming office clerks, and how Sissel and to some extent Kirsten, after fieldwork was completed, also got new interests by going to school. Education and labour market policies are obviously channels to bettering the lives of my informants and women like them, to changing the magic circle of their lives. More interesting and inspiring work for a woman means that not all paths out of the home lead back to it, that one gets several emphases in life instead of one. From the point of view of society, bettering the work conditions of women means that better use is made of their talents and enterprising abilities.

Another policy-relevant point is the importance of having relatives and friends in the neighbourhood, both for children and grown-ups. Instead of regulating the housing market in ways that hinder people from moving into neighbourhoods where they already have close relatives and friends, the authorities should facilitate such recruitment. Recruitment is at least as important as physical lay-out for the kind of social life that develops in an area. Having close relatives and friends near by, generally stimulates social networks and betters the living conditions of women and children.

Connected with the question of having relatives and friends in the neighbourhood are other kinds of improvements and community work in neighbourhoods. Working-class children are encouraged to explore the surroundings, and are thereby more dependent on these surroundings, both socially and physically, than are middle-class children, who, to a greater extent, are taken around to activities like ballet classes and piano lessons.

My aim in doing this study has not, however, primarily been to solve social problems, but to examine a way of life in its own right. This is, however, not unproblematical as a venture. While describing actions and the meanings of actions in different domains of their lives I have also shown some contrast to a few different status groups in Norwegian society, especially upper-middle-class academics and business people. We have seen that in some respects the women in this study are similar to business people (home decoration) and in other respects more similar to academics, especially those academic families where both husband and wife are highly educated (divorce rates). But there are also clear differences in life style, and thereby important communication barriers between different status groups. These are often not recognized or glossed over in moral terms. Attitudes and practices related to money and budgeting (chapter twelve), how to look after and educate children (chapter six), how to use alcohol (chapter ten), how to spend Sundays (chapter nine) are to some extent not only different in different milieus, but also conflicting. Middle-class persons tend to look at other groups as failed middle-class persons. This holds in different ways, for both radicals and conservatives, and for social scientists too. Radicals point to the misery of the lower classes and argue for changes. This is only half the story. I have wanted to portray the other half of the story, to examine a way of life and what makes it reasonable in its own terms.

Such a goal is not without problems. In spite of egalitarian ideologies Norway is also a stratified society, where some people are high-ranked and some people low-ranked, some people are more successful, some people less so. The problem involved in hierarchy is not only that some groups are better off than others, but also that the transition from a respectable life to a stigmatized or in other ways problem-ridden life, the way they see it themselves, is shorter for some groups than for others. Some people in

327

all classes become sick, insane, socially isolated, alcoholics, drug addicts, etc., but both the content of and the context for such problems varies. More people from the social groupings of my informants than people in what they call high society, become, for instance, clients of the social welfare system or do in other ways become "social problems" for public agencies to solve.

In this book I have tried to see such problems from their point of view, how they struggle to have their identities as decent ordinary folks confirmed, as opposed to different stigmatized categories; how they strive to develop personal relationships with people who are similar to themselves in these terms.

My approach is cultural, turning vertical ranking into cultural differences.[4] Seen through this perspective the people studied are not less successful, they are different. I have wanted to portray their way of life as a reasonable way of relating to the circumstances, when the circumstances are taken as given. They are not failed middle-class people but represent a subculture, a way of life in its own right.

Such information is, in my view, also highly relevant to policy-making and social planning. Pointing to problems legitimates arguments for something to be done. Pointing to subculture and problem-solving abilities indicates how and where means could be effective.[5]

Women's contribution to the building of culture

It should be clear by now that the women of this study are not mute in all domains of their lives. In some domains they are particularly articulate, elaborating basic notions of their culture. In their conversations they constantly debate what is right and what is wrong in personal relationships; they work intellectually to harmonize conflicting experiences. Men also debate these things, but not in the same way and to the same degree.

(1) When they are together with buddies they talk about other things, less about "private" matters.
(2) Good morals do not define men in the same way as women, and men, therefore, do not feel the same need to talk these things over.

In these matters women are articulate whereas men, to some extent, are mute. Women find some of their strength in their relations with husbands by the shared understandings that they develop. Shared understandings lend some legitimacy to their claims.

It may be useful, for the analysis of culture, to distinguish between, on the one hand, shared understandings in terms of sharing a code defining particular relationships, and, on the other hand, shared understandings in terms of joint experience and mutual understandings, i.e. to distinguish between what defines and governs communication and what constitutes the content of communication. The one does not necessarily imply the other, but to be able to have a social relationship persons must at least have complementary ideas about the definition of that relationship. Through interaction and joint experiences over time they may also develop broad mutual understandings, codified within the frames of the relationship. Mutual understandings are thus developed through interaction and are relative to interaction in specific domains.

We have seen through this study that the young women develop and share some mutual understandings that they do not necessarily share with their men. In the same way husband and wife understand things about each other that are not shared by outsiders to that relationship. Because of the private nature of marriage it is difficult to give a portrayal of these parts of marriage. To the extent that women could be said to have a separate "women's culture" it does, in my view, consist of joint experience and some mutual understandings, and does not consist of different basic codes. Women's culture is clothed in their subculture. To some extent women and men develop and maintain different and complementary parts of their subculture.

Throughout this book I have wished to demonstrate that it is crucial to observe and listen to women if one wants to understand how central parts of life style and subculture are created and maintained in everyday life. I also hope to have shown that by using women instead of men as the central actors in a study, one gets a new and very different picture of society. Nevertheless it remains the same society.

329

Appendix 1

Tables and figures

Table I

	Beate	Kirsten	Elisabeth	Ellen	Irene	Eva	Mette
Approximate age at the beginning of fieldwork	24 years	24 years	23 years	24 years	24 years	23 years	23 years
Marital status	Married	Married – Separated – Divorced	Married	Married	Married – Separated – Divorced	Married	Married
Number of children	One	Two	Two	Two	One	Two	Two
Number of rooms in the apartment	3	3	4	3	3	4	4
Where grown up	In the neighbourhood	In another part of the city	In another part of the city	In the same neighbourhood	In the same neighbourhood	In another part of Norway	In the neighbourhood
Support from parents/parents-in-law (child care, use of cabin during holidays and so on)	Much support; especially from her parents	Some support from mother who is a widower and has few resources. Little contact with former parents-in-law	Much support	Some support	Very little support. (Mother dead, little contact with father) No support from former parents-in-law	No daily support, but holidays in parents home. Some help from parents-in-law	Much support: child care, holidays (parents have a cabin) etc.
Number of friends and acquaintance	Many friends and acq.	Many friends and acq.	Many friends and acq.	Many friends and acq.	Many friends and acq.	Few friends and acq.	Many friends and acq.
Exchange of goods and service outside the market	Much mutual exchange	Little exchange	Some exchange	Some exchange	Little exchange	Little exchange	Much exchange
Economic situation as evaluated by themselves relative to others in the same milieu	Fairly well off	Problematical	Strained, but becomes better	Strained	Problematical	Strained	Strained
Paid work	Full-time work as office clerk	Part-time work as municipal home helper	Part-time as cleaner – full-time work as office clerk	Child minder + part-time work as cleaner – waitress	Technical worker – art student	Very little occasional work as child minder	Some part-time work in a store
Husband's paid work	Repair man in a garage		Industrial worker	Hairdresser		Foreman (stockworker)	Sales clerk
Emotional situation/relation to husband	Good, but stormy relationship to husband	Difficult emotional situation	Good relationship to husband, but not unproblematic because	Good, but stormy relationship to husband	Difficult emotional situation	Stable relationship to husband, but feels lonesome in the	Good relationship to husband

	Mona	Gudvor	Oro	Marie	Asbjørg	Audhild	Anne	Sissel
	20 years	24 years	37 years	29 years	31 years	32 years	18 years	23 years
	Married	Unmarried	Married	Married – Separated	Separated – Divorced	Married	Unmarried	Married – Separated – Divorced
	One	One	Three	Three	Three	Three	One	Two
	2	3	4	3	3	3		3
	In another part of the city not far away	In the same neighbourhood	In another part of the city	In another part of the city	In another part of the country	In another part of the country	In another part of the city, but not so far away	In the neighbourhood
	Some support	Much support from her parents	Some support	Some support	No support in everyday life. but in holidays on the farm. No contact with former parents-in-law	Much support, especially from parents-in-law	Much support from parents	Much support from her parents
	Many friends and acq.	Many friends and acq.	Some friends and acq.	Many friends and acq.	Few friends and acq.	Some friends and acq.	Many friends and acq. but not in the neighbourhood	Many friends and acq., but
	Much exchange	Little exchange	Little exchange	Some exchange	Little exchange	Little exchange	Little exchange	Little exchange
	Fairly well off	Problematical	Strained	Strained	Miserable	Fairly well off	Problematical	Strained
	Child minder + part-time cleaner – Assistant in a hospital (part-time)	Some (not so much) part-time work as clerk in a store	Part-time work as assistant in a hospital	Part-time cleaning – part-time work as sale clerk	Little paid work: occasional work as child minder	Part-time work as cleaner	Very little paid work: occasional work as a helper on market-place	Part-time work as cleaner – student at trade school
	Electrician		Telexoperator	Truckdriver		Industrial worker		Sales clerk
	Good relationship to husband	Difficult emotional situation with many problems in relation to the man she lives together with	Stable but somewhat strained relationship to husband	Difficult emotional situation	Difficult emotional situation	Good relationship to husband	Very difficult emotional situation	Difficult emotional situation which became better

Table II

Careers of motherhood and marriage. The figures for the ages of mothers and children are approximations of their ages at the beginning of fieldwork. At the end they were all two years older.

Beate 24 years Unmarried mother at 18 – Married another man than the father of the child One child – Wants another child	**Kirsten** 24 years Unmarried mother at 18 – Married the father of the child – Divorced – Married soon after pregnant with the second child – Two children age 5 1/2 and 2 1/2 – Divorced during fieldwork	**Elisabeth** 23 years Married early, a few months, pregnant Mother at 18 – Had another baby soon after – Two children age 5 and 1 **Mette** 23 years Married early a few months pregnant – Mother at 17	**Ellen** 24 years Married early, a few months pregnant – Mother at 19 – Had another baby soon after Two children age 5 and 2
Irene 24 years Married at about 22 – One child age 1 – Divorced during fieldwork	**Eva** 23 years Married a few months pregnant – Mother at 19 – Had another baby soon after – Two children age 3 and 1	**Mette** (cont.) – Had another baby soon after Two children age 6 and 1 **Marie** 29 years Married early – Mother at 17	**Mona** 20 years Married early a few months pregnant – Mother at 17 One child at the age of 3 – (Had another baby after fieldwork was completed)
Gunvor 24 years Unmarried mother of the age of 20 – One child, 3 years of age	**Gro** 37 years Married Mother at 22 – Three children age 15, 12 and 6	**Marie** (cont.) Three children age 12, 10 and 8 – Separated during fieldwork	
Audhild 32 years Married – Mother at 22 – Three children age 10, 7 and 1 1/2	**Anne** 18 years Unmarried mother at 16 – Lived in a common law union with the father of the child They broke up – One child age 2 1/2	**Sissel** 23 years Married early, a few months pregnant Mother at 18 – Two children age 4 1/2 and 1 Separated during fieldwork, but resumed married life one year after	**Asbjørg** 31 years Unmarried mother at the age of 22 Married when pregnant with the second child – Three children age 9, 5 and 1 Divorced during fieldwork

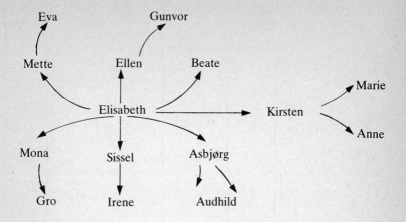

Fig.I

Elisabeth's friends and friends of friends: The way the fieldwork proceeded.

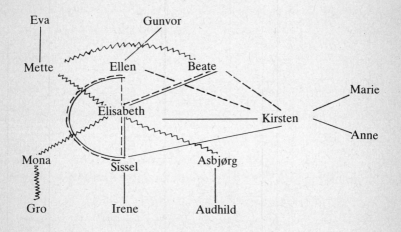

Fig. II ----- members of the same sewing circle

~~~~~ visit each other for morning coffee klatches

——— close friends (may also be in the same sewing circle and do always also visit each other for coffee klatches)

335

*Fig. III*

Where they lived during the fieldwork:

*Area I*
  Sissel
  Ellen
  Irene
  Gunvor

*Area II*
  Beate
  Elisabeth
  Mette
  Eva
  Asbjørg
  Audhild
  Mona
  Gro

*Area III*
  Kirsten
  Marie

*Area IV*
  Anne

*Fig. IV*

Where they grew up:

In the same area
where they lived
during the fieldwork:

  Sissel
  Ellen
  Irene
  Gunvor
  Beate
  Mette

In a neighbourhood
not far (half an hour's
walking distance) from
where they live now:
  Mona
  Anne

In another part of Bergen:
  Elisabeth
  Kirsten
  Marie
  Gro

Outside Bergen:
  Eva
  Audhild
  Asbjørg

# Appendix 2

## Inventory of occupations

Below I list the occupations of the women themselves, of their mothers and mothers-in-law, of their fathers and fathers-in-law, and of their husbands or boyfriends. Most of the young mothers have changed occupation one or several times during the fieldwork and after. There are therefore no figures indicating exactly how many women were in the various occupations at any given time. The intention is to give an idea of the range of occupations they have. The sample is anyway too small for statistical accuracy.

The inventories of mothers, mothers-in-law, fathers and fathers-in-law are not complete because I do not have an equal amount of information about all. There is no reason to believe, however, that the occupations I do not know about are very different from the ones I do know about.

*I. Inventory of the young mothers' own occupations*
  *dagmamma* (Takes care of other people's children at daytime during working hours. Paid in unregistered money.)
  2–3 hours cleaning a day.
  municipal "home help" for old people (clean and cook).
  helper in hospital (cleaning, bringing food).
  night attendant for senile old persons in their homes.
  private home help.
  waitress.
  extra help as saleswomen in a grocery store and in a textile store.
  extra help, selling flowers on the open-air market place.
  office clerk.
  ½ year trade school.

3 year trade school.
1 year auditor at an art school (Irene).

These are education rather than occupation.

Former occupations also include:
industrial worker
office girl
hairdresser apprentice
maid

## II. Inventory of husband's/boyfriend's occupations

2 hairdressers (barber), both are employed but one is a master.
2 (wall)painters
1 electrician
1 fireman
2 printers  (one skilled, one unskilled. The skilled printer is unemployed because of heavy drinking).
2 sales clerks
2 stockworkers (one foreman)
1 driving instructor
4 industrial workers (all are unskilled, but one is a foreman)
2 busdrivers
2 truckdrivers (self-employed, they own their own truck)
1 employed truckdriver
3 repair men in automobile garages
1 unskilled printer
1 telexoperator

## III. Inventory of occupations of fathers and fathers-in-law:

1 fireman
1 busdriver (a former captain who had to quit because of drinking)
3 taxi-drivers (two self-employed, one was a former mechanic)
1 furniture upholsterer (employed)
1 construction worker
2 construction worker + farm
1 printer (reprophotographer)
1 farmer
2 sailors

1 office clerk
1 self-employed floor polisher
1 plumber (foreman)
2 industrial workers
1 carpenter

IV. *Inventory of the occupations of mothers and mothers-in-law:*

3 charwomen
2 canteen helpers
2 saleswomen (in a newspaper kiosk, and in a garment store)
2 home helps
2 farmers' wives
2 former cleaning women receive disability insurance
benefit.
2 women have no paid occupation

# Notes

## 1. INTRODUCTION

1 I use the term class in a commonsensical (to social scientists) and imprecise way, as a shorthand expression to characterize the milieu studied. There is however a complex relationship between class and way of life. I discuss more closely later how stratification can be analyzed: analytical tools in chapter one, empirical discussion in chapter four. In chapter seven I give a detailed account of occupations.

   The number of main informants is 15. See chapter two, for a more detailed discussion of methodology.

2 The scene of female friends gathering around the kitchen-table of one of them and discussing their lives has given the book its title. This title plays on the title of a famous classic study in urban sociology, "Street Corner Society", by William Foote Whyte (1943) about male Italian-American youths. By borrowing Whyte's title I want to suggest not only a playful sex role complementarity, but also what tradition in urban sociology I am both indebted to and want to make a contribution to.

3 In accordance with current usage I use the word "gender" to mean social and cultural standards, expectations and attributes, making up sex-related roles and identities. The notion is both connected to and contrasts with the notion of biological sex.

4 Of ethnographic material about Norway published in English one could mention Barnes 1954, 1957, 1971, 1978, Barth 1963 (ed.), Blom 1969, Brox 1965, Haugen and Holtedahl 1982, Löfgren 1974, Park 1962, 1972, Rudie 1969/70.

5 A comprehensive bibliography on women's studies, up to about 1974 has been made by Sue-Ellen Jacobs (1974). Review articles have been written by Lamphere 1977, Quinn 1977, Rosaldo 1980, Stack et.al 1975, among others.

6 One might mention here Spradly & Mann (1975) on the cocktail waitress, Gullvåg Holter (1981) on the "pick-up-market" *(sjekkemarkedet),* and Anne Rasmussen (1983 and in an unpublished thesis from 1969) on a harbour café. Each of these studies is, however, focused on the specific forum in question and does not trace its influences on other domains of the women's lives.

7 In writing the following paragraphs about the relationship between the concepts of position and identity, I am indebted to many fruitful discussions with Jan-Petter Blom.

8 In Goodenough's (1965) and Keesing's (1973) analysis, identity and position are for instance closely connected. Social identity *is* social position. Goodenough (1965) defines status as rights and duties and social identities as culturally

341

distinguished social positions. He also makes the point that an ego is likely to occupy a number of coalescing social identities in the same interaction. Social identity, in his frame of analysis, is an aspect of self that makes a difference in how one's right and duties are distributed with respect to specific others. Any aspect of self whose alteration entails no change in how people's rights and duties are mutually distributed, although it affects their emotional orientations to one another and the way they choose to exercise their privileges, has to do with personal identity but not with social identity (Goodenough 1965).

Goodenough (1965) and Keesing (1973) are mainly interested in social identities as elements of cultural, rather than social systems. Their aim is an analysis of the normative and cognitive systems on which actual behaviour is based. My research focus is slightly different. I am interested in how normative premises are acted out, created or changed. Participants not only receive their identities from the culture, they also create their social identities in social interaction.

In the terminology of McCall and Simmons (1966), on the other hand identities are differentiated from positions and roles, but still corresponding closely to these.

9 One may question to what extent this is a sociological principle or an empirical generalization. In the Norwegian context it seems that the signs must be such that the identities it is possible to realize in the situation are harmonized. In other contexts people may probably be more willing to disregard discrepant or disharmonious information.

10 Source: *Statistical Yearbook 1980*
Table 7, page 7: Area and resident population
Central Bureau of Statistics of Norway, Oslo 1980.

11 Source: *Statistical Yearbook 1980* - op.cit.
Table 18, page 19: Persons 16 years and over by sex and main source of livelihood 1970.

12 Source: *Statistical Yearbook 1980*
Table 8, page 7: Resident population in densely and sparsely populated areas.

13 The information and the figures in this whole paragraph about population development in the three greatest cities are from *NOU 1979: 5 Bypolitikk* pp 16–25.

14 The German Hanseatic league was an organization of merchants from German towns and cities. It blossomed around 1300–1500, but existed also before and after. Its high point was a meeting in Köln in 1367 where 70 towns and cities joined in a confederation against King Valdemar Atterdag. Lübeck used to be the main centre of the league.

15 Source: *Statistical Yearbook 1980*.

## 2. THE FIELDWORK

1 The names used are not their real names.
2 The material about child-care solutions has been published in other works (Gullestad 1979b, 1981).

## 4. WHO FITS IN WITH WHOM

1  The contempt for "students" may partly be explained by the fact that intellectual knowledge is not as highly valued in Norway as in some other countries, like France. Book learning is regarded as not useful or a little suspect in many milieus. It is even regarded as dangerous to think too much. In lower class milieus practical knowledge is valued more than book learning. Male academics who live in predominantly lower class neighbourhoods may feel that they have to under-communicate the character of their work in order to be accepted (Anders Johansen, personal communication).

2  The difficulties involved in being different from others are given literary expression in fiction by the author Axel Sandemose in Jante's law *(Janteloven)*. Sandemose did, however, only see the negative aspects of egalitarianism, not the positive.

3  Recent research has shown that strategies at the workplace that emphasize equality as sameness presuppose unpaid work done by women in the homes. One needs instead arrangements that pay respect to the kind and amount of responsibilities which are not paid employment (Marit Hoel 1982).

4  It is worth mentioning here that in comparison to other European countries, even to Sweden and Denmark, there is less range of things to buy in Norway and less emphasis on fine things.

5  About ten per cent of the Norwegian population are members of some religious organization. Source: Hauglin, 1975. That none of my informants are active religious practitioners is one demonstration of the meaning of religious attitudes for who fits in with whom. Informants are chosen on the basis of networks of personal relationships, that is on the basis of who fits in with whom. The resulting population is not an average of Norwegian society, but one kind of reference group.

6  It is interesting that "students" make a separate category somewhat outside the implied vertical hierarchy of their model. This corresponds to some extent to Marx's placement of the traditional petty bourgeoisie and, for instance, Wright's (1978, 1980) location of what he calls semi-autonomous occupations as a contradictory class position. As we shall see later, in chapter eight about paid work, the fit is not complete, because those who are self-employed, e.g. belonging to the traditional petty bourgeoisie, are here not different in terms of life style from wage workers.

7  From the talks I have had with men in these social circles, my impression is that if I had used them as main informants I would have come up with more or less the same picture. The difference would perhaps have been that a few of them, especially the industrial workers, having somewhat more experience from and interest in trade unions and similar work organizations, might use words like working-class and capitalist in addition to ordinary folks and high-up people.

In chapter fourteen I examine more closely what happens when one of the spouses in a marriage does not manage to live up to standards of being a decent ordinary human being. In such cases outsiders expect the marriage to break up. Otherwise the respectable spouse is "contaminated" by the one who is not respectable. Independence, in such cases is supposed to be stronger than marriage.

## 5. HEARTH AND HOME

1 None of the photographs used in this book depict the neighbourhoods or homes of any of the 15 informants. Photographs are taken of other housing estates with homes and inhabitants similar in terms of life style to the ones described here.

2 The following dishes are regarded as traditional good Sunday dinners:

| | |
|---|---|
| *Kjøttkaker i brun saus med kokte poteter og grønnsaker* | Meat balls in brown sauce with boiled potatoes and vegetables |
| *Røket svinekam med kokte poteter, grønnsaker og saus* | Smoked saddle of pork with boiled potatoes, vegetables and sauce |
| *Lapskaus* | Stew made mainly of meat, potatoes and carrots |
| *Får i kal* | Mutton and cabbage stew |
| *Raspeballer med kålrabi-stappe, røkte svineknoker og vossakorv* | Potato dumplings with mashed rutabaga, smoked pork knuckles and sausages from Voss |
| *Svinekoteletter med kokte poteter og grønnsaker* | Pork chops with boiled potatoes and vegetables |
| *Svinesteik eller oksesteik med kokte poteter og grønnsaker, brun saus* | Roast pork or roast beef with boiled potatoes, vegetables and brown sauce |

These last dishes, roast beef and pork, are most expensive. If the young couple should eat a Sunday dinner at their parent's, they will perhaps be served such dishes. On the other hand, some of the other dishes, like stew, meat balls and potato dumplings may also be served on week-days. Thick soups, made of yellow peas and smoked pork knuckles or soup bones, potatoes and carrots are also part of traditional cooking that takes some effort.

3 The 1983 article by Kirsten Danielsen is based on the material of an unpublished thesis: "Borgerskapets diskrete sjarm. Identitetsforvaltning blant gamle damer på Frogner." Hovedoppgave. Institutt for samfunnsvitenskap. Universitetet i Tromsø 1980.

## 6. THE RELATIONSHIP OF HEARTH AND HOME

1 Source: *Social Survey 1980,* Central Bureau of Statistics in Norway. The figures in the nest paragraph are also from the same source.

2 This role is called a deputy host *(visevert)* and is often used in lower-class weddings.
3 When it comes to actual legal ownership, spouses own the home together. Regardless of whose money buys or rents an apartment, both husband and wife own it and are responsible for maintenance, even though each deals with different spheres of maintenance. Regardless, also, of whether the apartment is registered in the wife's name, the husband's name, or in the name of both, they own it and its equipment together. Apartment and household equipment cannot be sold without the consent of both spouses. In the case of divorce, she has to buy him out. Apartments are both owned in the husband's and in the wife's name.

## 8. VISITINGS AND OTHER SOCIAL OCCASIONS IN THE HOMES

1 Even if they work one at a time, the laundry room is, to some extent, a forum to meet neighbours. One woman is about to leave when the other enters and this often creates an opportunity for a chat. The side effects of doing the laundry for social contact are, however, poorer and contrast vehemently with, for instance, the English working class' coin-laundry culture.
2 Gunnar Skirbekk (1981) holds that Norwegians have a religious attitude towards nature. As a new nation Norway used nature as a symbol after liberation from Denmark in the nineteenth century.

## 9. PAID EMPLOYMENT

1 Source: ILO: Yearbook of Labour Statistics 1958, 1968, 1978. Rendered in Paxleksikon 1980, Volume 4, page 492.
2 Among married women participation in paid work is highest in the age group 25–44 years with 64%. *(Social Survey* page 32.) It is the married women aged 35–44 with the youngest child younger than 7 years, and those aged 45–54 with the youngest child older than 7 years who have augmented their paid work most, both groups by as much as 20%, between 1972 and 1979. In 1972 married women below 25 years with the youngest child below 7 years had the lowest participation in paid work. It was 26%. In 1979 these women still had the lowest participation, but their participation in paid work had risen to as much as 41% *(Social Survey* 1980, page 38).
3 It may be worth noting that the figures certainly under-report the extent to which women have paid work. In addition to being housewives women engage in what is known as hidden employment such as farming and other subsistence activities, work in a family business, and an unknown but certainly large number of women earning unregistered income, especially as *dagmammas*. The last kind of employment is important for the young women in this study, and for many other women with small children.

## 10. GOING OUT: EXCITEMENT AND MORAL DANGER

1 In her study of young unmarried female workers in a textile factory in Bergen, Hanne Müller (personal communication) has made a similar observation. According to her the most important occasion for informal social life in the factory is when good friends meet, most often two, sometimes three, together in the toilet to smoke and chat. One sits on the toilet, the other on the floor, and the third person, if any, stands in the doorway to the closet.

2 According to Statistical Yearbook, 1980, table 537, page 451, Norwegians consumed 3.1 litres of wine, 43.5 litres of beer, and 1.8 litres of 100% spirit per inhabitant per year during the years 1972–76. The figures for France were 104.3 litres of wine, 44.5 litres of beer, and 2.5 litres of 100% spirit.

3 One might mention, as an empirical parallel, Ulf Hannerz's (1969) study of a black American ghetto. He writes: "However, just as the female conception of 'no-good men' is somewhat ambivalent, so is the male picture of the 'good women'. Yet it is not quite the same sort of ambivalence. The women's imagery expresses the opinion that 'no-good men' are indeed 'real men' – sometimes and in some ways, at least – and thus in a sense good."

(Hannerz 1969, page 99)

## 11. WOMAN'S MORAL DISCOURSE AND ITS CONSEQUENCES FOR FEMALE SOLIDARITY AND CONFLICT

1 When interpreting the cases in this subchapter I am indebted to comments from and discussions with Jon W. Anderson and Harald Tambs-Lyche.

2 This couple is 5–10 years older than Beate and her friends. Their more "liberal" attitudes towards showing sexual interest in others than the spouse may have something to do with age and more experience. They are older and perhaps more secure about their own sexuality, and therefore able to be mutually "generous" in these matters. There are, however, numerous examples that could be cited to show that age does not necessarily bring along such changes.

3 Here the husband-wife relationship is ideologically dominant in contrast to, for instance, the Middle East where the father-son relationship is dominant (Barth 1971) or East London in the fifties (Young and Wilmot 1957) or the Bahamas (Blom 1970) where the mother-daughter relationship, in different ways, seems ideologically most important.

4 Sigurd Berentzen makes the same interpretation in several unpublished drafts about the black adolescents. The most important manuscript for the present discussion is "The young girls". "En fremstilling av en aldersgruppe piker og en diskusjon av noen gruppe-prosesser blant piker og gutter." Unpublished manuscript. University of Bergen 1976.

5 Tord Larsen (1982) might be cited to support this view. He holds that Norwegian identities tend to be combined in a few standardized packages. The reason for such standardization is, in my view, a strong claim for personal integration.

## 12. MARRIED LIFE: SOME MEANINGS OF MONEY

1 However, to borrow large amounts of money from impersonal agencies to buy an apartment is not shameful. Money for these purposes is borrowed in large amounts from the bank and sometimes from parents/parents-in-law.

## 13. MARRIED LIFE: NEGOTIATING DIVISION OF WORK

1 Annemor Kalleberg has, in a talk to an interdisciplinary work group in women's studies, made a similar point, that there is a value choice implied in the choice of working hours and child care solutions.

2 Other studies have pointed to the same connections between shift work at home and the quality of relations between spouses and between father and children (Rita Liljestrøm 1976 and Annemor Kalleberg personal communication.)

3 Similar observations have been made by Hanne Haavind in her study of families with 4-year-old children. Part of her material has been published in Haavind 1979, but I have also had the opportunity to read still unpublished sketches from her project. My way of interpreting these data is inspired by her, but I also disagree with the way she emphasizes female subordination.

4 As noted earlier (note 3, chapter one), I use, in accordance with current usage, the word 'gender' to mean social and cultural standards, expectations and attributes making up sex-related roles and identities. The notion is both connected to and contrasts with the notion of biological sex.

5 Inger Haugen has made the same observation in her study of a suburb in Eastern Norway, reported in Haugen 1978. In Haugen and Holtedahl, 1982, these data are compared to a rural community in Northern Norway. There husband and wife have separate reputations.

## 14. REFLECTIONS ON THE DATA: BEING A WOMAN

1 Aud Grandaunet has made this interpretation in an unpublished thesis, a study of female key-punch operators: "Det er mest vi jentene". Hovedoppgave i sosiologi, Oslo 1981.

2 One is reminded of Margery Wolf's description of Chinese adoption of future wives to sons and the problems of changing from sister to wife (Wolf 1971), and also of descriptions of Israelian Kibbutz life.

3 This may be seen as one exemplification of what Tord Larsen (1982) calls Norwegians' inability to create separate and independent secondary "play" worlds with their own rules, isolated from the primary world. Norwegian literary debate, for instance, in his view, often consists of finding out what the novel or the poem is "about". The idea of 'L'art pour l'art', he says, has poor growing conditions in Norway.

4 The reasons generally attributed to divorce are varied. The people studied generally give "spouses going too much out on their own" as the reason for rising divorce rates. In the mass media the reason found is often either that young families have too many economic problems or that women have read too

much feminist literature and thereby become liberated. In the social sciences, divorce has been explained by premarital pregnancy, young age when marrying, short time of acquaintanceship with spouse and low-ranked social position (Kristiansen 1975, referred in Moxnes 1981 and in Ve 1979). Each of these explanations, reflect in my view only selected dimensions of the phenomena. My hypothesis provides a competing explanation.

5 "It is common today that divorced persons remarry. This applies especially to those who divorce at 26–28 years of age, of whom 80–90% remarry. For divorced persons in older age groups the percentage is lower: at 35 years of age the percentage is about 50%. Men remarry somewhat more often after a divorce than women. The difference is not great, however, and cohabition without a wedding is also not included in these figures." Social Survey, 1980, page 105 (my translation).

6 In her statistical study of number of children and female employment An-Magritt Jensen (1981) writes that of those married mothers who have paid employment, women with higher education more often than women with lower education report that "the work is interesting" as a reason for having paid employment. Women with lower education most often give "needs to meet other people" and "economic reasons", as their reasons for having taken up paid work.

## 15. REFLECTIONS ON THE DATA: BEING NORWEGIAN

1 In the ethnographic descriptions of Norway made by foreigners, I have found some support for these generalizations. In Barnes (1954, 1978) there is support for the equality theme and in Park (1962) there is some support for the personal independence theme.

2 Inger Haugen (1978) has written an interesting article about management of inaccessibility (forvaltning av utilgjengelighet) as an important aspect of neighbourhood interaction. She does not, however, see this as a characteristic cultural theme, but tends to universalize a specific theme into a general perspective.

3 My formulation is inspired by Jon W. Anderson's (personal communication) work on the Pashtuns in Afghanistan. In his view, Near Easterners have turned a fundamental social problematic into a particular cultural theme, making that problematic accessible through cultural or presentational modalities of storytelling, genealogizing, hagiography, worship and philosophizing. Ideas of equality there do not seem to depart, as western social thought does, from a self-realizing or Cartesian individual. They depart instead from a notion of a community of equals, which in religious terms is put as the equality of every believer before God or in tribal terms as the equality of codescendants from a common ancestor.

In the same way he holds that exchange ("I give therefore I am") is a cultural theme in Melanesia.

4 This effort may of course be related to my own identity as a Norwegian, as much as to my identity as an anthropologist. Like most Norwegians I struggle with

how to handle difference in a complex society based on division of work and hierarchy.

5 I intend to draw more extensively on the policy implications of this material in later publications.

# Bibliography

Ardener, Edwin. Belief and the Problem of Women. The "Problem" Revisited./:
S. Ardener (Ed.), *Perceiving Women*. London: Malaby Press, 1975.

Ardener, Shirley (Ed.). *Perceiving Women*. London: Malaby Press, 1975.

Ardener, Shirley (Ed.) *Defining Females. The Nature of Women in Society*.
London: Croom Helm, 1978.

Ardener, Shirley (Ed.). *Women and Space. Ground Rules and Social Maps*.
London: Croom Helm, 1981.

Banton, Michael (Ed.). The Social Anthropology of Complex Societies. *A.S.A.
Monographs* no. 4. London: Tavistock, 1966.

Barnes, J.A. Class and Comittees in a Norwegian Island Parish. *Human Relations*,
1954, Vol. 7.

Barnes, J.A. Land Rights and Kinship in two Bremnes Hamlets. *Journal of the
Royal Anthropological Institute*, 1957, 87, pp. 31–56.

Barnes, J.A. The Righthand and Lefthand Kingdoms of God: A Dilemma of
Pietist Politics. /: T.O. Beidelman (Ed.), *The Translation of Culture*. London:
Tavistock Publications, 1971.

Barnes, J. A. Neither Peasants nor Townsmen: a Critique of a Segment of the
Folk-urban Continuum. /: F. Barth (Ed.), *Scale and Social Organization*. Oslo:
Universitetsforlaget, 1978.

Barth, Fredrik (Ed.). *The Role of the Entrepreneur in Social Change in Northern
Norway*. Oslo: Universitetsforlaget, 1963.

Barth, Fredrik. Role Dilemmas and Father-Son Dominance in Middle Eastern
Kinship Systems. /: Hsu (Ed.), *Kinship and Culture*. Chicago: Aldine, 1971.

Barth, Fredrik. Analytical Dimensions in the Comparison of Social Organizations.
*American Anthropologist*, 1972, Vol 74, pp. 207–219.

Barth, Fredrik. Scale and Network in Urban Western Society. /: F. Barth (Ed.),
*Scale and Social Organization*. Oslo: Universitetsforlaget, 1978.

Bateson, Gregory. Bali: The Value Systems of a Steady State. /: G. Bateson, *Steps
to an Ecology of Mind*. New York: Ballantine Books, 1972.

Beidelman, T. O. The Moral Imagination of the Kaguru. Some Thoughts on
Tricksters, Translation and Comparative Analysis. *American Ethnologist*,
1980.

Bell, Colin and Newby, Howard. Husbands and wives: the dynamics of the
deferential dialectic. /: D. L. Barker and S. Allen (Eds.), *Dependence and
Exploitation in Work and Marriage*. London: Longman, 1976.

Benedict, Ruth. *Patterns of Culture*. New York: Mentor, 1934.

Benedict, Ruth. *The Chrysanthemum and the Sword*. Boston: Houghton Mifflin,
1946.

Berentzen, Sigurd. Kjønnskontrasten i barns lek. En analyse av forholdet mellom

begrepsdannelse og samhandling i en barnehage. *Occasional Papers, Department of Social Anthropology, University of Bergen*, No 3, Bergen 1980.

Berentzen, Sigurd. Venninnerelasjoner og konfliktmønstre. En sammenligning av to pikemiljøer. *Pikeliv*. Forum for kvinneforskning, særnummer 1, Roskilde 1981.

Bjerén, Gunilla. Female and Male in a Swedish Forest Region: Old Roles under New Conditions. *Antropologiska Studier*, 1981, 30–31.

Blom, Jan-Petter. Ethnic and Cultural Differentiation. /: F. Barth (Ed.), *Ethnic Groups and Boundaries*. Oslo: Universitetsforlaget, 1969.

Blom, Jan-Petter. Problemer i studiet av Vestindisk familieliv og husholdsorganisasjon, *Antropolognytt*, 1970, No 1, Vol 9.

Borker, Ruth. Anthropology: Social and Cultural Perspectives. /: S. Mc Connell-Ginet, R. Borker and N. Furman (Eds.), *Women and Language in Literature and Society*. New York: Praeger, 1980.

Bott, Elisabeth. *Family and Social Network*. London: Tavistock Publications, 1957.

Bratrein, H. D. et al. (Eds.). *Drivandes Kvinnfolk*. Tromsø: Universitetsforlaget, 1976.

Briggs, Jean. *Never in Anger: Portrait of an Eskimo Family*. Cambridge: Harvard University Press, 1970.

Briggs, Jean. Eskimo Women: Makers of Men. /: C. J. Matthiasson (Ed.), *Many Sisters*. London: Collier & MacMillan Publishers, 1974.

Brox, Ottar. Natural Conditions, Inheritance and Marriage in a North Norwegian Fjord. *Folk*, 1965, Vol. 6, No. 1.

Brox, Ottar. *Hva skjer i Nord-Norge?* Oslo: Pax forlag, 1966.

Chesler, Phyllis. *Women and Madness. When is a Woman and who Decides?* New York: Doubleday, 1972.

Chodorow, Nancy. Family Structure and Feminine Personality. /: M. Z. Rosaldo and L. Lamphere (Eds.), *Woman, Culture and Society*. Stanford: Stanford University Press, 1974.

Dahl, Hans Fredrik og Vaa, Mariken. Norge. /: *Paxleksikon,* Bind 4. Oslo: Pax forlag, 1980.

Danielsen, Kirsten. Identitetsforvaltning blant gamle damer på Frogner. /: I. Rudie (Ed.), *Myk start, hard landing*. Forthcoming. Oslo: Universitetsforlaget, 1984.

Daun, Åke. *Förortsliv. En etnologisk studie av kulturell förändring*. Lund: Bokförlaget Prisma, 1974.

Dennis, N., Henriques, F. and Slaughter, C. *Coal is our Life*. London: Tavistock Publications, 1956.

Douglas, Mary. *Purity and Danger*. London: Routledge & Kegan Paul, 1966.

Eichler, Margrit. *The Double Standard. A Feminist Critique of Feminist Social Science*. London: St. Martin's Press, 1980.

Engelstad, Fredrik. Klasser. /: *Paxleksikon,* Bind 3. Oslo: Pax Forlag, 1980.

Flakstad, Anne Grethe. Kan endring innen kvinnearbeidet utløse strukturendringer? /: I. Rudie (Ed.), *Myk start, hard landing*. Forthcoming. Oslo: Universitetsforlaget, 1984.

Forsythe, Diana E. Urban Incomers and Rural Change. The impact of migrants from the city on life in an Orkney community. *Sociologica Ruralis*, 1980, Vol. XX, No. 4.

Frankenberg, Ronald. British Community Studies. Problems of Synthesis. /: M. Banton (Ed.). *A.S.A. Monographs 4*. London: Tavistock, 1966.

French, Marilyn. *The Women's Room*. London: Sphere Books Ltd., 1978.

Frykman, Jonas. *Horan i bondesamhället*. Lund: Liber läromedel, 1977.

Frykman, Jonas og Løfgren, Orvar. *Den kultiverade människan*. Lund: Liber läromedel, 1979.

Gans, Herbert. *The Levittowners. Ways of life and Politics in a New Suburban Community*. New York: Vintage Books, 1967.

Geertz, Clifford. *The Interpretation of Cultures*. (First published 1973). London: Hutchinson & Co Ltd., 1975.

Geertz, Clifford. "From the Native's Point of View": On the Nature of Anthropological Understanding. /: K. H. Basso & H. A. Selby (Eds.), *Meaning in Antropology*. Albuquerque: University of New Mexico Press, 1976.

Gluckman, Max. Gossip and Scandal. *Current Anthropology*, 1963, 4.

Goffman, Erving. *The Presentation of Self in Every day Life*. New York: Anchor Books, 1959.

Goffman, Erving. The Arrangement between the Sexes. *Theory and Society*, 1974, Vol. 4. No. 3.

Golde, Peggy, (Ed.). *Women in the field. Anthropological experiences*. Chicago: Aldine Publishing Company, 1970.

Goodenough, Ward. Rethinking 'Status and Role'. /: M. Banton (Ed.), The Relevance of Models for Social Anthropology. *A.S.A. Monographs*, No. 1. London: Tavistock, 1965.

Goodenough, Ward. Frontiers of Cultural Anthropology: Social Organisation. *Proceedings of the American Philosophical Society*, October 1969, Vol. 113, No 5.

Grandaunet, Aud. Det er mest vi jentene. Unpublished "hovedfag" thesis. University of Oslo, 1981.

Grønhaug, Reidar. Micro-Macro Relations Part II. *Occasional Paper, Department of Social Anthropology, University of Bergen*, No 7, Bergen, 1974.

Gulbrandsen, Lars and Torgersen, Ulf. Private Sentiments in a Public Context: Aspects of Cooperative Housing in Oslo. *Scandinavian Political Studies*, 1978, No. 4, pp. 255–283.

Gulbrandsen, Lars and Torgersen, Ulf. Rusling i et minefelt. *Kontrast*, 1981, 6, pp. 6–21.

Gullestad, Marianne. Lokalsamfunnsbegrepet og dets anvendelse i studiet av bysamfunn. /: Thuen, T. and Wadel, C. (Eds.) *Lokale samfunn og offentlig planlegging*. Oslo: Universitetsforlaget, 1978.

Gullestad, Marianne. Arbeidsdeling, forvaltning av lønnsinntekter og makt i familien. *Tidsskrift for samfunnsforskning*, 1978, Volume 19, pp. 415–430.

Gullestad, Marianne. Ulønnet arbeid i husholdningen. /: *Konsumenten i samhället*. Stockholm: Rabén & Sjøgren, 1978.

Gullestad, Marianne. *Livet i en gammel bydel*. Oslo: Aschehough, 1979.

Gullestad, Marianne. Passepiken. Om større barns tilsyn med og omsorg for mindre barn i en by i dag. *Tidsskrift for samfunnsforskning*, 1979, Volume 20, pp. 523–545.

Gullestad, Marianne. Dramatiske hendelser, kritiske variabler og etableringsfasen i familiens utviklingssyklus. /: Unge familier i Etableringsfasen. *Nordisk Utredningsserie*, Oslo 1980:17.

Gullestad, Marianne. Barnevaktens etnografi. Om bygging, vedlikehold og endring av sosiale nettverk i et norsk bymiljø idag. *Arbeidsnotat, RFSP Byforskningsprogram "Nærmiljø" No. 10.* Universitetet i Trondheim 1981.

Gullestad, Marianne. Socialantropoligiske perspektiver på husholdet. /: I. Rudie (Ed.), *Myk start, hard landing.* Forthcoming. Oslo: Universitetsforlaget, 1984.

Hannerz, Ulf. *Soulside. Inquiries into Ghetto Culture and Community.* New York and London: Columbia University Press, 1969.

Hannerz, Ulf. The Urban Village and Beyond. Paper read on Symposium on City Life. American Association for the Advancement of Science. Philadelphia. Pa., December 28, 1971.

Hannerz, Ulf. *Exploring the City. Inquiries Toward an Urban Anthropology.* New York: Columbia University Press, 1980.

Haugen, Inger. Om forvaltning av utilgjengelighet. *Tidsskrift for samfunnsforskning*, 1978, Volume 19.

Haugen, Inger and Holtedahl, Lisbeth. Regulating Togetherness. *Acta Sociologica*, 1982, Vol. 25, No. 1.

Hauglin, Otto. Religionen. /: N. R. Ramsøy and M. Vaa (Eds.), *Det Norske samfunn.* Oslo: Gyldendal, 1975.

Hoel, Marit. Arbeidertradisjon og kvinnefellesskap i industribedrifter. /: H. Holter (Ed.), *Kvinner i fellesskap.* Oslo: Universitetsforlaget, 1982.

Holtedahl, Lisbeth. Kan forhold mellom mennesker planlegges? *Plan og arbeid*, 1978.

Holtedahl, Lisbeth. Lokalkultur er kvinnekultur i Veggefjord. /: H. Holter (Ed.), *Kvinner i fellesskap.* Oslo: Universitetsforlaget, 1982.

Holter, Harriet. Husmoren: En sosial rolle i omforming. *Tidsskrift for samfunnsforskning*, 1966.

Holter, Harriet. Nærmiljø og sosialpolitisk forskning. *Tidsskrift for samfunnsforskning*, 1973, bd. 14.

Holter, H., Ve Henriksen, H., Gjertsen, A., Hjort, H. *Familien i klassesamfunnet.* Oslo: Pax forlag, 1975.

Holter, Harriet (Ed.). *Kvinner og fellesskap.* Oslo: Universitetsforlaget, 1982.

Holter, H. Von der Lippe, A. and Haavind, H. Venninner. /: H. Holter (Ed.), *Kvinner i fellesskap.* Oslo: Universitetsforlaget, 1982.

Holter, Øystein Gullvåg. *Sjekking, kjærlighet og kjønnsmarked*, Oslo: Pax forlag, 1981.

Hsu (Ed.). *Kinship and Culture.* Chicago: Aldine, 1971.

Haavind, Hanne. Omsorgsfunksjoner i småbarnsfamilier. /: Lønnet og ulønnet omsorg. *Arbeidsnotat, NAVF's sekretariat for kvinneforskning*, nr. 5, 1979.

Jacobs, Sue-Ellen. *Women in Perspective. A Guide for Cross-Cultural Studies.* Urbana: University of Illinois Press, 1974.

Jayawardena, Chandra. Ideology and Conflict in Lower Class Communities. *Comparative Studies in Society and History.* 1967–1968, Volume X, pp. 413–446.

Jensen, An-Magritt. Work, Children and Equality. On the adaptation of women to work and family. *Artikler fra Statistisk Sentralbyrå*, nr. 129, Central Bureau of Statistics, Oslo, 1981.

Jensen, An-Magritt. Number of Children and Female Employment. *Artikler fra Statistisk Sentralbyrå*, nr. 132, Central Bureau of Statistics of Norway, Oslo, 1981.

Kalleberg, Annemor. Familiebinding, jobbutforming og arbeidsmarked. En

analyse av kvinner i rengjøringssektoren. /: T. Hanish *et al* (Eds.), *Marked for arbeid*. Oslo: Universitetsforlaget, 1980.

Larsen, Tord. På jakt etter den norske konfigurasjonen. Paper presented at the annual seminar of the Norwegian Anthropological Association, Finse, June 1982.

Keesing, R. M. Towards a Model Role Analysis. /: R. Narrol & R. Cohen (Eds.), *A Handbook of Method in Cultural Anthropology*. New York: Columbia University Press, 1973.

Kjølsrud, Lise. Å bo som livsprosjekt. *Kontrast* 6, 1981.

Lamphere, Louise. Review Essay: Anthropology. *Signs: Journal of Women in Culture and Society* 1977, 2, no 3, pp. 612–27.

Larsen, Sidsel Saugestad. Omsorgsbonden – et tidsnyttingsperspektiv på yrkes-kombinasjon, arbeidsdeling og sosial endring. *Tidsskrift for samfunnsforskning*, 1980.

Leach, Edmund. Ritual. /: *International Encyclopedia of the Social Sciences*, 9–10. London: Collier – MacMillan, 1968.

Lévi-Strauss, Claude. *The Raw and the Cooked*. Ouverture pp. 1–32. New York: Harper Torchbooks, 1969.

Lie, Merete. Kveldsjenter og dagjenter, ungjenter og gamlejenter. /: H. Holter (Ed.), *Kvinner i fellesskap*. Oslo: Universitetsforlaget, 1982.

Liljestrøm, Rita *et al*. Roller i omvandling. *Statens offentliga utredningar 1976:71*, Justitiedepartementet, Stockholm, 1976.

Løfgren, Orvar. Family and Household among Scandinavian Peasants: An exploratory Essay. *Ethnologica Scandinavia*, 1974.

Lysgaard, Sverre. *Arbeiderkollektivet – En studie i de underordnedes sosiologi*. Oslo: Universitetsforlaget 1961.

Mauss, Marcel. *The Gift. Forms and Functions of Exchange in Archaic Societies* London: Cohen & West Ltd., 1966.

McCall, G. J. and Simmons, J. L. *Identities and Interactions*. New York: The Free Press, 1966.

Mead, Margaret. *Coming of Age in Samoa*. (First published 1928.) Middlesex: Penguin Books, 1943.

Mead, Margaret. *Sex and Temperament in Three Primitive Societies*. (First published 1935). Reprinted, New York: Dell, 1963.

Mead, Margaret. *Male and Female*. (First published 1949). Middlesex: Penguin Books, 1962.

Mead, Margaret. *Growing up in New Guinea*. New York: Mentor, 1961.

Moxnes, Kari. *Når kvinner vil skilles*. Oslo: Pax Forlag, 1981.

Oakley, Ann. *Housewife*. London: Allen Lane, Penguin Books, 1974.

Oakley, Ann. *The Sociology of Housework*. London: Martin Robertson Bath, 1974.

Park, George K. Sons and Lovers: Characterological Requisites of the Roles in a Peasant Society. *Ethnology*, October 1962, Vol. 1, No 4.

Park, George K. Regional Versions of Norwegian Culture: a Trial Formulation. *Ethnology*, January 1972, Volume XI, No 1.

Quinn, Naomi. Anthropological Studies on Women's Status, *Annual Review of Anthropology* 6, 1977, pp 181–222.

Rasmussen, Anne. Unge piker på en havnekafé. Et utviklingsperspektiv på deres samhandlingsformer i forhold til menn. Unpublished "hovedfag" thesis. Uni-

versity of Bergen, 1969.

Rasmussen, Anne. Dårlig rykte er kvinneskjebne. /: I. Rudie (Ed.), *Myk start, hard landing*. Forthcoming. Oslo: Universitetsforlaget, 1984.

Reiter, Rayna R., (Ed.). *Toward an Anthropology of Women*. New York: Monthly Review Press, 1975.

Rosaldo, M. Z. and Lamphere, L., (Eds.). *Woman Culture and Society*. Stanford: Stanford University Press, 1974.

Rosaldo, M. Z. The Use and Abuse of Anthropology: Reflections on Feminism and Cross-cultural Understanding. *Signs*, 1980, vol. 5, no 3, pp. 389–417.

Rudie, Ingrid. Household Organization: Adaptive Process and Restrictive Form. A Viewpoint on Economic Change. *Folk*, 1969/70, 11–12.

Rudie, Ingrid. Introduction. /: I. Rudie (Ed.), *Myk start, hard landing*. Forthcoming. Oslo: Universitetsforlaget, 1984.

Schlegel, Alice (Ed.). *Sexual Stratification. A Cross-cultural View*. New York: Columbia University Press, 1977

Skirbrekk, Gunnar. Nasjon og natur. Et essay om den norske veremåten. /: Eit våpen mot vanen. Oslo: Samlaget, 1981.

Solberg, Anne. Guttene får lønn og jentene får hverandre. /: H. Holter (Ed.), *Kvinner i fellesskap*. Oslo: Universitetsforlaget, 1982.

Solheim, Liv. Familieflytting og kvinnetilpassing. /: I. Rudie (Ed.), *Myk start, hard landing*. Forthcoming. Oslo: Universitetsforlaget, 1984.

Spradley, J. P. and Mann, B. *The Cocktail Waitress: Woman's Work in a Man's World*. New York: Wiley, 1975.

Stack, Carol. *All our kin. Strategies for Survival in a Black Community*. New York: Harper & Row. 1975.

Stack, Carol B. et. al. Anthropology. Review Essay *Signs*, 1975, Volume 1, pp. 147–159.

Sundt, Eilert. *Om giftermål i Norge*. (Christiania 1855) Oslo: Universitetsforlaget, 1967.

Sundt, Eilert. *Om renligheds-stellet i Norge*. (Christiania 1869) Oslo; Gyldendal 1975.

Tambs-Lyche, Harald. *London Patidars. A Case Study in Urban Ethnicity*. London: Routledge and Kegan Paul, 1980.

Thomsen, Michael. Det e' den løgneste gaten så går i to sko. Unpublished "magistergrad" thesis. University of Bergen, 1981.

Ve, Hildur. Skilsmisse og samfunnsendring. /: Kirsti Bull (Ed.), *Skilsmisse. En samling artikler til hjelp for alle som berøres av en skilsmisse*. Oslo: Gyldendal, 1979.

Wadel, Cato. *Now, Whose Fault is that? The Struggle for Self-Esteem in the Face of Chronic Unemployment*. Memorial University of Newfoundland. Newfoundland Social and Economic Studies No 11. University of Toronto Press, 1973.

Weber, Max. *Makt og Byråkrati*. (First published in Germany, 1922.) Oslo: Gyldendal, 1971.

Weiner, Annette B. *Women of Value, Men of Renown. New Perspectives in Trobriand Exchange*. Austin: University of Texas Press, 1976.

Whyte, William Foote. *Street Corner Society*. Chicago: The University of Chicago Press, 1943.

Wirth, Louis. Urbanism as a Way of Life. *American Journal of Sociology*, 1938, 44, 1–24. Reprinted in A. J. Reiss (Ed.), *On Cities and Social Life*. Chicago:

The University of Chicago Press, 1964.

Wolf, Eric R. Kinship, Friendship and Patron-Client Relations in Complex Societies. /: M. Banton (Ed.), *A.S.A. Monographs*, no 4, The Social Anthropology of Complex Societies. London: Tavistock, 1966.

Wolf, Margery. Chinese Women: Old Skills in a New Context. /: M. Z. Rosaldo and L. Lamphere (Eds.), *Woman, Culture and Society*.. Stanford: Stanford University Press, 1974.

Wright, Erik Olin. The Class Structure of Advanced Capitalist Societies. /: E. O. Wright, *Class Crisis and the State*. London: New Left Books, 1978.

Wright, Erik Olin. Varieties of Marxist Conceptions of Class Structure. *Politics and Society* 1980, Volume 9, No 3, pp 323–370.

Wærness, Kari. Kvinners omsorgsarbeid i den ulønnete produksjon. *Arbeidsnotat nr. 80. Levekårsundersøkelsen*, Bergen 1975.

Wærness, Kari. *Kvinneperspektiver på sosialpolitikken*. Oslo: Universitetsforlaget, 1982.

Yanagisako, Sylvia Junko. Family and Household: The Analysis of Domestic Groups. *Annual Review of Anthropology*, 1979, 8, pp. 161–205.

Young, Michael and Willmott, Peter. *Family and Kinship in East London*. (First published, London, 1957). Reprinted in Pelican books, 1962.

Øidne, Gabriel. Litt om motsetninga mellom Austlandet og Vestlandet. *Syn og Segn*, 1975.

Østerberg, Dag. Helhetlig beskrivelse av det norske samfunnet. (Innlegg på Sosiologforeningens vinterseminar, januar 1982.) *Sosiolognytt*, 1982, 1.

Ås, Berit. Om kvinnekultur. *Acta Sociologica*, 1975, 2–3.

Ås, Berit. Tilbakeblikk og sideblikk på begrepet kvinnekultur. /: Haukaa, R., Hoel, M., Haavind, H. (Eds.), *Kvinneforskning: Bidrag til samfunnsteori*. Oslo: Universitetsforlaget, 1982.

Aase, A. and Dale, B. Levekår i storby. *Norges Offentlige Utredninger*. 1978:52. Oslo: Universitetsforlaget, 1978.